POSTMODERN CURRENTS

POSTMODERN CURRENTS

Art and Artists
in the Age
of Electronic Media

Second Edition

Margot Lovejoy

Prentice Hall
Upper Saddle River, New Jersey 07458

Library of Congress Cataloging-in-Publication Data

Lovejoy, Margot.
 Postmodern currents : art and artists in the age of electronic
media / Margot Lovejoy. — 2nd ed.
 p. cm.
 Includes bibliographical references and index.
 ISBN 0-13-158759-5
 1. Postmodernism—United States. 2. Technology and the arts-
-United States. 3. Computer art—United States. 4. Video art-
-United States. I. Title.
NX180.M3L68 1997
700'.1'05—dc20

96-15913
CIP

Acquisitions editor: *Bud Therien*
Assistant editor: *Marion Gottlieb*
Production editor: *Jean Lapidus*
Copy editor: *Maria Caruso*
Manufacturing buyer: *Bob Anderson*
Cover design: *Bruce Kenselaar*
Cover photos: Three-pronged electric plugs.
 Courtesy of Margot Lovejoy.

Back cover copy credits:
Reprinted by permission of Cynthia Navaretta, editor,
 Women Artists News, V. 14, No. 3, Fall 1989.
Reprinted by permission of Roger Malina, Executive Editor,
 Leonardo Magazine, V. 24, No. 2, 1991.
Reprinted by permission of Joseph Nechvatal,
 Meaning #6 (Paris, France).

This book was set in 10.5/12.5 Weiss by Black Dot Graphics,
and was printed and bound by Courier Companies, Inc.
The cover was printed by Phoenix Color Corp.

Printed in the United States of America
10 9 8 7 6 5 4 3

ISBN 0-13-158759-5

PRENTICE-HALL INTERNATIONAL (UK) LIMITED, *London*
PRENTICE-HALL OF AUSTRALIA PTY. LIMITED, *Sydney*
PRENTICE-HALL CANADA INC, *Toronto*
PRENTICE-HALL HISPANOAMERICANA, S.A., *Mexico*
PRENTICE-HALL OF INDIA PRIVATE LIMITED, *New Delhi*
PRENTICE-HALL OF JAPAN, INC., *Tokyo*
SIMON & SCHUSTER ASIA PTE. LTD., *Singapore*
EDITORA PRENTICE-HALL DO BRASIL, LTDA., *Rio de Janeiro*

Figure 1 Mark Kostabi, Ink on Paper, *Electric Family,* (**Frontispiece**). *(Courtesy Ronald Feldman Line Arts, Inc., N.Y.)*

Contents

Figures

Foreword

Because innovation is continuous, it is difficult to establish precise boundaries between historical periods. Which painting or building signals the beginning of the Renaissance? Which work of the imagination or of scientific discovery signals its end? Answers to such questions are bound to seem arbitrary. Surely a historical period is not just the temporal site of certain artifacts and discrete intellectual events. We give names like "medieval" and "Renaissance" and "modern" to stretches of time that appear to be unified by characteristic beliefs and procedures—or, what is more to the point of Margot Lovejoy's *Postmodern Currents: Art and Artists in the Age of Electronic Media*, periods disrupted by characteristic conflicts.

No society can prevent discord in the relations between individuals and institutions. We know from our own experience and historical memory that those relations have often been difficult, even violent, in modern times. Politics attained modernity in the American and French revolutions. The burst of scientific and technological development in the late eighteenth century is called the Industrial Revolution, a phrase that evokes riot and new poverty, as well as abundant goods and new wealth. Nonetheless, we are sometimes tempted to assume that modern conflict differs from earlier varieties only in degree, not in kind. This assumption leads to the comforting reflection that certain other periods may have been even more violent than ours. Perhaps they were. But the relations between selves and institutions during the past two centuries have inflicted on ordinary life a new kind, not simply a new degree, of harshness.

The modern period began when technological change speeded up to the point where succeeding generations could no longer feel certain that they lived in the same world. As Lovejoy's *Postmodern Currents* documents in vivid detail, modern technology disrupts the history of experience; it changes not only the landscape but the way that landscape is seen. It shapes perception and induces a new kind of uneasiness, the distrust we feel toward tools and convenience that we would be reluctant to do without—devices that have, after all, done much to define what we are. But why should the familiar things of our world—automobiles, television sets, computers—be such frequent targets of our distrust? Lovejoy suggests an answer in her discussion of artists' access to high-level computer and video technologies.

Access is difficult when innovations sponsored by large corporate and governmental institutions remain under their control, as they so often do. No television network is likely to offer itself as an artist's medium, so video artists must work at a smaller scale. Yet, no matter how intimate and productive one's interaction with technology, there is always the sense that it remains the instrument of institutional authority that by its nature stands in opposition to the self.

And the still increasing rate of technological development makes that opposition particularly effective. Often bureaucracies and marketplaces can maintain an ascendancy over individuals (including their own personnel) simply by sustaining change at a destabilizing pace. During the past two centuries, to be a self is to be under relentless pressure to catch up. This pressure has no precedent in earlier times. Individuals were not prepared for it two centuries ago, nor have we adapted to it yet. Artists try to relieve the pressure of change by extricating technology from institutional agendas—that is, some artists engage in that struggle.

Lovejoy draws a distinction between artists who flee technology and those who try to engage it on terms other than the ones dictated by institutional purposes. The contrast is between art as nostalgia for a premodern, premechanical pastoral and art as a means of grappling with a quick-moving present. From this distinction follows another: between the artists who engaged their art with mechanical and photo-mechanical technology and those who grapple with the electronic technology that has appeared in the last few decades. Among the first group are Marcel Duchamp, the Dadaists and Surrealists, and the Pop artists—most notably Andy Warhol, who, as Lovejoy recalls, went so far in embracing the machine as to wish that he could become one himself. The second group is not so well known. Museums and galleries still do not pay much attention to video and computer artists. *Postmodern Currents* is an indispensable guide to an area of culture that is treated as marginal but has already become more central as the electronic media more powerfully define us and our world. Lovejoy singles out for close examination the artists who carry on with the task that has occupied the most courageous sensibilities since the time of the Industrial Revolution: to experiment with advanced technology not for some definable gain but for the sake of making it a more helpful mediator between individuals and institutions. Shaped by aesthetic motives, technology will be better at shaping us.

Carter Ratcliff

Preface

I have written this book out of a mixture of puzzlement, fascination, curiosity, and finally, commitment to share what I have learned over the many years it has taken to complete my investigation. It grows out of the concerns artists have about the development of art and the influence of technology on culture as a whole. Because artists' work is necessarily in the vanguard relative to later interpretation of it by art historians or critics, this book is meant as a frame of reference for the future. It is a survey designed to penetrate the morass of issues and historical detail, to uncover cross-disciplinary connections. In studying the ways technology changes the way art is produced, disseminated, and valued, and how new art forms grow from new tools for representation and new conditions for communication, I examined the conditions of our postmodern electronic age to find the roots of the present crisis in art.

Because this book is a survey, a major regret on my part is that I cannot include more of the important art works and artists. I have been only able to touch the tip of the proverbial iceberg. Difficult choices had to be made in order to complete my task without too much digression from the points that needed to be covered. Because each area of electronic media is now so large and has so many practitioners, I had to decide whether to present more historical illustrations or more current work. I tended toward the latter. As in any survey, much of the material has had to be greatly condensed. Although some technological information presented here will inevitably be superseded by new developments even before *Postmodern Currents* appears in print, I believe reporting on the current status of technology will help to create a flavor for the issues under discussion. Changes are occurring at an ever-increasing tempo. It is my hope that the reader will find this book to be an important signal along the path.

Margot Lovejoy

Acknowledgments

This book would not have been possible without the vital help of Kristin Lovejoy for her fundamental conceptual and research contribution; Ruth Danon for her consummate editorial expertise; Grai St. Clair Rice for image research; and my husband Derek, for his enduring support. To each, my profound thanks.

Apart from the many artists, galleries, and colleagues who helped make this book a reality, I owe a special thanks to the State University of New York at Purchase. A Guggenheim Fellowship is also partially responsible for the freedom needed to complete this work.

The author also thanks the following reviewers for their helpful comments: Kevin McCoy & Jennifer McCoy, University of North Carolina, Charlotte; Clifton Meador, SUNY New Paltz; Berta M. Sichel, New School For Social Research; Lisa Odham Stokes, Seminole Community College; Timothy Druckrey; and Benjamin Weil, äda'web.

Introduction

Our fine arts were developed, their types and uses were established, in times very different from the present, by men whose power of action upon things was insignificant in comparison with ours. But the amazing growth of our techniques, the adaptability and precision they have attained, the ideas and habits they are creating, make it a certainty that profound changes are impending in the ancient craft of the Beautiful. In all the arts there is a physical component which can no longer be considered or treated as it used to be, which cannot remain unaffected by our modern knowledge and power. . . . We must expect great innovations to transform the entire technique of the arts, thereby affecting artistic invention itself and perhaps even bringing about an amazing change in our very notion of art.

—*Paul Valéry*[1]

Living at the end of the twentieth century in new conditions produced by the electronic era, artists confront a revised cultural and technological context. The purpose of this book is to examine the relationship between technological development and aesthetic change. It views the cultural crisis of the present postindustrial age as parallel to the wrenching cultural, aesthetic and social crisis brought about by the Industrial Revolution.

Fundamental to the understanding of the impact of technological media on society as a whole, as well as on perception and the fine arts, is the work of Walter Benjamin.[2] He brought into a key position in critical discourse awareness of the relationship between art and technology. He argued that widespread integrated changes in technological conditions can affect the collective consciousness and trigger important changes in cultural development. His essay "The Work of Art in the Age of Mechanical Reproduction," (1936) is a significant assessment of the pivotal role played by photographic technologies (first as catalyst, then as instrument for change) in twentieth century art.

Benjamin was the first to study mass culture as a focus of philosophic analysis. In "Author as Producer" Benjamin anticipated the current crisis of identity, and the loss of moral authority of the author/artist. His interdisciplinary thinking anticipated the interwoven, layered structuring of associations and observations that has come to be understood as the postmodern. It is clear from his writing, particularly the "Arcades Project," that, while Benjamin understood the potentially positive influence of technology on art and on culture, he was also aware of the major losses created by what he called the loss of "aura," that sense of uniqueness and primal consciousness that attaches to a singular work of art and that is lost in reproduction. Whether consciously or subconsciously the

1

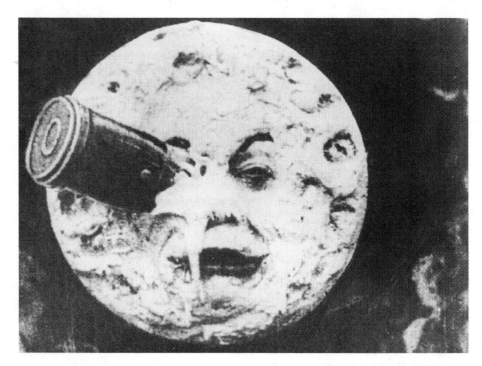

Figure 2. George Méliès, *Le Voyage dans la Lune*, 1902, Film Still. (*Museum of Modern Art/Film Stills Archive, New York*)

independence and the deep integrity of his thinking led him to move philosophy beyond what Adorno called the "frozen wasteland of abstraction" to a concrete engagement with historical concerns and images.[3] This entailed endless examination of the forces that formulate culture. His work is still alive for us today as a medium for "fertilizing the present."[4]

His work has influenced contemporary cultural critics and theorists including Roland Barthes, François Lyotard, Jean Baudrillard, Michel Foucault, and Jacques Derrida. In addition, aspects of his thought have deeply affected a generation of writers such as John Berger, Raymond Williams, Geoffrey Hartman, Celeste Olalquiaga, and Brian Wallis. His writings are included in important collections of postmodern essays such as "Art After Modernism: Rethinking Representation" (ed. Brian Wallis) and "Video Culture" (ed. John Hanhardt), among many others. Several of his essays serve as benchmarks for today's generation of students of the social sciences and the arts.

Cultural studies, which have gone beyond Benjamin to provide the most illuminating commentary on current representation issues vis-à-vis mass media and technological conditions, come from several sources: Baudrillard on simu-

lacra, simulation, and the hyperreal; Barthes and Foucault on intertextuality and interactivity; Derrida and the feminist movement on deconstruction. These theoretical understandings, which further those of Benjamin, are useful tools for probing and exploring art in its relationship to technology. This is so, especially now that it can be demonstrated that some of these theoretical concepts closely correspond to the structure and functioning of electronic media tools themselves.

I have written this book out of a need to explore the impact of electronic media on representation and on our culture as a whole, and, in the process, to extend the theories of Benjamin. Photography and cinematography created what Benjamin called "a shattering of tradition," a crisis in representation without fundamentally shifting the Western paradigm of art. However, digital simulation has finally shattered the paradigm of representation we have been operating under since the Renaissance. We are now, in many ways, living in a new world.

In this book I am using a definition of representation which refers to a system of iconography which contains both the perceptual and the aesthetic when related to art and has conventions of both tool and medium inscribed in it. At different moments of history, it changes relative to a paradigm which contains within it the unified framing of agreed upon assumptions that shape the understanding of what art is in a particular time period. Images or objects artists construct are not just simple responses to individual experience. They are always ordered, coded, and styled according to conventions which develop out of the practice of each medium with its tools and process, whether the medium is a traditional one such as painting, sculpture, printmaking, photography, or an electronic one such as video or computer. Artists' vision and artists' responses to the world are dominated by the conditions and consciousness of a particular time period.

The invention of the camera (Chapter 1) changed the nature of representation in drastic ways. Photographic images depend on the variable gaze of the camera eye. Photographs are inseparable from time passing and from the specific placement of visual reality. Cinematography provides the possibility of multiple viewpoints. The camera moves, rises, falls, distances objects, moves in close to them—coordinating all angles of view in a complex juxtaposition of images moving in time. Film (and video) offer a deepening of perception, for they permit analysis of different points of view and they extend comprehension beyond our immediate understanding by revealing much as did the microscope and the telescope in the Renaissance entirely new structures of a subject beyond those available to the naked eye alone.

The modern period, most often described as the period between the end of the Enlightenment (corresponding to the end of the eighteenth century) and the middle of the twentieth century, has been described from a variety of posi-

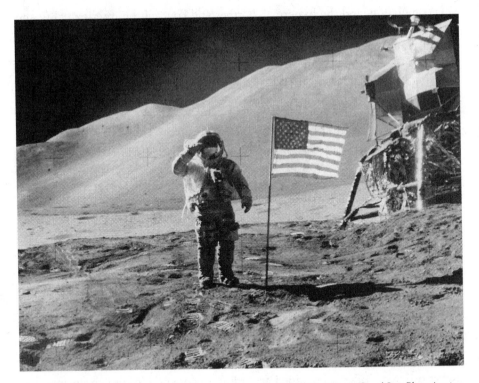

Figure 3. National Aeronautics and Space Administration (NASA), *Astronaut David Scott Plants American Flag on the Moon*, July 26, 1971. These two images reflect powerful changes in our awareness. Méliès's 1902 fantasy film about the moon landing evokes "man on the moon" mythologies—green cheese and all the clichés still embedded in our vocabularies about the moon. The 1971 reality of the moon landing, as seen internationally on living-room television screens, created a major generation gap between adults who saw it as proof of the impossible come true, and their young children, who saw it as just an every-day event on TV. For the children, it was the basis of the expectations of their age. Today's generation witnessed the 1988 scaling of Mt. Everest via a miniaturized TV camera so small it could be placed in the headgear of one of the climbers.

tions. In the use Walter Benjamin made of the term, "modernism" referred to a diverse historical period which evolved in the conditions and context of the Machine Age. New forms of representation such as photography and cine-matography contributed to a new consciousness and to more modern ways of seeing which reflected the idealism of a faith in progress through technological progress.

Benjamin pointed out, however, that the discovery of photographic tech-nologies from 1850 onward essentially undermined the existing function of art, not only because photography and photomechanical reproduction could pro-

vide visual reportage, but because it threatened the "aura" and value of the original, the handmade object that relied on the specialized skills of the artist. He understood that once a camera records images or events unique to a particular place and time, a disruption of privacy takes place. Its uniqueness is destroyed. A loss of its original magic, spirit, authenticity, or "aura" takes place. John Berger comments that in our present culture the unique is evaluated and defined as an object whose value depends upon its rarity and status as gauged by the price it fetches on the market. But because the value of a work of art is thought to have a value greater than a commercial one, it can be explained only in terms of "holy objects": objects which are first and foremost evidence of their own survival.[5] The past in which they originated is studied in order to validate them. Once the work is seen in many different contexts, e.g., reproduced in different forms such as a postage stamp or as a billboard, its meaning changes. It begins to mean something else and fragments into new sets of fresh associations.

Photography is not simply a visual medium but is also a photo-mechanical tool, a means of reproducing endless copies from a single original, an aspect that Benjamin acknowledged as the major factor affecting art in its relation to the age of mechanical reproduction. The copying processes of photography undermined the aura of the original and its value in the marketplace. Thus, it threatened the existing foundations of the art establishment which were based on hand skills, reflecting the genius of the artist. Photographic reproduction and the cinema raised social questions about the artist's role, about the audience for art, about art as communication rather than art as object, and thus brought into focus the social function of art. Because of its threat to the art object and the issues it raised in its association with Machine Age copying processes, as well as its challenge to established canons and institutions of art, photography's full development as a medium for art and its acceptance as a viable fine art form were suppressed until the beginning of the postmodern period.

Rather than using photography directly as a medium for their work, painters were moved from a preoccupation with forms of illusion and realism toward attitudes that led to abstraction and formalism. Many artists used photography indirectly as a tool or reference or aid in their drawing and painting activities only in the privacy of their studios. However, many were influenced by the aesthetic aspects of the new form of representation. The works of Manet and Degas reflect the influence of photographic imaging in the flatness of the pictorial space and in the unexpected and informal composition associated with photographic instantaneity.

Three avant-garde strains developed in reaction to the Machine Age (Chapter 2). Although both movements used photography and technology, they took different routes. On the one hand, the Dadaists and Surrealists developed strategies to use machine parts and photomontage as a means of commenting

on the alienating influence of rampant industrialization and the commercialization of mainstream art. On the other, the Constructivists and Futurists extolled the aesthetics of photographic reproduction, seeing hope in the machine age for a new kind of culture. They used photo-mechanical technology to extend and distribute their work. Paradoxically, the Cubists, whose painting aesthetic was deeply influenced by the visual experiments of Marey's chronophotography, did not use photography directly. Similarly, although the Bauhaus used machines to manufacture their work, they created an aesthetic of pure form.

By the thirties, the term "Modernism" came to refer to a special institutionalized movement, an aesthetic understanding of art shaped by the systematic critical writings of Clement Greenberg in essays he published between the 1930s and 1960s. Greenberg argued that art practice conformed to immaculate, linear laws of progression that were verifiable and objective. He favored an

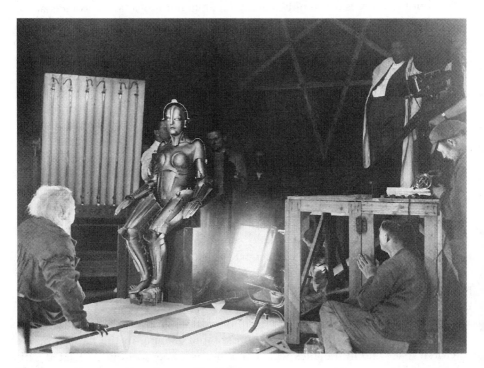

Figure 4. Fritz Lang, *Metropolis*, 1926, Film Still. Lang constructs a terrifying image of a twenty-first century totalitarian society dominated by technology. Here, he is shown on set shooting a scene from *Metropolis*, his last major silent film, where the mad scientist Rotwang reveals "The False Maria" robot he has created—the personification of technology used for evil persuasive purposes. (*Museum of Modern Art/Film Stills Archive, New York*)

understanding of art as pure form, a stance that excluded any literary or theatrical references or descriptions and shut out the real world as subject matter.

Mainstream Abstract Expressionist painting and sculpture, were countered by an avant-garde that centered around the ideas of Marcel Duchamp and the Pop movement. While the European avant-garde was more political in its opposition to the status quo and to technological conditions, the American Pop

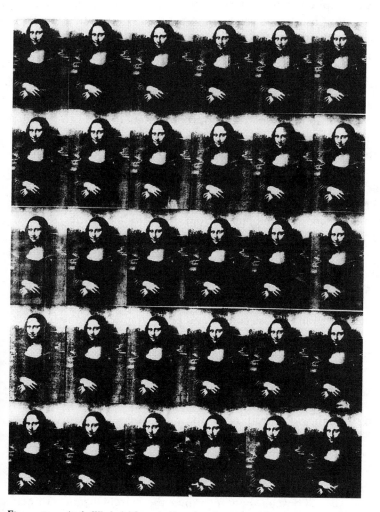

Figure 5. Andy Warhol, *Thirty Are Better than One*, 1963. Silkscreen on canvas, 110¼″ × 82¼″. Warhol creates an "original" constructed of thirty copies of the original. His appropriation of the most famous cultural icon of all time is a comment on the power of reproductive media to promote celebrity. *(Photo: Nathan Rabin)*

movement was avant-garde in its adoption of industrial technologies for making its work. When Andy Warhol began silk-screening photo images directly onto his canvasses, Pop artists began the appropriation of mass culture, photo-mechanically reproducing images directly into the field of painting. In so doing, they bypassed dealing with the social implications of photography raised by Benjamin. Although many photographers such as Stieglitz and Steichen asserted photography as a fine art medium, it was not until after its reproductive technology was brought directly into the field of painting by Pop artists, more than one hundred years after its invention, that it was accepted into the canon as a fine art medium like any other.

Postmodernism (Chapter 3) is a shift to an essentially far broader territory in which the suppression of social and cultural influence is no longer possible. The defining moment in the visual arts, when the shift to Postmodernism began, was the late fifties when architectural forms of representation began to be radically revised away from pure formalist tendencies towards a more "vernacular" style. The aloofness of the steel curtain walls with their purity and rationality seemed at odds with the times. New technological conditions, including electronic communication networks such as TV had deeply invaded private space creating a new kind of cultural infrastructure. Postindustrial capitalism based on electronic technologies under development from the fifties and sixties, ushered in a new kind of "information society," a "society of the spectacle."

Avant-garde movements in the sixties and seventies moved in opposition to the still-dominant modernist aesthetic, toward an expanded dematerialized view of art, for example, Earth Art, Fluxus, Performance, Conceptual Art, and work that incorporated the new electronic media tools, especially video and the computer. The incorporation of mass culture and photography into the fine arts by the Pop Movement, in tandem with the use in the arts of new forms of electronic representation marks the moment of a major crisis for representation.

Ironically, once photography was accepted into the fine arts canon, all the issues denied for so long under the rubric of modernism became the very focus, the very means of deconstructing modernism. The deconstruction of the fine arts canon began through widespread use of the tools of critical theory, whose influence emerged in the seventies. Of particular importance were the issues brought out earlier by Walter Benjamin (about aura, identity, the copy and the original, death of the author, originality, and genius); along with poststructuralism, psychoanalysis, and feminist theory. This process of deconstruction particularly by feminists, raised consciousness regarding the marginalization of certain artists not only because of gender, but because of race or class. Artists began to use theoretical issues as the very subject matter of their work.

In the arts, electronic media such as video and the computer challenge older modes of representation. New media have created postmodern conditions

and have changed the way art itself is viewed. Culturally, it is characterized by major change: From the concept of a single Eurocentric cultural stream dominated by white male privilege to one which recognizes diverse identities and voices interacting in a complex web of ideological and behaviorist associations. It is further characterized by the impact of mediated images on perception; by deconstruction of the major canons and narratives that have up to now formed Western thought; and by the development of a visual culture, transmitted by electronic technologies which have consciousness transforming-capacity, superseding one that relied mainly on the word.

Video was welcomed as a powerful new form of representation—a time/space medium capable of broadcast and transmission of images and sound over long distances. It was welcomed by a diverse range of artists from many fields, (Chapter 4). At first, it was rooted in formal modernist concerns. As its technology evolved, it began to converge with TV and film. Although different from them, it also became a consciousness-transforming form of representation. It has now become part of an expanded multimedia territory where it is combined with the interactive capabilities of the computer, as in CD-ROM production, virtual reality, and interactive installation works. It is also used as a means for capturing moving images to connect to the Internet.

The digital simulation capabilities of the computer create a break with the paradigm of representation we have followed since the Renaissance. The computer has the capability of combining sound, text, and image within a single database. Images no longer reside in the visual field but in the database of the computer (Chapter 5). To see an image, the information about the image's structure of lights and darks must be called up for display. The image is thus an information structure which has no physical presence in the real world. Not only is it a dematerialized image, but it is also one that can be destabilized and constantly invaded, changed, and manipulated by a viewer interactively through software commands. This possibility for intervention and interaction challenges notions of a discrete work of art, one that is authored by the artist alone. An interactive work is one that uses branching systems and networks for creating connective links and nodes. The artist who decides to work with technology now assumes a different role in relationship to creating work, one similar to a systems designer, and the work takes on a different route in relationship to the viewer who participates in the work's ultimate unfolding and meaning.

George Landow, in his *Hypertext: The Convergence of Critical Theory and Technology*[6] demonstrates that, in the computer, we have an actual, functional convergence of technology with critical theory. The computer's very technological structure illustrates the theories of Benjamin, Foucault, and Barthes, all of whom pointed to what Barthes would name "the death of the author." The death happens immaterially and interactively, via the computer's operating system.

By the eighties, the growing crisis in representation brought about deep changes in both theory and practice. The pervasiveness of media technologies in modern society creates a new set of questions which call for new theories of the relation between language, behavior and belief, and between material reality and its cultural representation. Baudrillard speaks about the veritable bombardment of images and signs as causing an inward collapse of meaning where "reality is entirely constructed through forms of mass-media feedback where values are determined by consumer demand." Is there any absolute knowledge when there is no longer an authentic message; when there is only the absolute dominion of information as digitized memory storage banks? The constant melting down of forms causes a kind of "hyperreality," a loss of meaning as a result of the neutralization of difference and of opposition, which dissolves all claims to universal truth.

Unprecedented forms of communication are occurring as a result of global interactive computer communications on the World Wide Web, (Chapter 6).

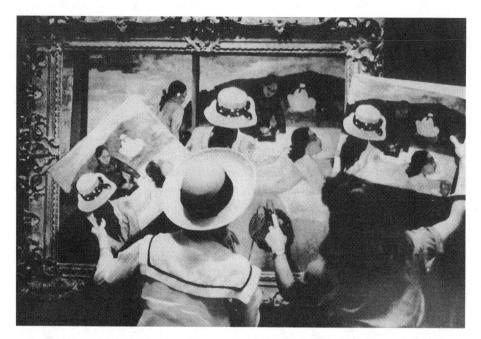

Figure 6. Paul Hosefros, *Gauguin and His Flatterers*, June 25, 1988. Photograph, *New York Times*. This Gauguin painting destined for sale to the public has its value increased by being shown on the front page of the *New York Times*. Copies of the original newspaper (sold for a few cents) show how copies of the original painting (sold for a few dollars) are here being compared to the original (sold for a few million). The right to reproduce this photographic copy (of the copies and the original) was purchased by the author of this book, for $100 to reproduce an agreed upon number of copies of the original.

Artists are now creating works for the Internet as interactive communication. The effect of technology is to expand the possibility for cultural growth and exchange. Fueled by market concerns, its evolution is breathtakingly fast. It is creating major social and cultural upheavals comparable to the social and cultural dislocation of the early Machine Age. Questions surface that still have no concrete answers. How will artists function in the new cyber environment? What role will art play in the evolving architecture of the electronic landscape? What kinds of cultural institutions will there be? What kinds of education will artists need?

Surveys offer the occasion for discovering crossover connections. This book is meant as an overview of the interrelationship between our technologized cultural conditions and artists' response to them. One of the goals of the book is to show how periods of major technological change transform consciousness, forcing a re-definition of representation and a disruption of the criteria used for evaluating it.

Inasmuch as any survey inevitably suffers from exclusions and from serious compression of the major critical and historical issues, this book is meant to function as a framework for discussion about the relationship between technology, representation, and perceptual and aesthetic change. I have written it out of my concerns as a contemporary artist aware of the gap in understanding in the relationship between art and technology. Since writing the book ten years ago, much has become clearer and much has shifted in my perception of technological change because of the rapidity of unfolding developments and their significance for the visual arts, particularly in the area of interactivity, and of virtual reality, and in the field of interactive telecommunications and the World Wide Web. In revising and updating it due to these major changes, I am addressing these new areas. Most of all, I wish to deepen the debate. Like many artists, I was excited by the promise of the new media. I am still engaged with them, but I cannot say that I do so without a great awareness of their dangerous social and cultural implications. I am also aware that the book is dealing with current issues and with technologies that rapidly become obsolete. My concern in writing it is to create the ground for future discussion about the relationship between art and technology.

Although this book does not attempt to break new ground, I have become aware of the need it fills for students who may be technologically adept but who do not understand the underlying issues. The book is also intended for art professionals including teachers of art history, critics, writers, artists, and for anyone interested in situating questions about the art of our time and the direction it is taking.

1

Vision, Representation, and Invention

The history of every art form shows critical epochs in which a certain art
form aspires to effects which could be fully obtained only with a changed
technical standard, that is to say, in a new art form.

—*Walter Benjamin*

Seeing Is Changing

The mind of any age is the eye of that age. Consciousness of the way the world
is understood changes at different moments in history relative to the available
knowledge of that period. A major shift in consciousness can change the
premises about how we should seek to understand the world; what is important
to look at and how we should represent it. Technological advances inform pow-
erfully our knowledge base and affect all the premises of life, altering the way
we see and think. They affect the content, philosophy, and style of artworks.
Technological development and artistic endeavor have always been closely
related in one way or another, whether in a linear sense or a paradoxical one.
Invention of technological tools for representation affect the way the world is
seen, how events are interpreted, and the way culture is formed.

Today's avalanche of powerful new representational electronic tools have
created a dramatic change in the premises for art, calling into question the way
we see, the way we acquire knowledge, and the way we understand it. Contem-
porary artists face a dilemma unimaginable even at the turn of the century when
photography and cinematography created a crisis in existing traditions of repre-
sentation. Electronic tools and media have shattered the very paradigm of cog-
nition and representation we have been operating under since the Renaissance.

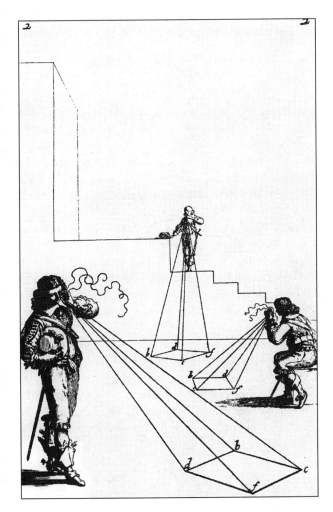

Figure 7. Abraham Bosse (1602–1676), *Perspective Drawing*. Sighting dimensional illusion using the mathematical structure of perspective.

Dick Higgins, contemporary poet, composer, publisher, and performance artist sums up the current paradigm shift by formulating a myth as illustration and by raising questions.

> Long ago, back when the world was young—that is, sometime around the year 1958—a lot of artists and composers and other people who wanted to do beautiful things began to look at the world around them in a new way (for them).

The Cognitive Questions (asked by most artists of the twentieth century, Platonic or Aristotelian till around 1958): "How can I interpret this world of which I am a part? And what am I in it?"
The Postcognitive Questions (asked by most artists since then): "Which world is this? What is to be done in it? Which of my selves is to do it?"[1]

What does it mean that a new form of digital hyperreality can be created through the agency of the computer? When the image is no longer located in the visual field but is located only as information in a database? What is the role of the artist in an interactive art work which invites the collaboration of the public to complete its meaning? Can art go completely beyond the object to be a form of communication located on the Internet for downloading through a localized printer? What is the function of art as a result of this major change? New technological media have transformed the nature of art, the way it communicates, the way it is distributed or transmitted. With the change of consciousness that accompanies the postmodern Electronic Era with its new technological tools for representation, the questions challenging artists today deepen and raise new ones: "How did we reach this point? What is the function of art? Is art unembodied communication? To whom am I speaking? How will I act?"

These questions force a confrontation with the legacy of artistic practices and myths rooted in the traditions of contemporary culture. This book is committed to seeking answers to these questions. To find a basis for answers to them and to create a new set of guiding assumptions, we must understand the relationship between technological development and artistic endeavor and how that relationship has profoundly influenced the evolution of culture since the Renaissance.

Vision and Art

Vision is one of the most powerful of the senses. Seeing is related to art through a system we call *representation*, a complex term that allows us to examine significant aspects of art practice. Images are not just simple imitations of the world, but are always reordered, refashioned, styled, and coded according to the different conventions which develop out of each medium and its tools—sculpture, painting, printmaking, photography, video, and computer among others. However, the way we see is shaped by our world-view which governs our understanding of what representation is. Thus, we can say that representation is a form of ideology because it has inscribed within it all the attitudes we have about our response to images and their assimilation; and about art-making in general, with all its hierarchies of meaning and intentionality.

A useful construct for examining the distinction between vision and representation is provided in an interesting current book by contemporary art historian Svetlana Alpers, *The Art of Describing: Dutch Art in the 17th Century*.[2] In it, she compares the differences in attitudes between Dutch and Italian Renaissance artists toward representation. Italian forms of representation were based in the humanistic textual world view of the Renaissance with its conceptual notions of perfect beauty and poesis. Artists' selections from nature were chosen with an eye to heightened beauty and mathematical harmony—an ordering of what was seen according to the informed choices and judgment of the artist based on particular issues and concepts rather than as a form of representation where the single most important reference is the natural appearance of things. It reflected the views of Plato as articulated in texts such as the *Republic* (Books VI, VII, and X). Plato regarded imagination and vision as inferior capacities, a product of the lowest level of consciousness. He believed that reason allows us to contemplate truth, while the products of vision and imagination can only present false imitations, part of the irrational world of illusion and belief inferior to philosophy and mathematics which he designated as higher forms of knowledge. He illustrated his ideas using the example of a bed, postulating that there are three kinds of beds: one the essential concept of the bed, created by God; then that of a real bed made by a carpenter trying to make ultimate reality; finally, the artist's representation of it which stands removed from its reality. For Plato, human vision and imagination is based in imitation, and thus never able to claim access to divine truth. Plato mistrusted and opposed visuality and imagination through his fear that various forms of mythology, where life was defined as a series of relationships between human beings and various deities, could become dominant ones. He held that the basis for understanding human existence was through reason and the mind. Imagination and the images produced by it could only be trusted if they were first, deemed to be imitations, never original; second, they were subordinate to reason; and third, that they serve the Good and the True. His need to create boundaries around the cultural legitimacy of products of the imagination was meant only as a means of protection for the "greater good." Reflecting Platonic ideals, in its rejection of a visual culture, Italian culture was based in a textual one: a search for truth, meaning, and knowledge.

By contrast, according to Alpers, Dutch seventeenth century Renaissance painting reflected an acceptance of technologically assisted seeing. Over several epochs in Holland, experiments had been carried on to perfect the accuracy of mechanically assisted means of seeing such as the optical lens. Confidence in technology and cultural acceptance of this form of research into technological visualization in confirming and extending sight through microscopic close-ups, reflections, and distant enhanced views was understood as the way to new and potent forms of knowledge. Such commitment became the

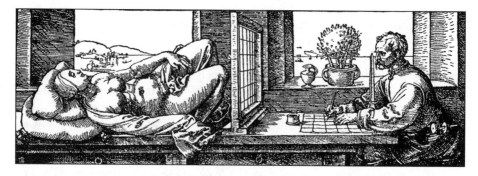

Figure 8. Albrecht Dürer, *Untitled*, 1538. Woodcut. Artists have always designed their own tools for creating the two-dimensional illusion on paper or canvas of what they see, such as this early grid with a sighting eyepiece.

basis for a more visually oriented culture based in objective, material reality. Dutch paintings of this period focuses on a world seen, a straightforward rendering of everyday life, based on observation, sometimes with the aid of the camera obscura lens, with all the spatial complexity and social detail of real interior views. Meaning in them is not "read" as in Italian painting, but rather they are energized by a system of values in which knowledge of the contemporary external material world is "seen" as a means for understanding.

In this sense, Dutch painting can be said to reflect the views of Aristotle[3] who was confident about the value and importance of vision and the direct observation of nature and taught that theory must follow fact. In his view, form and matter constitute individual realities (whereas Platonic thought posits that a concrete reality partakes of a form—the ideal—but does not embody it). Aristotle taught that knowledge of a thing beyond its description and classification requires an explanation of "why it is" and posited four principles of explanation: its function; its maker or builder; its design; the substance of which it is made. Also, he characterized imagination as a precondition for reason, describing it as a "mediating sensory experience rather than the experience which Plato thought would lead only toward dangerous illusions."[4] For Aristotle, imagining is based in the visual. Imagination lies between perception and thinking because it is impossible to think without imaging. Picturing in the mind, such as abstract forms or flashes of reality, accompanies abstract ideas, and thinking cannot proceed without such imaginings. Believing that imagination is not only a mediator between sensation and reason, Aristotle understood that it could also rearrange sense perception to form new ideas. It is essential in understanding abstract conceptions that go beyond human experiences of space and time to imagine the future.

Between these two poles of thought many different positions exist. Even though some Italian artists used optical devices in the production of their work—what they saw was informed by their philosophical attitudes. Reality can be an abstraction depending on the mindset of the artist despite the mechanical device one may be observing through. The distinction we must draw between Dutch and Italian painting lies in the differences between their outlooks and methods inscribed within their world views which define their approach to representation. We can draw a comparison between Vermeer's use of the camera obscura with Italian artists such as Bellotto, Guardi, Crespi, Zucarelli, and Canaletto, all of whom used it as an aid in preparing their drawings and paintings.

Art historian Charles Seymour has shown that the optical effects in Vermeer's paintings are the direct result of aided viewing and recording of phenomena that could be seen only in conjunction with a camera obscura. Seymour describes Vermeer's *View of Delft:*[5]

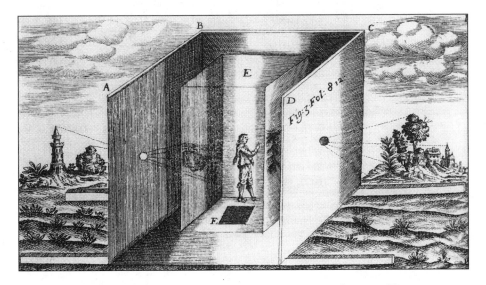

Figure 9. Early Camera Obscura, from A. Kircher, *Ars Magna Lucis et Umbrae*, 1645. The camera obscura was recorded by Aristotle (382–322 B.C.) and was well known to Arabs in medieval times. Leonardo described it in his *Codex Atlanticus:* "When the images of illuminated objects pass through a small round hole into a very dark room, if you receive them on a piece of white paper placed vertically in the room at some distance from the aperture, you will see on the paper all those objects in their natural shapes and colors. They will be reduced in size and upside down, owing to the intersection of the rays at the aperture. If these images come from a place which is illuminated by the sun, they will seem as if painted on the paper." *(Collection: Boston Athenaeum)*

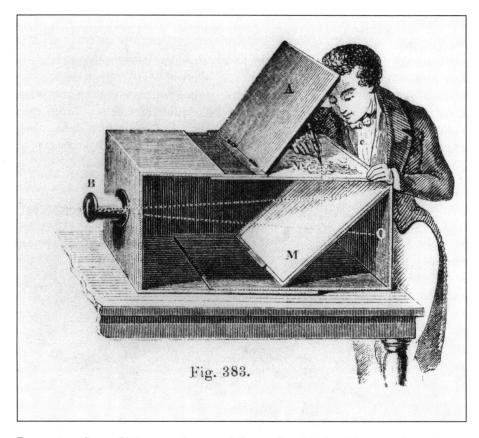

Fig. 383.

Figure 10. Camera Obscura, circa Seventeenth Century. By 1685, a portable camera obscura (in appearance, much like the first cameras) had been invented by Johann Zahn, a German monk. Described as a machine for drawing, this version concentrated and focused the light rays gathered by the lens onto a mirror which then reflected the image upwards where transparent paper was fixed in place for tracing the image. Count Francesco Algarotti confirms the use of the camera obscura as a tool in his 1764 essay on painting: "The best modern painters amongst the Italians have availed themselves greatly of this contrivance; nor is it possible they should have otherwise represented things so much to life. Everyone knows of what service it has been to Spanoletto of Bologna, some of whose pictures have a grand and most wonderful effect." Canaletto, Guardi, Bellotto, Crespi, Zucarelli, and Canale used it as an aid in preparing their drawings and paintings. (*International Museum of Photography, George Eastman House*)

The highlights spread into small circles, and in such images the solidity of the form of a barge, for example, is disintegrated in a way that is very close to the well-known effect of circles (or disks) of confusion in optical or photographic terms. This effect results when a pencil of light reflected as a point from an object in nature passes

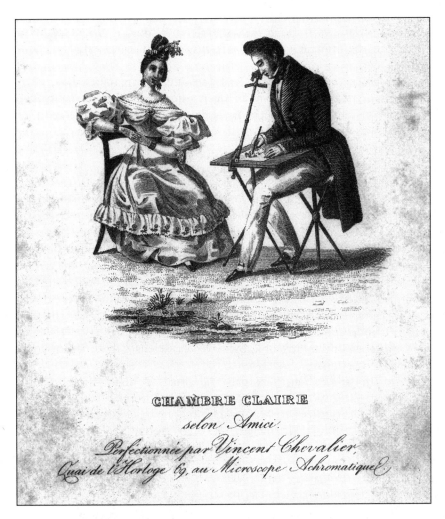

CHAMBRE CLAIRE

selon Amici.

Perfectionnée par Vincent Chevalier,
Quai de l'Horloge 69, au Microscope Achromatique.

Figure 11. Camera Lucida, circa Eighteenth Century. The camera lucida consisted of a lens arrangement that enabled the artist to view subject and drawing paper in the same "frame," and thus the image that seemed projected on the paper could be simply outlined. (*International Museum of Photography, George Eastman House*)

through a lens and is not resolved, or "brought into focus" on a plane set up on the image side of the lens. In order to paint this optical phenomenon, Vermeer must have seen it with direct vision, (through the camera obscura) for this is a phenomenon of refracted light.

The aforementioned Italian painters, although known for their use of the camera obscura, simply used the device as a reference tool for placement accuracy without incorporating any of its effects directly into their landscape painting.

These two distinctly different attitudes toward representation have characteristics similar to those distinctions between vision and technological seeing, which today are still important aspects of the discourse about representation.

Science and Art Converge in the Renaissance in Different Ways

The incomparable development of the Renaissance art of both the South and of the North, rested to a large extent on the integration of several new sciences in anatomy, perspective, mathematics, meteorology, and chromatology. Supporting the use Southern European Renaissance artists made of these important scientific discoveries lay Platonic convictions about the harmonious structure of the universe, emphasizing the rational relationship between the soul, the state, and the cosmos. Their goal was to reach heightened beauty and harmony as an embodiment of universal meaning and of supreme inner truth. The particular and detailed iconography of Northern Renaissance (i.e., Dutch) art reflected their intense interest in the tools of knowledge, those lenses that made it possible for them to observe nature accurately.

Seeking rational solutions for organizing visual information to create the illusion of three-dimensional space on a two-dimensional surface, artists adopted the mathematical principles of vanishing point perspective discovered by the Florentine architect Brunelleschi in 1420. Through perspective, line, form, and color, the visible experience of nature could be stabilized. As a consequence of the conventions of perspective, images are constructed so that the convergence of mathematically structured vanishing points addresses the central vantage point of the single spectator as being the ideal in the creation of illusion. God's will was connected with the mathematical regularity of optical phenomenon. However, as Berger suggests, "the inherent contradiction in perspective was that it structured all images of reality to address a single spectator who, unlike God, could only be in one place at a time."[6]

Another important mathematical consideration influencing artists in capturing the desired harmony and order to be found in the proportions of nature was the golden mean. Derived from the Golden Section, a Platonic strategy used in seeking the ideal of beauty in the designing of the Parthenon, it was confirmed by the Fibonacci series of numbers in the sixteenth century. This

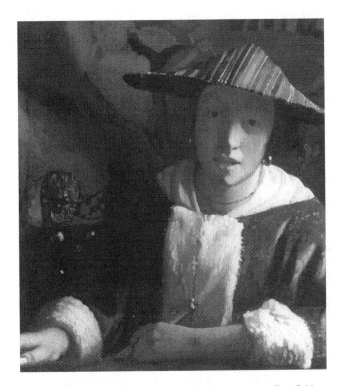

Figure 12. Jan Vermeer, *Young Girl with a Flute*, 1665, 7 ⅞″ × 7″. Vermeer's image with its many "circles of confusion" or shimmering unfocussed highlights as observed through the camera obscura is part of camera vision, quite different in style and intention from those painted by Italian Renaissance artists. While Vermeer developed a distinctive style by allowing the effects of viewing through the lens to become an active medium in what he painted, Italian Renaissance painters were mainly interested in using the camera obscura as a tool for solving problems of placement and accuracy although they despaired of its foreshortened compressed perspective and limited sense of depth. (*Widener Collection, National Gallery of Art, Washington*)

harmonious, abstract mathematical proportioning of space continues to be a strong influence in contemporary art, architecture, and the design of everyday objects. In some sense, these mathematical abstractions underpinning Renaissance art can be seen as direct antecedents to the mathematical algorithms of the computer.

For Leonardo da Vinci, (1452–1519), painting was a humanistic demonstration of universal knowledge. The depth and precision of his theoretical analysis of nature (botanical observations, notes on the turbulence of water and clouds), the drawings of his inventions (submarines, flying machines, engineering schemas), and his drawings of perspective and human anatomy are still stunning to us today. His notebooks are proof of the versatility and universality of his thinking as he attempted to fathom the riddles of human personality and the mysteries of natural phenomena. His painting was an expression for us of the search for the ultimate truth inherent in the human condition. For him, art-making was held in relationship to the concept of man as the measure of the universe. Although he has been called "the father of technology" and was fully aware of scientific invention, engineering principles, (and understood the relationship of tools to seeing), Leonardo was driven more by philosophic and aesthetic questions in creating his paintings and drawings and did not make direct use of technological devices for his art. In this sense, Leonardo's embrace of knowledge and of the ideal, rather than the direct use of technological tools for his art, anticipate in him, as we shall see, the later contradictions of modernism.

The Camera As Artificial Eye: A New Form of Representation

During the three hundred years of the use of the camera obscura as an optical mechanical aid before the chemistry of photography was developed, many artists used it to help them in their observation of nature. In Holland, Italy, and France, the camera obscura enjoyed widespread and continuous use throughout the seventeenth, eighteenth, and nineteenth centuries as a convenient tool for artists. The natural phenomenon of the camera obscura, in which light, passing through a lens (in the simplest case, through a pinhole) onto transparent paper can reflect, upside down, the image of nature captured and focused by the lens. Many different styles of "cameras" and optical lenses were designed to address the popular needs of artists to help them in their observations of nature. Other mechanical drawing devices (such as those depicted in Durer's fifteenth century set of woodcut illustrations), for converting a view of three-dimensional objects into two-dimensional drawings, include sighting devices for foreshortening; an eyepiece and framed grid on transparent glass for portrait sketching; and stringed moveable grids for mounting on drawing tables.

By the 1830s, the only missing link for permanently fixing the camera's images on paper was the light-sensitive chemistry of photography. Although scientists and inventors such as Schultze and Wedgwood made contributions to

the study of photosensitivity, it was an artist/printer, Joseph Nicéphore Niépce, who made the first real breakthrough in the link-up between the optical principles of the camera obscura with light-sensitive chemistry. In 1826 he successfully made an eight-hour exposure on a sensitized pewter plate in a camera—thereby capturing the world's first faint photograph of a scene from his window. However, the follow-up invention of the silver daguerrotype, in 1839, received far more attention.

But it was the British artist/inventor Henry Fox Talbot who succeeded in producing (1840), the first truly viable photographic process—the negative/positive system. His method is still in use today because from a single negative, an unlimited number of photographic prints can be produced, leaving the negative intact. Talbot called his discovery "photogenic drawing" and later published a book entitled *The Pencil of Nature*.

Because the camera was so related to its use over hundreds of years as an imaging tool for artists, the invention of the fixed images of the photographic process seemed at first an astonishing boon to the art community of the time. In its fullest sense as a revolutionary means of representation as well as a means of reproduction, duplication, and reportage, it created crisis in the art world which became fully evident only a century later.

Invention of Photography: Reaction and Counterreaction

The invention of photography produced intense international excitement in artistic and scientific circles and general recognition of its rich potential for society as a whole. In the arts, there were widely differing views. At first, there was acceptance.[7] Delacroix wrote an essay on art instruction (1850) in which he advised the study of the photograph.[8] Courbet and Ingres joined the host of artists who began to commission photographs as references for their large formal paintings.

However, in conservative circles, there was swift negative reaction. When the invention of the daguerreotype was announced in 1839, the critic Paul Delaroche declared, "From today, painting is dead." With the prime emphasis in art based on aesthetic principles established since Renaissance times, the invention of photography collided head on with the vision and attitudes of artists and intellectuals who were at odds with the realities of the Industrial Revolution. This crisis parallels that of our own era now that electronic technologies have changed the conditions of life and the consciousness of our own generation.

In England, social theorist/critic John Ruskin and poet/craftsman William Morris reacted strongly to forms and values of the Industrial Age and were able

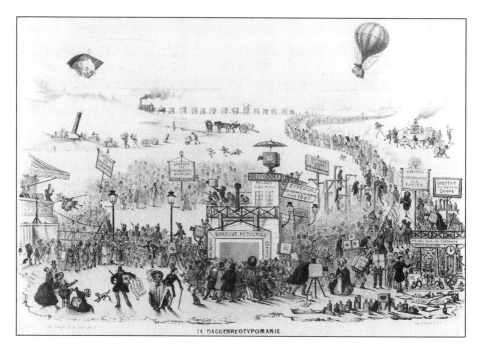

Figure 13. Théodore Maurisset, *La Daguerreotypomanie*, 1839. Lithograph, published in *La Caricature*. This first caricature of photography lampoons the social, economic, and cultural upheaval brought about by the invention of photography. There are cameras everywhere—on wheelbarrows, railway cars, steamboats, packed on heads, shoulders, backs, underarm, set on tripods, roofs, even hanging from a balloon. Cheering sections are marked off for daguerreotype Lovers and Haters. *(International Museum of Photography, George Eastman House)*

to articulate widespread negative feeling about the new social conditions. Photography came to be identified with the shift to the Machine Age with its alienating loss of human connectedness. It was seen as a threat to human intervention and to feeling itself. They proclaimed that artist and machine were essentially incompatible and that fragmentation of the work process robs the worker of pride and purpose in what he produces—in short, that "production by machinery is evil." They emphasized hand skills as a positive value over tools of industrial production—a prejudice that has persisted into modern times.

In the twentieth century, the critical social effects the photographic technologies were having on the formation of culture were analyzed by Walter Benjamin. He was the first to state that the work of art had been liberated by the processes of photography from its ritual *cult* seclusion (for example, in tombs, temples, or churches) to reside now without benefit of its *aura* of place on the pages of art books and magazines or on the pages of newspapers mixed with

texts or advertisements. Once a camera records images or events unique to a particular place and time, a disruption of privacy takes place. If the image is of a work of art, its uniqueness is destroyed. A loss of its original magic, spirit, authenticity, or *aura* takes place once an image is seen in many different contexts, for example, reproduced in different forms such as a postage stamp or as a billboard. It begins to mean something else and fragments into new sets of fresh associations.

Technological reproduction collapses what Walter Benjamin termed the "aura," the ritual aspect of the original, the one and only. He stated:

> Mechanical reproduction emancipates the work of art from its parasitical dependence on ritual. To an ever greater degree, the work of art becomes the work of art designed for reproducibility. From a photographic negative, for example, one can make any number of prints; to ask for the "authentic" print makes no sense. But the instant the criterion of authenticity ceases to be applicable to artistic production, the total function of art is reversed. Instead of being based on ritual, it begins to be based on another practice—politics.

Through reproduction, however, art is seen in contexts different from its original time periods and settings; as a result, artworks acquire meanings that diverge from those inherent at the point of production. Berger, in his *Ways of Seeing*[9] simplified Benjamin's text. Let us analyze, for example, Leonardo's *Mona Lisa* to illustrate the issues the way Berger would go about it. Torn from its original ritual "time and place" in a Medici palace, the most famous and valuable painting in the world now resides in a bullet-proof, glass-encased, climate-controlled setting at the Musée du Louvre in Paris. How can we separate the *Mona Lisa* from its baggage of fame and its much-touted financial value in order to see it only for its aesthetic value? Copies of this famous painting have been used countless times in contexts as wrenchingly different as a small art-book illustration or blown up as part of a giant commercial billboard advertisement. Through inexpensive multiple reproduction, the image has become transformed as an icon of the past, familiar as a cultural reference point and internalized as part of mass culture. As such, it has acquired new social meaning, value, and use.

This issue continues to be fundamental to understanding the schism between the fine arts and the direct use of more recent technologies for art making. Today's electronic technologies, including video, copiers, and computers, like photography, are also essentially copying devices. For the most part, reproductions of images from all of them can be produced in infinite numbers from the master matrix, software, or negative without wear or damage.

The social function of art as opposed to its commodity value is brought into focus as soon as reproduction or copying of originals becomes possible.

Oil painting, which had dominated the European cultural outlook for four centuries, is indissolubly linked with the system of private property as an original object that can be bought and sold. The value of the painting is tied to its material uniqueness—to its value as a precious object—rather than to its value as a form of communication, whereas a photomechanical reproduction, even of the highest quality, has much less market value. Paradoxically, the copying and wide distribution of an artwork not only increases its currency in the public consciousness, but also generates commercial worth because of its celebrity. In our present culture, the value of a unique object depends on its rarity and status gauged by the price it fetches on the market. But because the value of a work of art is thought to be greater than that of a commercial work, the work of art can be explained only in terms of holy objects: objects that are first and foremost evidence of their own survival. The past in which they originated is studied in order to validate them. Art that is enlarged, reduced, printed as postcards or posters, and widely disseminated for enjoyment of the public at large, reaches a broader audience, an expanded one beyond the confines of art institutions and the gallery system. As a consequence, the cultural sphere is broadened, enriched, and democratized.

The emphasis was now absolutely on the exhibition value of the work. Once a work of art could be reproduced, or was designed to be reproduced through photographic intervention, a crisis of authenticity arose:

> With the different methods of technical reproduction of a work of art, its fitness for exhibition increased to such an extent that the quantitative shift between its two poles turned into a qualitative transformation of its nature. This is comparable to the situation of the work of art in prehistoric times when by the absolute emphasis on its cult value, it was, first and foremost, an instrument of magic. Only later did it come to be recognized as a work of art. In the same way today, by the absolute emphasis on its exhibition value, the work of art becomes a creation with entirely new functions, among which the one we are conscious of, the artistic function, later may be recognized as incidental. This much is certain: today photography and the film are the most serviceable exemplifications of their new function. [10]

Myths from Renaissance times declared the divinity of masterful creativity and of genius. This outlook valorized art made by "hand of the artist." This sense of "pure" art was an attempt to extend the magical, ritualized meaning, the "aura" of a work which up to then related to its original value as a social production.

It became clear that photography was not simply a visual medium but a tool, a means of reproduction for making endless copies from a single original, an aspect that Benjamin acknowledged as the major factor affecting art in its relation to the age of mechanical reproduction. Photographic reproduction

raised questions about audience and communication which brought into focus the issue of art as object in relation to the social value of art as well as to its function in society.

Portraiture is perhaps the last aspect of the photographic image that still has cult value in the sense that remembrance of loved ones, those absent or dead is invested with a cult value. An aura emanates from the fleeting expression of a human face. In 1849, more than 100,000 daguerreotype portraits were taken in Paris alone. However, those painters who relied on portraiture as a livelihood were now threatened by the low-cost, eminently superior photographic method for capturing moments in time. They were affected by the same technological unemployment that affected scores of illustrators and graphic artists. A mood of panic developed. Faced with the inevitability of change, nineteenth-century art workers began to embrace the medium of photography for their everyday livelihood, similar to the massive changes faced by today's contemporary designers and graphic artists who have switched from photographic to computer skills to avoid technological unemployment.

Scientific Discoveries and Camera Vision Influence Development of a New Aesthetic

The new photographic technologies spawned scientific research into many areas of interest to artists, such as color theory and the nature of light and vision. This research is paralleled today by developments in computer imaging where a vast amount has now been discovered about the specifics of perception, optical functions, color theory, and artificial intelligence—all this being an attempt to understand the functions of how we see and how we think. Manet was the first to defy the five hundred-year-old conventions of pictorial space dictated by single vanishing point perspective that had been in control of the picture plane since its discovery during the Renaissance. His new way of seeing, influenced by photography, was at odds with the prevailing concepts of realism at the time.

The goal of the naturalists and the realists was also to define actuality or realism, but their vision was seen through the prism of classical Renaissance conventions. For example, the goal of the naturalists, based on the ideas of the painter Théodore Rousseau, principal figure of the Barbizon school (ca. 1830–70), was to recreate reality so as to establish a direct, metaphysically satisfying relationship with nature as a force concealing a purposeful order—a profound pantheism. Every bump on every tree bore testimony to the full scope of divine presence. On the other hand, Courbet's realist manifesto (1861) was a commitment to concentrate only on scenes from contemporary life, "To prove

that everyday life contains as much nobility and poetry as any subject from history or myth." It was a powerful reaction at the time to the frivolous eclecticism of the New Empire's Academy represented by Bouguereau, Gérôme, Meissonier, Cabanel, and Winterhalter. However, Courbet's realist pictures were self-conscious idealist allegories of everyday life, full of Platonic overtones.

Besides his rejection of the conventions of foreground, middle ground, and background and the modeling of space in diminishing tones to create the illusion of distant space, Manet interjected the immediate vision suggested by the momentary time frame of photography to create paintings which would "capture the immediacy of instant vision." In doing so, he rejected the entire tradition of academic painting's pictorial translation, with its dividing lines and modeling between picture planes, and substituted a flattened space where shapes disappear into each other and level out, much like the high contrast effects so characteristic of the photograph. Manet's rejection of classical tradition in an effort to create a new kind of visual presence is synthesized in the work of Monet, who thought of the object "not in terms of the form he knew the object to have, but in terms of the image which the light from the object reflected into the retina of the eye."[11]

Eadweard Muybridge's stop-motion photographs captured images of rapid movement through time which, up to then, had not been available for detailed analysis and study by artists. Internationally distributed by 1887, his richly illustrated book became a fundamental source of information in the art community. His multiple exposure photographic investigations of human and animal loco-

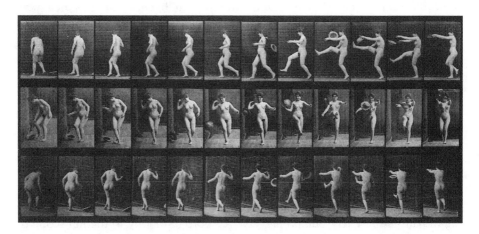

Figure 14. Eadweard Muybridge, *Woman Kicking,* 1887. Collotype, plate 367 from *Animal Locomotion,* 7½″ × 20¼″. Muybridge's books of stop-motion photographs of human and animal locomotion expanded the possibilities of perception by capturing time and movement frame-by-frame. Generations of artists have used these works, which are still current today. (*Collection: The Museum of Modern Art, New York. Gift of the Philadelphia Commercial Museum Fund*)

motion revealed clearly all the errors made up to then by painters and sculptors in their representations, for example, of the running stances of horses in battle scenes (e.g., Géricault, Delacroix, Velásquez). Degas's racing scenes painted after 1880 depict their natural gait made evident by the time-stopped photograph.

The momentary effect, the instantaneous and unexpected angle of view intrinsic to camera vision, also strongly affected artists' outlook. Degas's work reflects a fresh change of view as he incorporated the apparently "artless" compositional accidents of the serial camera "snapshot" as part of his style. For although the photograph had been criticized for its lack of style, literalness, and nonselective qualities, it had produced a fresh way of seeing which Degas transformed into a new kind of pictorial logic.

Influenced and stimulated by the work of Muybridge and others who were experimenting with the serial effects of motion and photography, Joseph Marey in 1882 invented a "photographic gun" which could capture linear trajectories of moving objects in a single image which he called *chronophotography.* Artifically lighted oscillations of movement were photographed against a dark ground by means of activating intermittently the shutter of the "gun" during a long exposure. The chronophotographs served as inspiration for the Cubists and Futurists, who were directly influenced by the broken, serialized abstract linear patterns of movement.

These influences led to a new way of conceiving pictures, explained Maurice Denis in the 1880s: "A picture before being a horse, a nude or an anecdote is essentially a flat surface covered with colors assembled in a certain order." A radically different aesthetic was developing—one which would eventually lead toward abstraction and away from traditionally held attitudes towards figuration and external influence. Paradoxically, the influence of photographic experiments led to abstraction rather than to an acceptance of the camera as a medium.

Photography Declared an Art Form

By the 1880s "art" photography, featuring still-life and draped models, had become commonplace. These works reveal clearly that a relationship had developed between painting and photography. A number of painters abandoned their trade and took up the new medium of photography, bringing to it not only their knowledge of composition and sensitivity to tonal qualities, but also their sense of style and interest in experimentation. Others made use of photographic projections on their canvases as a way of initiating work on a painting.

Photographers soon opened themselves to criticism through gallery exhibitions of their own works in 1855 and in 1859. However, criticism focused on

whether photographs could contain "the soul and expression to be found in true art." The poet/critic Baudelaire regarded the presumptions of the new art form as corrupting (much as electronic media are seen today): "It must return to its real task which is to be the servant of the sciences and of the arts but the very humble servant, like printing and shorthand, which have neither created nor supplanted literature."

Since existing French copyright laws applied only to the arts, photography had first legally to be declared as an art form before it could come under their protection. In a test case in 1862, arguments cleverly turned around the questions: Is the painter any less a painter when he reproduces exactly? Does not the photographer first compose in his mind before transmitting his perceptions via the camera? The court decision granted full copyright protection to photography as an art form (although engravers were not equally served by this law). These questions about photography as a viable art form obscured the primary question. Photography, both as a tool for mechanical reproduction and as a medium for representation, had challenged the existing tradition for art.

Photographic Technologies Spawn New Art Forms

Photomechanical reproduction of artists' line drawings (and later, photographs) through the use of photoengraving, photogravure, and photolithography revolutionized the commercial printing trades. Reproductive photography allowed for the study of art itself and made a powerful contribution to the development of communication through the proliferation of newspapers and popular illustrated magazines. Photographic reproductions of the art of the past could now be reprinted much more effectively than through the use of drawings or engravings. Artists could now contemplate and study the works of their international contemporaries at close range, in the comfort of their studios.

The profusion of photomechanically produced imagery available at the turn of the century gave rise also to a striking new art form. Outside of the mainstream, the Dadaists exploited publication techniques to develop an extraordinary new kind of found image—collaged images culled directly from printed newspaper and magazine materials. The Dadaists chose authentic fragments from everyday life because they believed these could speak more loudly than any painting. For them, photomontage was essentially a way of outraging the public and destroying the aura or market value of their work by revealing it as appropriated reproductions. For the first time, artists were using collaged photoimagery and photomechanical techniques as part of conscious artistic style. In photomontage, awkward joints and seams where the image sections were collaged together in the original could be hidden when the image was printed photomechanically, thus imbuing the reproduced collage image with a

logic of its own. Its powerful possibilities were brought into focus by artists such as Raoul Hausmann, John Heartfield, and George Grosz as a tool for expressing forcefully and directly a point of view about the social chaos of their era.

Independent of the Dadaists, the Russian Constructivists Rodchenko and El Lissitsky used photomontage methods to produce large posters and powerful graphic works because they could be reproduced and distributed at the same speed as a daily newspaper. The Surrealist Max Ernst developed his own poetic approach to photocollage in his small volume *Une Semaine de Bonté*. By reassembling and recontextualizing appropriated elements of Victorian engravings and changing the relationships between their parts, he created disturbing, sometimes nightmarish effects.

The Influence of Tools

Tool types have a bearing on the nature and structure of artistic production and conceptualization. Each type of tool offers its own possibilities, its own strengths and weaknesses. Each is characteristic of a particular epoch, and its marks are a reflection of that time period. Each is implicitly related to questions of time and space. Although the coherence of the artist's conceptualization process is the most fundamental aspect of art-making, the influence of tools and of technological conditions transform the production and dissemination of art.

For example, a meticulously detailed oil painting may require months of manual labor and planning and, in its final form, represent the focusing of both a mental and physical act. It is a unique production, a single cultural object imbued with the mark of the hand. By contrast, a photolithograph can be produced as a multiple image in a different time ratio using manual, mechanical, and photographic tools. These means of production will reflect characteristics of the mechanical era both as aspects of a photographic mechanism and as the gear of a press. "With mechanical aids, elements of time and space can be manipulated with new speed . . . application of energy by mechanical means alters our physical environment. . . . The arm with the gear is the symbol of the mechanical era which removed tedious labor."[12] The multiple print form makes the art work more available to a wider public.

When Delacroix wrote about the new medium of photography (see footnote 8), he expressed both amazement, delight and fear of the new.

A daguerreotype is more than a tracing, it is the mirror of the object, certain details almost always neglected in drawings from nature . . . which characteristically take on a great importance, and thus bring the artist into a full understanding of the construction. There, passages of light and shade show their true qualities, that is to say they appear with the precise degree of solidity or softness—a very delicate distinction without which there can be no suggestion of relief. However, one should not lose

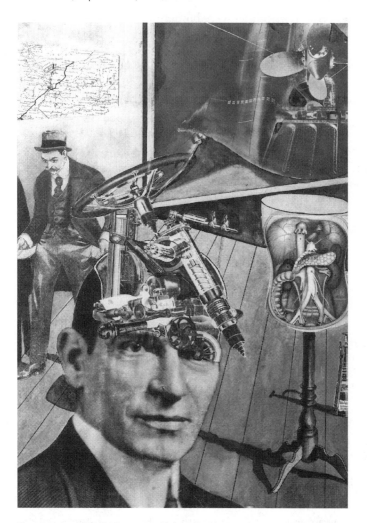

Figure 15. Raoul Hausmann, *Tatlin at Home,* 1920. Collage of pasted photoengravings, gouache, pen and ink, 41 cm. × 28 cm. Hausmann was one of the first to use the new form of collaging photographic images and illustrations from many sources—including magazines, letters, and newspapers. After World War I, Berlin Dadaists like Hausmann, who had always taken a critical, ironic stance toward the machine, now began to dream of a future in which supermachines would be placed in the hands of those who would build a new and better society rather than in the hands of the old warmongers. To Hausmann, the Russian Constructivist artist Tatlin was the living incarnation of these aspirations. *(Courtesy Moderna Museet, The National Swedish Art Museums)*

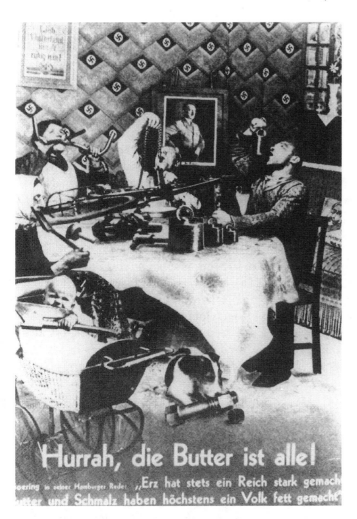

Figure 16. John Heartfield, *Hurrah, Die Butter ist Alle! (Hurrah, the Butter Is Gone!)*, 1935. Photomontage, produced for the magazine *A-I-Z* (December 19, 1935). Heartfield chose photomontage as an art form that was powerfully evocative, with expanded possibilities for the communication of his ideas. The text recounts Hermann Goering's Hamburg speech: "Iron has always made a country strong; butter and lard have at most made the people fat."

sight of the fact that the daguerreotype should be seen as a translator commissioned to initiate us further into the secrets of nature; because in spite of its astonishing reality in certain aspects, it is still only a reflection of the real, only a copy, in some ways false just because it is so exact.

Electronic tools have a "hidden point of view, far more complex than that which is built into a brush, a printing press or a camera."[13] Silently and instantaneously, they store, collect, transmit, and multiply visual and digital information according to the programmed instructions situated within their electronic system boxes, removing much of the tedium of routine manual and mental functions. "Think it—Have it."[14]

The electronic peripheral devices of computers (keyboard, digital drawing pad—manual; printer, plotter—mechanical; copier, film recorder, or video—electronic/photographic) combine and subsume all levels of art production tool types. The artworks produced by these systems inherently reflect the characteristic marks of their electronic production origins and are disseminated as multiples (photographic prints, copier prints) or transmitted as video. "The invasion of the very fabric of the art object by technology and what one may loosely call the technological imagination can best be grasped in artistic practices such as collage, assemblage, montage, and photomontage; it finds its ultimate fulfillment in photography and film (video), art forms which can not only be reproduced, but are in fact designed for mechanical (and electronic) reproducibility."[15]

A Shattering of Visual Tradition

Walter Benjamin identified cinematography as an entirely new aspect of visual representation, one that shattered all existing traditions. The movie camera created an entirely new aspect of representation by adding movement, edited views, and large-scale projections of imagery with sound. (Cinematography was invented by the Lumière brothers in 1895 following on the photographic experiments of Marey and Muybridge to capture movement.) Through slow motion, rapid panning, gliding close-ups, and zooming to distant views, space, time, illusion, and reality were fused in a new way. The camera moves, rises, falls, distances objects, moves in close to them, coordinating all angles of view in a complex juxtaposition of images moving in time. The flow of moving images permits an analysis from different points of view. They represent a deepening of perception, for they permit analysis of different points of view and extend comprehension beyond our immediate understanding by revealing entirely new structures of a subject than is available to the naked eye. New structural formations of subject and image become possible. Cinema appeals to our conscious impulses, as well as our unconscious, in the dramatic ways it can represent and record our environment. In film, montage became part of the

essential element of the grammar of the moving image. Through editing, juxta-position could easily create new meanings through interruptions, isolations, extensions, enlargements, and reductions.

> By close-ups of the things around us, by focusing on hidden details of familiar objects, by exploring commonplace milieus under the ingenious guidance of the camera, the film on the one hand extends our comprehension of the necessities which rule our lives, and on the other hand, it manages to assure us of an immense and unexpected field of action.[16]

The experience of seeing a film is very different from seeing a painting before which the spectator, as a single individual, can stand in contemplation of the work, concentrating his attention for as long as desired. With film, the indi-vidual usually becomes part of a collective audience whose attention is con-trolled by the moving image which cannot be arrested. The audience is in effect controlled by the constant sequenced changes of images moving in time, images which are designed to affect emotions and dominate the thinking process. Film, moving first from a silent phase and later to one of sound, led to an intense experience of the visual with greater collective participation. Some critics chose to call it merely a "pastime," a "diversion for the uneducated," a "spectacle which requires no concentration and presupposes no intelligence." However, from the beginning, film touched the core of an immense public need for creating new myths and legends which help in the adjustment to new times. The great silent filmmakers Eisenstein, Griffiths, Gance, and Chaplin brought the form to a high level. The form's arrival marks the beginning of a shift from a culture largely reliant on text to one with a greater reliance on image. This shift has become even more significant with the development of television. As time has gone on, it has become possible to argue that film has begun to replace or rival the novel as the most important narrative form.

Rise of a Modernist Aesthetic by the End of the Century

As Western culture began to take on the greater complexity of modern times, old premises about representation, dating from the Renaissance times, were challenged. Influences from the midcentury scientific study of optics, and the physiological principles of visual perception and color, had their effect in shift-ing the consciousness of the Impressionists to a modern system of seeing. How-ever, rather than accepting photography as a way of seeing, and as a means of gathering knowledge, the Impressionists embraced a system of restrictions which included their decision to work outdoors rather than in the studio. This was part of their working manifesto that they should deal solely with the truth and actuality of natural light and of everyday life as the only acceptable basis of their practice as painters. This tendency bred a modernist formality and dis-

tance which led to abstraction rather than figuration and can be thought of as the final stage of realism and the rise of a modern aesthetic based on an observation which, paradoxically, rejected technology.

Picasso commented on this shift of focus to his friend the photographer, Brassai: "Photography has arrived at a point where it is capable of liberating painting from all literature, from the anecdote, and even from the subject. In any case, a certain aspect of the subject now belongs in the domain of photography. So, shouldn't painters profit from their newly acquired liberty . . . to do other things?"[17] This attitude reflects a shift of focus away from pictorial realism to a new point of departure, a viable position from which to begin constructing a fresh modernist aesthetic. Even the naturalists and realists with their idealist attitudes were challenged by the new technological and intellectual climate to move toward abstraction.

The goal of the Postimpressionists, Fauves, Cubists, Symbolists, and Expressionists was to create images consonant with the integrated relationship between "what one sees and what one feels about what one sees." All experience, dreams, fantasies, poetry, music, and emotion itself became viable subject matter. They began to see that individual realities are only interpretations of the mind. Art, then, is illusion, interpretation, conception—not objective reality.

Underlying the new drive to movement and abstraction lay the fundamental contribution to perception that photography provided: camera vision as part of the vocabulary of the eye and as part of representation. It provided the impetus toward abstraction; alternation from positive to negative planes and forms; microcosmic and cosmic views of the universe; and also gave substance to arbitrary thought in the context of time/space through the moving image. A vast new arena of visual and intellectual communication was brought into play by photography, photomechanical reproduction, and the rise of cinematography, a restatement of the Aristotelian view of the value of material representation that we explored earlier through the example of the Northern Renaissance tradition.

Despite the important aesthetic development of photomontage and cinema in the 1920s and 1930s within radical avant-garde circles, the direct issues raised by photography were deflected—for the traditional mainstream art establishment saw photographs and photomechanical reproduction as a challenge to the "uniqueness" of art objects destined to be sold in the art market. Under the new theology of a "pure" high art, questions about the social value of art remained unanswered. The transformation of social consciousness by new forms of photographic communication created further confusion.

Photomechanical reproduction raised questions about the "uniqueness" of copies as works of art, thus undermining the existing function for art not only because it could provide visual reportage, but because it threatened the aura of the handmade object which relied on the specialized skills of the artist. Because

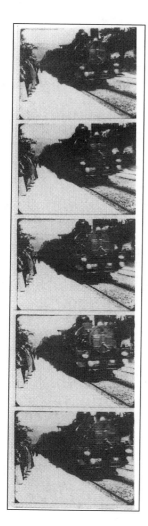

Figure 17. Lumière Brothers, Frames from *Un Train Arrive en Gare*, 1896. George Méliès captured the flavor of incredulity at the newness of perception provided by cinematography in this account of the very first public presentation of the Lumière Brothers' demonstration of the new Cinematograph in December, 1895: "I just had time to say to my neighbor: 'They've put us to all this bother for nothing but a magic-lantern show. I've been doing those for years.' Scarcely were the words out of my mouth, when a horse dragging a truck began to walk toward us, followed by other wagons, then by pedestrians—in a word, the whole life of the street. At this spectacle we remained open-mouthed, stupefied, and surprised beyond words. Then came in succession *The Wall*, crumbling in a cloud of dust, *The Arrival of a Train*, *Baby Eating His Soup*, trees bending in the wind, then *Closing Time at the Lumière Factory*, finally the famous *Sprinkler Sprinkled*. At the end of the performance, delirium broke out, and everyone asked himself how it was possible to obtain such an effect."

of these threats—its association with the copying processes of the Machine Age, its potential to challenge established canons and institutions of art—photography's full development as a medium and its acceptance as a viable fine art form was suppressed until the beginning of the postmodern period. Works executed by the "hand of the artist" were deemed doubly precious in an age dominated by the machine, a prejudice termed by Walter Benjamin as "a fetishistic, fundamentally antitechnological notion of art." Acceptance of these attitudes in the art world represents a break in the openness of artists towards use of mechanical tools and drawing devices and hardened artists' negative opinions about the overt use of photography in their work, although many continued to use photographs as a reference.

Parallel Attitudes for Today

Most artists were able at first to avoid facing the fundamental issue forced on them by the radical intervention of photography and cinematography. These issues had to do with creating a new social function for their work, a new subject matter, a new way of seeing and experimenting with new art forms and of dealing with the question of the copy as opposed to the value of the original. Instead of facing these issues, they developed a doctrine of l'art pour l'art, that is, a theology-based idea of a "pure" art, one which canonized it as a spiritual entity that lay beyond categorization.

Photography and cinematography served to shatter further the nineteenth century traditional outlook on representation. A new paradigm for art was needed which would better reflect the consciousness and conditions of the times. As we have seen, the moving image, with its ability to reveal entirely new structures of a subject; its coordination of all angles of view in a complex juxtaposition of edited images moving together in time, brought into the field of representation a powerful new consciousness-transforming medium and tool. Because it could be projected for vast audiences, it created social questions about audience and the function of art as immaterial communication. However, issues raised by cinematography have been kept apart from the visual arts canon until its recent convergence with video, TV, and digital forms.

The immediate co-optation of photomontage techniques by the commercial world further tainted their use. The very intrusion of the influence of photographic technologies into every aspect of life had the effect of prejudicing its direct use for art, except as an antiaesthetic statement by the avant-garde movements. Primarily, photography acted as a powerful catalyst invading every aspect of the cultural climate and the very fabric of society, creating the underlying conditions for a new kind of technological imagination and the impetus for invention of new forms of representation.

2

The Machine Age and Modernism

Photography had overturned the judgment seat of art—a fact which the discourse of modernism found it necessary to repress.

—*Walter Benjamin*

At the beginning of the twentieth century major technological change raised fundamental questions which fostered expanded consciousness in the arts, literature, music, and science, creating the radical innovation which even today, underpins cultural development. The theories that were, however to have the most profound effect in the shattering of tradition in the new century, were those of Sigmund Freud and Karl Marx. Freud's theories emphasized the importance of the instinctual and unconscious side of human behavior and asserted that emotions and urges are more important than rational thought. Marxist economic and political models of thinking gave rise to new criteria of value which promoted criticism of the most basic social forms, including the influence of technology in relation to the formation of culture.

Two tendencies evolved between, on the one hand, those artists who still embraced traditional materials, practices and forms, even though their consciousness had been changed by the deep technological shifts brought about by the machine age, and, on the other hand, those who, as a result of it, developed an antiaesthetic. The former, the Cubists, Fauves, and Postimpressionists repressed the influence of the machine by moving into the new territory of abstraction with its formal concerns. However, the Constructivists and Futurists gave themselves up to the spirit of the new age, glorifying the machine as a tool and the machine aesthetic as part of style. Another wing of the avant-garde, the Dadaists, were ready to question the very structure of art itself and its relationship to the art world and society as a whole. They used the machine as an icon to comment on sociopolitical realities.

Both wings of the avant-garde used photographic technologies as tools in their work. For example, the Constructivists used photomechanical methods as a rapid way of reproducing political posters while the Dadaists used "ready-made" photomontage as a way of attacking the values of the commercial gallery system. "Constructivists and Dadaists stand as the positive and negative sides of a total and a utopian critique in terms of order and chance, of art within social modernity."[1]

All artists had to come to terms with the machine. Whatever they did, they could not ignore its enormous influence. As part of a variety of responses to the machine that were taking place in the fields of painting and sculpture, Picasso and Braque led the way, in their Cubist works, by deliberately jettisoning the single viewpoint of perspectival space and the conventional structures of visual signification.[2] In a single image, they included the front, back, top, and sides of a subject. Part of their Cubist point of departure toward dynamic abstraction was influenced by the fractured, broken-up, serialized images suggested by Marey, Muybridge, and cinematography. Cubism mirrored the edited, fragmentary aspects of reality presented by film without using the apparatus itself. While their interests in formal issues, such as space, structure, rhythm, and composition were a response, in part, to developments in photography, they were also both a reaction to the irrevocable possibilities for representation opened by photography as well as a repression of it. Their attitude toward technological seeing—both being stimulated by it, yet not embracing it for their work, again illustrates the distinction we have been discussing about ways of seeing which represent two potential ways of thinking about representation. These two approaches are not just characteristic of the Renaissance.

Although the Industrial Revolution had been in progress for over a hundred years, the turn of the century saw its fluorescence. The Russian Constructivists welcomed the machine age positively—believing that the future of society lay in the liberating, beneficial forces of science, technology, and industry. They sought to fuse art and life through an expanded approach to mass culture, performance, and production. In proclaiming that "art must align itself with the magnificent radiance of the future," the Italian Futurists also embraced advances of the machine age. For Boccioni, Balla, and Severini, the machine provided heady iconography for their art. These artists broke up the static surface forms of cars, trains, and figures seeking "lines of force"—repeating shapes over and over to create swirling, spiraling movement suggestive of unrestrained energy.[3] For them, the beauty of technological apparatus and of mechanical reproduction was the effects associated with power, destruction, and war. This idealization of the machine was an aesthetic perfectly in tune with the nascent fascistic tendencies of those times.[4]

In a political break with tradition, the Dadaists confronted conventional art practices with antiart tactics. From avant-garde outposts in Zurich, Berlin, Paris, and New York, Dada periodicals insulted the bourgeoisie, the police, and the art establishment. They designed their ironic, irrational, contrived assemblages of machine parts and photocollage works to be the center of scandal. They used the formal public atmosphere of commercial galleries to raise fundamental questions about the "purity" of art; its commodity value as compared to its social value; and the uniqueness of hand-made objects in relation to the value of machine-made copies.

Figure 18. Etienne-Jules Marey, *Chronophotographe Géométrique,* 1884. Chronophotograph. This multiple exposure in a single frame of a figure jumping over an obstacle was produced with the aid of the photographic gun that Marey invented in 1882. The gun permitted twelve exposures per second. A scientist/inventor, Marey devoted himself to the study of movement in all its forms. His fascination led him to invent a series of tools for observing and recording movement too fast for the eye to perceive. His multiple exposures created a means for visualizing concretely the abstract fluid aspects of motion that had such an impact on the imagery of the Cubists and Futurists.

Art Going Out into Technology: Fusing Art and Life

Beginning in 1917, the Constructivists began using a combination of technology and art in the hope of building a new social order in revolutionary Russia. Their art was based not only on their political ideals, but in respect for new technologies, materials, techniques, and the logical structure which arises from these. Tatlin called it: "Art going out into technology." Rodchenko called for a public art and declared the new era: "A time for art to flow into the organization of life." By 1920 visual artists began to involve themselves in an Industrial Design Movement to bring culture to the public as located in everyday living —textiles and clothing design, books, furniture, and interiors. At the same time they also designed and distributed political posters, created public monuments, and involved themselves in agit-prop street theater. They designed a train that carried an agit-prop exhibition cross-country and produced work in the form of "spoken newspapers" and "telegraphed posters" which were intended to inform a largely illiterate public.

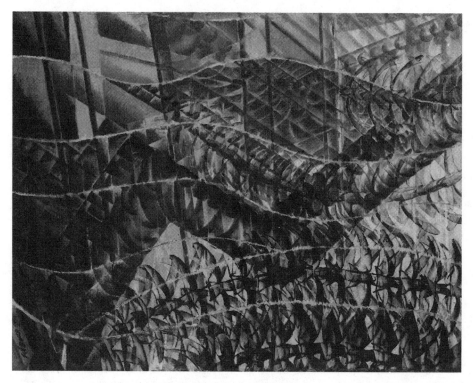

Figure 19. Giacomo Balla, *Swifts: Paths of Movement + Dynamic Sequences*, 1913. Oil on canvas, 38⅛″ ×
47″. Balla's dynamic Futurist painting shows the direct influence of Marey's experimental motion
chronophotographs which made the flowing aspects of sequenced movement visible for the first time.
(Collection: The Museum of Modern Art, New York. Purchase)

The poet Mayakovsky summed up the prevailing spirit of artistic involvement
in creating mass public cultural awareness when he declared: "Let us make the
streets our brushes, the squares our palette." Prominent among the Construc-
tivists at that time were Tatlin, Rodchenko, Lissitsky, Gabo, Pevsner, Malevitch,
and the film director, Vertov.

Their enthusiasm for an experimental fusion of the arts expressive of the
Russian revolution led to explorations of the connections between theater,
architecture, film, and poetry. Lissitsky and Malevitch (like the Cubists and
Futurists) were deeply interested in theater costumes and lighting, and designed
public spectacles and performance works which were the precursors of today's
multimedia works. By the 1920s the momentum of change had brought "just
about every possible technique and style of painting, theater, circus, and film
into play. As such the limits of performance were endless; nowhere was there an

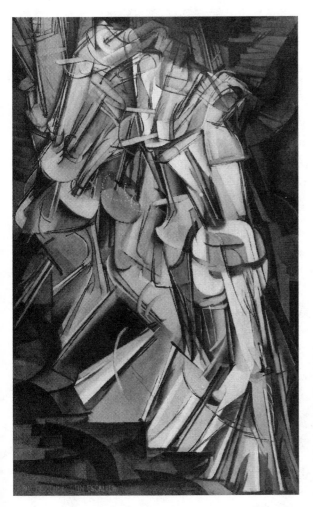

Figure 20. Marcel Duchamp, *Nude Descending a Staircase, No. 2*, 1912. Oil on canvas, 58″ × 35″. Duchamp admitted that the influence of Marey's multiple exposures led to this radically different painting which created such a controversy at the famous New York Armory show in 1912. *(Louise and Walter Arensberg Collection, Philadelphia Museum of Art)*

attempt to classify or restrict the different disciplines. Constructivist artists committed to production art worked continuously on developing their notions of art in real space, announcing the death of painting."[5]

The Constructivists maintained a separation between their public art with its social value and their private work in which they continued their prerevolutionary explorations of abstraction. The formal aesthetic inquiries in their paintings and sculptures first developed through their involvement with the Suprematist movement. By the 1920s Rodchenko, Lissitsky, Malevitch, and Popova, in their private works, took the lead in radicalizing abstraction by moving to an extremely reductivist analysis of their painting aesthetic. Malevitch's white

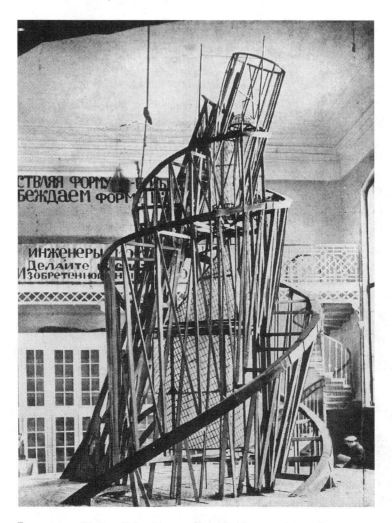

Figure 21. Vladimir Tatlin, *Monument for the Third International*, 1920. Reconstruction of finished model, 15′ 5″ H. Tatlin was one of the first to proclaim a new way of using materials, that material—wood, iron, glass, and concrete—itself is the message, and that the expressive importance of material lay in their substance, not their form. His point of view was that form should follow function. His work embodied a long-desired integration of sculpture and architecture. Although *Monument* was never realized, it was originally designed to be 300 feet higher than the Eiffel Tower. Its spiral framework was to enclose four glass-walled rotating chambers (turning at different speeds) to house different functions. The lowest level, which was to revolve once a year, would be used for conferences. The next level, a slanting pyramid, would rotate once a month and be used for executive activities. The third level, with a hemisphere on top, would contain an information center, and rotate once a day. He left spaces for gears and machinery and girded his tower with functional stairways. (*Moderna Museet, The National Swedish Art Museums*)

square and Rodchenko's black painting were far in advance of their time. Neo-constructivists of the midcentury were to repeat these experiments in aesthetics. For example, Rauschenberg created the "White Paintings" in 1951. Rodchenko's 1921 *Last Painting* comprised three canvases, each painted with one of the primary colors (red, yellow, and blue, a strategy also used later by Yves Klein). These critical studies brought many artists of the time to the crucial point of decision at which painting as a private special activity was rejected in favor of art as a "speculative activity to social development"— where creativity and daily work were merged. Artists such as Naum Gabo, Nicholas Pevsner, and El Lissitsky did not share this level of social commitment and eventually migrated to Germany, feeling threatened by accusations that their art was connected to metaphysics and mysticism. By 1925, Stalin's rise to power brought rapid closure to this period of intense experimentation in the arts.

The Bauhaus: A Modernist Industrial Design Movement

Constructivists ideas for a fusion of the arts found fertile ground at the Bauhaus school (founded in Germany in 1919) where one of the most remarkable faculties in history was assembled: Vasily Kandinsky, Paul Klee, Johannes Itten, Oskar Schlemmer, Marcel Breuer, Herbert Bayer, Josef Albers, and László Moholy-Nagy. The philosophy of the Bauhaus represents an aspect of modernism writ large: an abstract aesthetic of pure form connected to the function of the object. Like the Cubist response to technological representation, the objects and images produced by Bauhaus artists were tied to a pure art—a notion of beauty of form—an outlook that did not run counter to using the machine to create it, for modern machine manufacture was embraced as a means capable of producing for the public, beautiful commodities to provide an experience of quality in everyday life.

The school's founder, Walter Gropius, was convinced of the need to create an art practice where unity between architect, artist, and craftsman could be achieved by training artists, engineers, designers, architects, and theater people to believe in a synthesis of the arts. Gropius insisted on a program revolutionary for its times, designed to liberate the students from past influences and prejudices. His idea of learning by doing, of developing an aesthetic based on sound craftsmanship, helped to create a unity between the fine arts and the crafts. The Bauhaus spread its ideas through publication of documents by its faculty and became the center for the propagation and development of new international experimentation in the arts.

Moholy-Nagy, one of the most influential and innovative faculty members of the Bauhaus, schooled his students not only in the use of photography and photomontage, but focused their attention on optical experiments, and the time/motion aspects of film and light as means for making art. In his books *The*

New Vision and *Vision and Motion,* he developed new theories of perception and vision as they apply to the technological world. For example, Moholy-Nagy engaged in studies for projected light and motorized movement for his new type of kinetic sculpture series of "time/space modulators" which explored optical illusion.

He embraced photography and film as the foundation for a "new vision," as a new way of reshaping individual consciousness and thereby as a way of seeing society from a different perspective. His "new vision" reflected his commitment to social change. For him, the camera was a tool for educating the eye, to extend and supplement natural vision and traditional perceptual habits. With his students, he used examples of his explorations into the play of light and shadow, unusual perspectives, multiple exposures, photograms, and photomontages to create a new "optical culture" born of a changed visual awareness. For him, photography was a medium that suggested experiment in art, that posed specific formal questions which (if explored freshly) could lead to new understanding. He saw its relationship conceptually to space, drawing, and text which led to a unique approach to graphic art. Along with Stieglitz, Moholy-Nagy is credited with raising photography to the level of an art form in its own right.

Moholy-Nagy was a tireless technical innovator[6] as well as a painter, thinker, and writer. His powerful influence extended far beyond the Bauhaus when he founded the Chicago School of Design in 1939 after fleeing from Germany. Moholy-Nagy saw light as essential to the production of art and the expression of form. In his kinetic sculpture series of *Light Space Modulators,* his aim was to produce a work which lay between the movement of film and the light and dark of photograms, while concerning himself primarily with optical illusion, light, shadow, space, and movement.

In direct contradiction to prevailing prejudices of the European art establishment of the twenties, where emphasis was still on traditional materials and hand skills for art-making, Moholy-Nagy used industrial plastics to make sculpture. To demonstrate that other possibilities existed in art-making apart from hand skills, Moholy-Nagy ordered the fabrication of a work of art by telephone. He asserted that the skills of hand-making fundamentally limited the artist, not only from taking full advantage of technological means of representation, but also in placing such emphasis on the genius of the skill of making, that it limited the possible idea or concept behind the work. Just as photography freed the hand of the artistic functions of delineating reality, where the eye perceives more quickly than the hand can draw, the process of pictorial reproduction could keep pace with the mind's functioning.

The pioneering influence of Stieglitz (1862–1946) is inestimable. Stieglitz made a contribution to the birth of a modern spirit through the activities of his

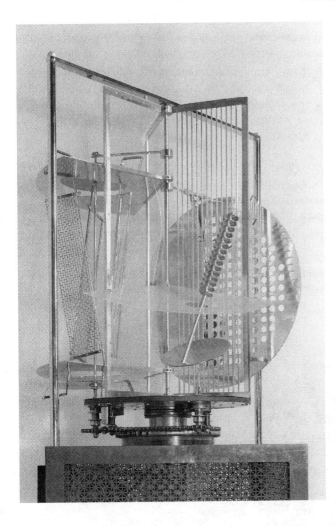

Figure 22. László Moholy-Nagy, *Light Space Modulator*, 1923–1930. Kinetic steel sculpture, 151.1 cm. H × 69.9 cm. Base × 69.9 cm. C. Moholy-Nagy's "Light Prop," an electrically driven, mechanically complex machine crafted over a period of several years at the Bauhaus, is a monument to the Bauhaus Constructivist enthusiasm for the machine aesthetic. The powerful play of light and shadow patterns captured an extraordinary dimension of space-time, achieved through superimpositions, mirroring, and prism-like effects of moving light. Moholy-Nagy predicted that light would be an entirely new medium. (*Courtesy The Busch Reisinger Museum, Harvard University Art Museums*)

291 Gallery. Established in New York by 1905, it became an important meeting place for both American and European artists. Besides photography exhibits, he was also able to introduce to an American audience the two major strains of the European avant-garde and to create a meeting ground in America for them. They included most of the foremost French painters of the time: Matisse, Picasso, Cézanne, and Braque, as well as the antiart group Duchamp, Picabia, and Man Ray. His gallery, in effect, became a clearing house of ideas where American experimentalists could enter into a discourse with their European counterparts. This resulted, in a lively trans-Atlantic exchange.

Steiglitz's own work, grounded in documentary subject matter, was influenced by painterly style. His important work in photography and the

publication of the influential journal "Camera Work," laid the groundwork for the later "official" art-world acceptance of photography to the fine-art canon in the 1960s.

However, all of the arts, the moving image made the greatest impact on public consciousness. Film emerged as the art form most expressive of the fusing of art and life in the new technological age, one which naturally led to a fusion of all the arts—theater, music, poetry, and literature. In 1923, the constructivist filmmaker Vertov identified with the movie camera.

> I am an eye. A mechanical eye. I, the machine, show you a world the way only I can see it. I free myself for today and forever from human immobility. I am in constant movement. I approach and pull away from objects. I creep under them, I move alongside a running horse's mouth. I fall and rise with the falling and rising bodies. This is I, the machine, maneuvering in the chaotic movements, recording one movement after another in the most complex combinations. Freed from the boundaries of time and space, I coordinate any and all points of the universe, wherever I want them to be. My way leads towards the creation of a fresh perception of the world. Thus I explain in a new way the world unknown to you.

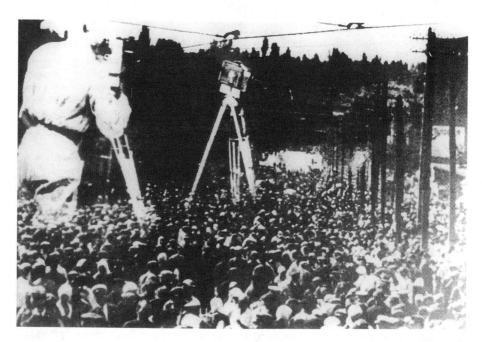

Figure 23. Dziga Vertov, *Man with a Movie Camera*, 1929. Film still. Vertov's passion for the movie camera's potential to create a fresh perception of the world by freeing time and space—"coordinating all points of the universe"—is captured in this montage of the cameraman towering over crowded streets.

In film, the spectator's thoughts are captured and forcibly propelled through a timed, edited, sequenced version of reality. Unnatural juxtapositions of a variety of moving images create a radically new synthesis of them. Film's form and process were avant-garde because of their technical and physical shock value. Film, like Dada, played an important role in undermining nineteenth-century cultural assumptions and institutions.

Vertov's sense of the "kino-eye" and Eisenstein's theories of montage especially influenced "independents," those filmmakers who existed outside of the growing international commercial film industry. By the forties, these "independent" film-makers were producing poetic and nonnarrative work. From then on, the underground cinema movement grew rapidly. By the fifties, it had created its own traditions, film cooperatives, distribution system, and film journals, and had attracted many painters, sculptors, and photographers such as Léger, Dali, and Balla, all of whom made short experimental films over the years. Though film as a genre has been largely excluded from the art history canon, the growth of interest on the part of artists led to their intense interest in the sixties, in the new time-art medium of video as a way of expressing their social and perceptual interests.

Duchamp Raises Fundamental Questions about the Function of Art

Although Marcel Duchamp (1887–1968) began as a Cubist and was claimed by both the Dadaists and the Surrealists, he developed concepts that were beyond the confines of any movement and created a philosophic domain of his own which questioned "every assumption ever made about the function of art."[7] He felt that the machine had formed modern consciousness. More in keeping with the spirit of the machine age than with painting, Duchamp experimented with new manufactured materials and with the iconography of the machine itself. He introduced (and experimented with) almost every concept or technique of major importance to avant-garde artists for the next fifty years. His controversial *Nude Descending a Staircase* (which was influenced by Marey's photography) was exhibited in the 1913 Armory Show in New York. Its *succès de scandale* made him an immediate celebrity.

In 1915, he began a large work constructed of metal and glass, a project that occupied him for the next eight years. Often referred to as his masterpiece, *The Bride Stripped Bare by Her Bachelors, Even* (also known as the *Large Glass*) playfully suggests the idea of a "love machine." The Transparent Large Glass,[8] (richly overlaid with puns and references to science, philosophy, and the art of the past) bears within it a totally new approach both with respect to the thinking process in art and with respect to the materials and the making. His use of machine parts with references to popular culture overlaid with their allusions to Freudian thought were the basis of aesthetic ideas and attitudes which continue to be a profound influence.

In 1913, Duchamp exhibited a standard manufactured object, a bicycle wheel mounted on a stool, as a "ready made"—an object elevated in the iconoclastic Dadaist tradition to the realm of art. Duchamp's ready made asked questions about the status of an art object extracted from its functional context. Is it a commodity produced and distributed within an institutional framework that is very much like any other marketplace? Is it an object made by an artist's own hand? Is it denying the very possibility of defining art? By appropriating an ordinary copy—a mass-produced machine-made object—and placing it in the context of a gallery, Duchamp also created the opportunity for altering its significance: a new thought about the object aimed to "reduce the aesthetic consideration to the choice of the mind, not to the ability or cleverness of the hand."[9] Later, he chose other manufactured objects—a bottle rack, a urinal, a coat rack—as ready mades.

As he said years later: "I came to feel an artist might use anything—a dot, a line, the most conventional or unconventional symbol—to say what he wanted to say. This proposition can be demonstrated by choosing—it is the act of choice that is decisive."[10] Duchamp was widening the question posed originally by photography about the reproducibility vis-à-vis the uniqueness of a work and the necessity of hand skills. He shifted the possibilities for art-making to place the most important emphasis on the conceptual process, thus introducing the possibility of using the techniques of industrial manufacture as another aspect of choice. Questions he raised concerning the commodification of the art object; the appropriation of ready-made materials as part of art-making; and the contextualization of a given work within the gallery system as a way of questioning its value; directly influenced the Pop artists of the sixties. For them, Duchamp became a cult figure whose ideas helped to coalesce groups of artists who were simultaneously influenced by his ideas in the late fifties. They became the new avant-garde, in both England and the United States.

The New Kinetics Use Light and Movement and Machine Parts

Curiosity about natural phenomena, scientific and mathematical puzzles, and their relationship to aesthetic problems led many visual artists to experiment with machine parts and materials, to probe new phenomenological mysteries for their aesthetic potential. These perceptual experiments in both real and illusory movement and time were of special interest to sculptors such as the Constructivist Naum Gabo, who produced, in 1920, the first motorized kinetic sculpture called *Standing Wave*. Moholy-Nagy also worked with motorized movement and light in his *Light Prop*, begun in 1922. Kinetic sculpture relies on the physical use of light and movement and makes use of simple motor-driven devices, motorized light boxes, and various static fluorescent and incandescent light sources.

Figure 24. Marcel Duchamp, *The Large Glass* or *The Bride Stripped Bare by Her Bachelors, Even,* (the orignal: 1915–1923, replica: 1961 Oil, lead, foil, and varnish, 109¼" × 69⅛". This construction presents an ironic attitude towards machines and human beings. Duchamp is said to have been influenced by Raymond Roussel's play in which the functions and forms of machines are related to the sex drive. *The Large Glass* was made of unconventional materials and contains many innovative elements. Because it is on glass, its relation to the viewer and the space it inhabits is dynamic and constantly changing. *(Louise and Walter Arensberg Collection, . Philadelphia Museum of Art)*

While working on the *Large Glass* and the ready made, Duchamp had experimented with ideas about the fourth dimension and with movement of various kinds. By 1920, he had built a machine which he called *Rotary Glass Plate,* consisting of narrow, motorized panels revolving around each other. When seen from the front, the moving blades appear as one undulating spiral creating the illusion that a three-dimensional object is two dimensional, an ironic denial of reality. A few years later, he again played with optical illusion in his *Rotary Demisphere Machine,* which made spinning convex surfaces seemingly become concave. "Underlying Duchamp's optical machines is the concept of a gliding system of dimensions and realities."[11] He also invented a kind of playful measurement system in which he substituted chance as an alternative to the rational approach of science.

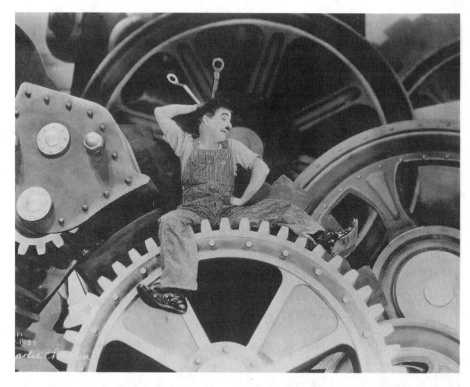

Figure 25. Charlie Chaplin, *Modern Times*, 1936. Film still. Although *Modern Times* is a powerful manifestation of the pessimism of the 1930s toward technology and the way that life was being standardized and channeled, Chaplin demonstrates engagingly how to outwit machines as a way of drawing attention to the deep problems presented by technology. (*Museum of Modern Art/Film Stills Archive, New York*)

These beginnings of a kinetic sculpture movement led to work by Alexander Calder, and a host of other artists, particularly in the post-World War II years, and eventually to the Zero and Grav movements in Europe and the American Art and Technology movement which expanded the concepts of kinetic art into the realm of collaboration between artists and engineers and the use of new technologies.

End of Era—Who Owns and Controls the Machines?

If the twenties were a period of hope for change, through advances in technology and machine culture, the Depression of the 1930s brought fear and despair, a mood that dominated the art of the Surrealists. For them, the machine represented an intrusion, a menace. Their program was a retreat "to the inner depths of man's mind," and for that there was no need of machines. Confidence in rational technological progress gave way to disillusionment because of rising

unemployment, rampant commercialism, and the rise of fascism—all of which raised deep political questions about the market economy and about the ownership and control of machines. Chaplin's brilliant film *Modern Times* characterizes this period by demonstrating that machines ironically create abundance but leave want—materially and spiritually—when they are utilized only for the benefit of property interests. The swift takeover by German, Italian, and Japanese fascist forces at the outset of World War II, led to a frighteningly devastating struggle through the use of technologically advanced air power and weaponry, which destroyed the infrastructure of most of Europe and parts of Asia. It lead to the deaths of millions, including the systematic killing of the Jewish people in a form of "holocaust." Following the atomic bomb blast and destruction of Hiroshima, fear and horror further sapped faith in technology and confidence in rational behavior.

Two directions in early twentieth-century art, both aspects of modernism, found their first North American meeting ground at Steiglitz' Gallery 291. One tendency we have associated with the antiart of the Dadaists, the Constructivists, and the Futurists, who were reacting to the increasingly technologized conditions of modern life, either through a positive embrace of technological advance and a use of it for representation, or through a use of technological seeing and materials to comment on its alienating influence. The second tendency was towards abstract formalism and the growing focus on the solution of formal aesthetic problems among the foremost painters of the time. These two comprise what we broadly refer to as modernism in art.

In an important sense, the war shattered the radical impetus and political commitment of the European avant-garde with its historical, cultural, and philosophic modus operandi. In America, it was as though the avant-garde belief in the power of art to either transform society or to challenge it lost its political thrust, was defused, and became pragmatically transposed by a utopian American belief in progress through technological development and the marketplace. Endemic to American culture is a direct pragmatism which is in contrast to the more philosophic tradition of the European. Many European artists (among them Duchamp and the Surrealist Max Ernst) had stayed on in New York after the war. Untouched by the devastation of the war in Europe, the American economy's postwar boom conditions produced a group of wealthy American collectors eager to invest in art. The pendulum of the art world began to shift from Paris to New York, although in Europe new critical thinking which resulted in Structuralism, Poststructuralism and Deconstruction was evolving which would have a direct effect on the evolution of the postmodern issues and aesthetics.

Modernism Becomes an Aesthetic Style

Up to now, modernism has been discussed not only as a way of identifying a radical break with the past in terms of social and cultural history, but also as a

major aesthetic development brought about by changes in perception and new attitudes towards representation. However, another institutional version of modernism came into focus after the war shaped by Clement Greenberg's persuasive essays published 1930 to 1960. This view is one which even today governs our concept of art. It encompasses Modernism, as a self-consciously experimental movement which came to mean that a work of art should be rendered "pure" by being confined to the effects specific to its own medium, that is, to the aesthetics of the object itself; to the identification of art with the tradition of painting and sculpture and thus to the aesthetic of the object. It is this famously succinct "Less is More" version of Modernism to which we refer in the ensuing discussion.

From the early 1950s, the new Modernist ethos now oriented itself fully towards solving formal problems of form, color, and texture. A group of American artists—Jackson Pollock, Willem de Kooning, Philip Guston, Arshile Gorky, Robert Motherwell, Adolph Gottlieb, Mark Rothko, and others who loosely came to be known as the Abstract Expressionists—produced work that was heroic, apolitical, and introverted, based on inner sensation and experience, with an emphasis on the medium of painting itself. They made use of traditional materials and painterly gesture. Their work was aesthetic expression as an exalted virtue, as a vehicle for metaphor and symbol. It was the idealist Modernist abstract ethic at its most "pure."

This kind of Modernism, a neo-Platonic form of representation, became a movement based on denial of issues outside of the art system, whether they be historical issues, social issues, or issues of artistic cultural production. Any characteristic considered to be extrinsic subject matter—particularly narrative, description, or literary reference—was excluded as impure. It was a reductive system—an art of expression and form exemplified by abstract painting or sculpture. Stylistic change was based wholly on innovative conceptual or technical advances which could increase the aesthetic purity and pleasure of a work. Modernism, with its progression of "great ideas" and "great masters" evolving from Abstract Impressionism through to Minimalism as a critical and aesthetic stance became the dominant mainstream movement.

An alienated counterculture called the *beat generation* arose in the 1950s, influenced by writers Jack Kerouac, Allen Ginsberg, and William Burroughs. It raged against the double standards of fifties' purveyors of mass culture. Marshall McLuhan wrote in 1951 about the power of commercial interests to control the public mind. He also suggested that "the very considerable currents and pressures set up around us today by mechanical agencies of the press, radio, movies, and advertising . . . [are] full, not only of destructiveness, but also of promises of rich new developments."[12]

Younger artists felt oppressed by the official mainstream acceptance of the heroic stance of Abstract Expressionism. To them it seemed dated, mannered, and bankrupt. It was in direct opposition to the more open radical approach to the arts which had been developing at Black Mountain College since 1933.[13]

There, the spirit of debate and openness to innovate led to the founding of a different American avant-garde. Poetry, music, film, and theater were lively adjuncts to the painting and sculpture program. Josef Albers, Merce Cunningham, Buckminster Fuller, Willem de Kooning, Clement Greenberg, David Tudor, and countless other influential figures were all associated with the program at Black Mountain. Among their students were Jasper Johns, Robert Rauschenberg, Dorothea Rockburne, among many others. The musician John Cage (influenced by Eastern aesthetics as well as by Surrealism, the work of Duchamp, and Abstract Expressionism) performed theater events that combined his ideas about chance in music with aspects of painting and sculpture. Cage was an especially important influence, for he also taught at New York's New School for Social Research where his course in experimental composition became a major revelation for a broad spectrum of artists from diverse disciplines. These included Allan Kaprow, George Brecht, George Segal, Yvonne Rainer, Al Hansen, and other close contemporaries. Cage's classes led to dare-devil willingness to break new ground by "trying anything." New forms evolved: Assemblage, Happenings, Environments, Performance Art, reflecting the exhilaration of the early sixties.

Influenced by Antonin Artaud's *The Theater and Its Double* (translated by M.C. Richards, a Black Mountain faculty member) John Cage began to think of theater as beyond narrative, as a territory of time and space inhabited by unrelated but coexisting events. While Artaud's "theater of cruelty" encouraged a powerful ritualistic dialogue with the audience, Cage's *Theater Piece #1* was emotionally distanced, but at the same time equally enigmatic. It was performed at Black Mountain College in 1952, and became legendary as the first "happening" and the beginning of chance operations in music and dance works. Providing context for the performance, Rauschenberg's *White Paintings* were hung overhead. Merce Cunningham danced throughout the audience and the performance space followed by a barking dog. Coffee was served by four boys in white. David Tudor performed on the piano in competition with Edith Piaf recordings played on an old phonograph by Rauschenberg. Cage sat for two hours on a step ladder sometimes reading a lecture on the relationship of music to Zen and sometimes simply silent, listening.[14]

Cage created, and organized the event around chance operations where everyone did whatever they chose to during certain assigned intervals or blocs of time. The experience was a near sensory overload. Each observer's experience of the event was completely different, an aspect central to Cage's performance goals. "The event," as it came to be known, established Cage's unmistakable imprimatur of a kind of intertextuality which we can say were the precursors of a nonlinear, inclusive postmodern aesthetic.

Like Duchamp, Cage insisted, that the true source of art lay "not in subjective feeling and the creative process but in the everyday presence of

events happening in an environment." He felt the purpose of art was above all else "the blurring of distinctions between art and life." Cage encouraged the use of accident and chance as nature's own principle: "one that required the artist to avoid rational creation of hierarchies, and points of climax, in favor of repetition and a kind of all-relatedness."[15] Unlike Duchamp's subversive and ironic stance toward art, Cage was more in tune with the joyousness of Zen. In his nearly pantheistic thought, he influenced various developments occurring towards Minimalist Art; toward the Happenings movement of Allan Kaprow; toward the Judson Theater Movement; and toward the paradoxical punning games of Conceptual Art. He even influenced the use of found images from popular culture by the Pop Artists and the Fluxus movement. The shared, ultimate purpose of these groups was, to quote Allan Kaprow: ". . . [the] release [of] an artist from conventional notions of a detached closed arrangement of time-space. A picture, a piece of music, a poem, a drama, each confined within its respective frame, fixed number of stanzas, and stages, however great they may be in their own right, simply will not allow for breaking the barrier between art and life. And this is what the objective is."

A Neo-Dada collective, Fluxus was a loosely knit nonconformist group that evolved in the early sixties inspired by both Duchamp and Cage. Group members came from the field of music, performance, film, and visual art. Like the Dadaists they used technological methods, tools, and materials as a means to extend their work as part of its shock value. They were noted for the creation of Happenings, mixed-media events, publications, concerts, and mail-art activities. Dick Higgins presided over the "Something Else Press" which energetically spewed out books and pamphlets fueling the movement. Allan Kaprow labeled Korean performance artist, (later video guru), Nam June Paik a "cultural terrorist" for arranging for the tipping over of a piano, as a "Happening," at a Dada-like concert. Chris Burden undertook a series of death-defying acts. As a performance piece, Yoko Ono allowed audience participation in snipping off her clothing. Fluxus strategy was to democratize the art-making process by destabilizing the status of the art object and dematerializing it. Their events were repeatable by anyone, involving a battery of props made up of everyday found objects. The ironic, witty, Fluxus style was anarchically irreverent and subversive in its commentary and, compared to more conventional work, placed the artist in a different position with regard to the audience.

The Pop Movement—Transition to the Electronic Era and Postmodernism

In the seven-year period 1957 to 1964, the arts in America went through a dramatic upheaval as the formal strategies of Abstract Expressionism, and of the formalist International Style-Modernist edifice as a whole, began to seem irrelevant in the light of popular consumer culture and in the context of a complex economy that was becoming based more and more on mass electronic communications. A younger group of artists began to demonstrate the direct connections between art and an increasingly technologized society; they declared

their independence from Modernism and Formalism and began the unprecedented use, as the subject matter of their work, of images appropriated from the mass media. They used directly in their work everyday pulp images to reflect the cultural style of the consumer society that spawned them. The work of these Pop movement artists marks the transition into the Postmodern period.

The Pop aesthetic was antiart in the Duchampian sense, anti-American in its ironic commentary on the cultural effects of rampant commercialism, and yet profoundly American in its appropriation of the same technology developed and designed for propagating consumer culture. Pop artists borrowed specific photographic images from magazines and billboards, TV, and newspapers and created a new context for them by adding photographs or drawn elements of their own. Some artists such as Andy Warhol, actually earned their living as commercial artists. James Rosenquist, for example, painted huge billboards above Times Square and spoke about his experience of painting gigantic images of spaghetti. It was natural for Pop artists like Rosenquist to begin the direct use of photographic imagery in their paintings and prints, using photomechanical processing for printed effects as part of both style and of the total rhythm of their creative process.

Figure 26. *James Rosenquist Working in Times Square,* 1958. Photograph. Taking on the occupation of a billboard sign painter for a time, Rosenquist painted images so large that he remarked, "I could hardly tell what they looked like except for their textures but I had to be accurate and make them look like the things they were supposed to be." Swaying on planks 22 stories above the street, Rosenquist mixed paints and created supercolossal figures. He had to walk three blocks away to be able to scale the size relationships in the images he was painting. This experience had a profound effect on his work. (*Courtesy Leo Castelli Gallery, New York*)

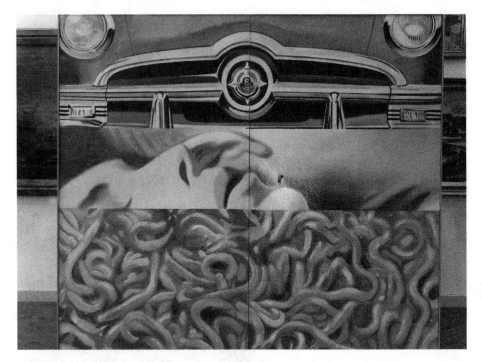

Figure 27. James Rosenquist, *I Love You with My Ford*, 1961. Oil on canvas, 210 cm. × 237.5 cm. Rosenquist juxtaposes realistically painted mass products such as cars in out-of-scale relationships to other pictorial elements to make us see more clearly, while at the same time proposing a deeper mystery. His work is typical of how Pop artists made use of consumer society images to produce ironic statements. (*Courtesy Moderna Museet, The National Swedish Art Museums and ARS*)

In England the Pop movement arose simultaneously. There Richard Hamilton and Eduardo Paolozzi were its leading exponents. In the United States, some of the best known artists included Andy Warhol, James Rosenquist, Roy Lichtenstein, Tom Wesselman, Robert Rauschenberg, Jasper Johns, Jim Dine, and Claes Oldenburg. Members of both groups, deeply influenced by the theories and example of Duchamp, met each other at the Duchamp retrospective held in California at the Pasadena Museum in 1963.

The familiarity and commercial popularization of photographic images (which at the end of the nineteenth century prejudiced artists against the direct use of photography in their work) now attracted the most progressive painters and sculptors. In opposition to the formal abstract tendencies of Modernism, figuration—a more public stance in art—began to return, a shift that has become fully established in the Postmodern period. Pop artists renewed questions also about the potential of industrial manufacturing techniques, not only as part of a work's execution, but as part of its total aesthetic, its look, its style,

its meaning. The fusion of technical process with aesthetic concern became a fundamental and characteristic aspect of Pop art. Although the subject matter of their work was popular culture, Pop artists distanced the subject from its social relations without assigning a political spin to it—a strategy that served to reify it, and place it within the realm of high art emblems as part of style, thus blocking the social commentary on the means of reproduction as discussed by Walter Benjamin.

By 1962, Andy Warhol began to screenprint high contrast photoimages onto his canvases. More than any of the other Pop artists, Warhol fused the method and style of industrial production. That photographic images and screen printing were despised, commercially tainted media considered inappropriate for art-making only increased their allure for the avant-garde. They were in fact ideal for translating the style and scale of the serial sequenced images that Warhol devised. Photoimagery and photomechanical reproduction methods became a vitally important aspect of his aesthetic. Once silk-screened photographic images were printed onto canvas, old prejudices about photography could be sustained only with the greatest difficulty.

Explaining how Warhol produced his "printed" paintings, John Coplans wrote: "Since a major part of the decisions in the silk-screen process are made outside of the printing itself (even the screens for color can be mechanically prepared in advance) making the painting is then a question of screening the image or varying the color. These decisions can be communicated to an assistant. . . . What obviously interests Warhol is the decisions, not the act of making."[16] Warhol deliberately appropriated existing popular mass-media photographic images and embraced industrial assembly line procedures for the production of his serial images as part of his overall style. He dubbed his studio "The Factory" and declared "If I paint this way, it's because I want to be a machine."

Warhol understood the dynamics of popular culture and the way images functioned to create desire and fascination within consumerist, celebrity-crazed society. Damned as a charlatan for being inarticulate, he ironically and paradoxically caught the tone of the times again and again with images such as *Electric Chair, Campbell Soup Cans,* and *Brillo Boxes,* and with portraits of stars all the way from Marilyn Monroe to Mao-Tse Tung. Like the Dadaists, Warhol wanted to create scandal, to shock, to raise questions. Like Duchamp, he became an infamous figure lionized by part of the art world for his extreme ideas. He also became the ironic subject of media attention. His line "In the future, everyone will be famous for fifteen minutes" is equally famous. For the mass public, Warhol's life style and art as promoted by the media created a new phenomena—the artist as celebrity.

Warhol began making experimental films in his studio and created a vérité style in which there was no editing of the final product. He simply placed the

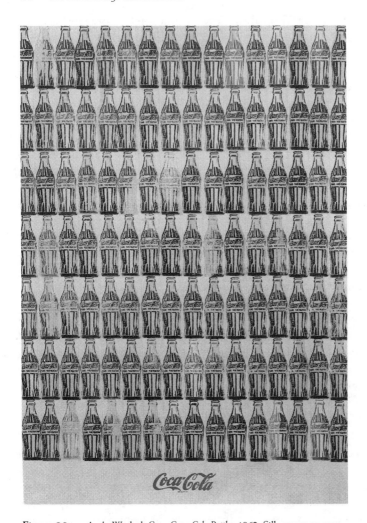

Figure 28. Andy Warhol, *Green Coca-Cola Bottles*, 1962. Silk screen on canvas, 82¼" W × 57" D. Warhol chose for his work advertising promotion images that were designed to tap into the consumer's inner system of desire. Fascinated by consumer culture, its economics, and its profound effect on the psyche, Warhol came closest in his "Factory" studio to producing machinelike effects in these sequences of bottles that suggest mass-production patterns. (*Courtesy the Whitney Museum of American Art, New York and ARS; Photo: Geoffrey Clements*)

camera in a corner of the room and let it run, an attitude later taken up by video artists. Later, his films became sensationalistic, tackling sex, psychology, and power, based on the personal lives and styles of his group following.

Daniel Wheeler writes of Warhol's unequivocal acknowledgment of the impact of media to decisively and coolly register the terrifying emptiness and

terrible loss entailed. Warhol's cooptation of the appropriative mechanical reproductions for his work reflects "the loss of faith in the kind of visionary subjectivity that had moved the Abstract Expressionists to reach for, and sometimes even attain, the sublime. The consequence may be felt not only in the riveting hollowness of Warhol's art—particularly in the Brillo boxes, those leading indicators of postmodern simulacra—but also in the cold, deadpan stare of the late self-portraits with their look of insatiable, inarticulate yearning for the unrecoverable."[17]

Collaboration and Research Lead to a New Range of Work

Beginning in the late fifties, new collaborative printmaking workshops began to spring up around the United States. An unparalleled spirit of investigation and invention spurred research into new materials and methods. The earliest of these workshops—Tamarind, Universal Limited Art Editions, and Gemini G.E.L.—invited rising avant-garde Pop artists Rauschenberg, Johns, Dine, Oldenburg, Lichtenstein, Rosenquist, and others to experiment, applying the full

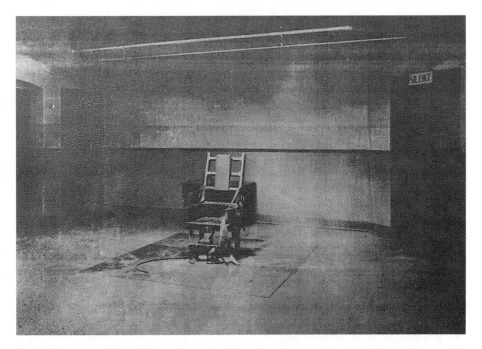

Figure 29. Andy Warhol, *Electric Chair,* 1965. Silk screen on canvas, 22" × 28". Warhol's choice of the electric chair as an emblem of contemporary America has a chilling effect. The artist's photographic rendering of the official execution machine as an icon prompts reflection on the judicial system. (*Courtesy Leo Castelli Gallery, New York; and ARS; Photo: Rudolph Burckhardt*)

range of known commercial technology to their art works. This system of collaborative studios offering technical innovation in-the-service-of-the-arts provided the springboard for a new kind of work which called on unorthodox use of processes and materials. Available to them were light-sensitive resists for metals, large positive aluminum lithographic plates (for use with the precise registration of offset presses), new synthetic meshes and special inks for silk screen, photomechanical production aids such as a range of large format high-contrast film types, contact screens, and process cameras, plastic molding technique—a veritable feast of technical and industrial processes that up to then had not been explored in the fine arts.

Attitudes gained from these experiences using photography, industrial photomechanical reproduction methods, and industrial technology in making fine art prints had spin-offs, particularly in kinetic sculpture and large minimalist works, which emphasized industrial fabrication as part of their meaning and style. A new range of work—the hard edge and "Op" works of the sixties, poured paintings, molded canvas surfaces, the pristine, smooth-surfaced Minimalist, and the huge formal Super-Realist works of the early seventies—were made possible through research and technological development of new artists' materials such as acrylic paints, mediums, and pigments (synthetic color); adhesives and tapes; plastics (such as styrofoam casting materials); airbrushes; and projecting equipment.[18]

Painters Begin to Ask Questions About Photography

Because the Greenbergian "dogma of Modernism" had become so thoroughly entrenched as a new orthodoxy, and because the official establishment was so intolerant of any difference or digression from its formalist program, painting or sculpting models from life now became an act of rebellion. The return of mimesis in art came along several routes. Especially through the use of photographic references projected by the Super-Realist painters; photomechanical methods by the Pop, Fluxus, and Neo-Dada artists; and the use of actual photographs by the Conceptualists.

Conceptual Art is known as an antiform movement in which the gradual dematerialization of the art object takes place. Puritanically stern in their denial of pleasure in materials in order to distance themselves from the materiality and nonillusionistic character of Minimalism, conceptual artists began to use text and photography as a means of calling into question modernist notions of individualism and originality. In their use of photography, they also found a means for documenting their immaterial performances and environmental works. Without photography, Christo and Smithson, for example, would have had little record of their huge land works in real environments.

Conceptualism, the last of the truly international art movements, was in opposition to Minimalism in the sense that it ran counter to the Greenbergian

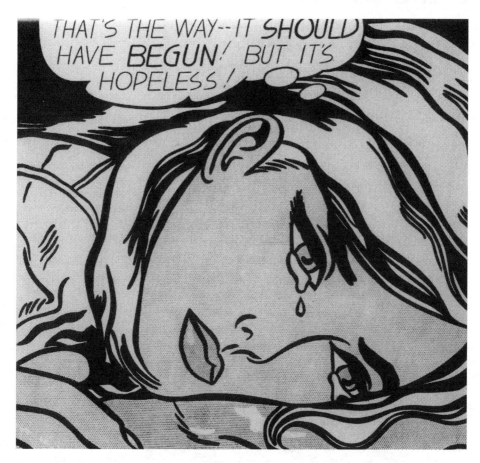

Figure 30. Roy Lichtenstein, *Hopeless*, 1963. Oil on canvas, 44″ × 44″. The Dada spirit for recycled images (inserted into the discourse of the sixties by Duchamp) influenced painters like Lichtenstein, who began to use mass-media images as subject matter. However, he maintained that his use of comic strips was for their "look," for purely formal reasons—not for the same kind of ironic reaction to social conditions that had earlier motivated the Dadaists and Surrealists. © *(c. Roy Lichtenstein, Courtesy Leo Castelli Gallery, New York)*

version of Modernism as being posited only in painting and sculpture (an iden-tification which led naturally to the value of the object). The Conceptualists opposed the commodity state of the object and promoted the idea that art as idea could become common property. Because of its reliance on language and text, conceptual works could be disseminated beyond the context of the gallery, and took on many forms, for example, in public projects which were then recorded in magazines or books. Too extreme for the public to follow, too removed from the material object to be viewable or saleable in traditional con-texts, too scandalous also, in that it arose in opposition to the Greenberg for-mulation of Modernism, it began to suffer when those theories lost credence.

Figure 31. Eduardo Paolozzi, *Artificial Sun*, 1965. Silk-screen print, plate 1 from *As Is When: Interpretations of Ludwig Wittgenstein*, 28″ × 22″. When Paolozzi presented his collection of found materials from Pop culture magazines, newspapers, and advertisement posters to a group of artists at the Institute for Contemporary Art in London, he influenced a whole group of British artists to begin thinking about their work in a different cultural context. In this series of silk-screen prints based on Wittgenstein's writings, Paolozzi used photo silk-screen to create completely new relationships between the disparate elements. *(Donated by Dr. and Mrs. Paul Todd Makler, Philadelphia Museum of Art)*

The strategies of Conceptualism and its discourse laid the foundations for the deconstruction which followed. During this period new lines of inquiry and engagement opened out. Conceptualist influence has carried over and is an extremely important aspect of new work by both American and European artists still influenced by it.

Photorealism or Super-Realism was an outgrowth of the extreme purism and formalism of Minimalist art. It brought trompe l'oeil naturalistic imagery into the field of painting (created on a giant scale). The work patterned on two-dimensional photographs and represented a new attitude after such renunciation. This style accentuated the abstract qualities of extreme spatial foreshortening, variable focus, smooth emulsionlike surfaces and sparkling luminosity found in photographs. Photorealist paintings create a double deception, for in

their referencing the real from a photograph, and painting a reproduction of the photograph, rather than the real, they were producing what Jean Baudrillard called a *simulacrum*—a copy of a copy. Paradoxically, photographers, institutionally marginalized for generations by the art establishment, had been seeking high art institutional acceptance and validation for their work by mimicking painting, and forcing their medium to deal with only formalist issues. However, photography now became an accepted and widespread part of art-making itself.

By 1964, two clearly opposing directions in art had become evident. The first was a Neo-Dada avant-garde with an interest in popular culture, an assemblage approach to art-making, and openness to technological media and cultural influence. The second, Minimalism, represented an extension of the formalist ideals of Modernism. Paradoxically Minimalism was subverted by the Conceptualist and Photo-Realist movements which began to make use of photography for art-making.

Figure 32. Richard Hamilton, *Kent State*, 1970. Silk-screen, printed in color, composition, 26⁷⁄₁₆″ × 34³⁄₈″. When Richard Hamilton photographed his TV monitor during an international news broadcast of the shooting of Kent State University students demonstrating against the U.S. invasion of Cambodia, he captured a historic moment. His translation of the scene into a screen print still bears the blurry striated quality of an early overseas transmission. He intended the print as a commemoration of a moment in time not to be forgotten. (*Collection: The Museum of Modern Art, New York: John R. Jakobson Foundation Fund*)

3

The Electronic Era and Postmodernism

> We are in the midst of a vast process in which [literary] forms are being melted down, a process in which many of the contrasts in terms of which we have been accustomed to think may lose their relevance.
>
> —*Walter Benjamin*

> Works of art are repositories for ideas that reverberate in the larger context of culture.
>
> —*Marcia Tucker*

The Postmodern Shift

The transitional moment between the end of an entire epoch and the arrival of a new age was encapsulated in a 1968 exhibition "The Machine As Seen at the End of the Mechanical Age." Curated by Pontus Hultén at the Museum of Modern Art, it was a response to the demise of a modern manufacturing society based on manufacturing machines as the "muscle" of industry and the rise of a postindustrial, postmodern information society culture based on instant communication services. Besides showing artworks which either commented on technology, or were a demonstration of the machine aesthetic as part of style, it previewed computer and video electronic media works as new aspects of representation. A major feature of these powerful media is their ability to transmit sound, image, and information over long distances, invading every aspect of contemporary life, deeply affecting the public consciousness, forcing an end to a modernist culture based on suppression of the outside world. The new media became the threshold to a new territory of postmodern conditions and cultural issues.

In the sixties, architecture, a cultural form always a direct barometer of change because of its direct ties to economic, technological, industrial, and social development, began to revise radically its formalist tendencies. "International Style" buildings, seemed suddenly irrelevant and out of place in turbulent times. Everywhere images of war, environmental pollution, and political upheaval seemed to challenge the purity of polished glass and steel curtain walls.

Architects Robert Venturi and Denise Brown reacted against the utopian, austere International Style's rationally determined steel and glass boxes and concrete bunkers, criticizing their failure to reflect the times. The dispiriting effects and aloofness of Modernist buildings, which fell short of acknowledging cultural memory, context, living patterns, and individual needs, led them to write in the 1970s their now famous essay "Complexity and Contradiction in

Figure 33. Robert Rauschenberg, *Signs*, 1970. Silk-screen print, 43″ × 34″.
Rauschenberg stated that this print was "conceived" to remind us of the love, ter-
ror, and violence of the previous ten years. Danger lies in forgetting. His photo-
graphic juxtaposition of Martin Luther King's death, the moon landing, the
Kennedy brothers, Janis Joplin (later to die of a drug overdose), soldiers, and pro-
testers against the Vietnam War was a restatement of the old issue of photomon-
tage. *(Courtesy Castelli Graphics, New York; Photo: Pollitzer, Strong, & Meyer. © Robert
Rauschenberg, VAGA, New York 1994)*

Architecture: Learning from Las Vegas." They called for a return to the vernacu-
lar, to the "complexity of Main Street" and for reform of architecture's elitist
language. This essay has been said to have announced the arrival of the post-
modern condition. Mies Van der Rohe's 1920 statement "Less is more" now
became "less is a bore."

At the same time, televison[1] projected the world of the sixties directly into the public's consciousness transmitting dramatic, disturbing images of the Vietnam War mixed with scaled-up images of consumer objects which attempted to hook the viewer into believing that both kinds of images were of equal importance. With the "delirious circularity of the channel dial," all assumptions of coherence vanished in the new cultural infrastructure. The disorganization and nonlinearity of the networks defined television as a site of multiple intensities. This chaotic form in which information and theatrical effects were mixed with the totally banal, in which art, culture, politics, science, and so forth, were all brought together outside of their usual contexts and connections, began to create a vast meltdown within the public consciousness. Television became the arena of a confusion, a melting pot of forms, concepts, and banalities which acted as the crucible for a postmodern consciousness, (Chapter 4).

It was Venturi's interrogation and condemnation of Modernism's purist International Style which inspired the term "postmodern." He rejected the rational utopian ideology inscribed in architectural forms of representation. Because architecture must be lived with, Venturi saw that Modernist aloofness and cool distance was inconsistent with the chaotic contradictions, complexity, and diversity of everyday life. Formal glass and concrete slab buildings could

Figure 34. Keith Haring, *Untitled*, 1983 Sumi ink on paper, 72″ × 134″. Part of the Neo-Pop phenomenon, which grew out of street culture. Haring has the ability to synthesize and capture contemporary ideas in a powerful vernacular. One part doodle-graffiti, one part Paul Klee, one part design, he sets out to influence public opinion about such things as drugs and nuclear war. In the image shown here, he comments on the control of the public by TV. Haring's popular success made him into an art star with important clout for disseminating his ideas. (*Courtesy The Estate of Keith Haring, New York; Photo: Ivan Dalla Tana*)

not satisfy a populace who wanted and needed a more accessible architecture, one less monumental, more human in scale, one which was more messily vital, multivalent and layered—"like life"—rather than one with a dominantly formal structure. His more "vernacular architecture" accepted the needs of the public to be factored into the architectural equation, along with the chaos, instability, and the many-layered complexity of commercial mass culture. He called for a return to "the difficult whole" where various parts, styles, or subsystems are used to create a new synthesis. Postmodern architecture began to embrace pastiche as a strategy, creating an aesthetic of quotation, appropriation, and incorporation of traditional styles to provide recollection of the past.

The postmodern presumes the modern, and includes both an academic, or "high" aspect and a "low," or vernacular one. Postmodernism views texts and images as radically polyvalent. Around 1960, French Structuralist and Post-Structuralist theorists such as Foucault, Barthes, and Lyotard attacked the very concept of objectivity and of fixed meaning—especially in language. Making use of linguistic theory these writers argued how much our interpretation of the world is shaped by the language we use to describe our experiences. While modernist beliefs are based on a linear view of progress, a defining feature of postmodernity is the impossibility of that kind of evolution. The world began to be seen as an experience of continually changing sequences, juxtapositions, and layerings, as part of a decentered structure of associations.

Using tools provided by structuralism and deconstruction, Feminist theory began to deconstruct modernist assumptions and to assert the value of feminist art. Issues of gender, identity, and race, long suppressed, were foregrounded. Feminist influence encouraged recognition of the interaction of many diverse voices. The feminists and the cultural critics began to deconstruct the major canons and narratives that had formed Western thought. They influenced the development of a visual culture transmitted by electronic technologies which have consciousness transforming capacity, superseding one that relied mainly on the word.

"Post Machine" Electronic Art and Technology Exhibitions

Several exhibitions with art and technology as a theme celebrated the arrival of the electronic era. Although they focused on electronic media, the work was still based on Modernist premises in its aesthetic attitudes. These early works can provide useful measure of the extent to which technologically based art works have been reflected in aesthetic change from the 1970s to the present.

"Cybernetic Serendipity," curated by Jasia Reichard, a large-scale exhibition which included computer printouts of musical analysis, computer-designed choreography, and computer-generated texts and poems, opened at the Institute of Contemporary Art in London and later traveled to Washington. Other exhibitions with art and technology as a theme were in preparation. "Software"

Figure 35. John Baldessari, *I Will Not Make Any More Boring Art*, 1971. Lithograph, 22′ × 30′. Exasperated by modernist dogma with its distance from social issues and its formalist agenda, John Baldessari, in 1970 destroyed all thirteen years of his artwork and publically cremated their ruins as a dramatic protest against the constraints of modernist hegemony. Like a boy forced to stay after school to atone for breaking the rules, he scrawled the reiteration of his protest: "I will not make any more boring art." (*Courtesy of Brooke Alexander Editions, New York*)

at the Jewish Museum opened in 1970. At the Smithsonian Institute, Washington, D.C., "Explorations" opened in the same year. This exhibition was curated by Gyorgy Kepes, director of MIT's important new Center for Advanced Visual Studies, which was established in 1968.

The guiding principle of MOMA's 1970 exhibition "Information" was that art exists only conceptually and as such is "pure information." The computer was a natural metaphor for this exhibition. Many of the works demonstrated the concept of systems analysis and its implications for art. "Information" explored groups or networks of interacting structures and channels as a functionally interrelated means of communication. These exhibitions were part of the avant-garde movement of the sixties and seventies which moved toward a dematerialized view of art that refused the object.

They were also a tribute to the new spirit of openness towards use of industrial techniques in art-making which had an especially dramatic impact on the art

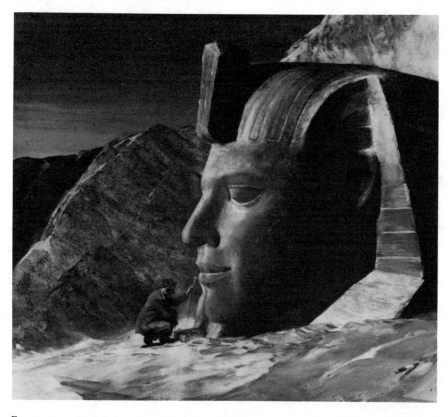

Figure 36. Mark Tansey, *Secret of the Sphinx*, 1984. Oil on canvas, 60″ × 65″. Tansey's paintings amass a wealth of information and combine with imaginative inventiveness to create mysterious commentaries on history and meaning in contemporary life. Making obvious use of photographic style, Tansey subverts it to make his stories seem more real and to raise questions about technology, history, and contemporary life. (*Private Collection, Courtesy Curt Marcus Gallery, New York*)

of the sixties and seventies. By the time of the 1961 "International Exhibition of Art and Motion" at the Stedelijk Museum in Amsterdam (also curated by Pontus Hultén) and the 1964 "Documenta" exhibition in Kassel, Germany, interest in kinetics had grown in Europe toward an escalation of technical means. The Zero and Grav groups (Neo-Dadaist and Neo-Constructivist kinetic sculptors) began serious work using industrial machine technologies. In the United States, sculptors especially began to harness new electronic tools that were rapidly being developed: electronic communication systems and information technologies; computers and lasers with their scanning possibilities, along with innovation in television and video; light- and audio-sensor controlled environments; programmable strobe and projected light environments with sophisticated consoles.

Figure 37. Jean Dupuy (Left), Jean Tinguely (Center), and Alexander Calder (Right) with *Heart Beats Dust* at "The Machine as Seen at the End of the Mechanical Age Exhibition," Museum of Modern Art, New York, 1969. E.A.T. (Experiments in Art and Technology) arranged a competition for collaborations between engineers and artists. *Heart Beats Dust* was the winning entry. The jurors issued this statement: "In each of the winning entries a spectrum of technology was used with great impact on the art forms. Evident is the realization that neither the artist nor the engineer alone could have achieved the results. Interaction must have preceded innovation. . . . The unexpected and extraordinary, which one experiences on viewing these pieces, result from inventiveness and imagination, stimulated not by the brute force of technical complexity but by probing into the workings of natural laws." (*Photo: Harry Shunk*)

Figure 38. Jean Dupuy, artist, and Ralph Martel, engineer, *Heart Beats Dust*, 1968. Dust, plywood, glass, light, electronic machine. The essential material of this sculpture is dust enclosed in a glass-faced cube and made visible by a high-intensity infrared-light beam. Alexander Calder activates the dust by placing the scope to his heart, triggering acoustic vibrations by the rhythm of his heart beats. The work manifests a form of collaboration with nature where natural forces within and outside the human body are brought into play. (*Photo: Harry Shunk*)

Although computer graphics research was, by the late sixties, being conducted internationally in the highly industrialized countries of Europe, North America, and in Japan, few artists had access to equipment or were trained in the specialized programming needed at that time to gain control over the machine. Those artists, primarily from the fifties Neo-Constructivist tradition, whose main interests lay in the formal modernist study of perception and the careful analysis of geometrically oriented abstract arrangements of line, form, and color, rather than descriptive or elaborated painting, were especially drawn to finding a

means of researching their visual ideas on the computer, (Chapter 5). They sought the collaboration of computer scientists and engineers as programmers. By 1965, advances in television technology had spawned the new medium of video. The first video camera/recorder, Portapak, was released in New York by the Sony Corporation. This relatively portable equipment drew widespread interest amongst artists[2] because of its transmission-receiving aspects and its implications for low-cost immediate feedback in comparison with film. The medium was ideal as the starting point for informal, studio closed-circuit experiments with concepts of time and motion—as a continuation of the formalist tradition of kinetic sculpture. The first video artists (Chapter 4) conceived their works as modernist sculptural installations and performance.

Experiments in Art and Technology: Collaborations in Two Kinds of Thinking—Art and Science

Convinced there was a need for an information clearinghouse to make technical information and advice available, and a service for arranging individual artist-engineer collaborations in the United States, artists felt the need to seek collaborations with engineers and scientists to help in producing innovative work using new technologies. The artist Robert Rauschenberg and scientist Billy Klüver formed a new organization called "Experiments in Art and Technology" (E.A.T.), which published its first bulletin in January 1967. Because of its governmental and corporate contacts, E.A.T. was in an ideal position to act as a liaison between artists,[3] engineers, and corporations and to provide a meeting place where seminars, lectures, and demonstrations could be presented.

Bell Laboratory physicist Billy Klüver's friendship with members of the progressive Swedish avant-garde such as poet and painter Oyvind Fählstrom and Moderna Museet Director Pontus Hultén, had brought him into contact with both European artists (as an advisor for Hultén's 1961 Stedelijk Museum kinetic exhibition) and with the New York art world. "Klüver saw many parallels between contemporary art and science, both of which were concerned basically with the investigation of life . . . [he had] a vision of American technological genius humanized and made wiser by the imaginative perception of artists . . . Klüver seemed to speak two languages, contemporary art and contemporary science."[4]

In 1965, when an invitation came to American artists from a Swedish experimental music society to contribute to a festival of art and technology, Klüver became the logical liaison between artists and engineers. Although the project fell through, it helped to establish a relationship between a group of choreographers associated with the Judson Memorial Church, and musicians John Cage and David Tudor, multimedia artist Robert Whitman, and Oyvind Fählstrom. They began to combine technology with performance events known as "Happenings" named after the interactive participatory performance-based

work of John Cage and Alan Kaprow (Chapter 2). The excitement and energy of the emergent avant-garde were characterized in the efforts of Rauschenberg and Klüver, who in 1966 brought together thirty Bell Laboratory engineers to work with visual artists, dancers, and musicians. They raised funds for an ambitious project called "Nine Evenings: Theater and Engineering" by contacting individual corporations, foundations, art dealers, and collectors. However, from the start, the artist-engineer collaboration system encountered difficulties, for the engineers were not used to working against theatrical deadlines and frustrated artists were unable to rehearse properly without finalized technical support.

Aesthetically and technically, "Nine Evenings" was less than anticipated, but it proved that collaborations between artists and engineers were possible. In many ways, its most important function lay in defining the nature and basis of the problems (not the solutions) inherent in artist-engineer collaborations. Both artists and engineers had to learn new ways of thinking in which the practical and the creative could interact. The experience they gained illustrated clearly not only the high financial costs of such ventures but also the enormous amount of time and effort needed in planning and coordinating such complexity of activity and thought.

For example, the most ambitious (and ill-fated) project undertaken by E.A.T. came in 1967, in the design and construction of an art and technology pavilion for the Pepsi-Cola Company at Expo '70 in Osaka, Japan. Following months of discussion and consultation, a construction and maintenance budget was decided on and a preliminary concept for a mirror-surfaced domed interior was approved. Sculptures inside and outside, some using laser light and motion, would create a setting for the interactive and performance pieces to be presented inside the dome. The accent was on experimental programming which would involve the public and alter the functional relations between art and the public in a popular setting. Fog jets would shroud the exterior of the pavilion in a perpetual cloud of mist. No one could have predicted the enormous effort and difficulty of realizing such a project which overshot its budget so alarmingly that, in the end, Pepsi's tolerance was exhausted and E.A.T. was asked to leave even though work on the pavilion had been completed successfully and (miraculously) on time. The pullout represented a serious setback for E.A.T. in its role as corporate mediator. Many of its 6000 members began to grumble that they were being bypassed and merely used as statistical fodder for E.A.T.'s grant proposals. Questions began to be raised about the cultural value of such expensive experimentation.

Artists and Industry

The most costly and ambitious exhibition of collaborations between artists and engineers was "Art and Technology," an exhibition curated by Maurice Tuchman, which opened at the Los Angeles County Museum in 1971. Five years in preparation, the show featured the work of 22 artists who had been paired to work

with specific corporations under an elaborate contract system that covered costs of technical assistance, production, and maintenance of the work for the three-month duration of the exhibition. The contracts represent probably the most consciously thorough practical attempt of all the art and technology exhibitions to ensure there would be no pullouts or inadequate provisions for technical assistance in case of malfunctions. There were three categories of artists using new technologies: first, those whose formalist work was primarily concerned with the direct use of machines to explore the aesthetics of light and kinetic movement. These included Robert Whitman, Rockne Krebs, Newton Harrison, and Boyd Mefferd. The second category was comprised of well-known New York artists whose experimental work made use of fabrication technology (i.e., using the machine as a tool to produce their work), such as Claes Oldenburg, Roy Lichtenstein, Richard Serra, Tony Smith, Andy Warhol, and Robert Rauschenberg. The final group—James Lee, Ron Kitaj, and Oyvind Fählstrom—provided poetic and humorous relief in their serendipitous works by using the machine as an icon.

Figure 39. Pepsi-Cola Pavilion, Osaka, 1970, Environment designed by E.A.T. The pavilion was designed as an interactive environment inside and out to be responsive to sound and light through strategically located systems, most of them triggered by the behavior and movement of the spectators. The outside of the dome was enveloped in a fog produced by mist jets. (*Photo: Harry Shunk*)

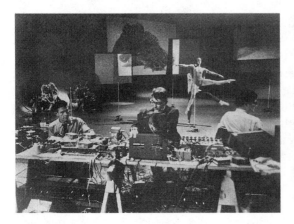

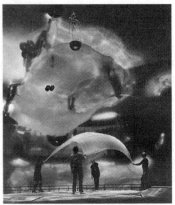

Figure 40. *Variations V,* 1965. Performance work. Foreground, left to right, John Cage, David Tudor, Gordon Mumma. Rear, left to right: Carolyn Brown, Merce Cunningham, Barbara Dilley. Choreography: Merce Cunningham; Music: John Cage; Film: Stan Van Der Beek. *(Courtesy: Elelectronic Arts Intermix. Photo: Herve Gloaguen)*

Figure 41. Remy Charlip, *Homage to Loie Fuller,* March 8, 1970. Performance inside the E.A.T. Osaka Pavilion. The spherical mirror at the top of the dome, the largest one made at the time, reflected not only the viewers, but intensified the color and movement of the many performances that took place inside. The mylar walls created illusionistic reflected effects that produced a sense of participation and interactivity. *(Photo: Harry Shunk)*

Although the tumultuous five-year period (1966–1971) from the exhibition's original inception to its final presentation was marked by unforgettable sociopolitical malaise, none of the artists in the exhibition used technology to comment on the technological violence of the Vietnam War, which millions of Americans were watching on television. The war engaged a profound problem in the American ethos, for it challenged the belief in the American dream—man and machine creating a new democratic utopia through technological efficiency and progress. The sixties' mood of hope and optimism was replaced in the early seventies by rage and frustration in a sea of events that seemed out of control. There began to be a growing awareness of the fatal environmental effects of some technologies. That technology could be poeticized and humanized by art suddenly seemed irrelevant when its use had been unleashed for such destructive ends.

The critics attacked—insinuating that the exhibition represented a nefarious marriage between advanced technology, the museums, and big business. They coined new terms—"corporate art" and the "culture of economics."[5] A serious economic depression followed the ten-year war. It signaled a significant cutback in government and corporate support for the arts, a serious threat to costly technological collaborations. A crisis was also brewing in the art world.

In the early seventies, the costly formal experiments (especially those kinetics employing computer technologies) that had taken place in the realm of high technology in the service of the arts, confined mostly within conceptual framework, had led to an art not easily displayed in conventional museums and galleries. The work presented physical problems related to technological maintenance, obsolescence and sheer size, problems related both to the preserving and to marketing functions of art institutions. There were few curators and critics who had the institutional training or interest to go beyond the usual parameters of art to explore the new aesthetics presented by the various technological thresholds of the new work. A consensus between museum curators and critics, arose from these realizations, which resulted in a major change in their attitudes towards the validation and inclusion in the fine art canon of art works which relied directly on technological means, except for the new electronic medium of video, (see Chapter 4).

Art as Pure Information

"In Conceptual Art," wrote Sol LeWitt, "the idea or concept is the most important aspect of the work . . . all planning and decisions are made beforehand and the execution is a perfunctory affair. The idea becomes the machine that makes the art." When art's importance lies beyond what can be seen or touched, it thus becomes "dematerialized." The movement against art as material form was launched in various ways and took various forms. Rauschenberg's 1961 portrait of a Paris art dealer consisted of a Dadaesque telegram: "This is a portrait of Iris Clert if I say so." Yves Klein delivered a lecture at the Sorbonne in 1959 entitled "The Evolution of Art Towards the Immaterial." For Klein, immateriality meant freedom, boundless open space, and levitation. This tendency towards dematerialization of the art object which began when photographic technologies were developed became even more of an issue with the evolution of digital imaging.

By the midseventies, important advances in technology opened possibilities for the computer to become a truly personal tool for artists, (Chapter 5). The invention of the microprocessor and more powerful miniaturized transistor chips, (integrated circuits), changed the size, price, and accessibility of computers dramatically. Commercial applications in design, television advertising, and special image processing effects in film and photography became an overnight billion dollar industry, providing the impetus for increasingly powerful image-generating systems. The need for such intimate collaboration between scientists and engineers with artists now seemed no longer so urgent, for custom "paint system software" and "image synthesizers" began to appear on the market. Artists began to challenge the computer to go beyond the formal tasks it had up to then performed and found it could be used as both a tool and a medium. Imagery becomes dematerialized information in the computer's data base. When digitized, this information affects a completely new outlook on the visual

field. Digital modeling began to create a crisis in representation. Because any kind of imagery can be digitized and reformulated, the computer, by the 1990s, had subsumed photography, video, and film (Chapter five).

Photography Becomes a Tool for Deconstructing Modernism

As we have seen, in line with refusal or violation of the formal purist aesthetic of Modernism, the photographically represented world (with all its media, genres, and materials) was not drawn fully into the arena of mainstream expression. Ironically, once photography was accepted into the fine art canon, issues denied for so long under the rubric of modernism became the very focus and the means of its deconstruction. Strategies used were appropriation or quotation of pre-existing historical images, texts, forms, and styles. Mass media influences originating in ironic "Pop" imagery were brought into a new, more political forum.

The formal, Modernist aesthetic of fine art photography—hand-made prints with their own claims of an acknowledged particular object presence or "aura"—has essentially separated photography from the more expanded Postmodern view of it, as expressed by Walter Benjamin. As seen against his view of photography as a powerful form of mass communication, with a social function which dominates the culture of everyday life, in forms such as photomechanical reproduction, cinema, and television, "fine art" photography had become trapped in the meshes of a confining system. Abigail Solomon-Godeau, in an essay entitled "Photography After Photography," writes about the nexus of postmodern attitudes with photography.

> Virtually every critical and theoretical issue with which postmodernist art may be said to engage, in one sense or another, can be located within photography. Issues having to do with authorship, subjectivity, and uniqueness are built into the very nature of the photographic process itself. Issues devolving on the simulacrum (authenticity versus artificiality), the stereotype, and the social and sexual positioning of the viewing subject are central to the production and functioning of advertising and other mass-media forms of photography. Postmodernist photographic activity may deal with any or all of these elements and it is worth noting, too that even work constructed by the hand . . . is frequently predicated on the photographic image.[6]

Barbara Kruger's work offers a good example of these major tendencies in art and its relationship to technology because she raises ironic questions about representation relative to social constructs. She uses the copy and appropriation as the major strategies for her conceptually based work. She reproduced found images from mechanically produced sources and adds texts to them so that they function effectively as active commentary. Her pieces, as she says, "attempt to ruin certain representations, to displace the subject and to welcome a female spectator into the audience of men." Kruger's media conscious work is at the

intersection of mass media/mass culture and high art. Her work is confrontational, agitational, and is aimed at destroying a certain order of representation: the domination of the "original," which up to now has largely been male identified.

In another example of deconstruction, Sherrie Levine created a radical critique of originality (the hand of the artist) by rephotographing and thus "appropriating" in their entirety the works of other well-known artists (such as Walker Evans, Rodchenko, or Mondrian) and by signing the fabricated copy. Her Neo-Dada work created a sensation and forcibly brought the issue of the copy into strong focus. Her work comments on the uncertain subjective basis for validation and justification of art. Paradoxically (both because her work aroused so much controversy and because of its special postmodern relevance) it has been reproduced countless times, thus raising its market value.

Figure 42. Barbara Kruger, *Untitled,* 1982. Unique photostat, 71 ¼″ × 45 ⅝″. Kruger reproduces a (patriarchal) cultural myth to comment on different levels of value—for example, the value placed on hype about "genius" and "originality" in relation to art market value as opposed to the communication value of the artwork. Through creating her own work from found, appropriated images, she confronts the art market method of assessing the artist as part of the "cult of genius" and the original as related to the hand of the artist by discarding both concepts. (*Collection: The Museum of Modern Art, New York. Acquired through an Anonymous Fund*)

Mike Bidlo (another artist who, like Levine, appropriates other artists' work in order to critique the originality, authorship, and market system) has created an entire exhibition of Bidlo Picassos including "Guernica," the Gertrude Stein portrait, and "Les Demoiselles d'Avignon," which he showed at the Castelli gallery. His work poses the questions: When is a copy an original? And what is its market value in relation to the original? Bidlo and Levine challenge the authenticity of the original, the primacy of the creative act, and the mastery or genius of the artist. Walter Benjamin provides an apt context for their efforts: "The criterion of authenticity ceased to be applicable to artistic production. Here the total function of art is reversed. Instead of being based on ritual, it begins to be based on another practice—politics." Copying processes are a threat to the value system of the gallery world. Copy artists also reveal in their work the tension between the high value the arts have placed on "the real" and on commodity value in relation to the postmodern emphasis on the immateriality of mediated signs and referents.

Neo-Pop works, which have dazzled gallery viewers with their punk sensibility since the early eighties, have used photography and have appropriated commercial images from comics and media along with collage and an effluvia of found materials. However, the new Pop differed in its implicit critique of commercial culture by unmasking the "manipulative nature of the message-bearing images fed . . . through various media and designed to keep us consuming goods, goods produced solely to be consumed. The result is not only an appropriation of that imagery but also an appropriation of the power of that imagery."[7] The methods used by artists such as Keith Haring, Kenny Scharf, Rodney Alan Greenblatt, and Jeff Koons to convey their messages make use of the same mannerism, exaggeration, and sense of easy fun mixed with wrenching disjuncture that characterizes television itself. While sixties Pop established an equation between aesthetic appreciation and commodity consumption of images, and as a result, made their works more accessible to the public, the work had a "disinterested" nonpolitical subjectivity to it which in effect refashioned the images, abstracted them, and effectively detached them from the context of their social relations. The reincarnation of Pop however, was socially aware and used incongruous, out-of-context imagery of all kinds to make its point. This new work aped the energy and the glitzy unabashed directness of commercial advertising style, of television and magazine style, but with its own political agenda.

Levine's use of other artists' work to question "the copy" and "the original" recalls the issues raised by Duchamp when he exhibited his ready mades in a gallery—objects not only made by machines, but produced industrially as multiples of an object. Duchamp had pointed out that the meaning and value of art is a constructed product of the mind and that changing the context of an object could create a new meaning for it and enable it to be seen differently through a different perspective. This act of appropriation and repetition indicates a kind

of cultural exhaustion which has important shock value because it dramatically brings into focus major issues which normally lie below the surface, issues which need to be questioned. Seen in today's context, Duchamp's ideas, about appropriation, have gained fresh impetus by bringing up issues of the copy and the original, and the privileging of the object. Duchamp's ready-mades set an important precedent because they recontextualized and reoriented art away from its own identity as a form (as in Minimalism or Abstract Expressionism) towards the kind of instability, and undecidablity of Postmodernism.

Deconstruction Strategies Open Alternatives in the Field of Representation

Feminism, which evolved in its last incarnation as a result of the dramatic social change of the sixties, contested the Modernist canon. Feminist artists questioned the male-dominated litany of aesthetic values, of artistic criteria, and of art-historical practices. Suppressed and marginalized for so long by the dominant power structure, they began to profoundly interrogate and alter the subject matter for art, and the way art is practised and positioned. By introducing feminist content into their work through the use of innovative new materials and techniques, they brought into the field of representation new views of gender and identity; of the body as subject matter; and dismantled, as we have seen, traditional notions of originality and authorship. With their fresh outlook they created new forms of mixed media exploration such as the body-art of Hannah Wilke, the performance work of Carolee Schneemann, and the installations of Adrian Piper.

In "The Death of the Author,"[8] Barthes asserted that the author (or artist) is never the source and the site of meaning but rather that meaning is never invented, nor is it locked in. A work exists in a "multidimensional space in which a variety of works, none of them original, blend and clash. The work is a tissue of quotations drawn from the innumerable centers of culture . . ." the artist/author is no longer the only container for feelings, impressions, passions, but is rather "this immense dictionary from which he draws a writing (image) that can know no halt: life never does more than imitate the book, and the book itself is only a tissue of signs, and imitation that is lost, infinitely deferred." This position of refusal to find fixed meanings or originality in either the author/artist or their work is a fundamental refusal of what he regarded as an ossified and essentially backward looking humanism. "Since to refuse to fix meaning is, in the end, to refuse God and his hypostases—reason, science, law."

The debate about these ideas and the aesthetic attitudes that grew out of the discourse led to appropriation, parody, and pastiche as critical imaging methods (key features of Post-Modernism). As we have seen, the unmediated appropriation exemplified by Levine and Bidlo's works has a transgressional political edge. Appropriation can be seen pessimistically as merely looking

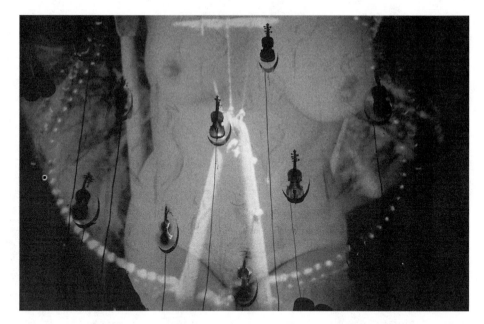

Figure 43. Carolee Schneemann, *Cycladic Imprints*, 1993. Four slide projectors, dissolve units, stereo sound collage. Schneemann's work through the past three decades has focussed on the body as a site for shifting identities and political struggle. In "Cycladic Imprints," her use of technology is both a conceptual and a sensual interface where specific forms of mechanization introduce randomizing configurations: seventeen motorized violin bodies are continuously in motion superimposed on a wall 18 × 30 feet long, painted with patterns of an archaic double curve. Projections from programmed slide projectors dissolve hundreds of images further animating the piece. "Schneemann has time and time again invented kinetic machinery and projection systems to dissolve the boundary between painting and film, working on the edges of dissolution where static elements are overcome, overtaken into motion." (*Courtesy Carolee Schneemann*)

backward. Alternatively, appropriation may be seen as renewal. It adds the context of history to current affairs. As pastiche, it can be a hybrid of imitations of dead styles, recalling the past, memory, and history with satirical intention. It can be referred to as a kind of radical eclecticism in which various styles or subsystems are used to create a new synthesis. Similarly, parody can be employed in different ways. The work of the Neo-Expressionist artists can be seen as a satirical quotation of older work but it can also be seen as an effort on the part of contemporary German artists after the war to find new ground.

Deconstructive strategies opened the way to alternative representations involving social and cultural contexts for ideas. Eurocentric thought assumed a centered, authoritative voice based on a single world-view, structured through domination and transformation of subjected cultures. This attitude now seems outdated in the face of a globalized transnational, information economy. Even the process of analysis itself is suspect.

In the wake of cultural deconstruction and the shifting consciousness of the times, resistance to technology as an integral aspect of art-making and cultural development began to erode. Not only had new media invaded and changed the very fabric of public life by the midseventies, (Chapters 4 and 5), they also began to play an integral part in altering perceptions and attitudes about the structure of art and its production and dissemination. The wider dispersal and dissemination of artistic practices could no longer be contained within the old framework. "The shift from art that could only refer to itself, to an art that could refer to everything, took place almost overnight."[9]

The New Consciousness

After fifty years, television has contributed strongly to a new cultural condition, a shift of assumptions and attitudes. A chaotic condition—in which information and theatrical effects are mixed with the totally banal, where art, culture, politics, science, etc., are all brought together electronically outside of their usual contexts and connections, has created a vast meltdown of forms within the public consciousness. Use of compressed, intensified images and messages, with their edited forced sequences and shock value, has now become part of everyday visual vernacular, by now, an absorbed aspect of Western aesthetic tradition and mass culture. Television's image flow has created a visual cultural phenomenon surpassing, and subsuming, the influence of the printed word, radio, and cinema. Television has the power to communicate, intensely mediate, and transform the public mind set.

Television itself is now undergoing a major change. In today's home entertainment center, TV is only one of many options which vie for the public's attention. With the rise of computer technologies, the public may surf the Internet rather than the TV airwaves. Computer games, CD-ROMs and CDIs are beginning to make inroads in the public consciousness. Watching rental videos of films on the home VCR, and Home Box Office Channel TV rentals, is causing the demise of the public cinema where "cineplex" projection facilities are becoming smaller and smaller, offering as much variety as possible for the viewers, rather like choosing another "channel." Interactive shopping channels are replacing the trip to the department store. The affordable small hand-held Hi-8 camcorder with NTSC broadcast capability or digital capability built into its technology is creating a whole new arena where the public are becoming videomakers, showing their works on their own TV monitors. The public is thus brought face to face with itself.

On MTV, now available by satellite around the world, visual effects borrowed from earlier independent artists' films and video are routine, producing a mass public with a far more sophisticated visual sense than ever before. One spin-off of global TV is the large number of films being produced with startlingly innovative visual effects. Films are becoming more visual, designed to avoid language problems in the culture of the global market.

For the Body: A New Kind of Time and Space

The contemporary body as it now exists inhabits a new kind of simulated environment in which time and space have become obsolete. Celeste Olalquiaga, in her book *Megalopolis: Contemporary Cultural Sensibilities*, describes the postmodern experience.[10] The contemporary body now exists in a new kind of simulated environment in which our conception of the corporeal self has been altered. Connected by the 800 (or 900) number and the ubiquitous, all pervasive plastic card, confused by a video landscape that has made a simulacra of reality in one's image, stripped of identity by controlled government and corporate information processing and surveillance to the point of total exposure, the postmodern individual is experiencing a major transformation of perception and consciousness.

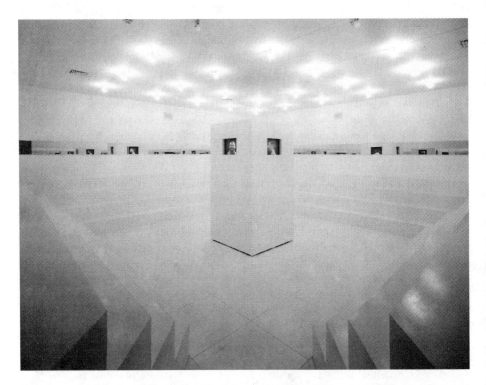

Figure 44. Adrian Piper, *What It's Like, What It Is*, # 3, Installation, Dislocations Exhibition, Museum of Modern Art, 1994. Piper believes that artists have an unusual social responsibility "to crystallize and convey important information and ideas about the culture." She designs many of her works to situate the viewer directly into the drama of first-hand experiences of racism: for example, to be the only black person in a white social community; to feel as though one has to be on guard at all times—back, front, sides—as the only person targeted by racially denigrating terms. She wants the viewer to identify with someone suffering racism. This work isolates her black subject in an all-white panopticonlike space, forced to identify with What It's like and What It Is. (*Photograph: Scott Frances/Esto*)

The skewing of time by the constancy of artificial compressed viewing of TV, its distortion by time/distance factors of jet lag, faxing, e-mailing, communicating on the Internet—our hours jammed with sensory overload—results in a strange kind of distracted state of exhaustion. "Spatial and temporal coordinates end up collapsing: space is no longer defined by depth and volume, but rather by a cinematic (temporal) repetition, while the sequence of time is frozen in an instant of (spatial) immobility." As a result, the body yearns for concrete intense experiences of reality, saturating itself with food, consumer goods, and an unhealthy fixation on sex.

Postindustrial urban space is artfully designed to create a feeling "of being in all places while not really being anywhere."[11] Lost in a maze of well-lighted continuous display windows of architecturally transparent shopping malls with similar stairs, elevators, and facilities, the consumer wanders disoriented in a flat homogeneous space trying desperately to remember which spiraling space is the parking lot needed for the escape back to reality.

Walter Benjamin commented on the way new knowledge is acquired through apperception and distraction. "The tasks which face the human apparatus of perception at the turning points of history cannot be solved by optical means, that is, by contemplation alone. They are mastered gradually by habit, under the guidance of tactile appropriation." In reducing experience to the efficient common denominator of information, aspects of the body and of the computer have begun to transmigrate. The body becomes more mechanized at the same rate as the computer becomes more "friendly." The boundaries between the spheres of the body and of technology have begun to transgress, overlap, and blur. The computer's capability to create completely simulated worlds has further distanced the body from tactility. Alice Yang comments that the body as a physical dimension is not only a *subject* of representation,

> but is the means through which we make and experience art. It is through the bodily process of looking, touching, and moving around in space that we have come to apprehend art. Thus the impact of technology has significant repercussions also for notions of art making and art viewing . . . slowly and perhaps inevitably, technology is uprooting aesthetic experiences located in the body such as tactility and human vision."[12]

A concrete example of this change is the degree to which the interactive CD-ROM has changed the bodily experience of reading and of looking at visual images. Instead of the touching and feeling relationship the view has with the book as an interactive object, the computer provides an immaterial interactive experience. It allows for the branching out of visual or textual material to present choices to the viewer through a series of document blocks linked to different pathways. It creates interconnected webs of information and is able to link various kinds of image files and other types of documents, network them

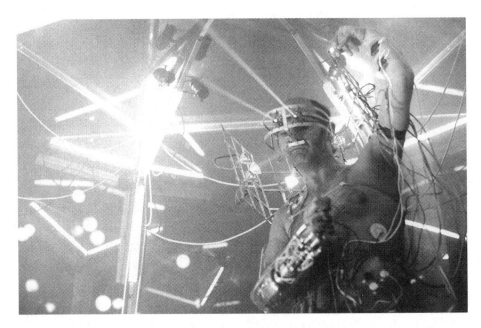

Figure 45. Stelarc, *Amplified Body, Automated Arm and Third Hand,* 1992. Performance in three 15 minute segments. This Stelarc performance event is meant as an interface and interplay of human and machine systems—of muscle and motor motion. The left arm is activated by muscle simulations, it jerks up and down involuntarily while the right side controls the attached third hand. Amplified body signals relate internal physiology to sound and motion. Later, eye pulse is in phase with the heartbeat . . . *(Courtesy Stelarc. Photo: Tony Figallo)*

and create paths and nodes to connect them. CD-ROM multimedia implies visual or textual material or sound with possible electronic linkages which can be manipulated and rearranged at the viewer's command.

Technological Conditions Lead to a More Public Art

Proliferation of electronic technologies has increased cultural participation of the public in art events (as a form of empowerment and education). With roots also in avant-garde art attitudes from the 1960s and 1970s, derived from the "Happenings" movement, which focused on public participation and performance and in conceptual projects, a more public art began to evolve. Conceptual art was immaterial with no object value. Meaning resided not in the autonomous object, but in its contextual framework. The postmodern idea that the physical, institutional, social, or conceptual context of a work as being integral to its meaning, took root and became the basis for expanded notions of sculpture and of a more public art in the 1970s.

This hybrid cultural practice with its intentions of connecting to a wider audience and as a means of subverting the usual commercial forms, became an activist art which encouraged collaboration amongst artists. Some of these collaborations were anonymous group entities such as Gran Fury, and the Guerrilla Girls. Others challenge art world notions of individual authorship, the cult of the artist and of private expression, by assuming group names, such as Group Material or the Artist and Homeless Collaborative. It was felt that anonymity provided a greater focus on the work itself instead of the usual attention to artists as personalities. The goals of these groups were to act as critical catalysts for change and to create an arena for public participation. Their work took the form of a combination of grassroots activity using media tools. Reaching out for media coverage of their work is an important part of their strategy.

Group Material, founded in 1979, describes itself as an organization of artists "dedicated to the creation, exhibition, and distribution of art that increases social awareness." It believes strongly that art should not be just for "initiated audiences of the gallery and museum" but is intended to "question perceived notions of what art is and where it should be seen." Its work, also seen in

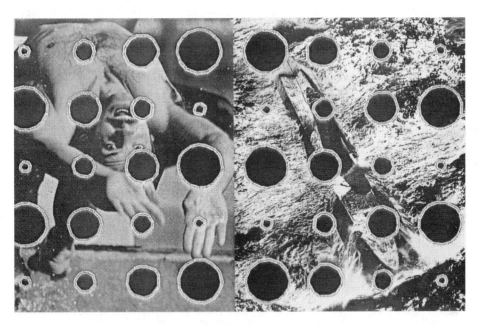

Figure 46.　Larry List, *An Excerpt from the History of the World,* 1990. Color photocopy print, 10 ½″ × 17″. The copier is a natural interactive tool for Larry List, who is interested in "making an art that suspends one in a state of flux between seeing and reading, questioning and answering." Image and words are combined in innovative graphic ways like a labyrinthian puzzle, underscoring their function as they overlay the image structure beneath. This layering of intentions creates an extremely intense bonding relationship between image and word. The photocopy machine is used as an integral, characteristic aspect of his layered work. (*Courtesy Larry List*)

exhibitions throughout the United States and internationally, bridges the culture gap between high and low, elite and popular. The group organizes public lectures and discussions for important forums such as the Dia Art Foundation. For example, their part of the 1988 program centered on issues of the crisis of democracy. Ironically, the artists' galleries—Mary Boone, Josh Baer, Barbara Gladstone, Metro Pictures, and John Weber cooperated. Paradoxically, the artists expanded public image in the community helps them to attain the status and recognition which will increase interest in their public voice. Grants and sales of their work support some of their public activities.

In May 1988, Group Material (funded by the Public Art Fund) created a project called "INSERTS"—a twelve-page newsprint booklet to be inserted in the Sunday magazine supplement of the *New York Times*. The insert contained copies of ten art works created specifically for the project by well-known artists—Barbara Kruger, Louise Lawler, Richard Prince, Nancy Spero, Jenny Holzer, Hans Haacke, Mike Glier, Felix Gonzales-Torres, and Carrie Mae Weems. Their project was designed to get art off the wall, out of the plaza, and into everyone's hands through the daily paper. The Guerrilla Girls have also created a powerful public dialogue through their strategies of anonymity, theater, irony, and humor. They have scored stronger feminist points, by their collective spirit and their strategy of using information and its print technology in the form of posters and billboards, than any one painting could have.

Mierle Laderman Ukeles stands out for her strong social commitment and for the innovative video methods she used in producing the "Touch Sanitation" show. Ukeles chose to work with the New York Department of Sanitation thus not only focusing on the stigmatization of those workers by the public, but also showing that the work they do participates in an important relationship between culture and maintenance. She created a four-part video environment utilizing thirty-four monitors, twenty eight of which were stacked into four fourteen-foot high TV towers in an environment which is a reconstruction of two sanitation lunch/locker room facilities. (These were literally taken out of the real workplace and reinstalled in the gallery space.) Ukeles dramatized her eleven-month involvement with the workers through a kind of performance in which she criss-crossed the city making contact with all of them through her video documentation. She engaged them directly in the process of creating the installation.

Dennis Adams's bus shelter projects with their double-sided illuminated display panels are similar to regular bus shelters but use large photographic transparencies to comment on history or to underscore the politics of poverty and wealth apparent in city neighborhoods. Krzysztof Wodiczko's mammoth night projections beamed onto city buildings and monuments create a strong political statement whenever they appear. Using the idea of spectacle and risk in the urban environment, he dramatizes the architecture of public buildings to supply the real identity of its public function. For example, he projected the

image of a missile on a war monument; the figure of a homeless man on a public monument in Boston.

Another aspect of the greater public stance of art, made possible through the agency of technology, is in the field of artists' books. Printed Matter, in New York, the leading distributor of artists' books, carries more than 3000 titles by 2500 visual artists. Artists such as Paul Berger, Keith Smith, Johanna Drucker, Paul Zelevansky, Warren Lehrer, Joan Lyons, Phil Zimmerman, and Sue Coe are committed to the project of creating part of their work in book form, thus creating a gallery of ideas available in bookstores as art for a broader public. Although artist book outlets mostly exist in museums and small specialty shops, the movement is being strengthened by quality electronic reproductive equipment like the laser photocopy machine and computerized "desktop publishing." Recently, "Galerie Toner" in Paris took advantage of this technology and commissioned several artists to create books.

Extensions of Modernism and Crosscurrents of Postmodernism

Some contend that the multifaceted inclusive nature of the Postmodern paradigm allows for Modernism as one of its aspects to survive in the final part of the century. Most of the major formalist artists such as Johns, Stella, Serra, Lichtenstein, Martin, remain at the peak of their prestige—exhibited, commissioned, and collected. Even though Modernism is dead, it is still dominant. Many in the art-world community such as the curator of the 1995 Whitney Biennial, Klaus Kertess, and Robert Storr, curator of painting at the Museum of Modern Art, do not accept that the project of modernism is at an end. They see that it simply needs adjustment, even though cultural conditions have been altered by such radical change in technological standards. A broad range of postmodern strategies exposed the "coded" languages of popular media and revealed the hidden context of art-world politics. Postmodernism has led to new attitudes and new understandings and a pluralistic acceptance of many approaches to art-making, including formal ones. However, the impact of technology is gradually uprooting aesthetic practices which supplant art's mimetic functions, just as photography did. Computer imaging allows for the fabrication of immaterial worlds which are increasingly severed from the human observer, and which are capable of invading the image and destabilizing it.

The split we have been following in artists' attitudes toward representation has continued to be present. Some see values eternal to the human condition and inscribed in their work as overriding all other considerations. Others point to imperatives of today's issues and the need to reflect the technological culture we live in, commenting on it through the use of contemporary media tools. Rather than seeing that the postmodern thrust toward appropriation, instability, decentering, intertextuality, and acceptance of diversity, leads to decay of meaning, it is possible, say some, to see an enrichment of ideology and style taking place.

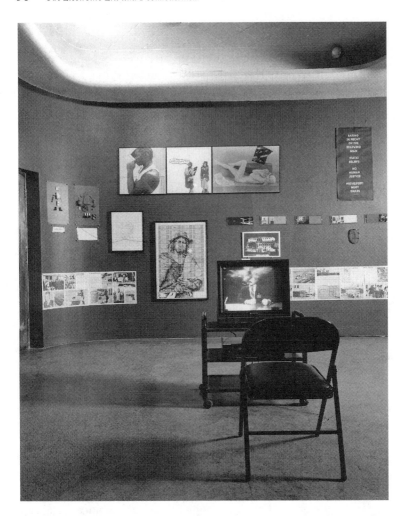

Figure 47. Group Material, *Anti-Baudrillard*, 1987. Mixed-media installation with video at White Columns, New York. This installation was meant as a kind of forum to raise questions about differing interpretations existing in the art world based on the influential theories of the French philosopher Jean Baudrillard. The Group Material collaborative sees their work as a site for cultural resistance to mainstream values. They see their "art materials" as being culture itself, rather than succumbing to the idea that art must stay within a certain system of boundaries that characterize the traditional concept of what an "artwork" is and where it should be seen. (*Courtesy Group Material; Photo: Ken Schles*)

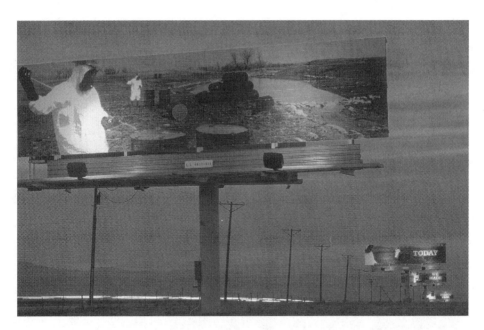

Figure 48. John Craig Freeman, *Rocky Flats Billboards*, 1994. In 1987, John Freedman decided to break the public apathy about the extremely dangerous plutonium pollution at the Rocky Flats Nuclear Weapons Facility near Boulder, Colorado. He created a series of antinuclear billboards along Route 93 to dramatize the need for a major clean-up of radioactive materials. Using scanned-in photographs blown up by as much as 3200 percent and printed out as giant tile sections on a poster-maker printer, the final billboards were hand assembled. The sequenced billboards read in one direction: "Today . . . We . . . Made a . . . 250,000 Year . . . Commitment" From the opposite side it read: "Building . . . More . . . Bombs . . . Is a Nuclear . . . Waste." Digital activist Freeman believes that a public art can circumvent problems of the gallery system such as the commodification of culture and the perpetuation of an exclusive, elite system for art. He believes in bringing art to the public: "If people are too busy to go to the gallery or museum, it makes sense to bring art to them. They don't even have to get out of their cars." *(Photograph: Jenny Hager)*

Looking back on this century, Roland Barthes remarked that "in a way it can be said that for the last hundred years, we have been living in repetition." When we examine his premise, from the vantage point of the visual arts, it projects an overview of all the major ideas and movements of the modern period from the early 1900s. Abstraction and Cubism, Constructivism, Dadaism, Expressionism, have all been repeated through Neo-Dada, Neo-Constructivism, Neo-Expressionism. In the eighties and nineties there has been a replay of mainstream movements from the fifties and sixties including Neo-Minimalist, Neo-Pop, Neo-Conceptualist. This has occured with slight progressions and extensions, but with no real new break in the field of perception or systems of meaning which offer a serious challenge to traditional western notions of representation. Technologized seeing and forms of representation have now, how-

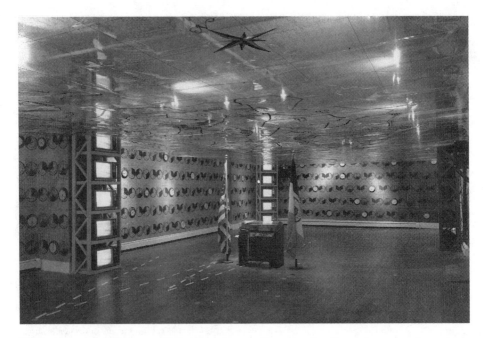

Figure 49. Mierle Laderman Ukeles, *Touch Sanitation Show,* 1984. Installation, four-part video environ-
ment with TV towers. Through this immense multimedia installation Ukeles posits maintenance as a lit-
eral artwork existing in real time. Five years in preparation, this exhibition has resulted in a new kind of
public art. For the first time, a public service agency collaborated with an artist in a project that portrays
the important relationship between culture and maintenance. Virtually every unit of the Department of
Sanitation participated with the artist in the creation of these art-environmental works. The four-part
video environment includes thirty-four monitors, twenty-eight of which are stacked into four fourteen-
foot-high "TV Towers," running five different tapes in eight separate locations. The installation, some of
it prepared by the sanitation workers themselves, also includes a 1500-square-foot transparent map of
New York City suspended overhead, a special print installation of clocks in fifty-three colors, and forms
designed for all the walls of the gallery. (*Courtesy Ronald Feldman Fine Arts Inc.; Photo: D. James Dee*)

ever, passed well beyond photography and cinema, to embrace the radically
new aspects of electronic representation opened by TV, video, globalized elec-
tronic Internet communications, and to the computer with its revolutionary
capacity to create digitized structures that produce "virtual" images and interac-
tive possibilities. As a means of representation, these media, like photography
in the 19th century, been, until recently, largely marginalized by the main-
stream. Nonetheless, the social and economic implications of their use have
affected society since the early sixties.

New York Times critic Michael Brenson comments on the Postmodern shift:
Art can now "be conceptual, photographic, figurative, or expressive. It [can] mir-
ror and engage the mass media, particularly the visual media like television and
film. It [can] have mythical, personal, and social subject matter . . . It [has] some-

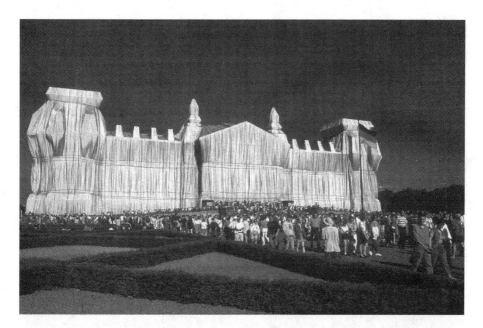

Figure 50. Christo and Jeanne Claude, *Wrapped Reichstag, Berlin*, Front (west facade) View, June 25, 1995. Christo and Jeanne Claude's huge public environmental works have become celebrated over the years not only because of their extravagant beauty, but because they are inclusive and tend to bring people together. Financed by the artist through sales of the original drawings, photographs, and sketches for each of the projects, the works are free from encumbrance from the usual funding problems. Each project is allowed to exist only for a brief two to three weeks. The original landscape the artists invade or "wrap" is returned to its original state, with photographs or video as the only documentation of the event. Often permissions to create such works take many years of negotiation to achieve. It took twenty-four years of such lobbying before Christo and Jeanne Claude succeeded in wrapping Berlin's Reichstag, a building that symbolizes a century of European strife. The project ultimately utilized 1,076,000 square feet of aluminized polypropylene fabric. The *Wrapped Reichstag* as an unexpected gleaming magic mountain seemed to package the past and to suggest the possibility for a new phase for a Germany, unencumbered by its history. (*Courtesy Marius A. Ronnett*)

thing to say about the giddy excitement and awful conflicts of late twentieth-century life." Whether it is conservative or progressive, the need for aesthetic experience is felt more deeply than ever before by a larger number of people as they strive to situate themselves in the complexity of the electronic age.

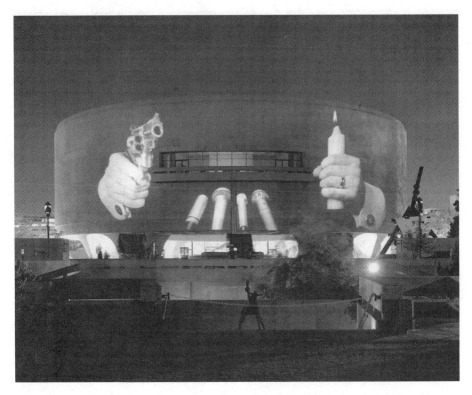

Figure 51. Krzysztof Wodiczko, *Projection on the Hirshhorn Museum*, October 25, 26, 27, 1988. To draw attention to the power relations that exist between cultural institutions and the public, Wodiczko created an environmental projection work which covered the facade of the Hirshhorn Museum in Washington. The image was projected from three xenon-arc projectors. (*Courtesy Wodiczko and The Hirshhorn Museum and Sculpture Garden, Smithsonian Institution. Gift of Joseph H. Hirshhorn, 1966. Photograph: Lee Stalsworth*)

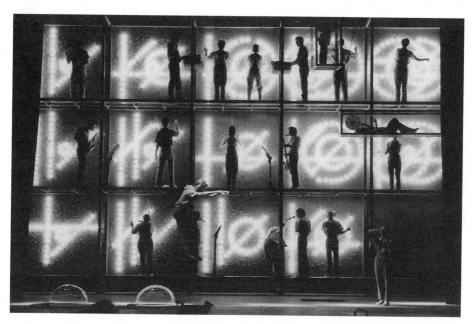

Figure 52. Robert Wilson, *Einstein on the Beach* (Final Scene by the Lightboard), 1986. Wilson's *Einstein on the Beach* is a new genre of work, a performance-visual arts form that fractures language and content and alters our perception of the possibilities of theatrical experience. With composer Philip Glass and choreographer Lucinda Childs he has created a "cosmos" of the arts. As an evocation of ideas and elements covering the span of Einstein's life with the emphasis on technological advancements from steam engine to space exploration, it brings together symbols and referents that seem to evoke a "fourth dimension" where time is atomized. The melding of space and time in Wilson's spectacle parallels scientific thought, where space itself is endowed with time attributes and vice versa. *(Photo: Babette Mangolte)*

4

Video: New Time Art

If two drawn circles are shown to overlap, the first representing indepen-
dent film (with its crossover roots in both film and the visual arts tradi-
tions), the second representing TV, the overlap can be seen to be video
with influences from all these circular areas resonating one with the
other. . . .

—*Nam June Paik*

Any image from everyday life will thus become part of a vague and
complicated system that the whole world is continually entering and
leaving . . . There are no more simple images . . . The whole world is too
much for an image. You need several of them, a chain of images . . . No
longer a single image, but, rather, multiple images, images dissolved
together and then disconnected. . . . Art is not the reflection of reality, it is
the reality of that reflection. . . .

—*Jean Luc Godard*

Away from the world of network TV transmission and distribution, video, as a
TV tool used by artists, paradoxically began its existence as an independent
medium in the cloistered space of artists' studios, galleries, and museums.
Within the Modernist framework of its beginnings, video production as a valid
practice for artists did not seem at first to overlap with broader social attitudes
about the congruency of culture, consumption, and ideology which were grow-
ing. However, the extremely rapid development of video technology itself
brought it to the level where its capabilities began to converge with film and
where it could be used as a potential media tool—one whose productions could
be broadcast. This development brought with it deep changes in attitudes
towards the use of video as a medium in the fine arts. The relationship of artists'
video to broadcast television and to cinema, and the differences between them,
form the context of an important history and confrontation.

Video, A Transmitter/Receiver Time Medium

In 1965, the first video camera/recorder, Portapak, was released in New York by the Sony Corporation. The early equipment was relatively heavy and its black and white half-inch image quality was poor (not NTSC broadcast quality). There was no editing equipment. However, it provided the first access to the potential creative use of video as an artists' TV medium. Until then, video equipment existed only as enormously expensive, cumbersome television-camera-and-broadcast-apparatus restricted to use within tightly controlled broadcast transmission facilities.

Nam June Paik and Wolf Vostell, part of the first generation to grow up with television, began using TV sets as part of their Neo-Dada assemblage combines. They were influenced not only by tendencies in the art of their times

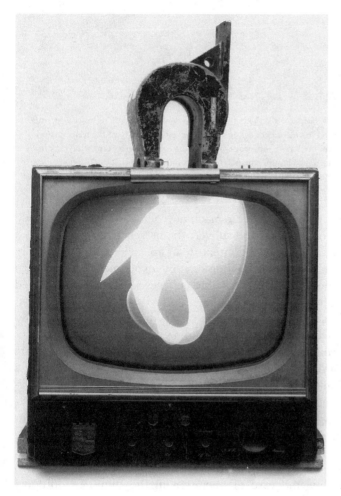

Figure 53. Nam June Paik, *Magnet TV,* Black and white 17″ television set with magnet, 1965. This is one of Paik's first works using TV as a medium. Here he experimented with electronic effects through disruption of the electronic scanning components of TV with magnets. His Neo-Dada delight in subverting and playfully demystifying its invisible broadcast technology has proved to be a continuing theme of his work, in one form or another. For him, the TV set itself is a mass culture ikon which needs to be satirized, humanized. He saw that it could be used not only as sculpture but as a means of global communication for art. (© *1996: The Whitney Museum of American Art New York, Purchase, with funds from Dieter Rosenkranz)*

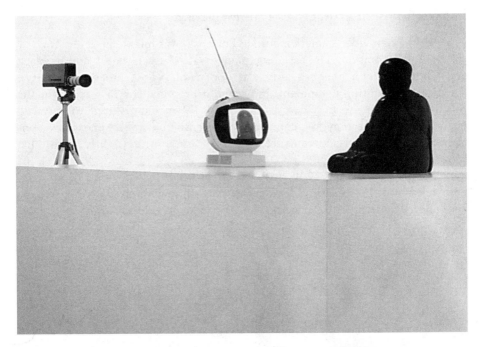

Figure 54. Nam June Paik, *TV Buddha,* 1974. Video installation. Paik's *TV Buddha* represents an impor-
tant early phase of experimentation in video feedback in which the self-reflexivity of the transmission
technology of the camera was exploited in various ways. The camera focused on a point which could then
be seen on a monitor. In this piece, Paik captures the playful yet ironic distance that exists between the
mindless technological stare of the TV monitor and the Buddha's contemplative gaze. (*Courtesy the Museum
of Modern Art. Photo: Peter Moore*)

but also by commercial television. Their machine collages using ready-made
TV sets were meant to comment on and subvert the presence of television as a
mass culture icon by placing it out of context in an art gallery. They playfully
demystified its "invisible" broadcast technology by experimenting with the
medium's scanning components. Paik's machine collages with their unexpected
electronic effects were first exhibited at the Galerie Parnasse in Wuppertal,
Germany in 1963. That same year Vostell was displaying his brand of partially
demolished TV collage works at New York's Smolin Gallery.

The unique electronic recording capability of video provides immediate
"live" feedback in seeing moving images recorded by the camera directly on a
TV monitor screen. Unlike film technology, there is no processing lag time in
seeing what has been captured by the camera, and images are stored on inex-
pensive video cassettes which can be erased and reused. Video is capable not
only of recording images, but of immediately transmitting them in closed-cir-
cuit systems on multiple monitors (or for long distance transmission of its signal
via cable or on the public airwaves). Part of the strong attraction of the video
Portapak was its flexibility and ease of operation in the studio or outdoors

without the need for special crews or operators. In their studios, artists could direct the camera at themselves to explore personal narratives or as a record of performance or body art. Out-of-doors, they could record real events as part of political statements or as experimental documentary interpretations of the urban or rural environment (to be played back later on a monitor). Some saw video as an agit-prop tool. Installed in closed-circuit elaborated gallery settings, the video camera with a delay feedback loop could confront and interact with the viewer in a new dialogue which placed the spectator within the production process as part of the formal conceptual intentions of the artist. Combined with sound, music, or spoken dialogue and text, the medium opened up new aesthetic ground for exploring time/motion/sound/image relationships in a broad range of contexts.

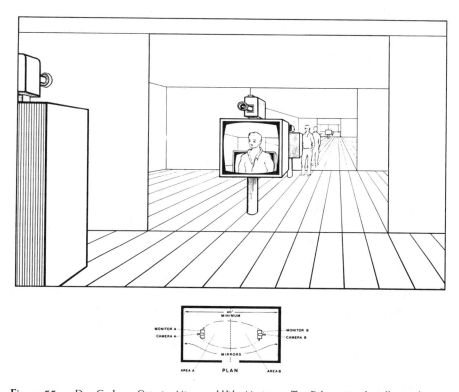

Figure 55. Dan Graham, *Opposing Mirrors and Video Monitors on Time Delay,* 1974. Installation diagram showing position of mirrors, TV monitors, TV cameras, and recording decks. Graham was one of the first video artists to fully explore the relation between video and the process of viewing and being viewed; between architecture, illusionary space, and the "time-present" transmission aspects of the medium. In this early experiment of time delay, he pointed the video camera mounted on monitors at opposing mirrors. The viewer became involved in a fascinating experience of illusion and perception. Interaction with the viewer in a closed space was important. The length of the mirrors and their distance from the cameras are such that each of the opposing mirrors reflects the opposite side as well as the reflection of the viewer within the area. *(Courtesy Dan Graham)*

Some artists were attracted to the newness of video for the very reason that it had no past history, no object-hood, and no agreed-upon-value. They attempted to distinguish it from other art forms by stressing its uniqueness as being an exclusive new category of its own and by denying its influence from other mediums. It was not film, not TV, not theater. In his 1970 *Expanded Cinema*, Gene Youngblood separated the video medium from the history of film and of film language and theory because of its very self-reflexivity, its personalized ability to provide the immediate feedback of a mirror image. The individual artist could use it experimentally. It was seen as a personal rather than as a collective institutional enterprise such as film. In many ways, the early video screen had the fascination of projected "luminous space," suggesting a painterly but conceptually abstract site for the play of light and dark which in a metaphysical sense is reminiscent of Malevitch's 1918 *White on White* painting and Moholy-Nagy's early experiments with light and shadow. Its ability to organize a stream of audio-visual events in time suggested poetry and music.

Pioneering Video

Because no editing equipment was available until the midseventies, and the tapes were not compatible with the broadcast signal, most of the early artists' videos focused on real time closed-circuit conceptual projects. Installed in public places or controlled elaborated sites in museums, the video camera, with a feedback loop, could confront the "on-camera" spectator who became part of an interactive dialogue as an aspect of the artist's intentions—a unique way of exploring fresh relationships in the triangle which exists between artist, object, and viewer. In Bruce Nauman's *Corridor* (1969–1970), a passageway became a sculptural space surveyed and mediated by the video camera's point of view. The viewer, although he could never see his own face on the monitor, progressed through the corridor as part of a self-reflexive (art about making art and its own materials) interactive inquiry into time and space. The real time of the camera (which stays on continuously) is watchful of the viewer's intrusion into the space and the space becomes abstract, flattened information on the black and white monitors.

Other important pioneers who used video for exploring the camera's viewpoint as part of a study of illusionistic perception and architectural space relations were Dan Graham, Peter Campus, Ira Schneider, and Frank Gillette. Their closed-circuit multimonitor works took on a variety of forms as complex installations, where one could see immediately what the camera was recording or see it as part of a delayed playback loop, as part of an illusionistic play with space and time.

Apart from these interactive video installations in site-specific architectural environments, other types of installations use multimonitor, multichannel forms as more self-contained sculptures and assemblages. Video sculptures are compact units and are usually composed of several monitors located within specifically built sculptural forms. Shigeko Kubota's *Nude Descending a Staircase* (1976) is a witty video tribute to Duchamp's key twentieth-century painting. Kubota's con-

temporary work is a plywood staircase with four monitors inserted into the risers showing a colorized videotape of a nude repetitively descending a stairway. Other multimonitor installation works weave together prerecorded contrasting elements as in Beryl Korot's *Dachau*, a video about the Holocaust. The audience views the carefully edited four-channel work from a single vantage point.

Another direction in early video manifested itself as a variety of what critic Rosalind Krauss has termed *narcissistic* performance. Here, the body or human psyche of the artist took on the central role as the most important conduit in the simultaneous reception and projection of the image received via the monitor as a kind of immediate photographic mirror. Vito Acconci in his twenty-five-minute work *Centers* (1971), centered his body between the camera and the monitor and pointed to the center of the monitor. The viewer's line of sight could encompass simultaneously the artist's, sighting his plane of vision towards the screen along his outstretched arm and the eyes of his transmitted double on the monitor. Krauss describes this narcissism as a kind of psychological strategy for examining the conditions and traditions of the relationships between the process of image-making and the viewer's perception of it. Nancy Holt, Richard Serra, Lynda Benglis, and Chris Burden are a few of the artists who explored conceptual aspects of performance-oriented video.

The new apparatus separated itself from traditional representation by opening the way to exploration of a completely new way of communicating, involving elements of time and space, use of sound and performance, audience participation, and use of a moving camera, which, although video could not be edited at that time, could show different angles and vantage points from close-up to distant views. However, the same split developed among the practitioners towards issues of representation which, as we have seen, date to Renaissance times. On the one hand, artists such as Bruce Nauman and Dan Graham were interested in the more formal conceptual aspects of the medium, incorporating it as part of their existing outlooks on art. Others such as Nam June Paik were interested in exploring the new ways of seeing it offered and what could be learned about expanding notions about art and representation through a full understanding of the implications of this revolutionary new visual tool.

Art World Acceptance

The phenomenal early growth of museum response to video is a result of two major factors: the growing interest by a diverse group of major artists in the medium's open possibilities; and important shifts in museum acceptance and evaluation of radical, conceptual work which questioned the museum's very role as preserver and collector of "art as object." Art movements at the end of the sixties and early seventies focused "on art as idea and art as action." Art became "dematerialized," as expressed through energy and time-motion concepts. The medium itself defies objecthood. It is dispersible through transmission; it is reproducible, interdisciplinary, and can call for interactive participation.

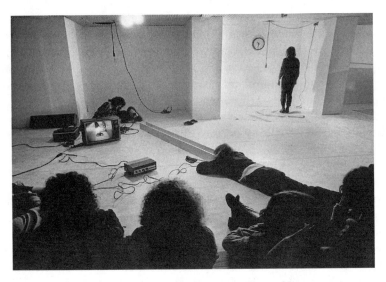

Figure 57. Vito Acconci, Dennis Oppenheim, and Terry Fox, Performance, Reese Paley Gallery, New York, January 15, 1971. Acconci thought of video "as a working method rather than a specific medium." Using the video camera as an impulse for witnessing and recording, he focused on the physical reality of his body-presence, orchestrating his movements and gestures, investigating interior/exterior dialogues between himself in relation to the viewer—role playing, conceptualizing his body as a container, as a locus for action or contemplation defined by its presence in a public space. *(Photo: Harry Shunk)*

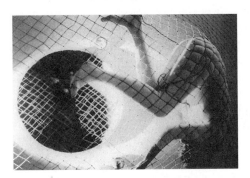

Figure 58. Ulrike Rosenbach, Detail of *Meine Macht ist Meine Ohnmacht*, 1978. One of the foremost European video performance artists, Rosenbach creates feminist rituals by projecting images from art history and popular culture iconography in which her own presence is captured and recorded within the scene. In this early 1978 piece, she is shown trapped as an unwilling victim in front of TV monitors that are in turn reflected from an overhead sphere. *(Courtesy Ulrike Rosenbach)*

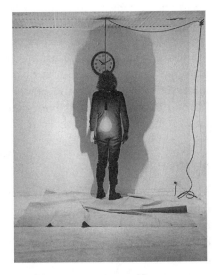

Figure 56. Vito Acconci, Performance Reese Paley Gallery, New York, January 15, 1971 *(Photo: Harry Shunk)*

By 1969, Howard Wise, a New York gallery owner who later established Electronic Arts Intermix, one of the first organizations to distribute video and act as a postproduction studio, created the first video exhibition, "TV as a Creative Medium," featuring the work of Nam June Paik, Frank Gillette, Ira Schneider, Paul Ryan, Eric Siegel, and others. The works in the exhibition demonstrated strong differences in artists' approaches to video. Some saw video as a way of integrating art and social life through a critique of television as a dominant cultural force or as a social documentary tool. Others saw video as a new artists' tool for formal conceptual projects or for synthesizing and transforming images with electronic devices such as the computer.

One of the most interesting works in the Wise Gallery show was Frank Gillette and Ira Schneider's multimonitor/multichannel installation work *Wipe Cycle*. The piece (with its nine monitors, live camera imagery of observers in the exhibition space, mixed with prerecorded tape units, delay loops, and unifying gray wipe that swept counterclockwise every few seconds) was an attempt at manipulating the audience's time and space orientation by including the viewer as an integral part of the "live" installation. The complex structure of the work, which fed live images from one set of monitors to the other, was typical of many video installation works which explored the self-reflexive formal codes suggested by the time-delay feedback aspects of the medium itself. As cameras recorded events within the installation, the events themselves were manipulated and transformed to create an illusionistic model of communication and dialogue.

"Vision and Television" at the Rose Art Museum (near Boston) in 1970, and "Kinetics" at the Hayward Gallery in London (international) are examples of interest in video as a viable art form. These exhibitions reflected the different attitudes towards representation we have been discussing and included examples of the leading artists in the United States, Canada, and Europe previously described. As interest grew in the new medium,[1] the prestige of its practitioners and their innovative new work attracted the interest of funding institutions (such as the National Endowment for the Arts and the Contemporary Art Television [CAT] Fund for Independent Video, among others), which began supporting video production centers and individual artist production grants. As networks of production centers grew, so did exhibition possibilities in Europe, Canada, Japan, and the United States. Annual video festivals and conferences[2] helped to promote exchange and broaden interest. These provided a forum and an intellectual meeting ground for artists as well as important exposure for their work. As a result, magazines which normally focused on photography and independent film such as *After-Image,* and the *Independent* began to provide critical response to video work. New journals such as *Radical Software* and *Art Com* were established as a response to the growth of new media including video and the computer. These magazines helped to unify the video movement, to give it a history, a critical base and a sense of community. They also provided information on new technical advances, new media centers, and grant opportunities.

The first museum video department was established in 1971 by James Harithas and curators David Ross and Richard Simmons at the Everson Museum in Syracuse, New York, with a closed-circuit gallery. Two years later, Ross set up the Long Beach Museum program in California. That same year, video artists Steina and Woody Vasulka founded the Kitchen, (in New York), which is still a major center for independent performance and video work. In 1973, the Whitney Museum of American Art included video in its important Biennial exhibition and soon afterwards added video as part of its independent film department headed by John Hanhardt. The Museum of Modern Art instituted a video department in 1974 under the direction of Barbara London. *Video Art*, the first comprehensive video survey, was organized in 1975 as a traveling exhibition by Suzanne Delehanty at the Institute of Contemporary Art in Philadelphia. It consisted of single-channel videotapes and multichannel sculptural installations reflecting the wide variety of video usage by seventy-nine international video artists.

Convergence with Film (and Television)

Early experimental emphasis on the conceptual, formal image transmission/reception aspects of video technology separated it completely from the moving image medium of cinema. However, artists who saw the use of video as a communication tool for social action and documentary were attracted to it because of its flexibility, immediacy, and its low cost in comparison to the use of film. By 1968, a diverse group of artists took their Portapaks into the streets to record real events or outdoor performance works. They faced difficult technical obstacles. Appropriate professional editing facilities[3] were inaccessible, Portapak batteries were heavy, and image quality was poor. Tapes produced were not broadcast quality and therefore could not be publicly transmitted. They could be exhibited only to small audiences on TV monitors in corners of galleries and museums and not under the controlled darkened theatrical conditions normally provided for the projection of film.

Although these major technical differences separated video work from the cinematic medium of film, a link between film and abstract formalist tendencies in the visual arts had already been established by avant-garde independent filmmakers whose work with flexible hand-held 16 mm cameras[4] had grown in opposition to the dominance of American commercial cinema since the 1940s. (In Europe, independents such as Jean-Luc Godard found a greater public consensus for their important work.) Independent filmmakers experimented with the dynamics of camera movement and the relation of image sequence through shooting and editing strategies that questioned the reality of spatio-temporal events. They broke away from the established theatrical story-telling "grammars" or conventions of commercial shooting and editing techniques and substituted intense, abstract "metaphors of vision." Their use of edited repetition and juxtaposition to build psychological or poetic parallels created a different kind of visual structure with more complex layers of meaning.

Two broad tendencies exist in the aspirations and history of avant-garde independent film which somewhat parallel artists' intentions in video: film as related to, or associated with, the "formalist trajectory" of the fine arts; and film as the "ideological site for the mediation of social and political concerns."[5]

These two views are a touchstone to our ongoing discussion about representation. Although technologically, film is radically different from video, the strong influence of the experimental vision of avant-garde cinema is apparent in the work of video artists who experiment with more conceptual projects rooted in performance and illusionistic concerns as well as those who attempt analytic and social documentary critiques. This split reflects the divergent approaches between Platonic idealism in search of purity of form and idea and the more Aristotelian question of how we go about doing things in the real world. Evidence of this divergence is useful because it provides a continuing framework for looking at new work and new media.

"Open Circuits: The Future of Television" a conference organized in 1974 by Douglas Davis, Gerald O'Grady, and Willard Van Dyke under the sponsorship of the Museum of Modern Art opened discussion of what was seen as the beginning of a new period for art. However, in a critical mode, Robert Pincus-Witten indicated that video works based on exhausted conventions of Modernist practice were often dismissed, not because they were poor, but because they no longer reflected relevant issues. He referred to the genre of video that relied overly on experimental self-reflexive "art about making art"—manipulation of the electronic image-making components of the medium. He commented that video art was "deficient precisely because it was linked to and perpetuated the outmoded clichés of Modernist Pictorialism." He criticized it for aping Minimalist preoccupation with medium, and for overusing and becoming subservient to the powerful potential of electronic image-making media, itself becoming lost in its vocabulary of Lissajous pattern-swirling oscillations endemic to the capabilities of the medium at the time.

However, those video artists whose work resonated with their interests in other fields, particularly feminists who were less rooted in traditional mediums such as painting and sculpture, were critical of the hermeticism and separation from life often associated with Modernism. They were the first to grasp and make use of the important technological changes coming to the fore to move their work to new territory. From the late sixties, video became important to them as an alternative, progressive, and flexible medium for expressing their political and cultural objectives. Women's video collectives sprang up during the seventies and an annual women's video festival was organized, helping to unify the movement. Many of the early works were documentary in style, influenced by cinema vérité and focused on issues of sexual difference and feminist consciousness. Part of its attraction was the newness of video as a medium and its lack of other cultural baggage and connotation.

Early videomakers neither used the camera as an objective observer nor clearly separated the filmmaker and subject. In their work these were combined,

and the artist performed for the camera using it as a mirror. They would perform in front of the camera until the tape ran out—tape length became performance length. Video was perfect for this type of "real time" performance. Warhol's experimental fixed-camera-position films (*Sleep* was eight hours long) had established the precedent and were a strong referent for performance artists such as Joan Jonas, Bruce Nauman, and Vito Acconci.

This intensely personal real-time video practice of some artists was far removed from the condensed time of commercial film and of the segmented, broken-up, regimented time of broadcast television with its highly produced, fast-paced programming. By 1975, when important advances in video technology became available—editing facilities and the time base corrector—some artists began to see video as a possible tool for TV media production.

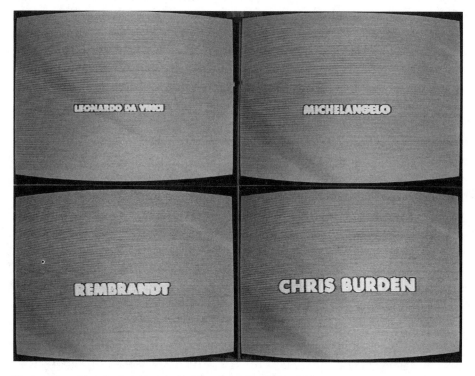

Figure 59. Chris Burden, *Leonardo, Michelangelo, Rembrandt, Chris Burden,* 1976. Photo documentation of TV commercial. Best known as a conceptual artist, Burden is noted for his startling performances where he explores the psychology of personal risk. In 1973, he began to purchase commercial advertising time on local TV stations in Los Angeles. He showed short ten-second clips of his work. In the illustrated commercial shown here, he drew attention to the idea of high art and its relation to the commercial world of advertising. The work has shock value in that "genius" is presented as a commodity like any other consumer product on TV. Another commercial consisted of three statements: "Science Has Failed," "Heat Is Life," and "Time Kills." Burden spoke the statements, then they were flashed as graphics on the screen, followed by the words "Chris Burden sponsored by CARP." This commercial appeared a total of 72 times in a five-day period. (*Courtesy Ronald Feldman Fine Arts, Inc.*)

Figure 60. Juan Downey, *Information Withheld*, 1983. Color video, 29 minutes. In his work, Downey applies his fluid camera style to investigate the semiotics of culture and society. A native of Chile, he is familiar with government policies of internment and persecution of political enemies. Here he equates the transmission and reception of information with the "mind oppressive" nature of the television medium which he sees as part of a coercive attempt to control. (*Courtesy Electronic Arts Intermix*)

By the early eighties phenomenal technological advances (the introduction of color, radically improved computerized editing systems, lighter improved cameras, computer processing, and digital animation), brought video to an important point of ascendancy as an electronic (broadcastable) moving-image medium relatively accessible to artists. By now it could challenge and sometimes rival, co-opt, and absorb the industrial technology of film as a dominant mode of communication and representation. Television itself had, from its very beginnings, appropriated film and co-opted its existing commercial productions. It could broadcast film to a vastly expanded audience.

Thus, some artists using the video medium today find themselves confronting the issue of seeking a different, mass audience for their work. For these, the convergence of artist's video with TV raises important issues about public and private art, about access to the public airwaves mostly controlled by commercial interests, and about art as a means of communication or art as a cultural object.

The relationship of artists to television has always been complex. On the one hand, its potential as a showcase for reaching a broad audience is a strong

attraction. Yet, it presents the danger of losing control over production of their work because commercial network television is dictated by a complex system of hierarchies, conventions, and economics, with its programming pitched towards mass audiences. It raises questions about how to reach this audience. For in relation to the mainstream programming designed for specific audiences, the relatively esoteric works by artists shown out of context is rather like reciting poetry in the middle of a soap opera or like seeing an Abstract Expressionist painting reproduced on the front page of the *New York Times*. This is a factor confronting artists today as they prepare work for the World Wide Web.

With roots effectively reaching back into the 1940s,[6] television is no longer merely an activity of the culture. It is a powerful agent of culture—an electronic conduit via cable, network, and satellite services to a global public which is increasingly dependent on electronically communicated ideas and information. Some artists in the midseventies saw their video work as a possible new cultural voice with a special relationship to TV.

Early TV: A "Window" on the World

The concept of public broadcasting, of public service in mass communications centrally transmitted via the airwaves to private home receivers, was developed first for radio. Government commissions were established to license stations, to set laws, and to consider the implications of programming and its potential impact on the public. In the United States, television regulation was placed under the jurisdiction of the Federal Communications Commission (FCC) and followed a framework already set in place by 1937 for radio transmissions. The FCC debates public service issues such as political fairness, public morality, and social usefulness. By 1941, the National Television Standards Committee (NTSC) had been formed to set government regulations regarding the number of transmission lines per picture-frame[7] and what technological form the new mass communication service should take.

Decisive development of sound broadcasting came about in the late twenties when production of radio receivers became a successful, profitable, aspect of manufactured "consumer durables" aimed at private urban dwellings—an industrialization of the home. Manufacturers were quick to seize on the parallel consumer market potential in the development of television. By 1958, TV was in forty-two million living rooms.[8] The phenomenal growth of global TV broadcasting has been fostered by satellite communications and cable facilities set in place by 1972. Yet public access to the means of broadcast transmission is tightly controlled through FCC regulation. It regulates the content of programming and the quality of broadcast transmission, licenses access to the public broadcast frequency band, and scrutinizes compliance with regulatory legislation.

By 1972, more than 90 percent of the seven-channel broadcast band was licensed to corporate networks. Access to the public airwaves is almost com-

Figure 61. Ant Farm, *Media Burn,* 1974–1975. Edited for TV 1980. Color and black-and-white videotape, 30 minutes. The Ant Farm Collective—Chip Lord, Doug Michels, and Curtis Shrier—worked in the areas of architecture, sculpture, performance, and media in San Francisco from 1968 to 1978. Their trailblazing work in the social aspects of art led them to explore its relation to popular culture, the media, and violence. In their Media Burn happening, presented before a large crowd, they created a performance spectacle where a car fitted with video cameras and driven by two of the group crashed through a pyramid of burning TV sets. Beforehand, a mock address by a John F. Kennedy impersonator proclaimed: "Who can deny we are a nation addicted to television and the constant flow of media?" (*Courtesy Electronic Arts Intermix*)

pletely dominated by powerful commercial networks through sales of TV time to advertisers who normally recoup the high costs of TV production by using it to sell their products and a way of life based on them. Even in the eighties, consumers have invested at least ten times more for their home TV receivers than commercial network owners have spent on their transmitting facilities. In this one-way situation, the commercial network stations hold licenses to transmit on specific channels within the broadcast frequency spectrum, while the consumer/receiver pays for a selection of programs almost entirely mediated by corporate management, which allows for little, if any, programming innovation.

The viewer becomes a consumer—one who selects but cannot control—with, until recently, the on-off switch as the only option. The experience of television, with its homogenized format of standardized packaged programs, with required edited content and formularized break-up of program time, has established an expectation for home viewers for its ideological and informational perspective. The familiar design of broadcast time, structured around 30- and 60-minute time blocks punctuated by commercials, competes for audience attention in the home installation.[9] Today's commercials, often more visually

interesting and compelling than the actual programs themselves, are oscillating with more and more frenzy. Time blocks are smaller and smaller followed by more and more commercials. Paradoxically, the time-bite format of the punchy commercial has given rise to a spate of artists' works designed for TV.

Subsuming film and different from it, TV can transmit to the spectator at home fragmented edited versions of reality from every vantage point in real time. Its apparatus can deeply penetrate and transmit unmediated reality as it occurs from different angles, through close-ups and from multiple, sometimes hidden vantage points. From real-time views of a court trial or coverage of the Congress in action as seen on the networks or on cable, the spectator is there as events occur, interrupted only by the banality of commercial breaks for beer, shampoo, or dog food every few minutes. Later, these same events can be seen as skewed, edited mediated events on the evening news, their original content carefully controlled while seeming to deliver the myth of television being an unedited window on the world,[10] with its transmitter/receiver production process invisible to the viewer.

A different nature opens itself to the TV camera than to the naked eye if only because a penetrated space is presented to the spectator in his home, a

Figure 62. Daniel Reeves, Production Still on Location for *Smothering Dreams*, 1981. In this powerful videotape based on autobiographical experience, Reeves weaves myth with the reality of organized violence as seen through the eyes of a soldier and the imagination of a child. In this production still, we see Reeves shooting on location. The work was broadcast on PBS in 1981. *(Courtesy Electronic Arts Intermix; Photo: Debra Schweitzer)*

space not explored by the viewers who at the same time feel themselves to be there. Through repetition—liftings and lowerings of the camera, from enlargement to close-up and isolation of one scene juxtaposed against another, TV can transmit directly into the cultural mainstream a level of psychological effects (Walter Benjamin called them *unconscious optics*) which have been deeply affecting the collective subconscious. The prime time world of commercial TV offers a seriously skewed picture of reality, for viewers tend to see the real world much as it is presented on TV.[11]

Television Leads to a New Kind of Apperception

Our overloaded TV-image culture has brought about changes in the way we see, how our consciousness is formed, and the way we lead our lives. Television has trained us to focus on many planes all at once and to assimilate large quantities of information both obviously and subliminally. Within the frames of our household viewing space, we often do not watch television directly—we have learned to glance at its easily assimilated packaged time segments as a distraction while answering the phone or working. For large numbers of people, the TV stays on, an appendage to other aspects of life. It contributes to a diverse, multifocus experience, a way of consuming effects and information. Walter Benjamin examines for us the difference between the perceptual distraction produced by mass-media forms such as film and TV and the concentration required by a traditional work of art. Before a painting, viewers abandon themselves to their own associations while before the technical structure of film or TV they cannot. "No sooner has my eye grasped a scene that it is already changed . . . I can no longer think what I want to think. My thoughts have been replaced by moving images."[12] While the single viewer in a museum, concentrating on the artwork is absorbed by it, the distracted mass audience absorbs the work of art as it travels into their own viewing spaces via TV as part of a history-of-art cultural program. Often the viewer stumbles on such a program while idly switching channels. The painting may be something totally foreign, something one knows nothing about and cannot relate to. It becomes part of a distraction rather than a deep experience.

The habit of incidental perception, seen within a loaded visual field, creates a certain type of human optical reception where information or understanding is acquired gradually "by habit through constant exposure rather than by contemplation alone. The distracted person can form habits. More, the ability to master certain tasks in a state of distraction proves that their solution has become a matter of habit. . . . Reception in a state of distraction, which is increasingly noticeable in all fields of art, and is symptomatic of profound changes in apperception, finds in the film (and TV) its true means of exercise. The public is an examiner, but an absent-minded one."[13] Late night viewers may

be seeking distraction from the day's events. Under such viewing imperatives, the public will only superficially evaluate a complex classic Bergman film such as *Wild Strawberries* and may channel surf to a game show, an Oprah Winfrey rerun; a talk show; a shopping channel. Through distraction, the public is learning to deal with huge amounts of information created for their consumption in their home-entertainment centers which now contain VCR's, CD-ROM players, and computers connected to the World Wide Web.

The home-received TV broadcast represents a radical compression of time/space. This perception that we are home participants connected to "live" events is reinforced by a technologically induced manipulation of the time and space of reality which seems to provide immediate access to what is seen and experienced. Disconnectedness to real time and space effects our senses disproportionately and creates vicarious expectations for immediate gratification.

This artificial change in the sense of duration and of time flow is characteristic of the speeded-up effects of electronic media. "Space and time are found to be more constrained for children who watch TV than for those who read books. The edited, at most eight-minute, segment compresses space, making any point in that space immediately and passively available. Seemingly direct and intimate contact via satellite broadcasting further compresses space. Interaction takes place at the touch of a button, is detached, and is perceived as an abstract happening"[14] not bound by time.

A confusion between spatial and temporal boundaries has occurred through exposure to high technology, collapsing it and sometimes erasing the conventions that formerly distinguished fantasy from reality. Instead of relying on a sense of reality gained from direct experience and belief in a single authoritative system, we depend on a variety of communicated information. We alternate and are suspended between the reality of daily life and the representation or edited copy of it that we respond to via TV. This shifting response contributes to an assault on the concept of the self as the center of a single reality with a single viewpoint.

The structure of TV is about "asserting equal value for all the elements, including the advertisements within a programmed day. It is as if our continual stimulation by the programmed fusion of old movies, soap operas, depictions of family life news, and historical documentaries has contributed to a state where artificial representations of reality have become dominant features—an obstacle to direct personal meaning and significance. One of the first effects on the mind is the "marked mitigation of the distinction between public and private consciousness. A manifestation of this is an increasingly altered sense of ourselves as we become more media dominated; our tele-selves become our real selves. We lose our private selves in publicity."[15]

The phenomenon of communications technology is creating a different kind of meaning, not only in personal life but in the way culture as a whole is produced and experienced. A mass audience of millions participating collectively in powerful moments in real time, watching the same images—the

historic Moonwalk, the Gulf War, a World Cup Soccer final—before the per-
fectly regulated circuitry of TV, is a major new perceptual experience.

Guy de Bord, writing about TV in his *Society of the Spectacle* in 1967, spoke
about it as part of a dark vision.

> The spectacular character of modern industrial society has nothing fortuitous or super-
> ficial about it; on the contrary, this society is based on the spectacle in the most funda-
> mental way. For the spectacle, as the perfect image of the ruling economic order, ends
> are nothing and development is all—although the only thing into which the spectacle
> plans to develop is itself.[16]

He saw that a public distracted by the TV could lose sight of political and com-
mercial manipulation going on around them while feeling they were in control
through their remote control options.

Figure 63. Judith Barry, *Maelstrom* (Part One of a Multipart Video-Environment Work), 1988.
Video-beam projection installation shot from Whitney Equitable Installation Site. In her installa-
tions, Judith Barry uses video cameras, monitors, and projection systems to explore aspects of our
media-ridden consumer economy. She is fascinated by the way these systems function and the way
they communicate with our private and public selves and how we are potentially controlled by
them. In *Maelstrom*, she creates a video environment through the use of a video-beam projector
installed in the ceiling. It projects on the floor where the viewer steps, flanked by two large panels
displaying texts as questions. The welter of images engulf the viewer while demanding interaction
through a process of decoding the meaning of the messages displayed. The installation raises ques-
tions about real communication in relation to the information spewed out by electronic-media sys-
tems. (*Courtesy Judith Barry*)

First Artist Access to Television Broadcast Labs

The single noncommercial broadcast channel open to meeting the cultural needs of a sophisticated, diverse audience lay in the establishment in 1967 of government-funded national public television (PBS) and of cable transmissions. Although funding for PBS has been limited in comparison, for example, to the BBC in Britain (especially channel 4) or CBC in Canada, in the current conservative climate, it is in danger of being cut back completely. Even without adequate public funding, forced to rely more and more on corporate sponsorship, it sometimes demonstrates television's potential as a powerful cultural force.

By 1972, the Artists' Television Laboratory of WNET (Public Broadcast Corporation) was founded by grants from a variety of sponsors including the Rockefeller Foundation, the New York State Council on the Arts, and later others. PBS stations KQED in San Francisco and WGBH in Boston also initiated experimental video production. The TV Lab was founded to mediate between the fine arts and TV. A few artists (including Stan Van Der Beek, Douglas Davis, and Nam June Paik) were given access to these television labs. At a time when most artists had no editing equipment, this access to broadcast facilities was vital. Independent funding for use of broadcast technology created the opportunity for creative risk. In the realm of television production, budgets are tightly regulated, leaving little or no room for experimentation. Use of sophisticated high-tech devices at the WNET television studio represented an unprecedented departure from common practice, for artists were allowed to experiment for aesthetic effect. Some artists such as Nam June Paik, Ed Emshwiller, and later, Mitchell Kriegman, John Sanborn, Kit Fitzgerald, and Bill Viola received funding to do more than one artist-in-residence production. For these artists, multiple access to high-tech equipment represented a quantum leap in their professional growth in the video medium.

Early support of artist-in-residence institutional programs fostered visionary freedom and widespread utopian optimism that television could become a democratic alternative medium—one that could reject the priorities of the commercial industry and be used as a tool for cultural and social change. These hopes grew out of the global village attitudes of the sixties and did not take into account the huge distance between high-culture style and mass-media realities. Some artists were primarily interested only in seeing their work shown on television. Others were committed to subverting TV's dominantly commercial voice. Some took their cameras to the street as a form of guerrilla tactics.

Public TV screening of artists' video both in North America and in Europe created a clash of tastes. Video, growing out of prevailing philosophic and aesthetic currents in the arts, exists primarily for the art world as a special interest group (and has received funding and encouragement for its experimental independence). Public taste has been formed by fast-paced formula entertainment and information programs punctuated with smooth advertising messages. Unaccustomed to video's "difficult," unfamiliar vocabulary and greater intellectual

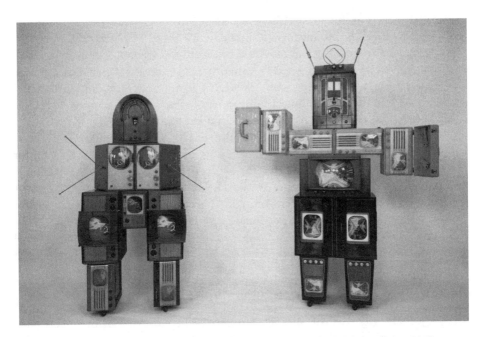

Figure 64. Nam June Paik, *Family of Robot: Grandmother and Grandfather,* Video Installation, Holly Solomon Gallery, 1987. Paik, long recognized as elder statesman and key figure in the history of video art, has explored every aspect of the medium as seen from his witty and unique Neo-Dada Fluxus stance. In this installation, his two video sculptures pose questions about TV as an ironic part of family history by the arrangement of a collection of vintage television sets into humanoid robot forms. (*Courtesy Holly Solomon Gallery*)

complexity and to the high level of attention and interpretive participation required, the average viewer tunes away and thinks of it as bad TV. The mass audience seeks leisure-time distraction: art demands concentration—it is a process of exploration, inquiry, and discovery. This clash between artists and the realities of the television world brought many issues into sharp focus.

Video artists using nonprofessional low-tech equipment were accustomed to independence in developing their ideas through spontaneous improvisation where they had integrated control over all aspects of writing, directing, and performing. By contrast, standard broadcast programs are generally produced by a consortium of writers, producers, and film crews whose work is subject to strict regulation by unions and to control by network owners, commercial sponsors, and the FCC regulatory commission. Eventually, artist-made works produced with the video tools artists helped to invent had a strong stylistic influence on TV production, although public broadcast of this work did not attract the popular viewing public.

Very few of the early experimental artist-produced works were ever broadcast. PBS owned the rights to them which they refused to relinquish.

Video and Television Review (Video/Film Review by 1979), a late-night Sunday series, was grudgingly produced as a showcase for these works by PBS in 1975. The big name artists at TV Lab attracted grants to the station. Although artists-in-residence were required to spend all their NYSCA funded stipends at the station, video makers had no rights and WNET was not obliged to air works produced at the Lab. This situation did not satisfy major funding sources. NYSCA raised several serious questions. Rockefeller pulled out.

Funding difficulties caused the demise of WQED's National Center for Experiments in TV in 1975, WGBH gave up its studio in 1978, and the WNET-TV Lab ceased operation in 1984, forcing artists to find other support systems for professional-level broadcast quality work. The only funding agency still operational is the Contemporary Art Television (CAT) Fund in Boston, founded in 1980.

It is ironic that more than a decade after the first broadcasts in 1975, a late-night program on PBS, finally aired these early tapes, in 1988 treating them reverently as historical documents.

Cable Transmission and Counterculture: The Right to Be Seen and Heard

Although many video artists turned away from the issue of public broadcast and remained within the exhibition context of museums for showing their work, those with an activist or documentary commitment embraced it and sought to air their work on the more open flexible public access cable stations. Cable[17] represents one of the few vestiges of the public service concept of TV communications still in place. Initially, FCC law required cable owners to include a prescribed number of hours to community-based transmissions. The growth of cable broadband communications (non-over-the-air broadcasting in the VHF or UHF frequency band) opened the way for at least eighty and, ultimately, many more operating channels. Many early video artists saw the future expansion of cable TV as a major opportunity for creating new cultural options, experiences, and perspectives as a public alternative to conventional network broadcasting.

By 1971, the counterculture group Videofreex began regular low-power TV programming in Lanesville, New York. Other groups began their own public access series—Byron Black, Clive Robertson, and Ian Murray in Canada; and Jaime Davidovich, and later the Artists' Collab. and Paper Tiger Television. Paper Tiger (Deep Dish TV) is a series which continues to be shown on Manhattan cable. The aim of these groups to inject alternative insights and criticism of the media monopolies—its genres, editing, camera techniques, and politics. They reacted to the segmented, formulaic handling of significant events and issues as edited, blanked-out interpretations. Counterculture video raised analytic questions about the hidden agendas behind standard programming formulas and challenged the delimiting power of commercial TV to set the dominant agenda for public assumptions, attitudes, and moods through its interpretation of news and information.

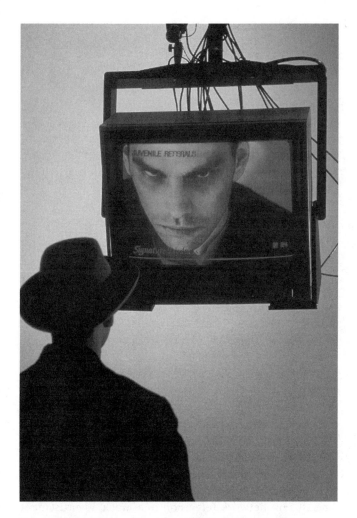

Figure 65. Julia Scher, Detail from *I'll Be Gentle*, 1991. Four monitor video installation. Scher is interested in exposing the power machineries behind the video surveillance camera. Her strategy is to contaminate the easy flow of video and computer information against themselves. Image scans of sites within the space flash across selected screens while on others, projections appear of the viewer passing through the installation. Ominous techno-security jargon texts slide over the screens such as "interrogation and bio-merge centers"; "chemical castration." Seen over the image of the viewer, these serve to classify the status of the viewer as an object under the control of the surrounding surveillance technology. Soothing, nurturing female voices warbling continuous sugar-coated anomalies create a sound environment which masks the installation's malevolent connotations. *(Courtesy Julia Scher)*

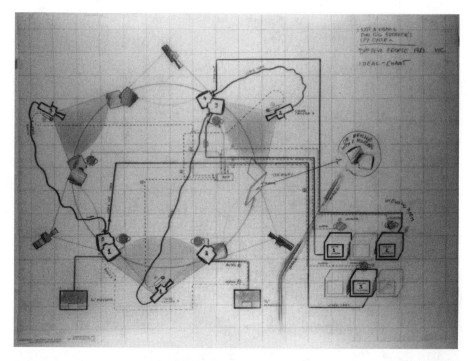

Figure 66. Dieter Froese, *Not a Model for Big Brother's Spy Cycle* (Unpräzise Angaben), 1984. Installation diagram, 8½″ × 11″.

From the early seventies, counterculture video artists such as Telethon (William Adler and John Margolis), Tom Sherman, and Stuart Marshall have appropriated elements of broadcast programs as "found materials" in their analytical critiques of the medium. The latter continued to produce video which addresses commercial television. Chris Burden took another tack when he bought a commercial time slot on network television in a mock advertisement for the value of his artwork-as-a-commodity product.

In 1972, the Time Base Corrector became available. Its arrival meant that "nonprofessional" independent video could now be broadcast on national television, for deviation errors in the video signal caused by inconsistencies in equipment could be electronically corrected. Among the first documentary videos made with nonprofessional equipment was Downtown Community Television Center's report on Cuba and coverage by Top Value Television (TVTV) of the 1972 political convention. Both were aired on WNET.

Founded much later, in 1981, Paper Tiger Television—a group that still actively broadcasts a weekly series on public access Channels in New York— attacks corporate economic control and the ideology of mass media. Its producers state: "The power of mass culture rests on the trust of the public. This legitimacy is a paper tiger" (thus the group's designation). Although their shows are

local, Paper Tiger TV "encourages its audience to consider global issues, to think about how communications industries affect their lives and their understanding of the world. Consciously mixing almost primitive video techniques with sophisticated ideas, adding humorous touches to enliven serious questions, Paper Tiger TV can be described as a 1980s version of Brecht's didactic theater (for it) weds analytic processes to popular forms in order to reveal social relations and social inequities."[18] Through its simple unveiling of its communications process, and its method of functioning as a broadcast apparatus different from highly stylized network productions, Paper Tiger TV raises questions for its audience about how television communicates. It reveals the power of broadcast communications and attacks the power and the economic structure of the mass-media cultural apparatus.

Costs for the half-hour program are about $200 as compared to the $150,000 normally spent on a typical half-hour commercial program (a comparison that is often stated for political effect at the conclusion of Paper Tiger

Figure 67. Dieter Froese, *Not a Model for Big Brother's Spy Cycle*, Bonn Kunstmuseum Installation. In his extensive gallery-wide installation, Froese combines closed-circuit television with a two-channel pretaped video work, using both real and dummy surveillance cameras and monitors. Walking up the stairs through the corridors and into the gallery space, the viewers become aware that they are part of a spectacle while they are also watching individuals being questioned about their political activities. Froese's intentions are to create a situation where the public postures and private lives of the viewer are observed and heard throughout the gallery spaces. Avoiding simple parody, he comments on video as a surveillance tool. (*Courtesy Dieter Froese. Photo: Kay Hines*)

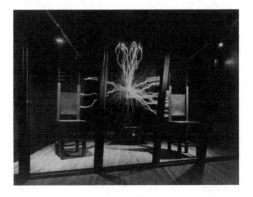

Figure 68. Doug Hall, *The Terrible Uncertainty of the Thing Described*, 1987. Three-channel video and electrical installation, steel (fence, mesh, frame, chairs), 144″ × 360″ × 480″. Interested in contrasting powerful documentary images of natural meteorological phenomena with concepts of our alienated experience of a world of our own making, Hall has curated an installation where the theatrical artifice of man-made lightning is evoked intermittently. In his installation work, *The Terrible Uncertainty of the Thing Described*, two large chairs and a ten-foot-high mesh barricade loom out at the viewer, hiding the existence of a Tesla coil which emits a large bolt of electricity at random points when the monitors depict extreme natural turbulence. (*Courtesy Doug Hall and the San Francisco Museum of Modern Art. Purchased through a gift of the Modern Art Council and the Art Dealers Association*)

programs). The style of Paper Tiger shows reflect practical and conceptual considerations. Their "talent" is a wide range of commentators, visual artists, writers, economists, lawyers, musicians, and psychiatrists. Their "live" format is eye-catching and spontaneous. Consciously avoiding the slick high-tech style of network programs, they opt for simplicity and low-budget effects. For example, titles and credits are displayed on a hand-cranked paper movie strip or hand-lettered cards are held in front of the camera. The flavor of their sets is equally inventive—often cartoonlike cloth backdrops depicting scenes such as the interior of a graffitied New York subway car; a homey domestic setting with flowered wallpaper; or a stone basement wall with its pipes and meters. The overt effects and content are meant not only to engage and attract the viewer, but to question the issues and methods implicit in media seduction and production.

Artists Design Electronic Image Synthesizers

From 1965, many artists saw a strong link between the computer and video both as an extension of kinetic art and as a means for electronic visualization, animation, and processing of their images. Early filmmakers John and James Whitney, Stan Van Der Beek, Ed Emschwiller, and Lillian Schwartz, working out of facilities such as Bell Labs, New Jersey and the New York Institute of Technology, used the computer to generate, animate, and mediate their imagery. Artist access to WGBH, WQED, and WNET-TV labs' array of post-production equipment fired the imagination of first-generation video artists and created the energy to develop artist-designed imaging tools such as the Paik/Abe video synthesizer by 1970. Image processing grew out of a sense of idealism combined with intense experimentation. In his first manipulations of the video signal, Paik had used a magnet to interrupt and interfere with the raster scanning process of TV, that is, the beam of electrons which moves continuously across and up and down to form the image on the monitor. The Paik/Abe video synthesizer was a tool specifically designed to cause interference with the raster scan and to direct it in a controlled way. Other kinds of manipulation devices such as colorizers, mixers, and synthesizers, could produce images that looked startlingly different from those on standard TV—tools which could produce moving, swirling colors, distorted forms, and disjunctive patterns by extensive intermixing of signals to create totally new images—a new genre of "tech art" that had strong appeal because of its relationship to the formal modernist concept, "the medium is the medium." Many idealistically thought in terms of a kind of lingo of futurism where technology would somehow create new realities which could link up the universe with the unconscious energy flow of the nervous system to achieve total communication.

The new image-processing genre of video depended on the pioneering efforts of a dedicated few who designed flexible, relatively inexpensive tools.

Because it is unusual to find both artistic and engineering ability in one person, the need to invent new tools led to important symbiotic collaborations such as Nam June Paik's with the engineer Shuya Abe, Stan Van Der Beek's with Eric Siegel, and Bill Etra's with Steve Rutt.

Some of these toolmakers—Steven Beck, Eric Siegel, Bill Etra—were obliged, in the end, to find outlets for their skills outside of the arts or to set up their own commercial companies. Some, like Tom de Fanti (Z-Grass) were able to get commercial video game commissions to design new equipment. Others, like Woody Vasulka (Digital Image Articulator), Dan Sandin (Digital Image Processor), and Ralph Hocking and Sherry Millner saw that sharing new development of tools could bring about important relationships in the video community. An awareness of easily learned inexpensive systems could counter the mentality that technology was too costly and unwieldy to be "habitable" or usable by artists. Artists as tool-makers challenge the bounds imposed by commercial origin. Sandin rejected the idea of marketing his device and instead offered to give the plans to anyone wishing to build it. His Digital Image Processor (completed in 1973) combined many functions in one tool—keying, colorizing, fading—and was set up as a set of stacked boxes which could be rewired or reconfigured.

The Community Center for TV Production, later called The Experimental Television Center, was set up by Ralph Hocking and Sherry Millner through a large NYSCA grant in 1970. It has been a major site for investigations into the video medium. Hocking and Sandin have been "committed to the idea that artists should be able to work with video technology much the same way as a painter works with his or her materials in isolation in a studio. In this sense, they both adhere to very traditional modes of art-making."[19] Both have had institutional support for their work.

By 1977, image processors had been programmed and built which could achieve new visual effects such as the mixing together of live and taped images on a split screen and the digital painting and matrixing of forms—effects which had not previously been possible even through the use of then-available professional broadcast equipment. These pioneering innovations to the technology of visual transformation by independent video artists dramatically highlighted the possibilities for replacing outmoded models of film/video practice and production. Their contributions were vital to software and hardware developments in producing the new generation of powerful but inexpensive computer/video instruments later built commercially.[20]

Artists continue to play an important role in defining new areas where specific software can be produced to fill a specific need. Many firms have found that important benefits can be derived from granting after-hours access to artists. Their intelligent use of equipment can often open unexplored aspects of a machine's potential or raise important questions for the future which have direct application to the development of a system.

Video Is a Cutting Edge in the Arts

Video, forty years later is now seen as a mature art form in the sense that it has influenced other art works or has become part of them. It has a corps of recognized practitioners, as well as an expanding body of criticism and analysis through such serious journals as *Afterimage, The Independent, Screen,* and important interpretive books such as *Transmission, New Artists Video, Video Culture, Videography,* and *Illuminating Video.* Catalogs of video exhibitions and festivals contain history and analysis.

The great majority of video artists have built their reputations through international museum and gallery exhibitions.[21] John Hanhardt, curator of video at the Whitney Museum of American Art, regards independent video as "a cutting edge." He sees it as being at the forefront of theoretical and aesthetic thinking in the arts, and, in its nexus with the media, is a vital, flexible link to interpreting the world around us. He is convinced that because technology is changing our way of living so rapidly, artists and the museum itself must respond to cultural changes positively by providing alternatives. In his view, the museum should seek creative use of the broadcast medium for special artists' projects and for interpretive programming through its education department, possibly via publicly and privately disseminated cable productions and on the World Wide Web. (Chapter 6)

New York Times critic Grace Glueck comments that video has passed the point where the public need be video-shy because of its newness or its considerable claim on time—for a video piece unfolds in time, and therefore demands a time commitment from the viewer.

> "We're accustomed to looking at art that addresses us in a more or less known grammar and time-honored materials," she writes, "art that can be 'placed,' both in a critical-historical context and literally—on a fixed site within the walls of a room. . . . The video screen lacks the surface richness to which art has accustomed us. While the basic property of video is that it moves and changes, we are used to an art that we can contemplate, that stands still for our eyes to return to in sensuous or cerebral appreciation. Yet we'd do better if we stopped trying to relate video to fine art, film, or even commercial television, and began to regard it as a developing medium in its own right."[22]

In 1982, video made a striking impact on the museum-going public through a major retrospective of Nam June Paik's video work at the Whitney Museum. By now identified as the "father of video" because of his long history in working with the medium and because of his strong influence on the entire field, Paik contributed also to the identification of video as the art form of the future. Paik comments: "As collage technique replaced oil paint, so the cathode-ray tube will replace canvas." Paik's early video works—*TV Bra, TV Bed, TV Cello,* and *TV Buddha*—combined the genres of performance, installation, and sculpture. His work now encompasses not only early Neo-Dada works, using television as building-block icons, but has passed on to include personal and intuitive, highly edited, single and multiple-channel tapes which make use of

chaotic stream-of-consciousness montage using image-processed materials from many sources. Paik's open strategies for video sculpture include an assemblage approach. He installs large numbers of monitors in elaborated contexts—from the ceiling, or, for example, set among plants in an out of context garden environment completely alien to normal TV usage. His intention is to subvert the viewer's normal visual relations with the familiar TV monitor by challenging the viewer's referential reading and interpretation of TV Assemblages of television sets piled in pyramids, arches, or as multiple channel "video wall" works in which 20 or more monitors are hooked together. His adventurous experimentation and wily analysis of the medium itself is a playfully irreverent pastiche of the language of the commercial reality of broadcast TV. Interested also in broadcasting itself as a form of public art, especially in "real time" international satellite communications, Paik has produced a number of live telecommunication performance works that bridge continents, East and West. (Chapter 6) "I think video is half in the art world and half out" he says, drawing two overlap-

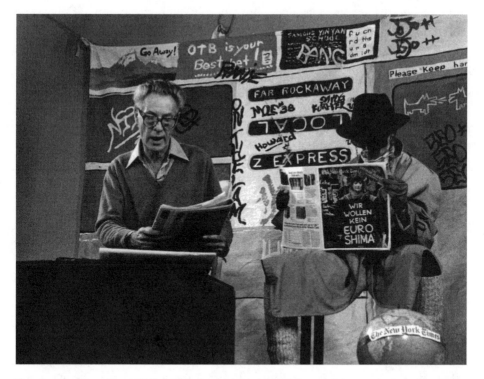

Figure 69. Paper Tiger TV, *Herb Schiller Smashes the Myths of the Information Industry* at the Paper Tiger Television Installation at the Whitney Museum, New York, 1985. The group is devoted to criticism of media monopolies and analysis of the politics of the communications industry. One of its leading advocates, Herb Schiller, is shown here giving one of his readings—a presentation of specific revelations critical of the press. (*Courtesy Paper Tiger TV, Photo: Diane Neumier*)

ping circles, one labeled ART and one INFORMATION, "I think I am here," he comments, pointing to the overlap.

Another major video artist, Bill Viola, whose work has completely different intentions from Paik's, was also accorded a major retrospective (1987–1988, Museum of Modern Art), where he showed both single channel works and installations. His works, drawing more on the traditions of independent film, are like "visual songs" which have all the elegance and music of a poet's voice. He has achieved a remarkable synthesis between using video, as a major technological medium of his time—with personal vision. His work has the quality of touching an inner core in his viewer through effortless exploitation of his technical medium in a radically expressive way. His use of slow motion, rapid editing, deep zooms, and panoramic scans is never obtrusive, but seems rather a natural process of perception. Several themes recur in his work: powers of the human mind; passage of time; personal identity; and contemplation of the nature of species. For example, Viola shares with us those images which have powerful archetypal significance for all time: landscape is seen as a sacred setting for humans and animals; metaphors for life and regeneration are suggested in the way he uses fish, bread, and wine by contrasting them with their antithesis: decay, overcrowding, industrial pollution.

Attracted early to the teachings of non-Western traditional cultures, which regard life as a continuum lived in its reference to nature, Viola has traveled and worked in the Far East, Africa, and the Pacific. In a 1986 single-channel work, *I Do Not Know What It Is I Am Like*, he contrasts a view of prairies in long, slow sequences showing movement of birds and buffaloes as a way of seeking, asking, who are we? At the tape's end, as a way of reaffirming the power of the mind, we see a view of Solomon Islanders walking on fire.

In his 1983 installation *Room for Saint John of the Cross*, Viola focuses on creating a metaphor for understanding the mind's capacity to escape the confines of any restrictions. He places within a larger room containing a black and white landscape with sound, a miniaturized reconstruction of the cell where the seventeenth century Spanish mystic, St. John, was imprisoned for his heretical beliefs. On a tiny TV monitor within the enclosed cell, a small color image of the mountain is shown with a voice-over of the monk's verse in Spanish. Viola helps the viewer to realize that St. John continued to write his ecstatic poetry despite confinement.

Viola's five room installation at the 1995 Venice Biennale was entitled *Buried Secrets*. Its title was inspired by the thirteenth century Persian poet Rumi. "When seeds are buried in the dark earth, their inward secrets become the flourishing garden." In the first "Hall of Whispers," the viewer passes between two rows of five projections of heads with throttled, gagged mouths and sealed eyes. Alternating projections on opposite walls dominate "Interval" which shows on one screen, the unhurried motions of a man showering while the opposite screen displays fragmented views of a slowed-down view of a chase and of a fire accom-

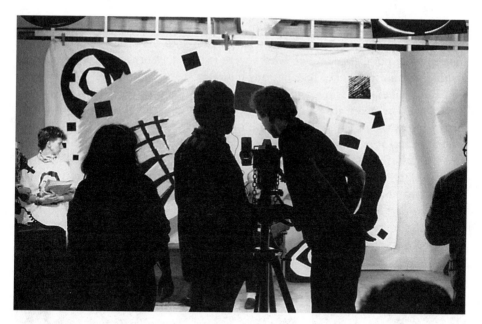

Figure 70. Paper Tiger TV, *Taping the People with AIDS Coalition Talk Back Show,* 1988. Paper Tiger TV Show. Paper Tiger TV is a weekly series on public access television in Manhattan. The group's sets, intentionally designed to be striking for their simplicity and low cost, are an important commentary on the power principles involved in the economic disparities between the public's right of access to the airwaves and those commercial companies that can afford to "buy time" from commercial network companies. (*Courtesy Paper Tiger TV*)

panied by frightening effects of deep sound. "Presence" offers reprieve in a murmuring choral sound-work. In "The Veiling," overlapping and merging figures of a man and of a woman in different sizes and juxtapositions are projected on ten different scrims which the visitor walks through. In the final room, "Greeting," Viola has chosen to slow down the action of a greeting between three women— an older and a younger woman who are joined by a pregnant woman in red. Their forty-five second greeting movements have been slowed (using 35 mm film) to a duration of ten minutes. This slow-motion effect is an eloquent meditation on psychological engagement and interaction between individuals. The experience of the work as the audience travels through darkness to light is of a passage from extreme isolation to one of social interaction and continuity. The implication of *Buried Secrets* seems to be that our truest nature, and our rootedness and growth come from inner spaces before coming to the light.

Today, video represents an astonishingly diverse range of ideological viewpoints, stylistic currents, and interpretations of aesthetic issues. Many artists whose major medium is painting or sculpture, theater or dance have made video a natural crossover for their art ideas (e.g., Robert Wilson, Merce Cunningham, Robert Longo, Joan Jonas, Laurie Anderson, and David Byrne).

This diversity was reflected in the important Whitney Biennials beginning in 1985 and continuing to the present where, relative to the other art forms represented, large numbers of video works were featured. Works ranged from single channel to multi-channel installation, figurative to nonfigurative using animation and image processing, and the use of autobiographic and diaristic formats. Issues often involved investigation into the meaning and relationship of word and image as they relate to representation itself, and explored through interpretations of historical and political texts and events. These were strong commentaries on the media itself and on the forms and styles appropriated from it. Some restate mass-media style directly or simply appropriate its entertainment format and mix it with other vestiges of popular culture, such as Lyn Blumenthal's two-part *Social Studies.*

Image processing and glossy high-tech style characterize many video works which rely on electronic effects and computer-controlled editing such as Woody

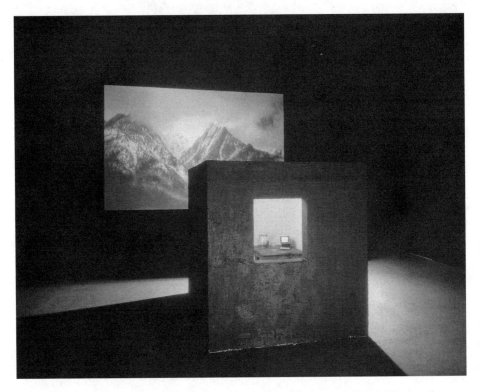

Figure 71. Bill Viola, *Room for St. John of the Cross,* 1983. Video installation. A black cubicle with a single illuminated window stands in the center of this video installation work. Inside the tiny lighted room, which is filled with amplified sound, is a small color monitor that transmits the same mountain view projected in black-and-white on the larger wall screen of the room. *(Collection: Museum of Contemporary Art, Los Angeles; Photo: Kira Perov)*

Vasulka's *The Commission* or Joan Jonas's *Double Lunar Dogs*—a science fiction parody with dramatic lighting and futuristic music. Others, like the Yonemoto's, quote pseudopsycho narrative to show the hollowness of their characters. Doug Hall's *Song of the 80's* presents brief, high-concept vignettes which convey anger and meanness below their glossy surface. He captures the look of media slickness with terrifying accuracy while exposing its rules and its strategies.

Installation works are a major interest of many artists. Judith Barry's *Echo* uses a video projection device to focus sound and image in unexpected places where the viewer is least expecting to receive a message. Some installation works combine video and film, others like Shigeko Kubota's consist of sculpturelike video objects. Bucky Schwartz combines his interest in perceptual problems into a work that intrigues the viewer into a balancing act of discovering relationships between all the parts. The rich possibilities offered by multichannel video walls have by now engaged the serious attention of important video artists: Nam June Paik, Mary Lucier, Dara Birnbaum, Marie Jo Lafontaine, and Miroslaw Rogala.

Exhibitions which are not video-specific integrate video as an important aspect of their theme development such as the "Sexual Difference" exhibition at the New Museum. While exhibitions of video installation works such as the 1984 Stedelijk Museum show are costly to mount, single channel videotapes can easily be shared by mail. An indispensable network of international festivals, conferences, and distribution centers has grown as a video support system and cultural circuit. Video is shown also actively in a wide range of alternative settings such as rock clubs and libraries as well as on cable and public television. For example, in the eighties, the Palladium, a converted movie house which featured art works by well-known artists, commissioned artists to make videos for its huge video walls—twenty-five monitors in a 5 ft × 5 ft block that is lowered up and down over the dance floor in time to the pulsing music and the computerized lighting ambiance.

Many institutions have ongoing video collections and exhibition programs. Video study and research centers exist at the Paris Centre Georges Pompidou, the Amsterdam Stedelijk Museum, the New York Museum of Modern Art, the Whitney Museum of American Art, the California Long Beach Museum, the Boston Institute of Contemporary Art, the London Institute of Contemporary Art, the Vancouver Art Gallery, and the National Gallery of Canada, Ottawa.

Participating in an Electronic Public Dialogue

Video critic Marita Sturken wrote as early as 1984 that "Network television as we have known it is slowly becoming obsolete. Vast, expensive, centralized, inflexible, it is the dinosaur of the 1980s and 1990s gradually giving way to an electronic cable entertainment industry that includes multiple channels,

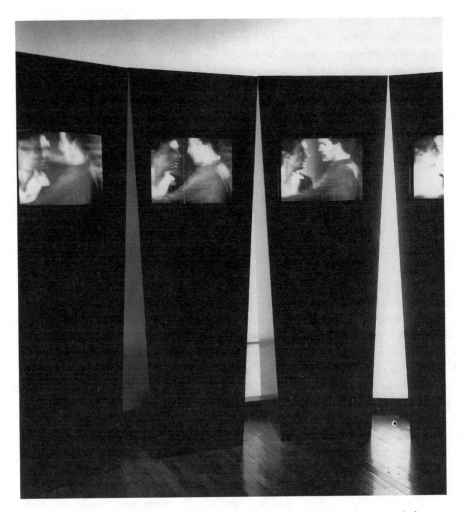

Figure 72. Marie Jo Lafontaine, *Victoria*, 1992. Nineteen monitors in wooden towers. In her multimedia installations, Lafontaine explores rituals of sex and death, power and domination, violence and seduction. In *Victoria*, a video installation made up of nineteen black wooden towers set in a spiral, each crowned with a screen, she recreates the archetypal male struggle for identity and power between Cain and Able. The viewer becomes enmeshed in a spiralling cul-de-sac of intense emotion as the two protagonists circle each other in fearful mortal combat, every drop of sweat, every breath visible. The focus is the face as they circle each other like matadors. In announcing the work as *Victoria*, Lafontaine seems to remind us that from a female point of view, any such primitive victory needs to be re-evaluated. (*Courtesy Jack Shainman Gallery*)

increased distribution via satellite, interactive shopping services, home recorders, and, for viewers, a radically new element of choice."[23] Economic forces that control distribution and new interactive technologies are prime factors in the state of commercial transition that is currently taking place. "Televi-

sion as a system which functioned from the 1950s into the 1970s is now disappearing, to be reconstituted at the heart of another network in which what is at stake is no longer representation, but distribution and regulation."[24] The ongoing refinement of high resolution TV and of the large home screen, is seen as a way for TV to significantly compete with the experience of film.[25]

Although much of the guiding impulse for early artists' video experiments in the 1970s grew out of a rejection of the monolithic warp of U.S. commercial television, there is no doubt that many of the new models they created outside of its mainstream were absorbed and eventually reflected in TV production, editing, image-making styles, and new imaging tools.

Contemporary video artists are posing new questions. These grow not only out of changes in the TV industry itself, but arise from Postmodern technological conditions, attitudes, and issues which are altering artists' view of television and their future challenges to it, at a time when video has become an increasingly accepted medium. Exploration of some of these issues involve distinctions between mass culture and high culture; their relation to a growing thrust towards democratic populism in the arts and how they might change the function and parameters of art through a more public cultural dialogue. These interests coincide with expanded viewer choice. As some video artists take up the challenge to work within the construct of the TV industry as a broader forum, they are unsure how it will change their art.

It is always the serious intentions of the artist that separate popular film from the art film, the popular novel from the more serious poetic work, pop music from symphonic, the Broadway musical from contemporary dance and opera. Although critical distinctions are made between these forms as to their popular or art intentions, the public perception is that they are democratically available by tuning into them via libraries, radio, cinema, or TV. Their cultural value is as relatively inexpensive forms of communication, not as material objects to be bought and sold. In the visual arts, the perception that art is a precious unique object to be sold to the highest bidder is a concept that became common only following the Renaissance, and has served to create far greater perception of painting and sculpture as elitist rather than as popular forms. The hierarchical conditions set up by the museum and commercial gallery system for validating the most important "art" has further set up strong distinctions as to what is popular or mass art, and what is high or elite art. Video is becoming a crucial testing ground in what is now becoming a major debate in the visual arts between "art as object" and art as "dematerialized" communication of ideas. This is further discussed in Chapters 5 and 6.

Testing of popular forms in mass media culture and reaction to the negative influence of TV media on society are issues for many artists who wish to produce work that can find a wider audience beyond the "high art" museum context. Their work often appropriates some existing "corporate style" formats from the TV media—news, sports, soaps, and sitcoms—but their direct quotation and stylistic influence is referenced to create new visual structures.

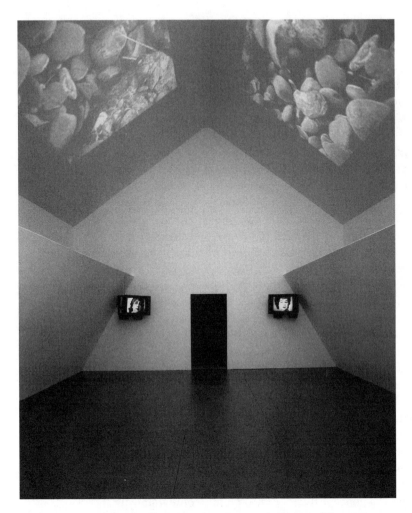

Figure 73. Mary Lucier, *Oblique House,* 1993. Four monitors, two video projections, five channels of laser-disc video, and audio. Within the form of what she terms her "cinematic sculpture," Lucier explores questions of memory and of survival and of extinction. *Oblique House* is the setting for the retelling of the effects on the inhabitants of Valdez, Alaska, of the effects of an earthquake, and of an environmental disaster. While Lucier interviewed hundreds of people who had experienced the trauma of both massive events, she chose only four who inhabit and tell their stories via monitors at each corner of the House. We experience the way each managed to reconcile the reality of survival, how they healed, how past traumas become integrated through the continuum of time. We hear their stories via processed sound but we witness through the slowed motion action of each face, a dimension of emotion far beyond what words can convey. Overhead projections of the rocky shore add the sound of foot hitting rock. (*Courtesy Mary Lucier, Photo James Via*)

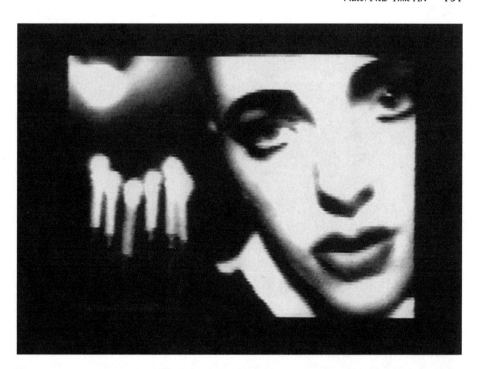

Figure 74. Sadie Benning, *It Wasn't Love #14*, single channel video, ca. 1992. Working with a primitive video apparatus, "Pixelvision," originally developed as a children's toy, Sadie Benning explores up-close "queer" identity politics. Not a confessional, her high-contrast graphic images are more "kitchen-sink" informal explorations of relationships. In the play between abstraction and representation, and the relation between movement and time, she reaches a new kind of video synthesis. (*Courtesy Video Data Bank*)

"Some restate mass-media style directly, whether to critique it or simply borrow its familiarity and emotional force for different ends, while others incorporate elements of media style into new syntheses in which art, video, film, and the "entertainment values" of popular culture are mixed together. . . . The media look that some of these works use is a style that's explicitly, self-consciously "attractive." It alludes to the flawlessness of fashion photography, the perky zest of "happy news," the posturing of MTV, the seamless manipulation of desire in advertising. It's a style that insists that you like it, that uses its seductive gloss to bludgeon you into buying this product, watching that show. . . . Media influence is expressed [also] through the superslick, high-tech style adopted by many of the works. The most obvious components of this style are the electronic effects and computer-controlled editing."[26]

Driven by synthetic rock soundtracks, glossy style, high-key lighting, and simplified plastic-colored graphic images, populist videos capture the slickness of media while commenting on it. Charles Atlas's *Parafango* and Ken Feingold's *The Double* are good examples of catchy TV images used as a form of collage to state very different intentions. The work grows out of a sense that a continuum

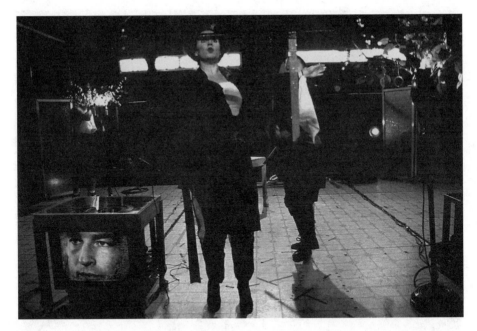

Figure 75. The Wooster Group, *Brace Up: Finished Story,* (left to right, Dave Shelley, Ron Vawter, Peyton Smith, Kate Valk) 1994. The Wooster Group has created a new aesthetic that uses video in connection with their performance work as a commentary on how conventions created by TV, radio, and film mediate our present reality. Live images on monitors become an active part of the live performance as part of a commentary on how the technological shapes our most fundamental perceptual habits. *Brace Up* spins off from Acts III and IV of Chekov's *Three Sisters* while tracing through snippets of biography and the story of a touring Japanese theater troupe. In the resulting collision of disparate realities, at least three levels of interpretation coexist: Chekov as seen by the Ichikawa Sentaro theater group of Japan, and then as seen by the Wooster Group who are also interpreting Chekov. At the core of this work lies Chekov's vision of lives of missed connections and ambitions devoured by time, and elements of ancient Eastern ritual reshaped by contemporary technology. (*Courtesy The Wooster Group. This work is dedicated to the memory of Group member Ron Vawter*)

exists—a circular relationship between TV, which makes the public, which in turn makes TV. Some artists see themselves as one of the links in the exchange.

Is Artist's Video Ready for Prime Time?

The traditions of "high" culture have always maintained a distance between artist and viewer. Unfamiliar "difficult" language has been used to frame the artist's vision and communicate its autonomy and independence. A painting is not conceived for mass viewing or reproduction, whereas film is specifically designed for a simultaneous mass collective viewing experience to be seen by thousands in large cinemas. Responses to film experience are designed along pathways and sequences organized to demand direct, immediate personal

response from audiences. Film is designed for reproduction to reach as large a viewing public as possible. Early experimental works produced at the television labs by artists coming from the visual arts traditions of painting and sculpture were utopian in their dream of reaching out to attract a broader audience for their art on broadcast TV because they had no experience as yet in designing work to be seen by mass audiences. Yet they wanted to obliterate mainstream parameters of the medium, not just stretch them. They looked to the promised development of smaller cable networks as a way of reaching more specialized audiences. However, these hopes were dashed by the late seventies when it was revealed that cable, too, had essentially been bought out by commercial interests.

By the early 1980s, a few artists—Dan Graham, Dara Birnbaum, and Richard Serra among them—came to the realization that unless a work was specifically made for TV, by addressing the specific conditions and needs of an audience not made up of gallery-going specialists, they could not begin to free the weight of their art from its high-cultural practice to reach a larger audience. Bertolt Brecht, struggling with the same problems of interpretation in the thirties, had argued "truth not only had to be beautiful but entertaining."

Artists put themselves at risk through evaluation of their work by a nonart public in a TV framework that offers no special museums or gallery ambiance. Risk also lies in the possible eventual contamination and co-optation of their ideas, or compromise of their methods, by a powerful, inflexible system which normally assigns editorial control to business executives rather than autonomous individuals. Artists searching for a more public forum must create a consensus for ideas, in order to intelligently layer intentions and arguments within a given work in order to shift old perceptual habits of viewers to alternative ground. It involves the concept of working within the system for change, rather than from the outside. Just as the art world has its traditional institutional boundaries such as the private collection, the gallery, and the museum, so does the world of broadcast television. These boundaries are defined by its programming formats, style of presentation, institutional setup of networks, channel distributors, and programming demands. For one to penetrate the other is so far extremely problematic.

To date, among the increasingly broad groupings of artists working in the video field, those who produce low-cost documentary or educational productions are closest to being able to subvert TV by creating a commentary in an accessible style that has "a certain look"—that is, immediately recognizable hooks—to attract the average distracted viewer who has no inclination for art world poetics or polemics. Access to the public already exists through nonprofit public cable stations which, like New York's Channel "L" and Global TV, are located around the country in most urban centers. Downtown Community Television has a special free training program oriented to expanding the use of media tools directly for those who wish to use them in the community.

One of the most striking examples of artists who have used video directly and whose work has been successfully shown on broadcast TV in Europe is Jean-Luc Godard, the well-known avant-garde French filmmaker. He has always seen his ideas and his goals as being conjoined in subverting the broadcast medium to create new cultural debate and meaning. He illustrates the relationship between its structure, its economics, its social relations, and its use as an instrument of repression. He has always been aware of the loaded, hidden agenda of images and his public forum for the use of them with words or captions or words standing in for images has been an important strategy in his television work. In *France/détour/deux/enfants,* he explored the specific relationship between mass media and his avant-garde work in film.

Can vanguard artists successfully participate in a public TV forum for their work? From among the many strands of new artists attracted to video coming from traditional documentary, performance, film, and visual arts, there is a new breed whose background is less in the traditional academic discipline of art but comes rather from film or media studies. Their concepts and vocabulary are oriented to the more public cinematic and media forms.

Because of the intense amount of viewing (50 hours per week is average), audiences themselves have become more sophisticated in their ability to understand complex story structuring such as flashbacks and dream sequences, highly metaphorical dreams and fantasies, and dealing with half a dozen interwoven stories, some left unresolved. Music videos have accustomed viewers to surrealist image sequences and editing tied completely to the rhythms of music.

The miniseries has introduced a new genre of epic storytelling made practical and possible only through the agency of the TV home entertainment center. Werner Fassbinder (*Berlin Alexanderplatz*) and Ingmar Bergman (*Scenes from a Marriage*) were among the first film directors to seize the challenge of creating

Figure 76.　Jean-Luc Godard and Anne-Marie Mieville, *Six Fois Deux* (Sur et Sous la Communication), 1976. Still frame. (*Courtesy Electronic Arts Intermix; Photo: Marita Sturken*)

Figure 77.　Frame from *Six Fois Deux.*

Figure 78. Frame from *France/tour/détour/deux/enfants*, 1978. Jean-Luc Godard's work is designed to raise questions about the relations between the media producer and the viewer. In the works shown here he sets out polarities, drawing distinctions from the way information is presented to the public. He inserts these questions over a live news report to dramatize the dynamic questioning of the power in mediating or editing information. He tries to reveal the hidden economic and ideological assumptions in media presentations by "professionals" who are "just witnessing an event"—but who claim not to bring to it any bias of their own or of their producers or of the media network carrying the report. He asks questions about the currency in photographs: "Who pays and who doesn't? What is the monetary value of news photographs colonized by photographers who benefit monetarily from their images of disasters—of wars, terrorist attacks, victims, etc.? He asks questions about captions, who writes them, and how they can be interpreted. *(Courtesy Electronic Arts Intermix; Photo: Marita Sturken)*

extended films which could be seen in segments made popular as a genre by television viewing. This new approach to the extended narrative as epic introduces an important new aspect of communication which lies outside of commercial cinema showings where such long viewings are impractical.

Given the new technologized conditions—the melting away of traditional distinctions between genres; the explosive growth of communications; the strong desire by audiences for program options; the TV industry's transitional growth through development of interactive telecommunications (see Chapter six); the valuable learning experience gained through models of past mistakes and gains; the miniaturization and availability of consumer VCR's; and the broadened base of video practice (which now includes many genres)—an opening to the future for a

vital new public access cable television art could eventually develop. The struggle to break down barriers, find support, and attract new audiences are bound to engage artists well into the next century. Many also look to the developments of the Internet as a means for gaining access to world-wide audiences (Chapter 6).

Influence of Independent Film on Music Video

Appropriation by popular music video of the legacy of visual ideas and poetic techniques used in early experimental independent film and video is testament to the influence of these genres. Recent rock videos have, for example, freely raided ideas from such films as *Un Chien Andalou, Blood of a Poet,* and *Scorpio Rising.* Here, resonating and overlapping with each other are Independent film (with its roots in visual arts traditions), and commercial TV in a circular overlap created by the influence of video.

The new generation, turned to music television (cable MTV or network broadcasts) or to videotaped[27] versions of the latest music/dance productions, is growing up on a steady daily diet of co-opted editing and shooting techniques, an extraordinary vocabulary pioneered originally by independent filmmakers. Though vulgarized and commercialized, the popular music video form is being elaborated and propelled by a broad front of new innovators. In a sense, music video has "upped the ante" in the dilemma about artists' access to television. Commercial co-optation and promotion of music video can or may create popular acceptance of avant-garde innovation; but it could also trivialize, consume, control, and corrupt the independent artist's voice. To work in more commercial areas, artists have always had to give up the pure, formal aspects of their work.

The problem is that music television isolates and appropriates visual ideas and techniques out of the context of their artistic application within coherent statements. Bill Viola remarked:

> The thing about the industry that I resent very much is that they're into the business of image appropriation, images as they relate to fashion, and fashion as it relates to capitalist economics . . . like a fashion designer from Paris going into Central Africa, not caring about the culture or cosmology of the people, just looking at decoration on spears so they can take them back and make a lot of money. . . . As experimental as people like to think music video is, the little parts of it that are experimental are also being consumed by the system. In only two years it's as pat as the standard dramatic narrative structure. And unfortunately, for a lot of people, it has become their avant-garde experience.

The conglomerate control by record companies and TV industry financing allows little chance for independents to create works which go beyond the usual sexual titillation and "star hype." A few more mature recording artists with enough vision and clout to gain control of their productions have realized

important videos. For example, David Bowie's *Ashes to Ashes* (1981) presents haunting views of identity changes where gestural choreography and camera presence suggest mysterious rites of passage, psychological alienation, and the mystical isolation of the self. David Byrne's "Talking Heads" group and Peter Gabriel in his CD-ROM production have also explored important themes about alienation and contemporary artificiality: the loss of instinct and anima; the confrontation between dream and action; the sense of living out of time.

Interdisciplinary performance artists such as Laurie Anderson and David van Tieghem whose work integrates theater, dance, and music are making highly developed, coherent contributions to artists' music television. Laurie Anderson's mature vision represents a developed critique of the politics of contemporary life and of technology. In *O Superman* and *Sharkey's Day*, she has created work which exploits the qualities of the TV medium. *Sharkey's Day*, a reenacted performance by Bauhaus choreographer Oskar Schlemmer (and dedicated to him) is a meditation on Nature and Art, Man and Machine, Acoustics and Mechanics. It is designed to demystify technology just as much as it comments on its influence. Although Anderson produced her work with state-of-the-art electronic technique, she always employs simple elements to create sophisticated effects, for example, using a light projection as a way of creating a huge shadow as in *O Superman*, or, a slide wipe made of cardboard coins and a string as in *Sharkey's Day*. Laurie Anderson's successful work as a performance artist, with feet in both popular Broadway productions and avant-garde camps, is an international phenomenon.

David van Tieghem, working with John Sanborn and Kit Fitzgerald, has constructed dance performance videos which encompass the streets themselves. Electronic visualization techniques and elaborate high-tech postproduction are pursued more and more by video artists as integral aspects of their approach to developing a new vocabulary of images.

Some artists use the brief intense visual music format (operatic cinema) as a base for works which do not as yet reach such a wide audience, but are important for their experimental contributions to its form. Max Almy, Bill Viola, and Michael Smith are artists whose videos, although they are not specifically made for TV, embrace both the museum context and television. Could public taste gravitate from MTV, once there is a realization that there are other kinds of things to look at? Most music videos are dull, have no soul, and do not sustain repeated viewing unless they are the work of someone who has unusual vision and a vast technical skill like Zbigniew Rizbczynski.

Is it possible that the very nature of TV's multiple viewing presentation of music video encourages more absorption of meaning than a museum or gallery can? Some music videos because of their extremely compact format may require a number of viewings to absorb all their I.P.M.'s (ideas per minute). The sheer exuberance and innovation of the well-conceived music videos produced by good video artists makes them viably interesting. Many high-budget productions are

originally made in 35 mm film—consciously encouraging the concept of a mini-movie style or "look." The pressures of changing technologies and of a different aesthetic climate is bringing about a new relationship between film, video, and TV.

Although it cannot be classed as music video, Robert Ashley's visual opera *Perfect Lives* has been produced as a three hour video and was shown on Britain's Channel 4 in 1983. Five years in the making, the TV opera was composed by Ashley and visually produced by John Sanborn and Dean Winkler. Its seven half-hour episodes are based on repeated "visual templates." These structure and illustrate the story of two traveling musicians who finally arrive at the last whistle-stop, a contemporary *Our Town, USA*. As composer-librettist Ashley sees it, *Perfect Lives* is meant as a comic opera—a curious metaphor for the Tibetan *Book of the Dead*—as a prayer spoken into the ear of a corpse to speed it through the seven chambers towards reincarnation. Ashley worked closely with Sanborn who developed the concept of visual templates as a structural foundation for the piece corresponding with each of its seven episodes.

Before production began, Sanborn and Ashley worked on the overall visual concept of the work based on an agreed-upon interpretation of the libretto. Sanborn used a ¾-inch deck and an inexpensive camera for shooting the images which were later image-processed and color enhanced by Winkler. Sanborn designed a visual "overture" for the opera's opening sequence by combining all seven visual templates. In one section, which allowed for a radical compression of time from twenty-eight minutes to one minute of visuals, Winkler devised a way of recording and re-recording the tapes fast forwarded at three times the normal rate each time until the images were radically compressed.

Perfect Lives required an enormous amount of funding and support over the years and involved high levels of collaboration on all fronts—financial, conceptual, technical, as well as in performance talent. It began as a video opera performance suggested by the Kitchen Center for Video and Music and evolved into an opera for television through additional encouragement, broad-based funding, and expertise. It is an example of how the lure of high-tech for postproduction of some artists' video works is straining the budgets of many arts support organizations.

Another aspect of video combined with the opera form is Miroslaw Rogala's innovative video opera installation presented at the 1988 Chicago International Art Expo. This complex production features a five-channel sound, programmed multiscreen video-wall, with live dance and performance elements. Entitled *Nature Is Leaving Us*, its theme is the destruction of the ecology by human misuse of technology. The video installation includes fourteen parts, each of which portrays a different aspect of contemporary life: birth—arrival; life—movement; death—leaving and absence. In an other work produced with the Piven Theater (and Optimus Inc.) in Chicago, Rogala conceived of using projected video as an on-stage presence of the "witches" as part of a live performance of Shakepeare's *MacBeth*. His witches offer us a radical revision of Shakespeare for a technological age . . . "They are pixillated, solarized, colored in,

frozen still and spun around at various times, their electronically processed speech never fully in synch with their electronically processed images. Rogala brings a heightened and immediate sense of doom to Shakespeare by infusing this work with Modern-age apocalyptic imagery."[28]

New Territory

Although some of the early pioneers gave up the medium around 1978, discouraged by financial, technical, distribution, and access problems, early artists such as Paik, Dan Graham, Joan Jonas, Juan Downey, Mary Lucier, the Vasulkas, Bruce Nauman, and many others have matured in the medium and have helped in defining its shift towards new territory.

As an artist who has effectively used the multichannel video installation form combined with still imagery, Dara Birnbaum stands out for her forceful exposition of television's hidden agenda and manipulation of public consciousness. She uses as texts a vivid fusion of TV commercials and popular news programs. To exhibit her 1982 work *P.M. Magazine*,[29] she papered the museum walls with enormous still photographs and set five monitors into the panels in an architectural environment dramatically lit to create an artificial videolike luminescence. The effect she achieves is to surround the viewer literally with the media, a headlong plunge into it—as an invitation to examine critically our relation to it. The densely layered images on five monitors are hypnotically repeated and manipulated against a raucous background of rock-oriented music to articulate the alienating influence on the human psyche of messages appropriated from commercial television.

Two important exhibitions featured the video work of well-established women artists—*Revising Romance: New Feminist Video* (a traveling exhibition organized by the American Federation of the Arts [AFA]) and *Difference: On Representation and Sexuality* (a traveling show originating at the New Museum of Contemporary Art, New York). Although the intentions of both shows were different, they were both based on the premise that there is a specifically different outlook and aesthetic related to gender issues and the way social and cultural issues are perceived. The New Museum exhibition explored the question of sexual difference and emphasized psychoanalytical approaches to discussing art. The AFA show broaches the issue of romance—a subject often associated primarily with women—and asks, in effect, what are the psychological, political, and aesthetic consequences of popular ideals of eternal passion and transcendent love? Stereotypical sexual roles are addressed through these tapes which portray the use of romance in popular culture.

Although often marginalized as avant-garde video, or as a minority voice in a male-dominated culture, the work of many women video artists continues to be an exploration of the mythologies and stereotypes, the economic and social realities that form the content and perception of female experience. Ranging in style from low-tech grainy images to the high-tech gloss of expen-

Figure 79. Dara Birnbaum, *Hostage,* video installation, 1994. In *Hostage,* Birnbaum explores two issues: memory-related distance and the effects of television's mediation of cat-astrophic events. Four video monitors are suspended in a diagonal which breaks the exhibi-tion space. Each monitor displays well-known mediated images of the political kidnapping of industrialist Hans Martin Schleyer by the Red Army Faction (1977). The image of the hostage relaying his captor's demands on German TV is contrasted with a "library" of excerpted U.S. newspaper images and texts of events. The continuously shifting display sug-gests the crescendo editing of electronic media. As viewers move into the viewing space, they break into the electronic path of media information. Held in fascination by the con-stantly changing display, viewers begin to realize how they themselves are held "hostage" by the mediated public spectacle. (*Courtesy: Paula Cooper Gallery, New York. Photo: Geoffrey Clements*)

sive postproduction collaborations, the work is diverse, intelligent, and provocative. Artists who raise issues that the dominant culture has suppressed—women, minorities, gays, political activists—still face difficult problems of access to equipment and funding to support production of their work.

Access and Distribution: Cultural Archives and Public Libraries in the Video Age

The making of a television production requires collaboration, a factor that a widening group of independent artists is taking into account. Artists are beginning to organize, to bring their ideas into focus, and to gain important experience in locating funding and support for their ideas, for building consensus and a reputation for their work, and for finding distribution outlets. Some are pooling their resources to acquire new image-processing equipment. Others are joining organizations such as the not-for-profit Media Alliance, an association of some sixty New York media arts centers and independent video producers. The Media Alliance in 1983 introduced On Line, a program that makes commercial-level postproduction facilities available at 50 to 90 percent of the market rate. Even so, it is a costly medium to work with and requires adequate postproduction facilities for a quality result. The fate of many of the organizations which make up the Media Alliance depends on funding from the New York State Council for the Arts and other public granting institutions now suffering from major cutbacks and restructuring. Not only has there been a conservative cutback in funds for media organizations and suspicion of progressive, minority group activism, but also a trend toward grants to institutions rather than to artists. The demise of midsized not-for-profit institutions such as Artist Television network, Ithaca Video Project, and TV Lab/Thirteen—all former Media Alliance members—points to a growing problem for independent

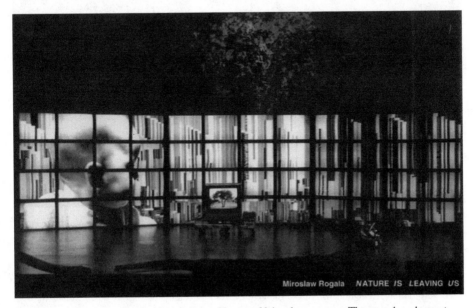

Figure 80. Miroslaw Rogala, *Nature Is Leaving Us*, 1989. Video theater opera. This complex, electronically extended mixed-media production employs a programmed multiscreen Videowall display system, live vocals, dramatic performance, dance, and five-channel sound. It acts as a contradictory commentary on humanity's frightening misuse of the environment while proposing a new electronic landscape.. (*Courtesy Miroslaw Rogala*)

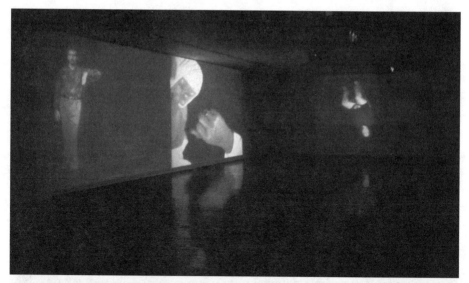

Figures 81 and 82. Bruce Nauman, *Falls, Pratfalls, and Sleights of Hand* (two views), 1993. Five video projections; five video disc players. Nauman is one of the most experimental and rigorously challenging of American artists. Exploring questions of language, philosophy, the body, and psychology while examining the very premises of art-making itself, his work ranges from multimedia installation to drawing and sculpture. In *Falls, Pratfalls, and Sleights of Hand*, he seems to suggest that the link between chance and accident in life is close. Through a nightmarish rigged game, he evokes a quiet sense of angst by slowing down the notion and sound of images in five separate video projections controlled by video laser discs. His figures appear, disappear. A woman in a chair flies upside down; a close-up of hands deals the cards; a man slips on a banana peel. Each action is repeated over and over, slow-motion, creating a maddening sense that the inevitable cannot be stopped. (*Courtesy the Leo Castelli Gallery and Bruce Nauman through the Artists Rights Society*)

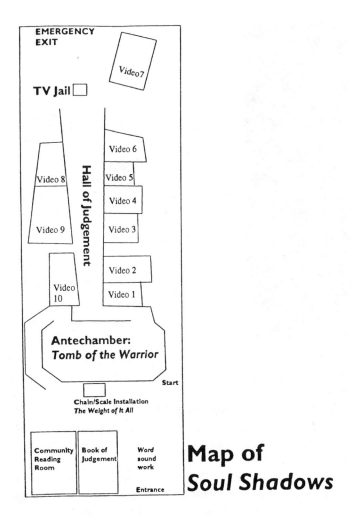

Within the map:

EMERGENCY EXIT

Video 7

TV Jail

Hall of Judgement

Video 6

Video 8

Video 5

Video 4

Video 9

Video 3

Video 2

Video 10

Video 1

Antechamber:
Tomb of the Warrior

Start

Chain/Scale Installation
The Weight of It All

Community Reading Room

Book of Judgement

Word sound work

Entrance

Map of
Soul Shadows

Figure 83. Dawn Dedeaux, *Soul Shadows: Urban Warrior Myths*, Multimedia Installation, 1992. On entering the work, the viewer becomes engaged by video documentaries in each of ten small viewing rooms situated around the outer perimeter of the piece. Each room is equipped with the generic jail-like security doors which typically fence in all urban American homes with motion detectors and fear. Inside, each video documentary reflects different family stories of poverty, crime, jail, and in some, family caring. Passing through the vibrantly lit central *Hall of Judgement*, the viewer enters the antechamber of the warrior, a mythological site, where "soul-shadows" reside. By not blurring the lines between the testimonial videos in their viewing rooms on the perimeters of the piece with the other more subjective interpretive elements in the interior Hall, she attempts to find the bridges, the mirrors, and the connective road to understanding the soul shadow world. (*Courtesy Dawn Dedeaux*)

Figure 84. Dawn Dedeaux, View of *Soul Shadows: Urban Warrior Myths*, Multimedia Installation, 1992. In this enormous multimedia video installation which completely encompasses the ground floor of an entire abandoned factory in downtown Rochester, New York, Dedeaux has created a challenging and disturbing work based on several years' work with underclass incarcerated juveniles, adults, and members of youth gangs who had been trapped in the web of drugs and crime. She encouraged them to explore their experiences via self-representation in video and in writing which she later used as unedited verbatim testimonial documents for the piece. Her intention is to find a way for the viewer not to blame but to understand. She aims to avoid the polemics of specific politics. (*Courtesy Dawn Dedeaux*)

video which is being pushed more and more into the entrepreneurial sector of the economy despite the rise of new video exhibition/production venues. The impetus of a vast new consumer interest in the miniaturized Hi-8 video camcorder with NTSC capability is now being felt. A two-hour Hi-8 tape costs less than a roll of 35 mm film with processing. By comparison, video needs no processing, and can be shown immediately on any TV monitor.

One of the most severe problems for independents is that of distribution. A remark made by artist Ardele Lister, panelist at a Media Alliance Conference in 1984, summed it up: "We all want an audience. I can make technically perfect work, but my work won't get on broadcast TV because it's weird." When it is "other" or "difficult"—intellectually challenging, expressive of strong activist points of view, abstract nonnarrative—independent video is denied showings through broadcast and cable television channels and has as yet no place to go except museums, galleries, or independent video distribution centers such as Electronic Arts Intermix, Video Data Bank libraries, or a few video boutiques.[30]

When ¾-inch video cassettes became commercially available in 1972, their advent made possible the first standardized, easy-to-handle format for artist's tapes and marked the beginning of video centers such as New York's Electronic Arts Intermix and Castelli-Sonnabend Tapes and Film, Toronto's Art Metropole, London's London Video Arts, and Berlin's Studiogalerie Mike Steiner. This independent artist video distribution network grew enormously.

As VCRs proliferate at an astonishing rate both in homes and institutions,

videocassettes are gradually replacing film as an audio-visual tool. Libraries (public or private) are a strong market to be tapped—apart from the existing institutional market in the educational field, and the cultural networks of museums and video institutes. The overall network has broadened and become international.

The Educational Film Library Association has found that small local libraries, which lack the money for film collections and screening facilities, are the most important beneficiaries of the new video technology and are only now able to build visual media into their offerings. Independent video makers could also benefit from the voracious appetite of home video VCR viewers who typically begin to experiment once they run out of well-known features. This is borne out by the experience of some librarians who feel that the greater casualness of at-home cassette viewing encourages risk-taking, particularly in users who prefer to rent their cassettes from the local library rather than the local video shop. If independent artists can reproduce their work as ½-inch home cassettes instead of solely using ¾-inch professional tapes, they can now coattail onto mainstream distribution channels and be seen by new kinds of audiences.

Widespread availability of historically important films and video in VHS videocassette form is creating the public opportunity for the study of "cinematic history." At the turn of the century, the study of art history became possible owing to the advent of the photomechanically printed reproduction of art. Videocassette reproduction of important cinema is producing a similar impact on the visual arts. Inexpensive reproduction of videocassettes is nearing a par with access to printed

Figure 85. Dawn Dedeaux, *John Wayne*, double-layered, hand-painted photograph, 8' × 4' 1991. From the *Warrior Myth Icon* series. Based on her knowledge of the mortal combat rituals practiced by black urban warrior youth gangs in their efforts to earn powerful forms of identity and glory through fearless death, Dedeaux constructed several tableaux of these heroes—vanishing black youths engaged in a kind of genocidal suicide. "In 1991, 87% of murders were committed by black males twenty-one years or younger. They're playing out the idea that death is what gives their lives meaning. None of the young men I spent time with expects to live beyond twenty-five. If the rules of the mainstream make no sense, then other rules that do make sense come about. It's a hybrid of the laws of nature and the laws of television . . . They assume the names of pop culture cowboy heroes such as Rambo, Marine Super Man, John Wayne. Why have they embraced death? Because they hunger for respect. Celebrated through the ages, the warrior hero earns his glory by fearless death. That's why no one in 'the game' runs . . . no warrior wants to die the 'gray' death. You face it." (*Courtesy Dawn Dedeaux*)

Figure 86. Tony Oursler, *Horror,* (From *Judy*), video sculpture 1994. Oursler's up-close discombobulated video sculptures combine projected or on-screen faces, discarded furniture, or scarecrowlike figures. Using miniature video projectors to illuminate the faces or objects he is addressing, Oursler aims to make the psychological real. In "horror" the tiny cloth figure is eerily brought to life and becomes a small talking object railing at us, nattering and cursing. We cannot ignore this emotional exposure that seems close to that of a mental patient hallucinating in a state of torment. (*Courtesy Tony Oursler and Metro Pictures*)

photographic references. Developments in video laserdisk technology will carry this accessibility a step further. For example, the Paris Louvre and the Washington National Gallery are cataloging their collections on laser videodisks which provide rapid computer-controlled visual and audio access to specific information. Even now, specialized museum publishing of videocassettes about artists such as Gauguin, Picasso, Hockney, and Degas are less expensive than books.

High-Tech Collaboration

Some recognized artists are able to put together enough funding for complex projects that involve high-tech collaboration. For example, when Dara Birnbaum received a large grant, she used it to gain access to the costly world of a commercial postproduction video house where special-effects tools for state-of-the-art electronic and computerized effects are available. Artists' access to these special-effects tools represents access to extensions of video's visual vocabulary. For *Damnation of Faust: Evocation*, she collaborated with well-known New York video editor John Zieman who served as the work's postproduction supervisor and co-editor.

Instead of using "found" or appropriated TV images as in previous work (such as *PM Magazine*) Birnbaum chose to shoot her unstaged images "live" in a fenced children's playground. The work has a different style and range. She worked with the technical limitations of a one-tube camera to create the unreal special mood and lyrical quality of the piece. As she explained: "I love to shoot but I'm not an

Figure 87. Ernest Gusella, *Operation Wandering Soul*, 1993. Single channel video, 60 minutes. The tragic life of American poet Ezra Pound is explored through the concept of the Japanese NOH play or "dance of the dead." A typical "Noh" play involves an authority figure on the journey, meeting a strange and ghostly figure who seems vaguely familiar. Upon questioning, the personage gradually reveals his former life and leads us to understand that his soul cannot rest because of some unresolved business on earth which has kept his spirit wandering. At the play's end, hope of salvation and deliverance fades away. Because of his stubborn refusal to admit error (like that of his open espousal of fascism) until late in life, Gusella considered Pound an ideal subject for "Noh" interpretation. The video was shot in India and Japan using aspects of butoh dance. (*Courtesy Ernest Gusella*)

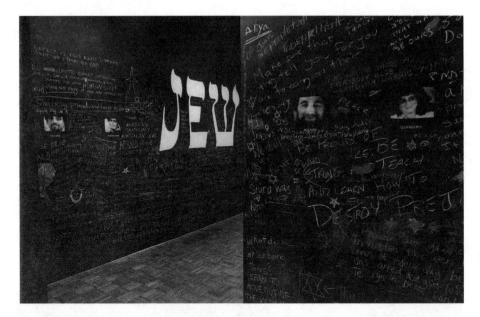

Figure 88. Pier Marton, *Jew,* 1991. Multimedia Video Installation. With the idea that "nothing short of complete healing (of psychological wounds) is required of each of us," Marton, a child of Holocaust parents, explores it in his video installation *Jew.* He invites the public to imagine a time in Europe when identifying as a Jew meant a sentence of death. He forces us to apprehend the fundamental fear and dread borne by those professing Jewish identity by intensifying the video's effect through the installation's setting: a simulated cattle car of the type used to transport victims to the gas chambers. Viewers are seated on its tight benches to view the work. They can add their names and remarks to those on the walls. Marton says: "I make work that asks questions more than it resolves questions. I hope to create a thick air of dialogue on the walls. . . . lets talk about it. I try to blow on the cinders that are burning so we can see the flames." (*Courtesy Pier Marton*)

experienced camera person. Zieman advised me not to use my budget to rent an expensive camera, but to save the money for postproduction. . . . [He said to] use my own single-tube camera, push it to the limits and take advantage of that single tube, knowing it can't give realism. A lot of what looks like special effects in Faust were actually done in the camera."[31] *Faust* is a layered, highly structured three-part work which uses its centuries-old theme simply as a touchstone in an evocation of a free-floating memory and a shifting dream of loss and change in the contemporary world. Zieman worked closely with the artist during the entire project by getting to know her ideas and footage and suggesting some of the final editing process. Birnbaum's multichannel installation was exhibited at the Whitney Biennial.

The Computer as Decisive Editing Controller

Computer-controlled video editing allows for freer decision-making and for a different set of conceptualizing strategies which lead to a completely new vocab-

ulary of image/motion/sound. The graphically represented Edit Decision List is somewhat analogous to a musical score, for it represents the entire composition as a whole as it will unfold in time. Thus, conceptualization of a work can even be predetermined via the Edit Decision List and approached holistically from many aspects—so that idea, image, and sound become an organic unity like a music composition before orchestral detail is determined. Added to this, the entire composition may be fed into the computer before any of it is edited.

Developed in 1974, the first viable computer-controlled editing system, the CMX, provided the equivalent of cinematic "sprocket holes" for video, and created the first opportunity for the editing of the original onto another tape and for re-recording the signal. However, basic optical techniques typical of film (such as slow motion control) could not be accomplished in video until the one-inch helical Video Tape Recorder (VTR) was introduced in 1978, when both the order and duration of motion sequences in video could be controlled by the logic of the computer as an addressable time code. Different from the tedious technique of

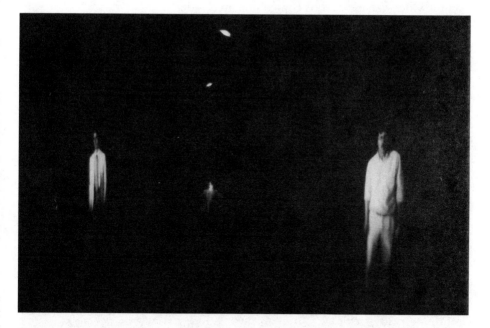

Figure 89. Gary Hill, *Tall Ships*, Multimedia Installation, 1992. Sixteen modified 4″ black and white monitors with projection lenses, sixteen laserdisk players, computer with sixteen RS 232 control ports. Hill's art is about making technology into an instrument of poetic inquiry in order to retrieve a sense of self and memory. He has often positioned cameras on his own body as he moves about in a natural setting. In *Tall Ships*, Hill constructed a magical environment where the viewer traverses a long corridor where apparitions of bodies seem to hover, approaching and receding in the dim light. Their silence and the gestures of their presence suggest isolation and deep longing for contact. Engaged by each of the phantasms, the viewer is pulled into a shared knowledge of the need for communication. (*Courtesy The Donald Young Gallery. Photo: Dirk Bleicker*)

hand-splicing film and audio mixing on an added soundtrack, video editing involves transfer of electronic image signal and sound to an auxiliary tape where it is assembled, viewed, and played back on a different tape. Electronic push-button controls are used instead of the slow hand work in splicing the original film and processing it. Multiple video signal transfers can result in loss of image quality. But advances in computer-assisted video technology have made possible far more accurate, less costly editing procedures than in film, while retaining quality.

Video previewing[32] techniques to assist in shooting, and computer-controlled editing are now regarded as indispensable by large numbers of leading filmmakers, including Francis Coppola, Jean-Luc Godard, and George Lucas. For example, unedited film footage is scanned by a video camera and etched by lasers into videodisks. In seconds, frames or sequences of frames can be located and flashed onto the preview monitor. Sequences are electronically marked and stored on a computer. When insertion is required, the editor calls back images needed and adds them to image footage already compiled. The computer list of marked frames is then turned over to a film lab where the actual film, rather than the video version of it, is copied in edited order.

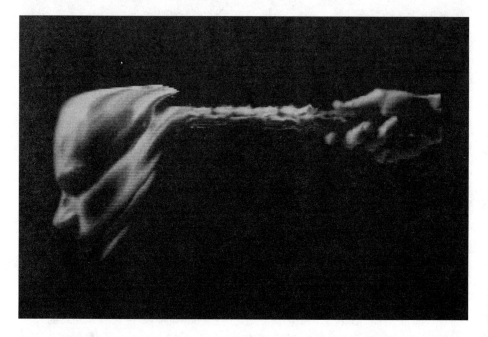

Figure 90. John Sturgeon *Inside Out,* 1991. Single channel video. This work focuses on concepts of the boundaries of self and of consciousness. It is the result of Sturgeon's personal research into the dream process. He combines studio sketches, performance, and poetic monologues with vivid camera-verité sequences videotaped on location in Uruguay. Computer-graphic technologies such as the Fairlight CVI, and the Amiga with Digi-View camera interface play an overall important role in the production process. *(Courtesy John Sturgeon)*

Figure 91. Lewis Klahr, *The Pharaohs Belt (The Cake Excerpt)*, 1993. Steeped in the iconography of pop culture, Klahr's video animations seem to capture the collective dreams of contemporary society in hieroglyphic form. Through a system of collage arrangements, he divests consumer images of their usual association by recontextualizing them, creating dreamlike scenarios. In one of these, a pyjama-clad boy can be seen cushioned inside the sugary hollow of a large cake both sheltered by its sweetness, yet drowning in its richness. A voyage of childhood liberation from the maternal takes place through a drama of adolescent conflict with desire. *(Courtesy Lewis Klahr)*

The aesthetic potential of this approach, where sound and image are both recorded and addressable as electronic signals and digital information in the data space of the computer, has now been realized with AVID, a new digital editing software which has emerged as a major advance. Some artists note that using a nonlinear editing system like AVID, is like "drawing with video." However, the handling of large amounts of digitized information for both complex sound and image formulations require expensive computational power and long hours of digital "rendering." Important research on image compression is under-

way which will simplify and speed up the process. Access to this technology is thus still out of reach for most artists except through outside funding, fresh training, or the intermediacy of a professional AVID editor.

The Future of Video Is Interactive

Early in 1996, the FCC announced the establishment of a new HDTV national transmission standard replacing the older analog technology (NTSC) after determining that systems using digital transmissions are superior. Digital TV sets will incorporate decoders for translating digital television broadcasts, much like set-top cable boxes that are now used to provide cable services. HDTV will provide viewers with dazzlingly clear wide-screen TV pictures and CD quality sound (see note 25). Existing services will switch to a single international transmission standard. This change represents a tremendous advance in TV technology allowing broadcasters to deliver not only HDTV, but (alternatively) multiple (low resolution) programs and spin-off data services. Transition to the new service will be gradual, allowing viewers to retain their old analog sets for a number of years. To accomodate the change-over, the FCC is lending a second channel in the limited broadcast spectrum to each TV broadcaster in order to facilitate the development of interactive digital TV programming and services. Following the trial time period, this second channel will revert to the FCC's control. Digital transmission will permit a more efficient use of the broadcast spectrum because it permits the use of very powerful data compression algorithms resulting in narrower bandwidths notwithstanding the increased data flows in HDTV. Many new services are being developed and "establishing presence" on the Internet in preparation for the extensive changes which are anticipated.

With these changes, we are witnessing the final conversion of video analog technology to the digital sphere. The rate of technological change through the convergence of telecommunications with the computer (chapter 5) has now become very great and is happening with such speed that it is difficult to comprehend and predict all of its consequences.

In a purely technical sense, the history of video as a medium can be seen as a history of its gradual convergence with the mediums of film and the computer by offering further control over optical effects, motion, and time; improved audiovisual storage, editing, image resolution and compression; and finally, projection possibilities on the scale of theater events.

A More Public Discourse

Use of compressed, intensified images and messages characterize the shift to diversity and postmodern pluralism. Instead of dealing with the specific, video artists are appropriating "found styles" and formats from mass culture—replete

with their widely known and understood cultural references and meanings—to create new "structures of meaning" by quoting from well-known media sources. This direction is opening toward open engagement with influences from the medium of television itself in the contemporary movement towards trying to establish a more active dialogue within mass culture as a whole. As yet, although video is a "mass-media" tool, the projects most artists have produced with it are still not mass audience works, many of them are still conceptually formal with personal vision a major aspect of the expression rather than an attempt to communicate with a mass public. However, a major aesthetic impetus is, for many, to comment on the influence of mass media by reacting to it, quoting from it, and seeing everything in relation to its perspectives.

The New York Video Festival now parallels in importance the annual New York Film Festival. In a review of the 1994 festival, the *New York Times* critic proclaimed that video is a more intimate medium than film, its small low-light camera can be less formal, thus less conspicuous, more body oriented. It allows the videomaker greater voice in production control because it requires less collaboration. Miniaturized camcorders with complex capabilities are now standard consumer items. With a sophisticated public now accustomed to choosing from a wide variety of TV, film and video materials, and with Video Festivals aimed at a larger mass audience, video has reached a dramatic new stage. Artists are also producing expanded video installations for major museums such as the Museum of Modern Art, The Whitney Museum of American Art, and The Guggenheim, as well as for inclusion in international festivals such as Documenta and the Venice Biennale. Art critic Arthur Danto titled a recent review about Bill Viola's work: "Art Goes Video."

5

Art in the Age of Digital Simulation

The computer represents the end of Renaissance space in art—the demise of Euclidean geometry . . . Digitization represents the new world order, the transition from simulacra to simulation, from copying to modeling . . .
—*Andrew Menard*

"The computer . . . begins to assimilate representation itself . . . video, film, and principally photography are being challenged to hold their authority against visual modelling systems that are emerging which eclipse their forms. . . . As representation and technology converge, a crisis emerges."
—*Timothy Druckrey*

Computers Represent a Challenge to Conventional Notions of Visual Representation

Until recently, images have been created through acts of human perception either through skills based in eye/hand coordination or through photocopying processes of media tools such as photography, cinematic film, or video, where what is seen is recorded through various chemical or electronic processes as an immediate copy of reality. However, the computer reads electronically scanned aspects of reality as information about light structures, storing this numerical information in its data base which can eventually be programmed to appear as visual imagery.

Computers greatly accelerate the process of mathematical abstraction in the visual arts. Digital images simulate the real by mathematically modeling it rather than imitating it through a copying process. Simulations cannot be considered as "simulacra" or copies, for there is no point in regarding digital information models as simple fakes or reproductions. They can generate any kind of imagery or any kind of "reality." Although the Cubists and Constructivists challenged classical notions of linear space, they retained the line, the plane, the forms so characteristic of Euclidean geometry with the body still the measure underlying the structure. Within the logical world of computers where number, not shape or volume defines geometric space, nature and the body as we know them do not exist.

Although a digital image looks like its photographic counterpart, it is very different from the light sensitized granules of film or the variation of light intensities in video. A digitized image is composed of discrete elements called pixels each having assigned precise numerical values, which determine horizontal and vertical location value as well as a specific gray-scale or color intensity

range. Such a structure of pixels is controllable through a series of enormously complex effects.

> A digital image does not represent an optical trace such as a photograph but provides a logical model of visual experience. In other words, it describes not the phenomenon of perception, but rather the physical laws that govern it, manifesting a sequence of numbers stored in computer memory. Its structure is one of language: logical procedures or algorithms through which data is orchestrated into visual form.[1]

A digital photographic image is then, a representation made through logical, numeric based mathematical language structures achieved through encoding information about the lights, darks, and colors of reality captured and digi-

Figure 92. Keith Haring, *Untitled*, 1984. Acrylic on canvas, 5' × 5'. (*Courtesy the Keith Haring Estate and the Paul Maenz Gallery, Köln, Photo: Ivan Dalla Tana*)

Figure 93. Joseph Nechvatal, *The Informed Man*, 1986. Computer/robotic—assisted Scanamural (acrylic on canvas), 82″ × 116″. In making the decision to enlarge his image to epic proportions using the Scanamural process, Nechvatal wanted to make a specific point in reference to *The Informed Man*, a painting produced electronically that is composed of degraded information patterns. The airbrush guns that reproduce the image are guided by computer-driven robotic arms fed with information derived from scanning the original artwork (as a small transparency) and enlarging it to 82″ × 116″ onto a canvas support. (*Collection: Dannheisser Foundation; Courtesy Brooke Alexander, New York; Photo: Ivan Dalla Tara*)

tized through any kind of lens or scanning procedure. The computer reads electronically scanned (digital) information about a scene and transforms it into numerical data which can be made visible as imagery. Once an image's structure of lights and darks, its "information" has been digitized by the computer into its numerical data space, its picture elements or pixels can be controlled individually. They can be altered, manipulated, weighted, warped, or repositioned to create not only a simulation of a photograph, but also an artificial or parallel "virtual" reality.[2]

Seeing Is No Longer Believing

Photographs were once recognized as the epitome of truth. A photograph is actually, of course, an illusion of the "true." It is through photography that many artists have examined questions of originality and authenticity. Now a photograph's information can be processed or changed by manipulating or warping its structural light components in the computer to create images that are complete simulations. The computer's artificial simulations of reality are indistinguishable

in appearance from photographs. The capability to invade images and create invisible alterations to photographs, thereby undermining their accepted "truth," authority, and authenticity through a seamless process of retouching and editing is a destabilization of the image. It is creating a crisis of belief which has political implications. We can no longer rely on the old system of "truth in images." For example, during the Gulf War, a photograph of Iraqi dictator Saddam Hussein, seamlessly manipulated on the computer so that his mustache was made to resemble Hitler's, was produced as wall posters for the city streets.

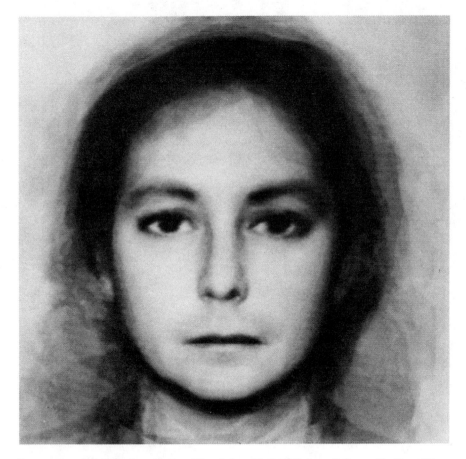

Figure 94. Nancy Burson with David Kramlich and Richard Carling, *Androgyny (Six Men and Six Women)*, 1982. Simulated photograph, 8″ × 10″. In this composite image, the portraits of six men and six women have been scanned into the computer and fused into one simulated portrait. The work suggests the tension and fascination of "face value"—that is, whether male or female characteristics predominate in a face. Yet, information simulation resonates with the impossible, revealing what refers to nothing, a ghostlike personality without real substance and history. Burson taps an important Postmodern vein in her subject matter and in her use of information as simulation. *(Courtesy Nancy Burson)*

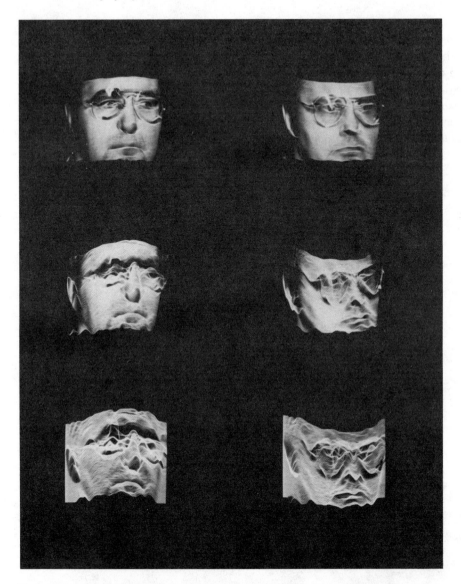

Figure 95. Woody Vasulka, *Number 6*, computer manipulated images, ca. 1982. These visual investigations make use of the process of scanning or digitizing the information about lights and darks into the computer. The information is then altered by a scan processer, an analog device, or other image-processing equipment. Vasulka has played a pioneering role in developing such image-processing tools. (*Courtesy Woody Vasulka*)

Writing in the catalog for the *Infotainment* exhibition, George Trow writes:

No wonder art has had another nervous breakdown: the invented image had been its specialty, its raison d'être ever since photography took over "lifelike rendering" more

than a century ago. Indeed, art's current crisis is analogous to that which occurred when photography was introduced, only now the crisis in art. . . . has finally reached vision itself. The discovery that seeing is no longer believing is not so frightening when you consider that truth itself can only be leased.[3]

Global Vision

Operating independently of the body's visual senses, the computer has subsumed all of visualization within the realm of mathematics. Paradoxically, the computer's capacity to "see mathematically" is helping us to see more completely than we can with the human eye alone. Vast amounts of visual information about a particular subject or scene can be encoded via a computer-controlled video disk as a visual data base. For example, a landscape view could comprise sequences of satellite photos which first show aerial views of a coastline, and compare them with multiple views of other coastlines hundreds of miles apart, then closer portions of the region. Distant views of New York City, and of Philadelphia can be compared in detail through closer views of their street patterns, and finally through isolation of individual buildings, with a tour of their rooms. The computer can sort out in a complex way the ordered structure of programs stored in its data base as coded information for later retrieval and display on command. Bill Viola, video artist, referred to the phenomenon:

> What fascinated me was that the progression was not a zoom or a blow-up. It's not as though they used four different lenses and made four different pictures. All the buildings in the close-up existed already in the global view because it's actually a computer data base and they're in the information so the image doesn't lose detail or become grainy when it's enlarged because it's computer enhanced. That's not zooming. You determine the scale of what you're seeing by processing information that's already there. Everything is encoded into the system and as a viewer or producer you just determine what part you're revealing.[4]

This new computer-enhanced, expanded "global information" vision, where a particular image or sequence of images can be called at will from the data bank, goes far beyond conventional photography to an area being termed digital image processing.

The New Alphabet: Sound, Text, and Image as Digital Information

Because the computer, with its new digital alphabet is capable of encompassing all aspects of information—sound, image, text within a single data base—a new fusion of disciplines is underway which will affect the way knowledge is acquired and created. The universality of the computer as a tool for working in the humanities, the sciences and the arts is creating interesting inter-

disciplinary effects whose promise we are only beginning to fathom. Scientists are now using visual images as a way of verifying visually, their research experiments for example, in meteorology and geology. Writers incorporate sound and visuals in their texts. Artists are accessing sound, text, and image in their multimedia productions.

Digital technologies have become the catalyst for tendencies in the convergence of disciplines, for the universal computer is both a tool *and* a medium. The new cognitive linkages and means of production are creating fresh relationships between fields of knowledge and understanding. These represent a major shift in the paradigm of representation, one that goes beyond the crisis described by Walter Benjamin when he referred to the edited, moving grammars of film as a shattering of tradition. Photographic technologies acted as the underlying structure for the evolution of nineteenth and twentieth century visual culture. However digitization has superseded and subsumed them, in a completely new paradigm for representation.

Simulation: Virtual or Hyper Reality

As we have seen, simulacra refers to a copy of a copy of the real. We can call a Photo Realist painting a simulacra because it was a painted copy of a photograph, which was itself inherently, a copy of the real. Through mechanical reproduction copies of copies of the original circulate in the culture in a way that changes their meaning. However, simulation refers to the creation of fundamental models which appear to be perfectly natural or real, but in reality have only been made to appear through the agency of programmed digital information. The simulation is thus a system of computerized mathematical instructions which can be made to imitate or approximate a kind of reality we can term *virtual* because it does not in fact have an existence as an object nor is it a copy of the object in the sense that it is a photographic trace of it. Simulation is a mathematical model of the real, a new kind of representation.

Electronic image production is immaterial, existing only as an image structure or accumulation of data, without physical substance. It does not lead necessarily to the production of a material art object unless the artist makes a conscious decision to translate it into one that can maintain a physical presence with a particular dimensional level within a perceptual field.

Virtual reality is virtual precisely because it is both abstract and real. The remarkable nature of simulation is that there are no limits to what can be realistically represented. However, the new virtual reality, three-dimensional environments, are only structures of human knowledge. They are the sum of our human knowledge about any one subject such as a bird or a human body. We can create models of objects and animate them to move around in virtual space using ultrasophisticated programming and millions of polygons.

French philosopher/critic Jean Baudrillard described simulation as follows:

Generation by models of a real without origin or reality: a hyperreal . . . The real is produced from miniaturized units, from matrices, memory bank, and command models—and with these it can be reproduced an indefinite number of times. It no longer has to be rational, since it is no longer measured against some ideal or negative instance. It is nothing more than operational. In fact, since it is no longer enveloped by an imaginary, it is no longer real at all. It is hyperreal—the product of an irradiating synthesis of combinatory models in hyperspace without atmosphere.[5]

The Platonic dilemma is that art can never transcend artifice. Anything that is represented as reality, even one's image in a mirror, or a photograph, is understood as a fake, a copy. This is a classical position which still informs the postmodern debate about aura, the copy and the original. Art critic Andrew Menard comments: "The transition from simulacra to simulation, from copying to modeling"[6] brings into conflict the philosophical boundaries presented by Plato's questioning of the relationship between appearance and reality with that of Aristotle. Copies (e.g., photographs or copies of copies—simulacra) are encompassed within Plato's debate about art where "even the best imitation of nature is a fake" and that appearance can never merge with reality. However, Aristotle's philosophical position is that art is *supposed* to imitate reality. Plato's understanding is illustrated in the myth of Pygmalion who sculpted a perfect copy of a female form (Galatea) so cleverly that his art concealed its artfulness and he fell in love with his own copy of reality—until the imitation was brought to life by Aphrodite—proving that art can never merge with reality.

Aristotle's outlook could be more relevant for us in our exploration of changes in representation brought about by technological means. In his view, "art isn't a question of authenticity, but of precision—the exactness of the imitation, its verisimilitude. What for Plato was a crisis of knowledge, is for Aristotle a technical problem. Authenticity depends on the quality or essence of imitation, on the virtuosity of artifice. Art = Artifice."[7] Menard stresses the point that even if we are never able to resolve the opposition between real and fake, copy and model, technical developments now take us into a territory where a parallel reality exists—one that resides within reality—where the perfection of mathematical modeling creates a reality which has been called *virtual reality.*

Information as Simulation: Living with Abstraction

Indicative of the change in the times is the fact that the curator of the "Les Immatériaux" exhibition at Paris's Centre Georges Pompidou,[8] was Jean-François Lyotard. One of the foremost theoreticians of Postmodernism, he used the exhibition to provoke questions about contemporary states of simulation,

artificiality and synthetic "nonbeing" which grow out of the instabilities and changes inherent in postindustrial society. The primacy of the manufactured object has been dissolved into other states of energy (or microelements) rather than into concrete matter: a "disappearance of the object" in favor of its artificial or virtual facsimile. The exhibition space, designed as a labyrinthian tour of "sites" or hanging islands, each with a separate theme, interpreted and defined many of the major features of Postmodernity as a new moment in culture. It offered a significant perspective on how the terms of our cultural conditions and their relation to historical and philosophical issues have brought about a crisis of outlook in the late twentieth century. "A series of key themes was brought forth and reiterated: the primacy of the model over the real, and of the conceived over the perceived. That we live in a world in which the relation between reality and representation is inverted was made clear by countless examples. Much attention was paid to the copy, to simulation, and to the artificiality of our culture. In fact, "Les Immatériaux" suggested nothing so much as our common fate in living with abstractions.[9] For example, completely artificial flavorings, fragrances, experiences are an inversion of former experience of "the real thing" as part of new but artificial states. The exhibition's dramatically lit theatrical spaces, where suspended objects and images loomed out of the darkness, demonstrated the already pervasive artificiality of our present existence— for example, *Site of Simulated Aroma, Site of All the Copies, Site of the Shadow of Shadows, Site of the Indiscernables, Site of the Undiscoverable Surface.*

Lyotard comments on this major change in the relations between the Modern concept of mastery and production as opposed to the Postmodern:

> Whereas mechanical servants hitherto rendered services which were essentially "physical, automatons generated by computer science and electronics can now carry out mental operations. Various activities of the mind have consequently been mastered. . . . But in so doing . . . the new technology forces this project to reflect on itself. . . . It shows that man's mind, in its turn, is also part of the "matter" it intends to master; that . . . matter can be organized in machines which, in comparison, may have the edge on the mind. Between mind and matter the relation is no longer one between an intelligent subject with a will of its own and an inert object.[10]

The Postmodern self is distracted and atomized into multiple heterogeneous domains sheared away from conscious life.

The Computer as a Dynamic *Interactive* Partner

Possibilities for change in the relationship between the viewer and the art work has been affected by increasingly sophisticated interactive systems for controlling artworks which are capable of responding to viewers' commands. The viewer must choose between the options to receive a single message from the many. Electronic nonsequential viewing has affected how art is produced and

Figure 96. Craig Hickman, *Signal to Noise #1*, 1988. Computer drawing. *Signal to Noise* is not a sequential book, designed to be read cover to cover, but rather one whose structure is more like music. Tuning in signals makes for a kind of "cultural stew" of different mixtures of music, noises, whistles, and overlapping sound distortions join and superimpose themselves. His interest in short wave radio led him to be fascinated in the space between receiving a signal (or message) and its bleeding out of focus to mere noise. The book explores three kinds of messages and plays with the system used to decode them. (*Courtesy Craig Hickman*)

how it is accessed by the viewer. It calls for a new way of viewing based on visual icons or touching devices and time blocks. Electronic media promotes perspectives on aesthetic experience as well as on artistic production because it changes the experience of art-making and ultimately the nature of what is seen.

Creation is dependent on collaboration between the intelligent system designed by the artist and the actions of the participant which trigger causal

relationships. The computer then perceives and interprets incoming information from the viewer and responds intelligently. Another type of interactivity is environmental—where the viewer's presence is monitored and sets up a pattern of interference triggering different aspects of a computer programmed display of lights or shapes which may appear on a large screen.

Interactive viewing is completely different from linear activity. For example, a painter's outlook on reality is from a natural totally linear distance while a film-maker penetrates reality through multiple fragments of it, edited together to make a new whole seen at a different speed, with added sound. Interactive multimedia work permits creation of a new kind of viewing which may take the form of an interactive accessing of picture elements in a synthesis of animation and sound. In effect, watching television provides an everyday interactive experience: Imagine TV as a web of image blocks from which we draw our own meanings while we choose our way through the day's programming choices.

"Hypertext," first referred to by Theodore H. Nelson in the 1960s as "nonsequential writing as a text that branches and allows choices to the reader" has come to mean an informational medium where blocks of texts are linked electronically. However, *Hypermedia* extends the original concept of hypertext by encompassing in the work other forms of information such as visuals, sound, and animation. The new technologies are changing the nature of what is seen and what is read.

Interactive CD-ROM multimedia works typically link blocks of images and electronic functions to each other or to other video segments mixed with still images, animations and sound. These can then be manipulated and rearranged at the viewer's command. A computer provides the possibility for interaction by allowing for the branching out of visual or textual material to present choices to the viewer through a series of document blocks linked to different pathways. The computer creates interconnected webs of information. It is able to link various kind of image files and other types of documents, network them and create paths and nodes to connect them.

The words "link," "node," "path," "network," used by Roland Barthes in his 1970 essay in *S/Z* have become literalized in the actual functioning of the digital medium itself.

> In the ideal work, the networks are many and interact, without any one of them being able to surpass the rest . . . it has no beginning; it is reversible; we gain access to it by several entrances, none of which can be authoritatively declared to be the main one; the codes it mobilizes extend as far as the eye can reach, they are indeterminable . . . the systems of meaning can take over this absolutely plural text, but their number is never closed, based as it is on the infinity of language.[11]

Implications of Interactivity for the Artist

Interactive implies that the viewer has the power to be an active participant in the unfolding of a work's flow of events and influencing or modifying its form.

An interactive multimedia work is one which allows some choice in moving through combinations of text, sound and still or motion images. It is a flexible, nonlinear interactive system or structure, one designed and coded with linking capabilities which allow the viewer to make choices in moving along different paths through the work. It is a system-based approach to creating work which has viewer participation as a primary aspect built into it.

Interactivity deeply entwines the functions of viewer and artist. In so doing, the artist's role changes. This convergence transforms what had been two very different identities of artist and viewer. What interactive art now solicits from the viewer is not simply reception, but an independent construction of meaning. In interactively participating, the viewer derives power nearly parallel with that of the artist: to choose one's own path and discover one's own insights through the interactive work.

Artists, in designing a collaborative piece meant for interaction, place themselves outside their traditional roles vis-à-vis the viewer. For the artist, this can contribute to the loss of the self and of the single voice in favor of a democratic, collaborative dialogue. The artist now becomes an agent who does not create specific images, but instead, creates novel processes for generating new images and experiences.

In a 1994 article "The Aesthetics and Practice of Designing Interface Computer Events,"[12] Stephen Wilson discusses the relationship of traditional cultural forms to interactivity. There are some aspects of interactivity inherently present in traditional cultural forms because they must be accessed through close viewer attention. A book is the cultural form which allows for the ultimate in rapid, easy access to all its pages, without the immediate presence of the technology that reproduced it. VCRs have fast-forward and reverse capabilities in accessing movies or other video materials. There is a level of emotional engagement and internal viewer adjustments/identification which forms part of most art forms including theater and music events. Most successful art is psychologically interactive. Critics of interactive artworks claim there is too much disruption in the viewer's focus of concentration. Its defenders claim that the richness and opportunity to explore more differentiated aspects of a discreet work make it a potentially revolutionary form which will force change in how we see and understand.

However, interactive media have special qualities. They avoid the linear sequencing of a film or novel. They allow instead a less linear choice system structured into the work which is designed to function only through viewer action. The viewer will only be able to understand the work's meaning or its conceptual structure by exploring the many layers and margins which form the context of the piece. Information about parallel related texts or images can be accessed in the data space of the work and brought onto the screen for review.

Up to now, artworks have always been shaped by visual artists, poets, writers, composers, choreographers, who assumed the total responsibility,

opportunity and challenge of creating their own discreet work without invasion of the work from outside participation. They had to decide on content, format, style, sequence, materials, medium. However, with interactivity, readers, viewers, listeners can pass through the boundaries of the work to enter it. This puts them in a position to gain direct access to an aspect of authoring and shaping the final outcome of a work in a way that never before existed before the advent of the computer. The viewer has a position of power in the work which one never had before. The artist gives up total control in favor of a new kind of viewer communication and experience, one which offers a less passive position for the viewer, one which also celebrates the inherent creative capacities of all individuals. Interactivity offers important new avenues to cognition to take place, where works can begin to flow with the more psychological internal associations of the individual viewer's make-up and identity in mind.

This fundamental change in the relationship between the artist, the artwork, and the public creates new potential for change in the arts and for expansion into new territory. Although, as we have seen, there has always been a continuing questioning and refusal of the boundaries of traditional forms in the evolution of art, interactivity as a new aspect of representation is different from the earliest attempts to include in their work some aspects of audience response by the Dadaists, Constructivists, Fluxus, and Conceptual movements when they invented new forms such as performance, free-form installation, and diverse kinds of theater events (see Chapters 2, 3, 4, and 6).

In order to understand how far we have come in relation to the profound crisis in representation brought about by digitization, interactivity, and simulation, it is important to review the brief history of how the computer has impacted the visual arts. Such a perspective can put into context the major issues and technical developments that have led to this major break in the visual field.

An Interface for High Speed Visual Thinking

In his historic May 1969 *Artforum* article "Computer Sculpture: Six Levels of Cybernetics,"[13] sculptor Robert Mallary analyzed the benefits of the computer as a tool for "high-speed visual thinking" in art-making. His prophetic understandings grew out of research into the possibilities for kinetic sculpture and optics at the end of the sixties, although developments in computer science were still in their infancy and few artists were able to gain access to computer labs to experiment and innovate. He grouped computer functions into two major categories: as a means of calculation (tools), and as an optimum creative interface between artist and machine (medium). In the first grouping, the computer performs calculating chores to specify articulation of color and form, sorting out visual data on receding planes of objects in space. It adds randomness to a structured idea to test variable solutions and new proposals where speed and precision lessen the need for tedious work, thus making possible a new level of

interactive decision making. The relationship between artist and computer can be symbiotic—for each depends on the other, and both do together what neither could do alone. However, this relationship may not always be advantageous and at every step, the artist may need to veto and monopolize the decision-making process, accepting, rejecting, and modifying while prodding and coaching the machine in the right direction. Another aspect of calculation functions can lie in the area of programming the computer to move in a set way over a prescribed route according to a scenario of set commands that contain guidelines and criteria designed by the artist for making tests and permutations on an existing idea. Such research can be stored for future reference and further decision making.

In the second context of artist-machine interaction, the computer begins to make decisions and generate productions even the artist cannot anticipate. At this level, all the contingencies have not been defined in advance. In fact, the program itself manufactures contingencies and instabilities and then proceeds to resolve unpredictable productions, not only out of random interventions (which dislocate and violate the structured features of the program) but out of the total character of the system itself, modifying and elaborating its own program. At this stage, there can be a redefinition of relationship between artist and machine—where the computer is alternatively slave, collaborator, or surrogate. The artist operates the machine, monitors it, or leaves it to its own resources. "He is active and passive; creator and consumer; participant and spectator; artist and critic." The computer can check against past performances of consensus criteria stored in its program file, for the heuristic[14] program embodies its artist's preferences. At this optimum creative level, the true synergistic potential of the artist-machine relationship can be achieved.

A broad range of both European and North American sculptors interested in kinetics were particularly drawn to the computer both as an influence and as a tool. This group, which included Nicholas Schöffer, Nicholas Negroponte, James Seawright, Aldo Tambellini, Takis, and Otto Piene, used the computer to control and move their constructions. Some artists sought collaboration with scientists or engineers. In some cases the enthusiasm for "technoscience" made too little distinction for art between artistic imagination, scientific innovation, and technological experimentation.

Early Years of Computing Images

Since computers had been developed originally[15] for solving scientific and engineering problems, it is not surprising that their use for producing digital sound and textual and visual images was initially limited only to those scientists who had access to the cumbersome mainframe machines located in remote air-conditioned settings in university research labs. Because music and texts represent

coded information, it was possible to program these into computer language as early as 1955. Composers such as Lejaren Hiller, Iannis Xenakis, and Herbert Brun, working out of university labs, used the computer as a compositional tool. These early experiments opened the way for later extensive development of computer synthesizers as the popular musical instrument in use today.

By 1965, computer research into the simulation of visual phenomena had reached an important level, particularly at the Bell Labs in Murray Hill, New Jersey. Here the pioneer work of Bela Julesz, A. Michael Noll, Manfred Schroeder, Ken Knowlton, Leon Harmon, Frank Sinden, and E. E. Zajec led them to understand the computer's possibilities for visual representation and for art. That same year Noll and Julesz exhibited the results of their experiments at the Howard Wise Gallery, New York, concurrent with Georg Nees and Frieder Nake's exhibition of digital images at Galerie Niedlich, Stuttgart, Germany. Research in Germany at the Stuttgart Technische Universität was conducted under the influence of the philosopher Max Bense, who coined the terms "artificial art" and "generative aesthetics," terms which grew out of his interest in the mathematics of aesthetics.

Some of the earliest computer experiments related to art included the ones by A. Michael Noll in which he simulated existing paintings by Piet Mondrian and Bridget Riley in an effort to study existing style and composition in art. In approximating the Mondrian painting *Composition with Lines*, Noll created a digital version[16] with pseudorandom numbers.

An Artists' Tool Programmed by Artists

Although computer graphics research was, by the late sixties, being conducted internationally in the highly industrialized countries, Mallary was one of the few artists who had access to equipment or were trained in the specialized programming needed at that time to gain control over the machine for their work. However, they saw the computer as a means of researching their visual ideas and sought the collaboration of computer scientists and engineers as programmers.

Ken Knowlton, in his essay "Collaborations with Artists—A Programmer's Reflections," points to important differences in temperament and attitude between artists and programmers as a major difficulty. He describes artists as "perceptive, sensitive, impulsive, intuitive, alogical," and often unable to say "why" they do things; whereas, programmers are "logical, inhibited, cautious, restrained, defensive, methodical ritualists" with layers of logical defenses which helps them to arrive at "why." Although these antitypes are obviously stereotypical, they illustrate the difficulty of finding in one person all the qualities which created that hybrid breed—an artist-programmer.

By the early seventies, a new generation of artists began to emerge who were able to retain their intuition and sensitivity while exercising a logical, methodical approach to work. For example, artist Manfred Mohr (self-taught in computer science) and Duane Palyka (with degrees in both fine arts and mathematics) began to

program their own software as a result of frustration with existing programs and systems which did not serve their creative needs. "Hybrid" artists have since made important contributions to the field of visual simulation. Some have custom-designed paint systems and video interfaces for interactive graphics as well as working with robotics in sculpture. Following development of powerful new microprocessing chips, their work was simplified by the advent of microcomputer turnkey systems which freed them at last from large mainframe support.

By the midseventies, important advances in technology opened possibilities for the computer to become a truly personal tool for artists. The invention of the microprocessor and more powerful miniaturized transistor chips, (integrated circuits), changed the size, price, and accessibility of computers dramatically. Commercial applications in design, television advertising, and special image-processing effects in film and photography became an overnight billion dollar industry, providing the impetus for incredibly powerful image-generating systems.

The need for intimate collaboration between scientists and engineers with artists was no longer so essential, for custom "paint system software" and "image

Figure 97. James Seawright, *Houseplants,* 1983. Microcomputer-controlled kinetic sculpture, 2″ H × 5″ D. *Houseplants* is an interactive computer-controlled sculpture that can respond to changes in environmental light levels or follow preprogrammed patterns of movement. The "plants" open to reveal their LED studded "leaves," and the flip disks on the domed plant click open and shut creating a whirring sound. Seawright has been producing interactive works since the early seventies. (*Courtesy James Seawright; Photo: Ralph Gabriner*)

Figure 98. Manfred Mohr, *P-159/A*, 1973. Plotter drawing (ink on paper), 24″ × 24″. Mohr's intense and imaginative investigations of the cube and its spatial relations have for many years been carried out through programming the computer and printing the results of his work using a plotter on paper or canvas. There is a rigorous, philosophic, aesthetic, and mathematical structure to which all of his work refers in its countless transformations and variations. In this early minimalist work, the process is revealed as Mohr uses the set of twelve straight lines required to create a cube in two dimensions. The cube's repertoire of twelve lines are assigned numerical values in order to unleash a compelling scheme of line arrangements, suggesting a form of movement and harmony. Mohr is a hybrid artist, at ease with both programming and visual innovation. (*Courtesy Manfred Mohr*)

synthesizers" began to appear on the market. Programmed and developed by "hybrids" such as John Dunn (Easel, or Lumena Paint software), Dan Sandin (Z-Grass, a digital image-processor), and Woody Vasulka (Digital Image Articulator), out of their own imperatives as artists, new interface software for the computer provides easy access to two-dimensional and three-dimensional image processing in combination with animation and video. As a result, artists may now come to the computer with their visual arts training intact, without

Figure 99. Mark Wilson, *NACL 17(C)*, 1986. Plotter drawing, acrylic on canvas, 44" × 84". Like Mohr, Wilson programs his own images and has experimented with different surfaces such as paper and canvas, and with materials, ink, and paint as part of the output aspects of his work. Plotters are capable of executing intricate detail in multiple colors. Pens can be easily changed in the apparatus. (*Courtesy Mark Wilson*)

the need to learn programming (in the same way that using a modern camera does not require full knowledge of optics). Learning to use a contemporary turnkey system with contemporary software is now comparable to a semester's course in lithography. However, programming is essential to any pioneering of new use of equipment. This need has continued to lead many artists, especially those interested in interactive applications, to collaborate with engineers or scientists or to study computer sciences for themselves.

Computer Exhibitions Launched in the Spirit of Modernism

The use of computers for art grew out of existing formalist art practices, especially with regard to Minimalist; Neoconstructivist; and Conceptual tendencies. However, use of the computer for art touched a deep nerve in an artworld fearful of the use of a mechanical device like the computer for the making of art. As we have seen (Chapter 3), Hultén commented in his catalog essay for the "Machine" show, "since the computer is not capable of initiating concepts, it cannot be truly creative, it has no access to imagination, intuition and emotion." In the catalog of the 1968 London ICA exhibition "Cybernetic Serendipity," the first devoted entirely to computer applications for poetry, sound, sculpture, and graphics, curator Jasia Reichardt commented:

> Seen with all the prejudices of tradition and time, one cannot deny that the computer demonstrates a radical extension in art media and techniques. The possibilities inher-

ent in the computer as a creative tool will do little to change those idioms of art which rely primarily on the dialogue between the artist, his ideas, and the canvas. They will, however, increase the scope of art and contribute to its diversity . . . This dizzying display of technology presented a paradisical vision of the capacity of the machine, and to this day it remains one of the central projections of a technological utopia based on the notion of modernization. Underlying it was the premise of "technoscience" as a prosthetic, or aid to universal mastery; the cybernetic revolution appeared to accomplish man's aim of material transformation, of shaping the world in the image of himself. Cybernetic Serendipity was launched in the name of modernity, an ideal that, since the time of Descartes, has focused on the will and creative powers of the human subject.

Many artists used the computer as a means of programming their kinetic sculptures which emphasized interactivity between optics, light and motorized, controlled movement such as those by Thomas Shannon, Jean Dupuy, and Hilary Harris. A witty attempt to humanize the computer was Edward Kienholz's motorized *The Friendly Gray Computer.*

In the catalog essay for the 1970 exhibition "Software: Information Technology; Its Meaning for Art" at the Jewish Museum in 1970, Jack Burnham used the body-machine-controlled-by-the-mind metaphor when he quipped: "our bodies are hardware, our behavior software." Curated by Kynaston McShine, the "Information" exhibition at the Museum of Modern Art demonstrated the concept of systems analysis and its implications for art. "Information" explored groups of networks of interacting structures and channels as a functionally interrelated means of communication. The computer was a natural metaphor for this exhibition. Agnes Denes, Hans Haacke, Les Levine, and Dennis Oppenheim were among the artists who explored use of computer concepts in their works. This was one of the first exhibitions to espouse the reductive, Minimalist principles of Conceptual art where the idea is the total work (no object is produced). Information as art.

As we have seen, the hostile response of the critics to the costly 1971 "Art and Technology" exhibition at the Los Angeles County Museum was a backlash against technological "corporate art" as it was termed. The Vietnam War and its aftermath of instability signaled a rupture with Modernist philosophical ideals and optimism about the future.

In the short thirty-year history of computer use in the visual arts, the first ten years ("first wave" 1965–75) was dominated by computer scientists with easy access to equipment. In the "second wave," significantly larger numbers of artists began to gain access and realize the potential benefit for their work. Many of these were interested in kinetic and interactive aspects of the computer. In the next decade, the continuing work of many pioneer artists probed at the edge of the computer's potential, participated in developing new software tools, and made vital contributions in laying the foundation for future achievements. In the early seventies the computer was still cumbersome, outrageously costly, and with limited access for artists. It was still better used as an analytic

tool for formal Modernist conceptual works rather than as an active partner. As a result, it became stigmatized as a medium for art production and receded into the background without its potential for the arts being fully realized in the onrush of developments which now took place.

Simulation: Quest for a New Realism—Reality Is Just a Test

The effort to simulate an artificial reality that is convincingly real is being approached seriously, with missionary zeal, as a major goal by high level computer scientists who are now analyzing a way to make persuasive simulations of trees, clouds, water, reflections, transparencies, textures, shadowing. They hope to coax the perfect cloud, mountain, or shining goblet with reflections and shadows from the computer. Charles Csuri, head of Ohio State University's computer graphics group keeps a reproduction of *The Origin of Language* by Réné Magritte on his office wall. The image is of a huge rock suspended above a shimmering sea, surmounted by a soft cloud of the same size. "It reminds me of what we cannot yet do realistically—water, clouds, rock, . . . fire, smoke. These are the major problems in computer graphics now. Natural phenomena, things that change shape over time, and things that are soft."[17]

Figure 100. Otto Piene and Paul Earls, *Milwaukee Anemone*, 1978. Mixed-media sky work. The figure depicts an inflatable flying sculpture by Otto Piene with outdoor laser projections by Paul Earls on steam emissions by Joan Brigham. Computer-controlled laser drawings have been used to produce a sky opera, *Icarus*. (*Courtesy Otto Piene and Paul Earls*)

The problems that artists have always faced in creating illusion—solving problems of rendering light, form, texture, and perspective, has now fully entered the computer realm through mathematical calculation. However, reality is vastly more complex than it seems. Scientists are devoting more attention than ever before to solving problems of vision and optics, color perception, perspective; they try to interpret textures such as softness and hardness. Artificial intelligence research is also investigating speech simulation and the workings of the mind.

IBM's Watson Research Center, scientists have generated persuasive computer imitations of landscapes and clouds. More than just pretty pictures, these scenes are proof that the branch of mathematics they work with, called *fractal geometry,*[18] accurately describes the real world. They can create programs using real data that simulate the growth of what seem like real clouds, and in this way, obtain a better understanding for example of how real clouds do in fact grow.

> Nobody's quite got it yet. In every image there's something that's a little off: the vase that looks more like plastic than glass, the shadow that's too sharp-edged, the city streets that are too clean. They're all missing detail, the richness and irregularity that our eyes and brains crave. And the world of computer graphics is mostly static and rather lonely—a viewer may swoop over a seascape or whirl around bottles on a table, but no waves lap at the shore and no people sit at the table. It's all a matter of the right instructions. Computers, of course, can't do a thing without instructions. But it's hard to think up a routine of steps that automatically and randomly puts cracks in sidewalks or mimics the action of wind.[19]

A variety of simulation techniques called texture mapping, ray tracing, three-dimensional modeling, and figure animation interpolation, have grown out of this high-level research which puts mathematics at the service of the quest for the "new realism."

One of the most formidable tasks the computer can accomplish is to simulate a three-dimensional shaded model. Once all the physical measurement information about the object has been fed into the computer's data bank, the simulated object then materializes on the screen. It can then be rotated, skewed, made to zoom in and out of space in perspective, with a choice of where the light source originates. According to instructions, the computer will calculate the range of highlights and shadings which define an object (depending on the choice of light source), add appropriate shadows, and animate it in full color.

At Lucasfilm, the computer graphics team has perfected the technique called procedural modeling, in which the computer is given the general characteristics of a class of objects and then makes many such objects, each unique. For example, the computer "grew" the flowering plants from a program that "knows" how a plant grows. Grass is simulated by providing the computer with information about range for the height and angle of the blade of grass and let-

Figure 101. Christa Sommerer and Laurent Mignonneau, *A-Volve*, 1994. Multimedia Installation, (D & B). In the interactive environment of *A-Volve* viewers drawing on a monitor screen with a sensor pencil can create 3-D forms or organisms which immediately become "alive" and will seem to move in a water-filled pool nearby. Reacting to the slightest movement of the hand in the pool, the creatures will change their form and behavior. *(Courtesy Christa Sommerer and Laurent Mignonneau)*

Figure 102. Edmond Couchot, *I Sow to the Four Winds*, 1990. Couchot is fascinated by the interactive instability of the digital image which can be invaded, and is thus completely unstable, mobile, changeable. In a poetic vein, he speaks of the life-time of such an image as only a breath, one which sows the fragments broken from its surface to be borne elsewhere possibly taking on a different form. In this work, a dandelion head moves under the influence of a "virtual" breeze on-screen. When the spectator breathes on the screen, clumps of seeds detach and softly fall until there is nothing left to dislodge. A new flower eventually appears and the interactive game, always slightly different, can begin again. *(Courtesy Edmond Couchot)*

ting it draw different blades; fire is produced by telling the computer the basic characteristics of a flame and letting it do the work. "Reality is just a test, like controls in an experiment. If you can make a convincing computer picture of a silk scarf falling on a wooden table, then you can make a convincing picture of a wooden scarf falling on a silk table."[20]

The computer can sort through all the instructions and models that describe the scene: its tone, color, optical laws—factoring in all the instructions, checking and sorting out what each piece the mosaic of pixels should represent. The more powerful the computer, the more image information the computer can process at greater speed. The more complexity and resolution demanded of the computer to create more lifelike simulations with reflections, highlights, and the like, with sound and movement the more memory the computer needs to calculate the information, and the more time it will take to render it.

Computer Animation

Films and videos are now being designed for insertions of animated figures with live photographed ones in the most complex interactions of reality and fiction yet attempted. In *Hard Woman*, the Mick Jagger music videotape by Digital Productions, the aggressive line-drawn animated figure seems to be in total control of the real-life action. At Lucasfilm in California, a powerful computer graphics machine called *Pixar* has been designed to capture the essential character of real forms and textures through the programming of digital instructions designed to simulate the diminishing size of tree branches as the trunk rises from the ground. The Lucasfilm team has even been able to recreate the blur of motion that is caused by a wave striking the shore or two billiard balls colliding. Various computer programs which build in a randomness factor have been developed to make images seem more lifelike.

Apart from generating specific images, the computer can calculate in-between frame of movement between separate drawings. This is the "interpolation" technique used by animators, where the computer is issued commands to compose as many slightly different intermediate images as required in the metamorphosis of a movement from one stage to the next. Thus, the animator's task in movement simulation and color transformations is enormously facilitated by the computer.

Computer-animated films have been produced by artists since 1961. A remarkable early example is Cannes Festival prize-winner "Faim" (Hunger) made by Peter Foldes at the National Film Board of Canada in 1974. Foldes not only generated by computer the film's intermediary motion frames, but used interpolation techniques to make transitions between two different themes— images of the starved "have-nots" transposed against the greed of the "haves."

Computer-assisted animated effects now dominate commercial advertising and have been used extensively for special effects in films such as *Terminator Two*,

Jurassic Park, and *Toy Story.* Artists' use of animation "paint" effects and drawing interpolation methods, combined with special effects generators, are a growing phenomenon now that software support animation packages are widely available. Expressive three-dimensional modeling of the human face and of the figure in motion requires still more powerful computers with compression software to manipulate the immense quantity of digital information involved.

At New York University's Media Research Lab, software has been developed for an artificial intelligence environment called *IMPROV.* Its narrative mechanisms include real-time personality and behavior attributes which create interactive, live, impovisational animation where the characters decide to respond to the actions of the viewer based on their mood and personality. Their reactions are generated in real-time as 3-D color animation.

Computer-simulated graphic images or animated passages can be encoded as a video signal and inserted into a work as part of its totality. Entire video passages can be digitized and edited from the AVID software, reformulated, manipulated and again reformatted as a video signal. This provides for an unprecedented expansion of pictorial variety and texture. In the future, the computer may play a greater role than the camera in film making. Although they will have the look of photographic reality, most backgrounds and locales in Hollywood films may eventually be computer generated. The actors may be electronically keyed-in, using computer/video techniques. By the early nineties, computer animation to perfect human or animal imagery produced the first examples of three-dimensional actor-simulated, feature-length animation. Amongst many others, were: "Who Killed Roger Rabbit"; "Forrest Gump"; and "Terminator."

New Potential for the Fine Arts Creates a Quickening of Interest

Although use of the computer by artists in the last twenty-five years has until recently brought the same rebuff by critics as early reactions to photography in the nineteenth century, the wide dispersal and greater access to greatly improved equipment for a far broader group of artists and to much more "friendly" technology has created important new conditions. More and more artists are gaining access to flexible and challenging ultrapowerful computer hardware and software at lower cost, and a new aesthetic is emerging as a broader range of artists come to the instrument with visual arts training rather than from computer science.

The computer allows for rapid visualization of complex spatial concepts at a different level of conceptual decision making, as well as for ease in quickly cycling through color harmonies when making decisions about color composition. Pluralistically, applications for the computer open out important new avenues to art-making beyond rigid categories. Interactive environments enter an expanded realm where a different set of abstract relationships can be brought into play.

Figure 103. Harold Cohen, *Brooklyn Museum Installation,* 1983. Drawing, India ink on paper, 22″ × 30″. The drawing turtle is an "adjunct" artist guided by a computer program designed by the artist, Harold Cohen, and used to generate drawings that investigate the cognitive principles that underlie visual representation. Called AARON, the knowledge-based program addresses fundamental questions—what do artists need to know concretely about the world in order to construct plausible representational objects? What kind of cognitive activity is involved in the making and reading of these? (*Courtesy Robert A. Hendel, Photo: Linda Winters*)

Harold Cohen, an internationally known British artist, has been involved with computers since his 1968 visit to the University of California, where he now teaches. Cohen thinks of the computer as an "interface for the creation of his work—a collaborator, and an assistant in the drawing phase."[21] Cohen's drawing program is what he terms a formal distillation of the rules and habits a human artist follows during the process of drawing. The computer sifts through these programmed rules and drives an artist-built drawing machine (called a "turtle") by steering it with separate commands.

Cohen applies artificial intelligence techniques to the process of image making. He instructs the turtle to be interested in such issues as spatial distribution, figure-ground relationships, and figure integrity (avoiding the drawing of one figure over another); and to be aware of "insideness" and "outsideness." Cohen has defined the rules for image making, but because the rules combine and interact in a complex, dynamic way, the results are satisfyingly unpredictable. If both wheels of a turtle move at the same speed, the mechanism will go in a straight line; different ratios make it move in arcs. The changing location of the turtle's path is defined for the computer by sonar devices installed at two corners of the paper. The complex works contain closed and

open figures, embracing abstract asymmetric forms which resemble natural shapes like fish, stones, and clouds. In 1983, the Tate Gallery in London and the Brooklyn Museum in New York both featured Cohen's mural-sized computer drawings.

A growing tide of international exhibitions in galleries and museums demonstrate the quickening of interest in the use of computers for art.[22] Many countries including, for example, England, Canada, Germany, Spain, Italy, Japan, and Mexico, have either originated exhibitions of computer-assisted art or have hosted traveling exhibitions such as the Siggraph Art Show.[23]

Up to now, the major museums have tended to acquire works which incorporate computer influence as part of their photography, video, and sculpture collections—works such as Jon Kessler's kinetic sculptures, Bill Viola's video installations, and Jenny Holzer's computer-controlled electronic message boards. These tend not to isolate the computer aspect of the art but, rather, to integrate and enhance its overall conception.

Use of the computer raises particularly thorny problems for some artists who fear they may lose control to a machine which has a powerful agenda of its own. It is invasive—replacing publishing mechanisms, photography and text processing to such an extent that it is becoming a standard studio tool for some functions (much as the camera eventually did), raising questions about what aspect of it can be used for their work, although most do not yet contemplate its use as a medium in its own right.

Art speaks according to certain rules (or against them). It is part of how we rewrite the present. How do we evaluate artists' work in terms of art? Periods of major technological change transform art and disrupt the criteria used for evaluating it. Technologically based art is a form of representation which explores different aspects of the real world in all its complexity and tends to be an art that raises questions.

The Computer as a Tool for Integrating Media

Use of the computer linked to other outputs such as video integrates elements in a new way. It leads to multimedia productions, where the computer program operates the entire program (for example, the audiovisual, computer-controlled projection installation works of Toni Dove, Dorit Cypis, and Carolee Schneemann, which include live performance, film, slide projections, and music).

The subject matter of Gretchen Bender's computer controlled video works is the media itself. Seeing television as a giant machine spewing out symbols, signs, referents, and image materials, which have often been reprocessed and again subjected to reprocessing, she confronts in her work the uncontrollable torrent of information with which we are flooded. She asks how an image, once absorbed into the undifferentiated flux of TV, can also have meaning by being brought into a system of control imposed by the artist and then by the viewer

Figure 104. Gretchen Bender, *Total Recall*, 1987. Electronic theater, 24 monitors, 3 film screens, 8 video channels. *Total Recall* is meant as a critique of the optical overload in the media culture of today. Employing sophisticated editing effects to manipulate a powerful array of logos and images appropriated from TV, Bender inquires into cultural desires and the techniques and seduction of media representation, and she investigates the networks of information-communication transfer. Bender uses the computer to control the video multiple-monitor performance film and synchronized installed effects. In this ambitious work, she bombards the viewer with high-speed images. (*Courtesy Gretchen Bender*)

Figure 105. Gretchen Bender, Diagram of Monitor Arrangements for *Total Recall.*

in a process of critical awareness. In effect she removes the image in order to examine it. Another system of control she makes use of and examines is the technological reduction of all image components, so they are addressable by a computer and video system. Images that can be created, edited, controlled and manipulated digitally, and reproduced for dissemination on a flat digital plane, where all aspects of it are undifferentiated, create a very different kind of fragmentation from that of a Rauschenberg collage in which images have been placed together compositionally according to form, color, and line. Her work often takes on the form of a multichannel video-wall, sometimes with accompanying film loops as in *Total Recall*. Part of her strategy in commenting on our social and perceptual experience of watching television is to intensify this

experience of watching, to create an ambiance of "overload" to force the viewer to extreme experiences of fragmented, multiplied versions of watching. Her quickly exploding collages full of swirling logos and frantic speeded-up movement, take advantage of digital systems to address any single part of any image.

The Message Is the Medium: A Public Art

Jenny Holzer makes use of computer technology to animate her aphorisms on anger, fear, violence, war, gender, religion, and politics. Invited by the Public

Figure 106. John Cage, *Europeras I and II*, 1988. Multimedia opera with electronics. John Cage combines elements of chance, randomness, information, and a fusion of genres in his *Europera*, first performed in Frankfurt in 1987. A combination of opera fragments (no longer protected by copyright), music scores (photocopied at random), singing types (chosen at random from the 19 styles), arbitrary stage backdrops (chosen from a range of available photographs), and sets moved in random time form the main scene, while a computer program, compiled by chance operations, controls the computer-assisted lighting process, generating 3,500 separate cues. Having combined this wealth of disparate elements into a giant collage, Cage proceeds to add elements of his own, including amusing visual jokes and puns interwoven with twelve alternate plots, thus creating a beguiling and entertaining pastiche of cultural productions of the past as a gaming collage for the present. (*Courtesy Summerfare, International Performing Arts Festival at SUNY Purchase*)

Figure 107. Keith Piper, *Tagging the Other,* 1992. Computer processed video and electronic composite images shown on four monitors. In the conditions of today's economic remapping of the globe, and as internal borders between nation states in Europe are dismantled, new kinds of boundaries of European-ness are emerging to keep out "the other." Central to his piece is the framing and fixing of the black European, through a technological gaze that seeks to delineate "the other" in a discourse of exclusion. *(Courtesy, Keith Piper and The International Center for Photography)*

Art Fund to create a work for their computerized sign project "Messages to the Public" above Times Square in New York City, she used the Spectacolor Board. It changed the direction of her art. The possibility of producing text art fitted perfectly with the capacity of her computer-based medium. Her conceptually based work consisting of tersely written texts attached to iconic images endow cliché "truisms" with a strong and wry twist. Her work refers to and updates the immateriality and social commentary of the Conceptual Movement. *What Urge Will Save Us Now that Sex Won't* has its moving image and text information equal-ized and written in raw color sign lights. Her work is intended as a way of com-municating with the public: "I try to make my art about what I am concerned with, which often tends to be survival. . . . My work has been designed to be stumbled across in the course of a person's daily life. I think it has the most impact when someone is just walking along, not thinking about anything in particular, and then finds these unusual statements either on a poster or a sign." Her work argues that art is an accessible language. If it is placed in a public environment by electronic means, the impact can be profound.

Following her first use of the computerized Spectacolor Board, Holzer began to use electronic message boards as a major medium of her own as her art

work. Her programs for LED machines have various levels of complexity but have been seen around the world from Paris, to Documenta, to the Venice Biennale and back, on huge message boards and on mobile boards mounted on trucks. In the same spirit as her electronic signs installation is her intention to buy fifteen second blocks of commercial time on TV to feature her texts—which she will adapt for TV. People buy her LED signs and objects but her art is not confined to museums and galleries: it is out in the streets. Holzer resists the traditional notions of art as a rare and precious object. Her works are unsigned. They question power. Her words and voices make room for thoughts and feelings that people generally keep to themselves and that art has generally excluded.

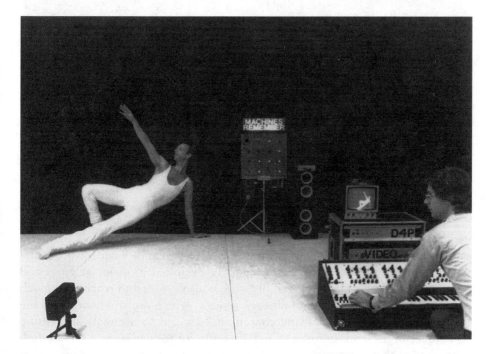

Figure 108. Christopher Janney, *Tone Zone,* 1983. Performance, commissioned by the Institute of Contemporary Art, Boston. Janney's experiments with movement, sound, and electronic media has led to interactive collaborative projects that rely on the collective efforts of dancers, musicians, designers, and technicians for their realization. *Tone Zone* translates the body's movements and inner pulses into sound. The musical score is thus produced by the movement patterns of the dancers. *Tone Zone* uses a synthesizer, an electronic sensing device, a video camera, and three dancers. The equipment is rigged to capture any move from the dancers. The synthesizer booms out sounds that reflect the speed and location of each movement. For example, a quick leg jab may create a sharp bleep or a slow twisting arm movement may produce a low braying sound. The choreography, composed by Tom Krusinski, is playful and open-ended, the perfect complement to Janney's electronic intentions. In *Heartbeats,* a solo designed for dancer Sara Rudner, a monitor is fastened to her chest so that the electrical impulses of her beating heart are carried on the sound system, creating the rhythm for the piece, like a percussion instrument.

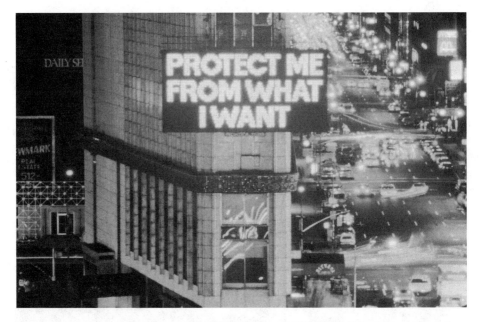

Figure 109. Jenny Holzer, *Protect Me from What I Want*, 1986. Electronic billboard, Spectacolor billboard over Times Square, New York. Influenced by her experience in creating messages for the Spectacolor board, Holzer went on to use electronic signboards as a personal medium for her truisms. Holzer's work speaks to many viewers because it uses the commonplace to voice the subconscious. (*Sponsored by the Public Art Fund. Courtesy Barbara Gladstone Gallery, New York*)

Les Levine has always used media tools for his work. He was one of the earliest artists to become fully identified with the use of video and the computer. Both a public and a private artist, Levine produces video projects and paintings, and installations that are regularly exhibited in major galleries and museums. However, a large part of his work is also devoted to reaching a much broader audience through his billboard projects which are sited within in the flow of urban public life. Levine consciously decided to use mass advertising techniques in his work in order to get attention for his messages. Like Warhol, he maintains that "Advertising style is the most effective means of communication of our time because it is specifically designed to capture public attention." In the confusion and complexity of city streets, the eye is bombarded with thousands of messages and details. Levine's pieces work at many levels so that an investigation of his questions would demand a response which keeps on resonating in the mind—similar in character to the power of an advertising message which cleverly hooks itself, by its own form of power, to the consciousness of a distracted public, which does not want to be bothered, but is nonetheless a participant in the circuit of desire which is part of the way we inhabit the present. (See also Public Art, Chapters 3 and 7).

The Artist as Publisher

A form which also enjoys a wider audience is that of the book. The book form allows an artist to explore ideas and concepts as sequenced images, a "gallery of ideas," a record which lasts far longer than an exhibition and, one which may have a wider audience. Prior to the arrival of desktop publishing, artists experimented with the photocopier for book production. In the same tradition, today's book artists self-publish text/image works with the computer. The kind of planning and decision making about the work puts it in the category of conceptually driven idea art which originally drew strength from Conceptualism and the Fluxus movement in the sixties.

Sometimes conceived as multiples, in order to reach a larger audience, they have appropriated mass media production modes while rejecting the seamless corporate aesthetic of conventional high-volume publishing. Artists books are independently produced artistic statements in book form. They are a small but important site for the aesthetic investigation of image, text, and concept. Emerging from the context of painting, sculpture, music and dance, artists' books explore new forms related to the conceptual premises of the arts. The aesthetic issues book artists explore are specific to the book: linearity, timing, sequence, image and text relations, narrative tension, image frequency, page design, structures and materials, openings, turnings, margins, and gutters. At their best, artist books have the essential complexity, density of ideas, and intimacy of any art form.

The computer has replaced the photographic darkroom in the production of books for it can produce the half-tone film output required by offset printing. It allows for unlimited image and text manipulation in the same space and for rapid preproduction that some think represents a democratic ideal in publishing. It transforms what was once an industrial process—requiring services of a typesetter, a graphic artist, a printer, a designer, and an editor—into a largely private one where the author becomes the producer.[24]

In his essay, "The Author as Producer," Benjamin pointed out that, with the accessibility and growth of reproduction technologies, everyman can now become a writer, not only through letters to the editor in the daily press, but also, now, through publishing opportunities made possible by advances in [electronic] technology. "For as literature gains in breadth what it loses in depth, so the distinction between author and public which the bourgeois press maintains by artificial means, is beginning to disappear." The new electronic publishing technologies open communications possibilities to artists which were never available before.

Laser copiers now provide the capability of printing on-the-spot, "on demand," entire books from a compact optical disk or from a microfiche the size of a playing card. Justification for this trend comes from savings in traditional printing, inventorying, and monitoring for reorders. Backlist and out-of-print books can be digitized and printed on demand. Many publishers are con-

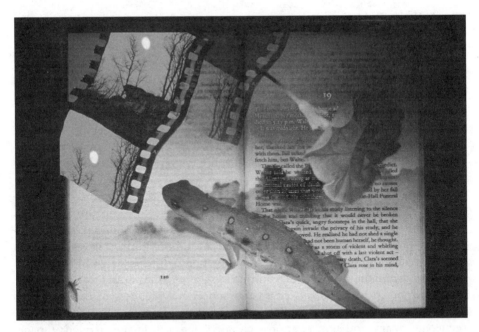

Figure 110. Peter Campus, *blunder,* digital photograph, 1995. Peter Campus was one of the first artists to appropriate tools of mass media in the late sixties and early seventies in his use of video and installation. Since 1988, he has become interested in using digital photography to alter and "reconfigure the relationship of painting and photography to nature." His newest collagelike constructions engage the viewer in a dialogue between disparate elements which have been digitally manipulated in color and scale to create works that are concurrently attractive and repulsive. As a result they seem to pulse with a level of emotional intensity. *(Courtesy Paula Cooper Gallery, Inc.)*

sidering the release of materials in the form of compact optical disks which can store hundreds of megabytes of information. Users could then print out information as needed. Electronic storage systems are of special importance to libraries already running out of floor space. Such systems are about to revolutionize not only the printing industry, but the dissemination and use of information. (See Chapter 6 for issues of print culture and of the future library on the Internet)

Transformations of the Book Form Dissolve Boundaries Between Media

Both electronic and print versions of a work often coexist in various ways. A printed book is functionally interactive. It seems natural to simply pack a disc into a printed bookwork as further outcropping to its ideas—as is "Swallows," a floppy disc inserted into the back of *The Case for the Burial of Ancestors* by Paul Zelevansky. Hypermedia on a disc may hold webs of texts which interactively connect to visual materials, with sound. Sometimes, a work originally produced as electronic communication (such as a video disc which holds moving images as well as sound and text), is reduced to a print format.

The electronic book today appears in several forms—not only as a CD-ROM, but also on-line, located on the Internet, eons away from the traditional material-bound, costly processes of hand-printing and binding. CD-ROM has become a mass medium for the publication of interactive works now that CD-ROM players, are built into desk-top computers. More and more artists are attracted to this medium because of its potential for harnessing in the same format, text, sound, and both still and moving images. With CD-ROM, the disc becomes "the gallery" and its accompanying text/brochure/book becomes the "catalog."

Pioneers of Interactivity

The whole process of creating interactive works is a pioneering experience of completely new territory where there are as yet, no traditions, no grammars, no guidelines. "I used to feel that interactive multimedia would build on existing

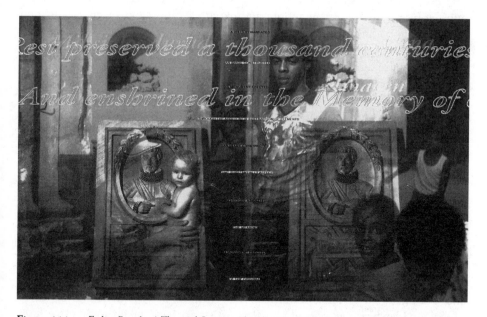

Figure 111. Esther Parada, *A Thousand Centuries*, (detail) 1992. Digitally generated color inkjet print 33″ × 52″. Interested in representations of North American cultural attitudes in the late nineteenth and early twenty centuries, Parada has constructed a collage of computer manipulated imagery and layered text. *A Thousand Centuries* is part of a larger series entitled *2-3-4-D: Digital Revisions of Time and Space* was part of a residency project entitled *Society and Perception: New Imaging Technologies*. In this work, she juxtaposes the kind of cultural foregrounding the "Columbus Story" has enjoyed in North America with its cultural spin-offs in the way other Latin American countries see themselves in relation to the context of their European or North American discovery, exploration, and economic development. Parada sees this as "a double-barrelled imperialism of representation." (*Courtesy Esther Parada*)

syntax," comments artist/producer George Roach. "I'm now beginning to believe that there's a whole new syntax needed by this medium that will be fundamentally different than television and film. Even the best of us are so shackled by our training. It's very hard to throw off all the vestiges of those previous forms. It will take a whole new generation that grows up inside of this medium to really find out what it's all about."[25]

Originally, interactive media grew out of developments in electronic computer games in the 1970s and 1980s. Because of the popularity of "games," the early technology became so developed that many artists decided to use the game concept of branched-out situations to involve the audience in a different kind of imaginative experience. Jane Veeder, Nancy Burson, and Ed Tannenbaum created different genres of interactive pieces.

About Face is an early example of an artist-designed interactive project. It was designed by Nancy Burson and prepared by the Rueben H. Fleet Science Center. *About Face* is also an example of how many interactive works originated in science museums, like San Francisco's, rather than in fine arts institutions. The projects are designed so that visitors will become engaged in the exhibition, by losing themselves in an interaction with a variety of experiences related to the range of "information" communicated by the human face. For example, when does a visual pattern become recognized as a face? (or, is it easier to mask an expression of anger or one of surprise?). The viewer can choose from among many sites where their faces are scanned and digitized and then manipulated according to the software programmed by the artist. The exhibition draws on findings in the fields of anthropology and psychology. *About Face* deals with questions of identity and desire by allowing, for example, playful manipulation of programs which allows people to create their own computer self-portraits by inserting on their own face a nose, eye, forehead, and so on, from famous prototypes.

Earlier work by Nancy Burson,[26] a series of "Warhead" portraits, combining the faces of the leaders of countries possessing nuclear weapons, statistically weighted by the number of warheads at each leader's disposal. She scans individual portraits for her composites into a computer by means of a television camera, encoding their images as digital information. Each of the scanned-in images are interactively adjusted as to size and format and then they are stacked and "averaged," stretched and warped.

Lyn Hershman is one of the first artists to have taken interactive laser disk[27] technology beyond commercial exploitation. Her project *Lorna* was produced by the Electronic Arts Archive, Texas Tech. It represents an important beginning artistic involvement with a potentially powerful interactive medium. Hershman is attracted to the interactive disk medium because its branching-out possibilities provide for a more intense way of dealing with reality, and because of her desire to actively involve her audience by empowering them to self-direct the video screen. Lorna, her heroine, suffers from agoraphobia (fear of

open spaces) and hides in her apartment, relating to the world only through objects that make her neurosis worse: the television and the phone. Viewers can use various channels to explore Lorna's options by accessing her possessions. When touched on the screen, these open out individually to comment on many issues—from women's rights to the threat of nuclear war.

Grahame Weinbren's and Roberta Friedman's complex interactive video disk project *The Erl King,* based on Schubert's song of the same title (*Der Erlkönig*), also exploits laser disk technology to shape a contemporary way of telling a story with images. It is a multidimensional narrative in which the viewer manipulates and reconstructs its images by touching the monitor's screen. In *Sonata,* a more recent work, Weinbren creates even more subtle relationships in his non-linear narrative. Weinbren wants to explore multiple points of view in work with a more response-type interface to create a subtle effect on viewers that seems more like a psychological flash-back than a separate response. In *Erl King,*

Figure 112. Lynn Hershman, *A Room of One's Own,* 1993. 18″ × 24″ × 36″. Interactive installation—miniature video monitor and video projection in miniaturized room. Continuing her feminist discourse about voyeurism in a *Room of One's Own* by forcing the viewer to see her work through a periscope peep-hole, Hershman adds the elements of how one responds to being looked at. The viewer's eye movements themselves are digitized and inserted into a small television set within the tiny specially constructed bed-room scene. The eye movements sends signals to a computer which causes the videodisc to access significant segments for viewing on the room's TV. Thus, the viewer/voyeur becomes a "virtual" part of the scene being viewed. Depending on whether one turns the periscope towards the bed, the pile of clothes, the telephone, the chair, or a monitor, one of the three screens on the back wall is triggered. For example, looking at the bed reveals unpleasant scenes of the woman shaking bars that ressemble a sexual prison.

Figure 113. Lynn Hershman, *A Room of One's Own* (detail) 1993. (*Courtesy Lynn Hershman*)

Figure 114. Grahame Weinbren. *Sonata* 1993. Interactive installation.

Figure 115. Grahame Weinbren. *Sonata* (detail) 1993. Interactive installation. In a deliberate investigation of the possibilities for a new kind of interactive cinema, Weinbren aspires to lay its foundations in a moment-by-moment collaboration between viewer and filmmaker. In *Sonata,* he juxtaposes a Tolstoy story of jealousy and mistrust leading to the murder of the wife with the Biblical theme of Judith and the enemy general Holofernes. The general is decapitated by the heroine Judith who thereby saves her people from a calamitous invasion. A primary aim of this multivalent narrative is to examine extremes of emotion. Weinbren structures the stories so they can be easily accessed by the viewer by pointing at the screen at any time. For example, the Tolstoy narrative segment is set on board a train as the protagonist, pardoned for the death of his wife, recounts his story. The viewer can interrupt the narrative flow at any time to visit visually the actual visual scenes being described verbally and then loop back to the main story. The viewer navigates around the narratives using a unique interface system where up, down, left, right all represent different temporal directions. Right and left move us forward and backward in time; down renders expansions of the present; and up, introduction of material outside time. Weinbren has found ways also to elaborate on these inputs. (*Courtesy of Graham Weinbren and The International Center for Photography*)

the viewer had actually to touch the screen of the monitor to activate changes. In *Sonata,* he positioned the infrared sensor beams several inches in front of the monitor screen so that the viewer needs only to move the hand, as though directing, to make changes. In general, his work stays closer than most to the concept of cinematic expression and provides a sense of the psychological workings of the mind—creating a fluidity of movement and montage that is deeply satisfying. The system he uses provides at high resolution thirty frames per second—much faster than image compression software can provide so far. In *Sonata,* Weinbren used two stories—Tolstoy's *The Kreutzer Sonata* juxtaposed with the biblical story of Judith and Holofernes. He also placed in the same

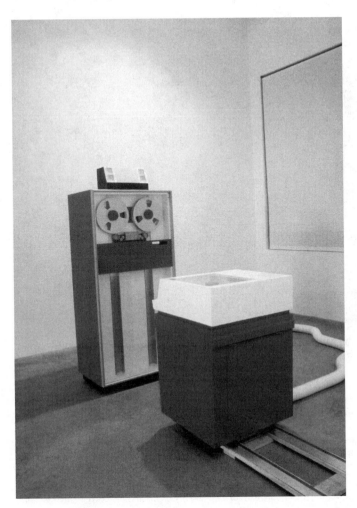

Figure 116. Jon Kessler, *Marcello 9000*, 1994. Mixed media with audiotape, lights, and motors. A pair of refrigerator-sized computers exchange fiery insults in a lover's tiff, with sound taken from the soundtrack of Fellini's *Dolce Vita*. The woman computer turns and departs along a short track shouting "Let me live"—but later returns to once again engage the argument. (*Courtesy Jon Kessler and Luhring, Augustine, and Hodes Gallery*)

databank, the text of Tolstoy's family diaries. At yet a further intertextual level of relationships, he inserts dreamlike images that are condensations of his feelings. While the viewer is free to move quickly and easily through the piece, Weinbren exerts control of the interactivity in one or two places where the viewer is not allowed to pass on at the high point of the intense climactic scene, such as when Tolstoy's character murders his wife.

Other artists interested in creating interactive alternatives to film are John Sanborn and Peter Adair. In *Smart Money*, which is designed to teach teenagers about money and credit, Adair uses a film narrative interspersed with a learning game procedure, where students make decisions about spending and saving issues in their lives. Although he designed it to be played only once, Adair has noticed the students play it again and again—first as a practical help, then as

fantasy. John Sanborn uses a choice mode as interface for a demonstration film he designed for a movie theater audience, who can use joysticks as a kind of "voting" device.

Creating an Interactive Aesthetic

The central issue in creating a non-linear media work is how the artist viewer relationship is altered and played out in the work. Some artist producers wish to retain a narrative format to sustain the emotional tension associated with film. Such artists are interested in issues of character and story development. Other artists want to create open spaces in the work where viewers can play and fantasize.

Driven by market forces, and extremely rapid technical evolution, interactive technology has entered the mainstream of mass audience entertainment, advertising and publishing. Much basic territory has already been explored.

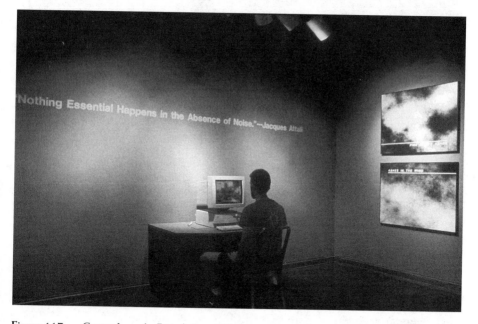

Figure 117. George Legrady, *Equivalent 11*, 1993. Interactive installation with computer monitor and keyboard. Interested in exploring the threshold between cognitive perception and cultural interpretation, Legrady asks viewers in *Equivalent 11* to consider the process by which we normally "read" images, (especially familiar photo representational ones) and the submerged social and historical structures of the cultural conditioning in which they exist. A computer program produces cloudlike images whose tones are controlled by typed-in text by the viewer. When key words stored in the data base are matched with those of the viewer, disruptions to the image-making process ensue. Later, the computer reveals previously entered words which match those in the current field. He asks questions about the relationship between ordered information (signal) and random information (noise). When a "noisy" image cannot be interpreted according to conventional experience, it becomes dependent on other sources for understanding it. (*Courtesy George Legrady and the International Center for Photography*)

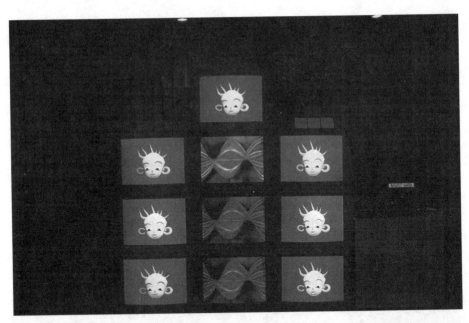

Figure 118. Naoko Tosa, *Talking to Neuro Baby*, 1994. Created in collaboration with Fujitsu Laboratories. An interactive performance system with voice input response and neural network software. With *Neuro-Baby*, we have the "birth" of a virtual creature with computer generated baby face and sound effects made possible by neurally based computer architectures. It represents an interactive performance system capable of recognizing and responding to inflections of the human voice which can trigger changes in facial expression of *Neuro Baby's* "Emotional Space." *Neuro Baby's* logic patterns are modeled after those of humans, making it possible to simulate a wide range of personality traits and reactions to various experiences. Tosa comments: "I created a new creature that can live and meaningfully communicate with many modern urban people like ourselves who are overwhelmed, if not tortured by the relentless flow of information, and whose peace of mind can only be found in momentary human pleasures. *Neuro Baby* was born to offer such pleasures . . . It is a truly loveable and playful imp and entertainer."

Many artists are already rejecting as too linear and simplistic options which provide the viewer with only one choice. Branching programs have a greater array of choice options; the viewer must actively search to find gateways to the next experience such as in the CD-ROMs *Myst* and Laurie Anderson's *Puppet Motel*. This type of choice is more challenging, intuitive, and allows for more associative connections to occur. Two further interaction interface types allow the viewer either to add texts or images, to the work or to establish new aspects of the program's capability in the form of new links to other sites or by importing new materials to the site.

As of today, a large group of pioneering artists are already involved in creating an interactive aesthetic and set of standards for clarity and functionality of the user interface. Their work in exploring the new media involves types of patterns of interaction.[28] Examples are: circular interaction; time sequenced inter-

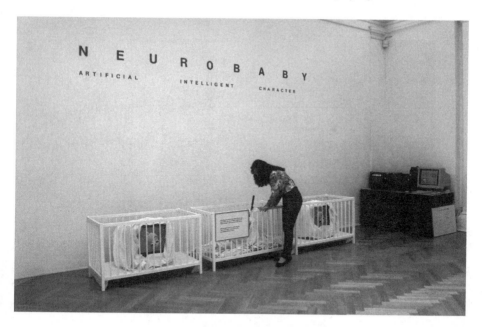

action; and the way individual events influence other events and permits access. Other questions are: what navigational actions and user control input points need to be present for the content of the work to be expressed; what form do the system responses take which could lead to further viewer action; what screen design and type of movement and sound will be used. In providing guidelines for multimedia work, Apple Macintosh advises several major fundamental operating guiding principles for a successful outcome. First, the user must be made to feel in control of the piece. Second, fundamental concrete metaphors must be established which are then supported by all the visual effects and sound elements. Third, users must be able to loop through the work and must always be able easily to find a way out.

Those artists who choose to design interactive multimedia systems and effective interfaces for viewers (users) of their work face even more daunting tasks than those of historically analogous interdisciplinary artists in video, film, installation, performance. Aside from creating the mise-en-scène and the context and metaphoric associations of the work, its movement, sound, and acting, they must also give primary consideration to viewer interaction. This means abandoning the traditional approach to create meaning through controlled linear structures. So far there are no defined criteria and no canon for this expanded media, although there are technological restraints. Its raison d'être is to break open old boundaries and to experiment with new artistic possibilities for art and communication. Mindful of the Bauhaus motto: "form follows function," function and aesthetic are closely allied in forging from hypermedia a new cultural form.

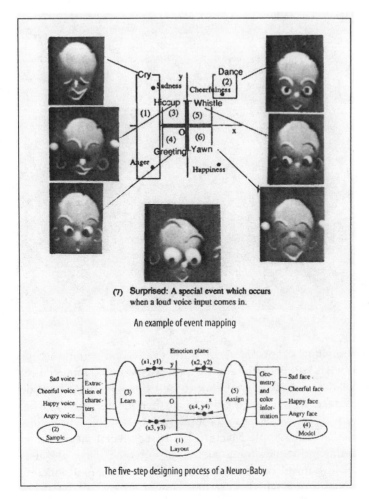

(7) **Surprised: A special event which occurs when a loud voice input comes in.**

An example of event mapping

The five-step designing process of a Neuro-Baby

Figure 119.
Naoko Tosa, *Talking to Neuro Baby,* (detail) 1994. *(Courtesy Noako Tosa)*

Crafting work where there are pathways, nodes, links, networks, and connecting loops between visual, sonic, textual, and graphic elements calls for enormous skill. Multifaceted procedures and coding require collaboration, a difficult task in a culture which promotes heightened individualism. Interactive multimedia brings us into the type of collaboration that makes a film, a theater piece, or an opera production a reality. The collaboration can be one where the director/producer is in charge of others; or it can be a more open-ended one where there is equal input and joint decision making by all of the players. The latter, more democratic model is full of difficulties, but on the whole, produces the most innovative work. As the culture changes, increased collaboration will be necessary.

In the future, technological advances will include alternative inputs to the keyboard or the mouse. Video and computer games are not the only models. Virtual Reality (VR) hardware now exists for head and hand motion; for the use

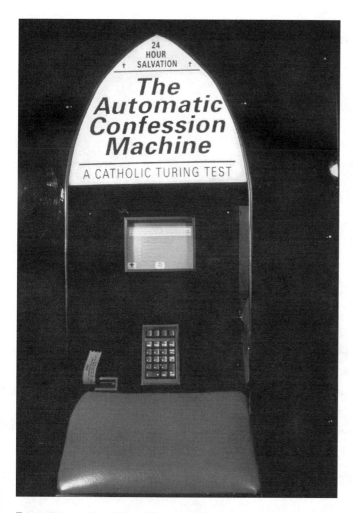

Figure 120. Greg Garvey, *The Automatic Confession Machine (ACM),* 1993. Wood, plexiglass, fluorescent neon light, interactive computer program. Put off by the commercialization of religion (pay for your sins through offerings with a credit card), Garvey came up with the concept of creating a computing program through which one can make a confession to God through the auspices of a computer. He wants his work to represent a warning against the inexorable intrusion of commercialism which may redefine spritual needs as yet another commodity to be researched, marketed, and packaged. The kneeling penitent uses a keypad to enter any venal or mortal sins or sins against the ten commandments. At the end of the program he or she receives a print-out of the balance of required penance. The sinner is then required to make a digital leap of faith and surrender to the belief in the power of "Silicon Absolution." *(Courtesy Greg Garvey)*

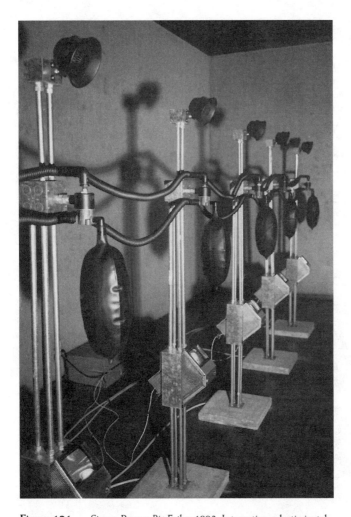

Figure 121. Simon Penny, *Big Father*, 1993. Interactive robotic installation. This work is meant as a commentary on new global system of digital communication and how it has become a colonial-type phenomenon in the sense that millions of sensor and effector nodes for gathering information are hooked into its system and thus become a sense organ of it. Operating on a vast range of scales, from the galactic to ground-based observatories and local surveillance and medical systems, this database can seem to invade and control our lives—not like Orwell's "Big Brother"—but more ominously as "Big Father." The viewer entering the interactive installation is confronted with five stations that individually breathe and sense the visitor's presence, triggering the transmission of audio and video material. *(Courtesy Simon Penny)*

of body characteristics such as touch, motion, eye focus, gesture/speech; and brainwaves. These possibilities as yet have been little tapped by artists. Access to robotics and artificial intelligence labs is still problematic. New ways of compressing and representing complex information and the procedural tools needed for users/audience to navigate are being developed rapidly, particularly in relation to the Internet and the World Wide Web. (Chapter Six)

Like most technological advances, interactive media offers hope for new forms of communication and for a new epistemology. However, cultural critics see that multimedia will also become a force for seducing and manipulating the public mind. (The public is already exposed to the fantasy of choice as the bedrock of market-place rhetoric even though choices are limited to ones between products or to events in video games. This kind of "choice" leads to a false sense of empowerment.) Already interactive multimedia hype has turned off many potential users. A danger is that the new forms could function as TV has. Viewers without critical consciousness or information are lulled into complacency. Unaware, they miss many of the information source options available to them.

Figure 122.　Tamas Waliczky, *The Garden: 21st Century Amateur Film*, 1993. By combining 16 mm color film footage about his daughter with 3-D models of a garden, Waliczky has created a poetic animation about childhood. The work entailed an arduous frame-by-frame process of releasing the figure from its background and then positioning the perspective coordinates in the computer model so that the background environment jibed with the child's movements. Because he wanted to make perceptible the atmosphere of a real garden he also entered coordinates for air movement, for changing light, and for wind blowing. In a garden everything is in motion. The final recording is on videodisk. *(Courtesy Tamas Waliczky)*

Figure 123. Christine Tamblyn, *She Loves It, She Loves It Not: Women and Technology*, 1993. This CD-ROM explores the historical exclusion of women from the technological realm while it also attempts to construct a revisionist history where women can play a major role in cyberspace. The (potentially) hour-long work involves a breaking down of boundaries between body and machine and between issues of art and theory. The viewer clicks on the author/artist's face or mouth to receive navigational advice throughout the work. Viewer's choices of sites include Quick-time movie clips, animated texts, and specific information about a particular topic. *(Courtesy Christine Tamblyn)*

The new interactive media require a better educated, well-informed, demanding public, and artists who are ready to deal with extended audiences beyond traditional settings. Artists must have far greater knowledge and grasp of the content that they are presenting—its history, mythologies, and psychological effects—as well as greater creativity in making decisions as to its form and its presentation. Creating a CD-ROM, for example, is similar to organizing a film production in its use of theatrical lighting, script-writing, work with actors, music and story board. Because CD-ROM is not linear, (although it may be narrative), it cannot evoke the suspension of disbelief that is the goal of most films. When we are comfortable with the form of representation whether it is film or painting, we accept the conventions of that form and enter into its arena of illusion. However, when there is constant interruption through acts of choice, there is a rupture of concentration and a need to leave the narrative space being inhabited.

Parameters of Artist Control: The Viewer Interface

The most common multimedia interactive works are designed for presentation on computer screens, although some take the route of immersive virtual reality environments because they feel computer screens confine their access to create new experiences with materials and spatial relationships. However, similar problems confront both types of interactive producers. For example, the interface with the viewer: How does communication take place to indicate how interaction should occur? How can the viewer be motivated to interact and to want to continue? What most interactive producers have found is that the interaction itself must be intuitive, meaningful, simple, attractive, familiar feeling, and noticeably responsive to the user.

Most artists are interested in providing as much freedom of exploration as possible while still taking control of shaping the experience cohesively. Those who have been struggling the longest with the media speak of the need for a rich lode of source material as content for the construction of the work.

Figure 124. Pattie Maes, *Alive, An Artificial Life*, 1994. Virtual immersive environment. The goal of *Alive* is to present a virtual immersive environment in which a real participant can interact in natural and believable ways with autonomous semi-intelligent artificial agents whose behavior appears to be equally natural and believable. Normally, navigation through a virtual space requires the wearing of gloves, goggles, or a helmet—cumbersome equipment tethered to a computer workstation. However, in *Alive*, a single CCD camera obtains color images of a person which are then composited into a 3-D graphical world where 3-D location and the position of various body parts are contained. This composite world is then projected onto a large video wall which gives off the feeling and effect of a "magic mirror." (*Courtesy Pattie Maes*)

Challenged by the relationship between interaction and creativity, Peggy Weil in a children's CD-ROM *Silly/Noisy House* created for Voyager, a major CD-ROM publisher, encourages exploration. Weil motivates creativity and curiosity by leaving "holes to fill" and providing as many possibilities as possible for manipulating images and concepts. She feels that "learning is not a game, it's a quest." Her work, although complex, is amusing and easy to use.

The dominant commercial mode of production for CD-ROM's is generally a "choice" system utilizing standard branching structures activated by a limited menu of predetermined options (like those used for electronic ATM banking operations). Other examples are as a CD-ROM book where the "reader" "chooses" between different roles for the characters or as in an encyclopedia with regard to which aspect of information they wish to retrieve. Alternatives to this mode are most often explored by artists who are trying to invent new forms. Pluralistically, applications for the computer open out to important new avenues to art-making beyond rigid categories.

In *Media Band*, a CD-ROM music work, the users can control the parameters of both the music and the video. Scott Rundgren has created an interactive music work in which viewer/listeners make changes in parts of the music.

The Most Advanced Form of Interactivity Is Hypermedia: Virtual Reality

Most artists attracted to work with virtual reality[29] as a medium want to create imaginative interactive environments where they can control all the objects or all the spatial coordinates and sound in order to achieve an aesthetic effect. Powerful computers are used to generate visual experience and to track body movements through the use of prosthetic devices such as data gloves, head-mounted displays and body suits which encase the body in fiber-optic cabling. Fully immersed in a completely controlled artificial environment, the visual, aural, and tactile capabilities of the body become totally absorbed in following three-dimensional representations which are continuously modelled and tracked through computer monitoring of the body's every movement. Participants experience environments which seem to be located in three dimensional real space. The effect is that of a technological invasion of the body's senses and a relocation of what can be seen and experienced to the realm of a synthetic private world severed from other potential observers. Jeffrey Shaw, artist-director of the Center for Media in Karlsruhe, Germany, describes it:

> "Now with the mechanisms of the new digital technologies, the artwork can become itself a simulation of reality, an immaterial 'cyberspace' which we can literally enter. Here the viewer is no longer consumer in a mausoleum of objects, rather he/she is traveler and discoverer in a latent space of audio visual information. In this temporal dimension the interactive artwork is each time re-structured and re-created by the activity of the viewers."

Figure 125. Perry Hoberman, *Bar Code Hotel,* 1994. Interactive environment. *Bar Code Hotel* partici-
pants receive 3-D glasses before positioning themselves behind long tables plastered with the familiar
black and white bar codes which are such an unpleasant fact of contemporary life. By running a light pen
over one of them, viewers find that the ugly black and white bars can be energized digitally to release
the most wondrous colorful shapes which are shown as large wall projections. Some of the bar codes
release every which way the word "jump" or "flee" and with those, the viewer can send the fantastic
objects—a rolling spiral; a lightbulb surrounded by pulsating globes; a strange porcupine sphere. Other
commands include ones which make the whole room grow smaller or larger, turn 360 degrees or change
color completely. The *Bar Code* turns out to be the means for inhabiting an exotic virtual world. (*Courtesy
Perry Hoberman*)

A small band of artists[30] in Europe and North America are challenging the
potential of virtual reality by exploring it as an imaginary space. Some project
their "virtual images" in space; some employ head-gear connected to sensing
devices which control the flow and placement of images within the space.
There are no guidelines for these new kinds of work—no vocabulary, no blue-
prints, because the medium, not in existence until very recently, has been
approached by relatively few artists to create new works. It is a wide-open
medium without boundaries. There is little, critical writing about its use.

Brenda Laurel, Perry Hoberman, and Toni Dove were all invited in the
period 1993–1994 to create works produced through a one-of-a-kind artist-cen-
tered high-tech program at the Banff Center for the Arts supported by the
Canadian government, where costly, complex equipment exists with an unusu-
ally knowledgeable staff necessary to build and operate it. The works are exper-
imental, like upper echelon scientific research, because of the specialized envi-
ronment, and are not likely to be widely seen in the near future. The artists

Figure 126. Perry Hoberman, *Bar Code Hotel*, 1994 Interactive environment.

were invited to produce their works in a structure that became lab-like in its devotion to finding solutions to problems presented by the artists.

Artist Brenda Laurel is drawn to VR because she believes that adults, unlike children, need a certain anonymity or ability to change hats to mask out reality in order to play. They need enhanced props and tend to like the electronic "smart costumes" they must wear in order to explore the interesting dramatic potential of the immersive narrative environments she creates. She believes in a mixture of freedom and constraint in her work. She calls VR costumes "prosthesis for the imagination." Laurel observes that "the relationship between human and machine has ceased to be purely technical and has entered the ancient realm of theater."[31]

On entering the exhibition space of Laurel's "Placeholder," participants find themselves in an environment featuring two ten foot circles surrounded by river rocks. On donning the headmount display, participants first experience darkness and then find themselves located inside a "virtual" cave where creatures—a spider, a crow, a snake, and a fish—talk, and seem to entice the visitor toward their locations as petroglyphs on the cave wall. On approaching each, the participants "become" the creature, assuming its physical features, and experience spatialized distortion of their own voice through the HMD speakers. A character called "The Goddess" offers advice, although her voice, unlike the other sounds, is not spatialized.

To create the work, Laurel collaborated with Rachel Strickland. They shot video footage near Banff National Park of a natural cave, a waterfall, a sulphur hot spring, and a fantastic rock formation. They digitized their images, added high quality spatialized sound, and created simplified character animation of the creatures.

Although sophisticated VR simulation technology was developed by the military during the Cold War, it was directed solely at the concept of a sedentary operator following the movement of a vehicle through a 3-D virtual world. Myron Kreuger, one of the artists who pioneered VR, comments that it is artists who have pushed farther in the imaginary uses of the medium.

> The sense that virtual reality was of fundamental importance came from artists who communicated it immediately to the public through their work. In addition, many aspects of virtual reality including full-body participation, the idea of a shared telecommunication space, multi-sensory feedback, third-person participation, unencumbered approaches and the data glove all came from the arts, not from the technical community.[32]

In Perry Hoberman's *Bar Code Hotel* viewers see objects within real space juxtaposed against 3-D representations of virtual objects projected in a virtual space. The virtual ones can be controlled interactively by the participants acting from

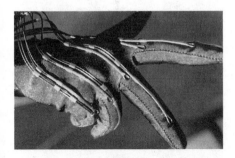

Figure 127. *Virtual Reality Gloves*, ca. 1994.

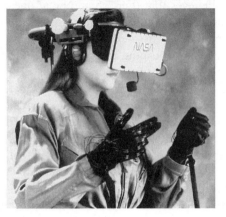

Figure 128. *Virtual Reality Headset*, ca. 1994.
These wired virtual reality sensor accoutrements contain the sensors which make visible to the viewer changes triggered by the body's movements within a specifically wired environment. (*Courtesy NASA*)

Figure 129. Toni Dove, *The Coroner's Dream* from *Archaeology of a Mother Tongue*, produced in collabora-
tion with Michael MacKenzie, 1993. A virtual reality installation with interactive computer graphics,
laserdisk video, and slides. Developed at the Banff Center for the Arts, Canada, this piece is an interac-
tive narrative comprised of three navigable environments. The *Coroner's Dream* is the first section—a
dream sequence in which the audience and/or interactive users are in the point of view of the dreamer.
Segments of spoken text and sound are attached to sections of the architecture and are triggered by
touching animated figures that follow narrative paths.

their position in the real space. Hoberman believes that there should be a "one-
to-one predictable relationship between a user's action and a system's response. It
should work like a light switch. . . . With interactivity, it's better to have nothing
to say than to try to say something. It's better for meaning to come out of the
interaction rather than controlling the experience."[33] This model is favored by
many contemporary artists over older ones based on choice modes or interactive
narratives. Hoberman feels that the best scenario for interaction is not a model
that interrupts the action by offering choice and interactive stories, but rather
one that initiates action in a program structure which is totally responsive.

　　When interactive technology is combined with three-dimensional virtual
reality modeling, the viewer can be projected and immersed into the narrative
space itself, far from the confines of the computer or film screen—more like an
environmental theater. Experimenting with collaborator Michael McKenzie at

Banff's Art and Virtual Environments program, multimedia artist Toni Dove[34] created *Archaeology of a Mother Tongue* in 1994, which involved a theater-sized rear-projection screen with interactive computer graphics, video and 3D scrims for animated slide projections. In an article published in *Leonardo* she writes about her experience as an artist in creating an interactive Virtual Reality Immersion environment.

> I approached the concept of interactivity with some resistance, wondering why I should replace intellectual challenge with multiple choice . . . I saw it as more of an extension of the passive television metaphor than an engagement with options that have substantial ramifications. What I discovered was a world of possibilities that I feel I have barely begun to explore.[35]

What she finally decided on was a system for producing a potentially vast number of nonlinear unpredictable responses based on her interest in the alternative concepts of immersion. Contrary to film, the experience offers a variety of entry points, a different, fuller sense of real-time passing, particularly when it is decided on by the viewer. For her, the potential of an immersive interactive environment was to create a work that is more fluid than linear, a multilayered structure which accessed text, both the written and the spoken, with visual elements and responsive sound. She describes the immersion experience as "a movie sprung free from the screen . . . In film, time passes with a cut. VR is continuous space." In virtual reality it is possible to have multiple streams of different media bombard the viewer in a "field of constantly changing experience."

One of her first decisions focused on choosing the best interface for presenting the work. It meant examining various response mechanisms such as whether to use a VR headset with liquid crystal display or data gloves. (Other tracking devices can also be added to the body through a headset fastened by cords to the control unit.) Because the forty-minute piece was too long to be seen comfortably in a VR headset, and because she was more interested in providing a more dimensional experience than that allowed by the headset, she decided on using the data glove as a more open type of interface. Once wearing the glove, the viewer was allowed to touch, move forward, or backward and was allowed to make choices. Guided by the glove's graphic icon, and by a Polheus tracking device, contained within a toy camera, which allowed observation within graphic space, the viewer became the "driver."

> The driver—a combination performer and camera operator who navigates through the adventure for the audience. This mode of presentation had powerful theatrical aspects, but curtailed the experiential possibilities for one person in a virtual space because of the constraints of entertaining an audience. It also kept the audience somewhat outside the interactive experience. For me, the most compelling aspect of this environment is the sense of being immersed in a narrative space.[36]

Working from the premises of a fractured fictional narrative, she takes her viewer through a dream sequence located in a wireframe architectural space. One of the characters, the Coroner, speaks aloud in the dream. The sound reverberates spatially with both local outposts and those attached to special locations within the piece.

Dove hopes to further the possibilities for integrating organic sound in her work such as breathing, or other body sounds as a way of suggesting the sensuality of a human or animal connection to that of a machine. She feels that using response interfaces based on touch rather than choice ones as a means for navigation could tap into different emotional responses.

Interactive Installation Environments

Other forms of interactivity extend beyond the computer monitor to include a room-sized venue as an interactive installation space. Here, various mechanisms of interactivity can be considered, depending on the artist's work. These could include sensing devices such as those for sound, movement, and temperature or those which focus on communications sensibilities, such as speech, touch, gesture. Questions most frequently asked by artists contemplating use of interactive media concern the loss of their usual control over a discrete work. How much control will the viewer have in directing the flow of the piece? How much can be altered or changed in the work? Will its intentions become diluted? At what point does it seem less interesting to artists if there is too much loss to the work's original intent or meaning? What kinds of new programming will evolve? Will they be able to develop modes of interaction which will offer more complexity and flexibility?

Lovers Leap by Miroslaw Rogala is an interactive installation environment in which shifts in the viewer's movements control a continuously evolving perspective. Produced at ZKM (Center for Media Art in Karlsruhe, Germany), Rogala's work comments on aspects of representation itself. His digitized images, (from a bridge intersection in Chicago and a satellite scene in Jamaica), are capable of being turned completely inside out, first showing a digitized fish-eye view taken with a conventional camera, skewed as the viewer moves through the piece (wearing a movement-sensitive helmet) to become a transposed digitally reformulated view from a 360 degree turnabout like a sock being turned inside out, only digitally. The images, projected at each end of a large room with high quality projectors, are impressive in scale and beauty.

Reflecting the intense desire of many artists to represent a reconnection between the organic human with the electronic digital sphere, Paul Sermon interrogates the gendering of electronic spaces in his video telepresence perfor-

mance *Telematic Dreaming,* (also produced at ZKM). The transmissions between two locations were via video monitors which allowed for communication between the viewer and a real-time interactive image of the artist. The image of the artist would stroke the viewer sitting or lying on a bed and the viewer could respond by also stroking. The work evokes a nostalgic re-enactment of sixties "love-ins," as experienced in the erotophobic nineties. Anxieties about AIDS make virtual sex the ultimate experience.

Access

In order to gain access to high-level equipment capable of modeling high-resolution animations of virtual models, artists must gain entrée to specialized centers through fellowships, grants, artist residencies such as at the Banff Center for the Arts in Canada; the American Film Institute's Advanced Technology Program in Los Angeles; the Center for Art and Media in Karlsruhe, Germany; and the Arizona State University Institute for the Arts. In Germany, Austria, and France, particularly where there has been a long tradition of support for the

Figure 130. Miroslaw Rogala, *Lovers Leap.* 1995. A interactive environment produced in collaboration with Ford Oxall and Ludger Hovestadt. In Rogala's interactive installation, a collision takes place between emotion and technology. As in a leap of trust and faith, Rogala explores the totally untried frontiers of representation. He questions the very parameters of perspective by turning its space 360 degrees in upon itself through digital means. The installation consists of two synchronized screens displaying opposite perspectival views with four layers, each with a different set of photographic information. When the viewer enters the space, he or she is aware that their movements are changing what is seen. If the viewer keeps moving through the environment, a series of abrupt shifts is created—the same relationships form a dramatic new perspective—which leap over the lover/viewer. Once the viewer/lover stands still or exhausts the relationship, there will be a sudden thrust into a new landscape—a vista that is out of the viewer's control.

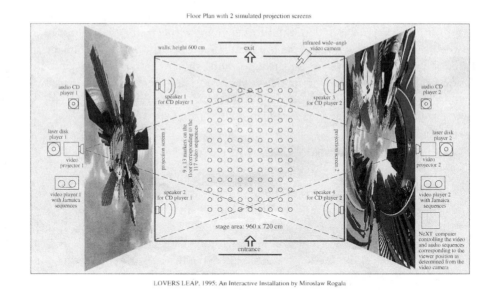

Figure 131. Miroslaw Rogala, *Lovers Leap*. 1995. Floor Plan with two simulated projection screens.

arts, financing of such centers has reached a significant level. One of the most advanced is the previously mentioned Center for Art and Media in Karlsruhe, a technology center for Germany. The center has thrived through an amalgam of city local industry, and state support. It is able to offer artist-in-residencies to artists to design and produce works with the help of programmers. Its plan for an Art and Technology Museum includes a design school modeled on the concept of the Bauhaus—a meeting ground for art, technology, and industry. The museum houses an art and technology collection but acts primarily as a site for exhibiting new work, which tends to be a mixture of virtual reality, modeling, animation, and interactive installation. It publishes "artintact," a magazine about art and technology as a CD-ROM, and acts as an important meeting and production ground for artists from around the world (Chapter 7).

Recent advances in new computer chip development point to further miniaturization of equipment, adding to its lightness, its low cost, and its more sophisticated possibilities for integration with other electronic media. However, "state-of-the-art" pictures are created with the newest, most advanced large systems. Of all the electronic media we have been discussing, the computer most strongly represents the split between this "have" power group and the "have not" artists. This distinction raises a question which has long plagued artists using electronic media—whether the aesthetic cutting edge need be tied to high-tech innovation. Without a store of ideas and strength of conviction, the

artist can become subservient to technology and its high costs. Crucial to the independence of committed, technologically based artists is access to costly production and postproduction media technology. This is a major political and economic issue for those who need to innovate and thus take risks as they rethink existing artistic forms and invent new ones. Control and direction of the creative process is the artist's essential task. Artists will need resources as they seek to find forms "appropriate to the energy of our time."

6

Art As Interactive Communications: Networking a Global Culture

Remember, today is like 1948 and they've just introduced a new medium. Help define the future of that medium before it ends up like television."

—*The Hot Wired Team—hot-wired-info@hot wired.com*

If the arts are to take a role in shaping and humanizing emerging technological environments, individuals and arts constituencies must begin to imagine at a much larger scale of creativity.

—*Kit Galloway and Sherrie Rabinowitz*

Across the communications landscape move the specters of sinister technologies and the dreams money can buy.

—*J.G. Ballard*

To engage in telematic communication is to be at once everywhere and nowhere. In this it is subversive. It subverts the idea of authorship bound up within the solitary individual. It subverts the idea of individual ownership of the works of imagination. It replaces the bricks and mortar of institutions of culture and learning with an invisible college and a floating museum the reach of which is always expanding to include the possibilities of mind and new intimations of reality.

—*Roy Ascott*

I am a citizen of the world.

—*Diogenes*

Communication Tools for a New System of Representation

It is not surprising that the very power and rapidity of technological advance, accompanied by such an avalanche of social and cultural change, has stirred deep-seated fears in so many quarters. The technological conditions of everyday life have been transformed in a way unimaginable even half a century ago. Walter Benjamin, although heartbroken by the loss of aura and by the loss of the mystical in art, wrote astutely about the implications of technological change and the value of art as communication. He was also wary of powerful consciousness transforming technologies controlling the voice of the artist—and wary, too of technology as a function of fascistic impulses. While new

212

information and communication technologies *can* provide greater accessibility for art, (for there are ways it can bypass the information marketplace), there is the fear that art could become lost and commodified in an infrastructure of technocratic domination if the artist's voice is not powerful enough to withstand it.

Artists need to be involved with new technologies in order to define and exploit their creative potential. In 1964, Marshall McLuhan wrote "We shape our tools and thereafter our tools shape us." Could artists' work, shown outside the context of the cultural community, become no more than a series of globally coordinated databases that are not really located anywhere but as interstices between commercials? The widespread rapid development of Internet communication especially since 1994 is forcing cultural change. How will it affect art? Can we control it?

The Internet as Art

As we have seen, forms of photographic and cinematic representation were subsumed by the development of video with its new electronic properties for transmission and feedback. The computer shattered the existing paradigm of visual representation by converting visual information about reality into digital information about its structure, modeling the visual rather than copying it and allowing for interactivity as a new aspect of representation. The visual, now as information in a data bank, has entered a realm where art and information meet. Now computerized communication technologies make possible the transmission of images, text, and sound to be accessed privately by the viewer interactively, at home. This interactivity makes it very different from television transmission. While the Internet is a medium that is like TV, because it involves audiences sharing from great distances experiences real or imagined while staring at a glowing monitor, the interactive aspect of the Internet makes it completely different from TV. Being in cyberspace is "closer to reading a book than to watching TV. Much of what we look for in the culture of the book can actually be found in the new culture of the screen."[1] The viewer can now type in text, scan in visuals, and access the Net, placing messages online, which can globally be seen on the World Wide Web and downloaded by others.

The Internet is a new kind of public space. Communication technologies, for interactively distributing information in development since the seventies have expanded, creating a new moment when widespread access and use of the Internet with its quickening development of on-line information services is allowing major cultural communication to take place alongside the commercial marketplace. We are experiencing not a computer revolution, but rather a communications revolution. Without a direction for it, we are moving into uncharted territory which holds great promise but presents great challenges.[2]

This convergence of television and telecommunication technologies with interactive computer technologies is creating a new form of representation which inhabits a kind of virtual space. It subsumes and includes the vocabularies of all earlier art forms as well as the new modalities of completely simulated images.

Artists have been pioneering work on-line from the beginning. How their work is seen and how it is produced is being utterly redefined by the development of the Internet and of the World Wide Web (itself a major subset of the Internet). The premise of display and of representation as we know it has been deeply challenged. This new medium of art as communication matters because it defines a new arena of consciousness and feeling. It is deepening the challenge to artists struggling to connect visible to invisible, to create works of independent witness, and to articulate meaningful responses to contemporary life.

The Global Network as a Web

"Information Super Highway" (some call it the "Eye-Way" or "I-Way") was one of the first potent metaphors for this global information network.[3] It was thought of as a massive on-line road system complete with freeways, feeders and local routes accessed anywhere. The access is through computers connected at each intersection, and capable of transferring information from country to country through telephone modems. An international method for handling information, it has the capacity to transmit electronic mail and has created communities of people who communicate in the "virtual cyberspace" of their computers.[4] The amount of free access information carried on the "highway" is staggering, although this will change as it comes more and more under the domination of market interests which are gearing up to exploit it as a major new area for commercial development.

Another metaphor for the Net, described by Michael Benedikt in his book *Cyberspace* is more organic.

> From vast databases that constitute the culture's deposited wealth, every document is available, every recording is playable, and every picture is viewable . . . The realm of pure information, filling like a lake, siphoning the jangle of messages transfiguring the physical world, decontaminating the natural and urban landscapes, redeeming them . . . from all the inefficiencies, pollutions (chemical and informational) and corruptions attendant to the process of moving information attached to *things*.

By now, a more suitable metaphor has evolved. It is that of a network or web which is the infrastructure—the paths, interconnections, and points of intersection where telematic[5] communication takes place. A network is a phenomenon which links together a wide range of disparate entities. It has no

sides, no top or bottom. Rather, it is many connections that increase interaction between all its components. It is open-ended and nonconfining with no beginning and no end.

Interactive systems such as the Internet replace conceptual systems founded on ideas of center, margin, hierarchy, and linearity. The metaphor of a web replaces them with those of nodes, links, paths, networks. Roland Barthes speaks about the interactive nature of networks and their lack of hierarchy as a metaphor for the postmodern. Access is through several entrances without any one being more important than another (much like television). It has no beginning. It is conceived of as a series of networks and links. It is never closed, and is based "in a system of references to other books, other texts, other sentences. It is a node within a network. . . . (a) network of references."[6] Barthes' description of intertextuality in "From Work to Text" articulates the concept that a text is like a woven fabric. It is not only a coexistence of meanings but also a passage, an overcrossing. Thus, it answers not to an interpretation, even a liberal one, but to an explosion, a dissemination of meaning "in which every text is held, it itself being the text between another text." Knowledge no longer exists in fixed canons or texts with epistemological boundaries between disciplines but rather it exists as paths of inquiry seeking integration and meaning by passing through them without any precise limit or location, (Chapter 5).

Planetary Networks Sans Frontières

Art on the Internet has little history and no cultural baggage. Its aesthetics are as yet undefined. It is like delving into a strange new world. Without a known direction, over the years, especially from 1977 onwards, artists with a utopian concept of a global culture pioneered it by collaborating between North and South American, Asian, and European cities to create interactive telecommunications activity in the arts.

Roy Ascott, one of the earliest pioneers of "telematics" speaks of global interactive communities as "a set of behaviors, ideas, media, values and objectives that is significantly unlike those that have shaped society since the Enlightenment. Whole new cultural configurations will bring about change in art practice, forcing new strategies and theories for art; creating new forms of display and accessibility; and developing new networks where exchange and learning can take place." His point is that "meaning is created out of interaction between people rather than being 'something' that is sent from one to another." Communication depends not on what is transmitted but "what happens to the person who receives it. And this is a very different matter from 'transmitting' information."[7] There is a difference between information and experience. He calls attention to what seems to him a now obsolete distinction between artist and viewer and calls for a composite construction in which viewers are participants in an inclusive system for creating meaning. For him, Art = Communication.

Figure 132. Roy Ascott, *View of the Laboratory UBIQUA*, 1986. Planetary networking and computer mediated systems, Venice Biennale. Based on the principle that each computer interface is an aspect of the unity of all the others which are connected to it in a network. Ascott coined the term "holomatic" to describe the phenomenon. Data exchanged through any network access point is equally and simultaneously held in the memory of the entire network. It can be accessed through cable or satellite links globally from anywhere, any time. A wide range of telematic media was used, including e-mail, videotex, slow-scan TV, and computer conferencing. This holomatic principle was well demonstrated by the "Planetary Network" project during the Biennale where the flow of creative data generated by the interaction of artists networking all over the world were accessible everywhere, not only in the rarefied elite atmosphere of the exhibition site itself. UBIQUA opened up the idea of the immediacy of global exchange in the arts. *(Courtesy Roy Ascott)*

One of the most compelling early art projects on the Net was *La Plissure du Texte: A Planetary Fairy Tale* conceived by Ascott as a homage to Roland Barthes's *Le Plaisir du Texte* as a project for the Electra exhibition at the Musée D'Art Moderne in 1983. It was designed as a way of involving groups of artists located in eleven cities around the world[8] in the creation of a text. "Each group represented an archetypal fairy tale role or character: Trickster, Wicked Witch, Princess, Wise Old Man, and so on."[9] The story unfolded as the group typed in text at terminals (located in public places), from the point of view of their assigned roles. Each day, the theme would be addressed as it developed from previous entries. Because each computer terminal was linked to data projectors located in the same space with the audience at the museum or gallery, the text could be seen and read. The public was able to contribute to the fairy-tale through keyboards available at different locations. "Many layers of meaning from diverse

sources became embedded in the text; a feast of cultural allusions, puns, flights of imagination and political criticism in an unpredictably meandering and branching story line were pleated together for this *Plissure du Texte.* Often the text was ingeniously manipulated to create simple visual images as well."[10]

In another large Internet project for the 1986 "Art, Technology and Computer Science" section of the Venice Biennale, Ascott acted as one of four curators, along with Don Foresta, Tom Sherman, and Tomaso Trini who were appointed as International Commissioners. The project included over one hundred artists dispersed throughout three continents. Organized through an extensive electronic mail network, the project used a digital laboratory UBIQUA, which included interactive video disc works, personal computers with paint systems, and cybernetically controlled interactive electronic structures and environments. The interaction of artists generating a flow of creative work from all over the world had the effect of releasing the exhibition from its rather rarefied and elite domain in Venice, by contextualizing it in a wider sphere.

Figure 133. Roy Ascott, *Organe et Fonction d'Alice au Pays des Merveilles,* 1985. Videotex from the *Les Immatériaux* exhibition, Centre Pompidou, Paris. *La Plissure du Text* was a creative action of "dispersed authorship," a fairy tale based on Lewis Carroll's *Alice in Wonderland.* It involved a network of orthodox computers and keyboards. The many participants on the line throughout America, Europe, and Australia (both artists and public) became involved in the layering of texts based on the original concept of Alice in a strange new world and in the semantic ambiguities, delights, and surprises that can be generated by an interactive authorship dispersed throughout so many cultures in so many remote parts of the world. The text was projected by a data projector, dramatizing the presence of the project—a demonstration of the "immaterial" concept of the exhibition (see chapter 5). (*Courtesy Roy Ascott*)

In the best sense, these projects reflect a playful and open attitude to interactively negotiate with other minds and sensibilities through a process of participating in a diverse intertextual play of different personal, social, and geographical concerns.

The Image as Place

Since 1975, collaborative artists Kit Galloway and Sherrie Rabinowitz have focused on researching, exploring, experimenting, and developing alternative structures for video and TV as an interactive communications form. As early as 1973, Galloway became interested in live television and its real-time technology as a communications system which could support live performance and conversations between sites internationally. Performances between artists in different countries took place in a special composite-image space he had invented. Live images from remote locations could be mixed at each receiving location so that performers could be seen on the same screen with their partners dancing together in "virtual" space. This is an exploitation of the phenomenon of the power of communication technologies to be able to mix spaces or exchange spaces as a new kind of collage.

> The video image becomes the real architecture for the performance because the image is a place. It's a real place and your image is your ambassador, and your two ambassadors meet in the image. If you have a split screen, that defines the kind of relationships that can take place. If you have an image mix or key, other relationships are possible. So it incorporates all the video effects that are used in traditional video art, but it's a live place. It becomes visual architecture.[11]

Together, these pioneers created major projects over the years, including the *Electronic Cafe* concept which began in 1984, and has operated internationally out of sites in Europe, the United States, and Asia. For the 1984 Olympic Arts Festival, the group designed a project based on "the concept of a new electronic museum, a way to link people, places, and art works in an electronic environment."[12] The Museum of Contemporary Art in Los Angeles officially commissioned *Electronic Cafe* to "link MOCA and five ethnically diverse communities of Los Angeles through a state-of-the-art telecommunications computer data base and dial-up image bank designed as cross-cultural, multilingual network of creative conversation. From MOCA downtown, and the real cafes located in the Korean, Hispanic, Black and beach communities of Los Angeles, people separated by distance could draw or write together."

By 1989, the *Electronic Cafe* opened a global-scale multimedia teleconferencing facility in Santa Monica, California. This project supports artists' networking but does not feature an ongoing on-line network. Instead, in a cafe

Figure 134. Sherrie Rabinowitz and Kit Galloway, *Satellite Arts Project: A Space with No Geographical Boundaries.* 1977. Virtual Space. The world's first interactive composite image satellite dance performance. The dancer on the far right, Mitsouko Mitsueda, was at NASA Goddard Space Flight Center in Maryland, and dancers Keija Kimura and Soto Hoffman were in Menlo Park, California. Their electronically composed image appeared on monitors around them. Through the live image, they could see, hear and appear to touch each other. *(Courtesy Sherrie Rabinowitz and Kit Galloway)*

cabaret setting, it promotes interactive events such as tele-poetry, tele-theater, tele-dance in exchanges between artists in more than sixty locations world-wide[13] using video, fax, audio, e-mail, and computer driven telecommunication technologies.

It is difficult to imagine now, as we easily tune in to the World Wide Web, the enormous difficulties faced by the early communications pioneers. They are committed to the role that artists have to play in the use of telecommunications technology—"so that we don't just end up as consumers of it." The technology of the Electronic Cafe is configured "to build a context in which artists could experience new ways of collaboration and co-creation, with geography no longer a boundary." Dance, music and performance art proved to be popular forms being beyond the need for language or translation. Teleconferencing equipment transmits near-TV quality audio and video with little time lapse. The more low-tech videophone line provides small black and white images that move slowly every three seconds. Now CU SEE ME software allows for the immediacy of video capture on the World Wide Web from real time performance.

Figure 135. Sherrie Rabinowitz and Kit Galloway, *Electronic Cafe*, 1984. Commissioned as an olympic Arts Festival Project by the Museum of Contemporary Art (MOCA), Los Angeles, *Electronic Cafe* was inaugurated July–September 1984, and was called "one of the most innovative projects" of the Festival. *Electronic Cafe* linked MOCA and five ethnically diverse communities of Los Angeles with a multimedia network including a computer data base and dial-up storage and retrieval image bank designed as a cross-cultural, multilingual network for "creative conversation." From MOCA downtown, and the real cafes located in the Korean, Hispanic, Black, and beach communities of Los Angeles, people separated by distance could send and receive slow scan video images, draw, or write together with an electronic writing tablet, print hard copy pictures with the video printer, enter information or ideas in the computer data base and retrieve it with Community Memory keyword search, and store or retrieve images on a video disk recorder which held 20,000 images. *Electronic Cafe* ran six hours a day, six days a week for seven weeks. (*Courtesy Sherrie Rabinowitz and Kit Galloway*)

Global Disco

Live via satellite from New York, Paris, and San Francisco in 1984, Nam June Paik's interactive television broadcast *Good Morning Mr. Orwell* was seen throughout the North American continent, Europe, Japan, and Korea as a form of what he termed "global disco." The piece, a collaboration of many artists and broadcast facilities, was meant to refute the "Big Brother Is Watching You" auguries made famous by George Orwell's *1984* as they relate to media. Paik explains: "Orwell only emphasized the negative part, the one-way communication. I see video not as a dictatorial medium, but as a liberating one. That's what this show is about, to be a symbol for how satellite television can cross international borders and bridge enormous cultural gaps . . . the best way to safeguard against the world of Orwell is to make

this medium interactive so it can represent the spirit of democracy, not dictatorship."[14]

After a three-year process of assembling the necessary international funding and sponsors, Paik masterminded a complex program that mixed diverse aesthetics—pop and the avant-garde, superstars of rock-and-roll, comedy, avant-garde music and art, performance artists, surrealism, dance, poetry, and sculpture. John Cage played amplified cacti, Laurie Anderson presented her new music video, Charlotte Moorman performed on Paik's TV cello, surrealist painter Salvador Dali read poetry, and French pop star Sappho sang "TV will eat our brains." Host George Plimpton presided over the array of global interactive events with all the aplomb of an avant-garde Ed Sullivan despite technical hitches as a result of the show's "live" international satellite format.[15]

Paik's decision to create a live interactive broadcast which challenged technological structures derives not only from his knowledge of the medium and what it represents, but also from his usual risk-taking sense of fun. "Live TV is the mystery of meeting onceness." Paik's excitement about global satellite communications as a real time live international performance work is also found in works by other pioneers such as Douglas Davis[16] and Don Foresta, who have used real-time television broadcast systems as a locus for their work.

Figure 136. Sherrie Rabinowitz and Kit Galloway, *Midi Mac Music and Dance*, 1984. Pioneering computer musician Marc Coniglio and Dancer Dawn Stopiello team up to create *Tactile Diaries*, an interactive videophone dance performance with partners in New York City. Stoppiello wears the small telemetry device which controlled the music, lighting, and the transmission of her image. (*Courtesy Sherrie Rabinowitz and Kit Galloway*)

Art = Communication

Creative networking involves explorations of community-building, cross-pollination of user interaction on the virtual space of the Internet, and the building of links between communities previously unable to communicate with each other because of language or other difference. Telematic art can create "operative new realities. It's meaning lies not in what it is, (identity or objectification) but what it effects. Ideas gain validity in their practice, use and integration into the ecosystem."[17]

The Art Com Electronic Network (ACEN), originally conceived by Carl Eugene Loeffler and Fred Truck,[18] evolved as a communications network in the years 1986 to 1990. Based originally in the imperatives of the magazine *Art Com*,[19] it gradually "evolved through the process of investigating the constructs and geographies of a working system of communications media defined by its users and the scope of its distribution axis." ACEN has become an ongoing organic process of creating cultural formation with the emphasis on participation, "Art = Communication." To the extent that technological tools can generate a more participatory culture, through, for example, shared story-telling and community building, these processes can engage the collective imagination.

Art in Cyberspace

Those artists committed to pioneering this new space speak in the sense of art as connectivity and of art as communication and of an emerging "telematic culture." Interactive telecommunications systems do empower the individual to connect with others globally and vastly increase the possibilities for inventing expanded forms for art. Artists' involvement is vitally important in humanizing and extending the new technologies in directions ignored by the marketplace. There is a vital need to explore and to take responsibility in critiquing the excesses of this updated system of representation.

Use of new technologies by artists are creating an amalgam of new forms. These include satellite transmissions, on-line network programs, fax projects, interactive computer and video works, and virtual reality projects.[20] Increasingly, technological development in electronic media have led to opportunities for interactive global dialogue where work can be shared in a larger cross-cultural community than through the confines of the gallery and museum system. There is also a rapid shift going on within the media themselves. For example, in a 1984, International project called *Electronically Yours* undertaken by CAT (Collective Art × Technology)[21], artists images were networked back and forth by fax between Morocco, Vienna, Toronto, San Francisco, and Japan. Receivers would add to the textual messages or images and send them on. Fax provided an immediacy that mail-art, its predecessor could never provide. Now however, communications on the Net goes a step further in immediacy—providing the

possibility of E-mail, teleconferencing and of exhibiting images and browsing through images organized in museumlike spaces. How can activities like these be named under old art categories?

Artists choosing to work with telecommunications do so because they enjoy experimenting. They often choose subjects which focus reflexively on the inherently structural aspects of their medium such as exploiting concepts which focus on the interdependence of world communities. Artists in five different countries might collaborate on a drawing that is downloaded and embellished at websites in each country; participants in a global on-line electronic mail conference are invited to share views about on-line artworks; via videophone, artists in art cafes in three different cities participate in a tele-performance opera. Artists often critique manipulation of the public mind through information manipulation itself. They invent ways to hook browsers into looking at their work as a way of entering people's living spaces. Another format is to play with the idea of anonymity as a structure—for telecommunications makes possible a special kind of interaction and experimentation in which, since we can't see others, we are forced to form a picture of them based on limited information. For example, a man threatened by the reality he inhabits may want to see what it's like to portray himself as a woman—old, young, black, white, or yellow. What kind of responses would he receive from other males (or females) as a method of expanding his understanding through play-acting?

Communication on the Net allows the participant to be invisible and anonymous. Because at this time, it is primarily a text-based medium, a psychological level of imagination and fantasy is released. In a sense, fantasy becomes part of representation. Some feel the Internet acts as a mirror where incarnated bodies float as avatars of other kinds of beings. For many, it is recreational, and fun to meet others also "surfing the net," to converse in its "Chat" Rooms or leave messages on its USENET billboard or Listservers. This new deeply psychological interactive medium is now unleashed through links to more than forty million possible participants. No one can yet gauge the undefined cultural implications, (although Congress attempted to enact a law against pornography on the Web in 1995). Today's inhospitable climate for free speech has extended to cyberspace the struggle to maintain first amendment rights. Understanding cyberspace is a way of understanding inner space as much as outer space.

CyberSpeare, a hypermedia adaptation of Shakespeare's *Midsummer Night's Dream*, produced by Marah Rosenberg and Hal Eager, was a multimedia performance which took place over the Internet in 1995 from their site at Purchase College, State University of New York. Out of their discussion about the increasing popularity of electronic escapism on the Internet, they made the connection to Shakespeare's play about the escape of urbanites to build a fantasy world in "The Woods" (which, in their production, became Cyberspace). The players created their own electronic identities or Cyber Egos as a "Home

Page" designed to personify their character in the play. The pages also represent their needs, wants, and desires as fulfilled by technology in an electronic universe. The concept of the project was to connect the audience as interactive participants via technology in the unfolding of the play. The hypermedia version of the play took advantage of the actors' familiarity with the IRC (Internet Relay Chatline) as well as their personal experience with technology to develop the rules and the script. The play was presented as both live performance and as "Home Page" sites in a computer laboratory. "Home Page" files on each of the characters could be opened for the exploration of a range of background material about each one as the actor performed amid the audience. The live computer performance was video taped using CU-SEE ME[22] software developed at Cornell University for uplink feed to the Internet.

CU SEE-ME software transmits live digitized video. Lowery Burgess, faculty member at Carnegie Mellon University, used CU SEE-ME as a means for live video performance works between as many as five sites including New York, Montreal, Vancouver, Syracuse, and Paris. According to Burgess,

Figure 137. Paul Sermon, *Telematic Dreaming*, 1992. Interactive Telematic Installation. In this work, Sermon exploits the bed as a heavily loaded object, rich in metaphor, meaning, fantasy, and dream—a psychologically complex object. Cameras at two locations point at two different beds and the two participants lying on them, generating live video feeds that are then mixed and projected on each bed surface next to the participant at each location. Sermon's exploitation of such a culturally loaded subject completely transcends the lowly technology of teleconferencing which is the basis for the transmissions. (*Courtesy Paul Sermon*)

Figure 138. Paul Sermon, *Telematic Vision*, 1993. Interactive Telematic Installation. This kind of intimate site, a couch, or a bed, is what creates endless opportunities for viewers to interact by moving close, shaking hands, cuddling, or employing other forms of inter-personal communication with someone who exists only as a projection or on a screen. Attracting lively attention wherever the works are sited, with line-ups of people who want to "play," the work raises the question of whether there is a boundary between art and techno-entertainment. (*Courtesy Paul Sermon*)

"The formal structure of our space-time experiences were extremely volatile impacting directly on the real-time presence of the performing artists in exciting and provocative ways, creating a condition that no one had ever experienced before in any other medium. Performance time and network time is interacted in such a way that an event which in performance was very fragmented and disconnected, was smooth in performance, and things which seemed smooth in performance often became disrupted and incoherent on the Net. Each event created a social heat that was seen as unique."[23]

One thing the group noticed was the soft focus effect which created a kind of shallow bas-relief.

A sense of abstraction or disengagement from the pixillated surface. . . . that activates this shallow space as if it were a thin lens with its own optics and expressional power . . . At the other extreme, the integration and rebroadcast of pre-packaged tapes and images brought to them a new romanticism, an interesting and nearly mythic nature. . . . in all, attracting and embedding the body and mind in a larger symbolic play.

In his experiences with use of technology with his students, Burgess is intrigued by the new kinds of multinodal and synaesthetic relationships that can arise from new types of electronic network interactions and transactions. Interaction and interconnectivity leads to hybrid forms that grow out of creative experiences with conceptually organized Internet projects.

A further example of live imagery being uplinked to the Web is *Alice Sat Here*, a collaborative project by Emily Hartzell and Nina Sobell in conjunction with computer scientists and engineers from New York University's Center for Digital Multimedia. On entering the gallery, the live viewer is invited to sit on a motorized throne which has a tele-robotic eye mounted on it. The viewer navigates within the gallery—or in the street—by steering the vehicle. The goal of the piece is to route what a tele-robotic videocam "eye" directly sees to a page on the Internet. This "in effect" turns the Web inside out to create a real physical 3-D space which Web-users can explore through a collaborative navigation with people who are actually in that place. What this "eye" sees is monitored and controlled by the viewer on the Web. Passers-by on the street are able to interact in this process of pointing the camera through a touch screen system surrounding a monitor located in the gallery's front window. A combination of software and hardware are used to create an interface which gives to Web-users control over an aspect of this physical environment. Feedback comes through the use of video monitoring which shows physical visitors the shape of the piece.

These artists have committed themselves to a live performance each Monday on the Web, using their interactive equipment. The "Alice" of their title, referring back to Lewis Carroll, suggests perhaps, "Alice in Cyberspace"?

> Alice opened the door and found that it led into a small passage, not much larger than a rat-hole: She knelt down and looked at the passage into the loveliest garden you ever saw. How she longed to get out of that dark hall, and wander among those beds of bright flowers and those cool fountains, but she could not even get her head through the doorway; "and even if my head *would* go through," thought poor Alice, "it would be of very little use without my shoulders. Oh how I wish I could shut up like a telescope! I think I could, if I only knew how to begin." For, you see, so many out-of-the-way things have happened lately that Alice had begun to think that very few things indeed were really impossible.

High Resolution Video on the Net

Wax: Discovery of TV Among the Bees by David Blair was one of the first feature-length fiction videos that went out over the Internet. *Wax* gained considerable attention through the on-line exposure and discussion. Blair believes that this is just the beginning of major future possibilities to be realized: "Everything you do with imaging, you do with text first. Look at MUD's and MOO's (see Footnote 4), these are multiuser text tools. When you add video it becomes multimedia."[24] Its original exposure was as part of a multiuser MOO site which

Figure 139. Emily Hartzell and Nina Sobell, *Alice Sat Here*, detail, 1995. Parked at the Gallery entrance, a wheeled "throne" with its telerobotic camera mounted on the handlebars is available for gallery visitors who navigate through space with the help of "virtual" participants on-line. They may use it either to ride through the exhibition or into nearby streets. (*Courtesy Emily Hartzell*)

provided the work with a large forum for its ideas. When it was broadcast over MBONE (for "multicasting backbone") the video was carried in a live, sophisticated, continuous multicast requiring extraordinary global bandwidth, which is available so far only on NASA's space shuttle feed, the Internet's digital-video channel. Only about ten or twelve research lab sites—Australia, Finland, and the U.S. West Coast tuned in to the first video Netcast. So far unavailable to regular household feeds because neither telephone or cable lines can yet offer the information bandwidth to act as carriers,[25] MBONE connections are currently only available through several thousand university centers and university labs, the most important sites located along the Internet's backbone. Reception for the digital video can only be received through a powerful workstation. Originally designed as a multicasting video conferencing tool, MBONE allows

Figure 140. Emily Hartzell and Nina Sobell, Images from *Park Bench performances Archive*, 1995. Informal real-time performances beamed on-line to the World Wide Web take place via CU-SEE-ME Software every Monday night at Hartzell and Sobell's studio located within the robotics department of New York University. In order to view previous performances, viewers on-line may choose one from this screen menu archive of images using a "browser" that supports moving, "dynamic documents." (*Courtesy Emily Hartzell*)

users to call up multiple video windows at the same time. This system offers a fascinating glimpse of what the future may hold when individuals may see each other in the same data base and share images.

Opening Out

The potential of the new technologies is toward interaction and communication—the kind of inclusivity which encourages global exchange through which fresh insights can evolve through experimentation with diversity and difference. When the technology of film was developed, Walter Benjamin wrote that it had the effect, similar to the Internet, of assuring us of an "immense and unexpected field of action."

> The film, on the one hand, extends our comprehension of the necessities which rule our lives; on the other hand, it manages to assure us of an immense and unexpected field of action. Our taverns and our metropolitan streets, our offices and furnished rooms, our railroad stations and our factories appeared to have us locked up hope-

Figure 141. Eduardo Kac, and Ikuo Nakamura, *Essay Concerning Human Understanding*, 1994. Interspecies telematic interactive installation. In this collaborative work, technology is used to question the nature of communication between species: interaction between a plant and a bird is presented as a dialogue which is as unpredictable as human communications are. A canary in a tall white cage located in Kac's installation at the Center for Contemporary Art in Kentucky sings in response to the electrical fields of a plant which have been converted to sound at the Science Center in New York. The bird's response is transmitted back as electrical fields the plant can sense. Just by standing next to the plant and the bird, humans immediately altered their behavior and begin a new round of interaction. The piece about an isolated caged bird having a telematic conversation with another species acts as a vivid metaphor for the role of telecommunications in our own lives. (*Courtesy Eduardo Kac*)

Figure 142. Eduardo Kac, and Ikuo Nakamura, *Essay Concerning Human Understanding*, 1994. Interspecies telematic interactive installation.

lessly. Then came the film and burst this prison-world asunder by the dynamite of the tenth of a second, so that now, in the midst of its far-flung ruins and debris, we calmly and adventurously go traveling. With the close-up, space expands; with slow motion, movement is extended. The enlargement of a snapshot does not simply render more precise what in any case was visible, though unclear: it reveals entirely new structural formations of the subject. So, too, slow motion not only presents familiar qualities of movement but reveals in them entirely unknown ones "which, far from looking like retarded rapid movements, give the effect of singularly gliding, floating, supernatural motions." Evidently a different nature opens itself to the camera than opens to the naked eye—if only because an unconsciously penetrated space is substituted for a space consciously explored by man."[26]

Today's communications open to a global network. Those who can access the technology are in daily contact with a far wider world than that afforded by film. The new telematic technologies are not just extensions of other existing media, but rather they support a new open-ended field of creative endeavor, one which is without an aesthetic of closure and completeness and which is all flux and flow in its holistic potential. Roy Ascott describes it:

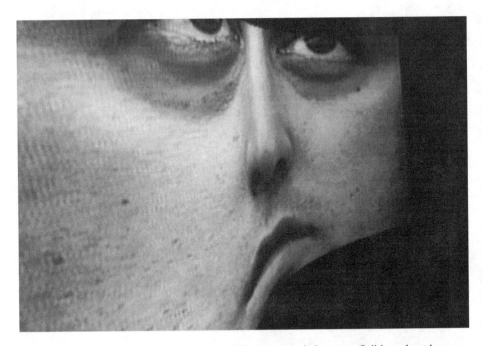

Figure 143. David Blair, *Wax, or the Discovery of Television among the Bees*, 1994. Still from the videotape. *Wax* was the first feature-length fiction video that went out over the World Wide Web's digital video channel called M-BONE (multicasting backbone). This feed orginates with NASA's space shuttle and cannot be accessed with a phone connection because it requires the type of receiving bandwidth and software available only through some universities and research labs. (*Courtesy David Blair*)

The essence of the interface is its potential flexibility; it can accept and deliver images both fixed and in movement, sounds constructed, synthesized or sampled texts written and spoken. It can be heat sensitive, body responsive, environmentally aware. It can respond to the tapping of feet, the dancer's arabesque, the direction of a viewer's gaze. It not only articulates a physical environment with movement, sound, and light; it is an environment, an area of dataspace in which a distributed art of the human/computer symbiosis can be acted out, the issue of its cybernetic content. Each individual computer interface is an aspect of a telematic unity such that to be in or at any one interface is to be in the virtual presence of all the other interfaces throughout the network of which it is a part.[27]

An On-Line Electronically Produced Public Artwork

An on-line, electronically produced artwork is synonymous with it being transmitted and disseminated like television. But it is completely different from television because of its interactive potential. It can be accessed as part of an electronic network where the outcome is a kind of sharing and join-in-the-dialogue impulse. Such accessibility changes the work itself because it must be created with a broader audience in mind, one which is larger than through conventional exhibition possibilities.

Sherrie Rabinowitz, comments that the implications of the new technological conditions are that we must begin to imagine a much larger scale of creativity—one which opens to the possibility for new communication across all disciplines and boundaries. Linking this idea of using the interactive potential of the medium to empower other people instead of one's self creates a powerful opening for a new role for the artist and a new kind of public art—one with all the constraints and freedoms to communicate within a wider sphere. It implies a new way of being and communicating in the world. Viewers become collaborators in an interactive dialogue, adding notes, drawings and comments at the site of the exhibition or printing out sections of images or texts for exchange or discussion. It can act as an enormous bulletin board—a space where communication takes place.

"The File Room," an ongoing project about censorship by Antonio Muntadas inaugurated in May, 1994, was one of the first art works on the World Wide Web. This important historical work takes the form of a cultural archive of censorship infractions from the time of the ancient Greeks. It opened with over 450 well-researched entries. Members of the public daily add new entries to its interactive data base on-line including current harassment around religious, intellectual, and sexual orientation. Current, as well as historical issues are being documented. Over two hundred visitors to the site each day also find links to directories of information about free speech organizations like the American Civil Liberties Union. Muntadas' determination to move his work from its original form as an installation[28] at the Chicago Cultural Center to

exploit the Internet as a vast information resource reflects his interest in using communication systems to decentralize and subvert power structures. In early notes about the project, he referred to it as a social sculpture à la Joseph Beuys which "gains its meaning through a group effort of individuals, organizations, and institutions." The site allows, for example, anonymous documentation of offenses by totalitarian regimes, some of which are still in power.

The impulse to create art to involve the public is very different than merely placing artwork on the Net. Such Internet exhibition activities do allow artists to bypass cultural gatekeepers. Some service providers charge galleries for "posting" art on their site. Exhibitions of conventional art work have been placed in Websites on the Internet and can be down loaded through a normal computer printer. This may include the artist's bio and price list for the original. These conditions are rapidly becoming the norm in everyday cultural practice.

Limitations and Difficulties of Creating Visual Works for the Net

The limitation of the Net is that it doesn't yet allow the production of a richly visual art. As the technological infrastructure improves, this issue will gradually be addressed. For the average consumer not yet able to access the wide-band lines it is still basically a text-based medium tied to the speed of transmission through telephone lines. This communication problem will be resolved when domestic telephone lines are converted from copper wire to cable, satellite-dish or optic-fiber. (See Note 25) Greater image compression is another vital technical consideration which could affect better image delivery in the future. Loading up images, which need a greater amount of information space on-line than for text, has forced artists to evaluate options regarding the quality of their visual images and the way they are used. Because they are being viewed on a relatively small monitor between the screen's control bars top and bottom and scroll bars on the sides, the visual images are necessarily small and difficult to "read" unless they are prepared graphically with this in mind. The artist may decide that the "loading" speed of work is a paramount issue and reduce the amount of resolution information to the minimum by assigning more text and fewer images with fewer dots per inch resolution or creating in black and white. Since the work is interactive and nonlinear, the artist must create a construct of the page unfolding process and the dynamics of the paths or links for the viewer to travel on, linking them with each other or with other sites.

The "Home Page" of an artist, an introductory screen with graphics and text resembling a kind of magazine, may contain an interactive art work linked to information about past work, resumes, and reviews. Thus, the art work has a close relation to other information. Both reside in the same data bank simultaneously, raising questions about the relationship between the artwork and its ancillary links. In my own 1996 work, I found that this strengthened my original museum project about domestic violence by providing the possibility of access and links

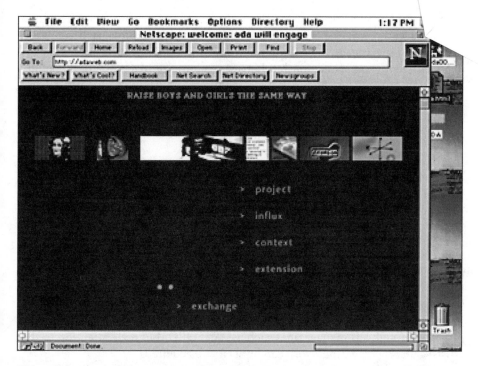

Figure 144. Jenny Holzer, *Raise Boys and Girls the Same Way* 1995. *äda'web* screen page format for her World Wide Web project. The goal of *äda'web*, a Website devoted to exploring and developing the possibilities for defining the parameters of the World Wide Web as a laboratory for artists to reflect on the definition of a new vocabulary of forms and ideas. Named after Lady Ada Lovelace, daughter of Lord Byron, who with Sir Charles Babbage was instrumental in discovering early concepts about computing, *äda'web* invited Jenny Holzer to be one of the first artists to create a work for its Website. (*Courtesy äda'web*)

to additional information about statistics, resource centers, and action groups, plus an interactive site at which stories and drawings from the participants could reside. I could thus expand my multimedia work originally intended as a Museum installation by redesigning it as a Website project for public interaction. Anyone wishing to acquire information and images from the site could down load them through a regular printer. Once the structure and imagery has been determined, it is programmed and coded for the uplink to the World Wide Web.

Due to her art star status, Jenny Holzer's äda'web project, "Please Change Beliefs" helped to generate a great deal of interest in art on the web when it was announced in June of 1995. In this repurposed, text-based conceptual work with strong social commentary, she invited web participants to access and respond to her "truisms"—statements she has used as a mainstay of earlier work originally meant to be placed in the street, in the public eye. Julia Scher's work at the same website compellingly makes us realize that we can also be watched from the Web itself via CU SEEME software and the robotic eye.

Like other sites for artists on the Web, (such as **Artnetweb**, and **The Blue Dot**), äda'web provides a forum for artists to create digital projects. It is a Web-site devoted specifically to exploring new forms of visual creation and to engaging a different type of relationship between cultural production and its public. Its mission states "The site functions as a laboratory, documenting an ongoing thinking process." It works with artists to explore the Internet as a new medium and participates in its artistic definition. It offers web site visitors exposure to the evolving ideas of the artists and the creative process.

The Arts and Libraries Go Global Via the World Wide Web

Artists are democratically free to enter the Web through any number of "Web Servers" which feed the World Wide Web (WWW). However, finding Servers which are connected to arts projects helps to define specifically a community which can more easily be found and accessed and where its cultural context combats the commercial aspects of the Net.

The downside of this is the possible creation of an infrastructure for art in Cyberspace which resembles the prevailing Earthbound system with all its power structure intact. For example, galleries are now promoting their artists' projects through ads in magazines such as *ARTFORUM* to draw attention to the artists' gallery where other work can be seen and acquired.

What we are experiencing as a result of the expansion of the WWW into networks of users who can now tap into a vast range of information directories, resources data banks of all kinds, cultural archives, international library holdings, is a reinvention of the intellectual community (and, at a different level, that of popular culture and business communications and exchange). The Net has become a lightning rod for issues raised by electronic technologies—how we as individuals, communities, and nations, use them—"by what rules, toward what ends, under what conditions knowledge will circulate and be exchanged in the modern world."[29] These questions have less to do with actual technology itself than with the negotiations regarding forms that knowledge can take and the methods of exchange to be used.

Within the new interactive operative structures of change is a recasting of the notion of artist and viewer. The viewer can now access not only the artwork one has chosen, but other linked works and related information in the form of art histories or related stylistic influences and can leave margin notes for others to see as a contribution to the piece. In the Internet, we have the commingling within a vast global community of international resources of both high and low cultural appeal. Some see the screen as a linguistic leveling device which flattens and devalues the use of language. Others see a rich evolution of language occurring on the Web, not as it evolves in novels but as an experience of communication beyond the usual hierarchies of mediated publishing. John Barlow comments: "The Internet is CB radio only typing"—a form of private communi-

Figure 145. The X-Art Foundation, *Blast 4: Bioinformatica, Parangole,* 1994. Collector's vehicles, Interface Installation: Sandra Gering Gallery, December 1994 to January 1995. In the gallery, visitors wearing vividly colored capes (parangoles) can engage with participants in an on-line cyber-gallery known as a MOO (see footnote 4) which includes a "lobby," a "gallery," and a virtual "poet's coffeeshop" where different kinds of discussions can take place. An oversized projection of the computer screen on a gallery wall facilitates real-time enteraction via keyboarded messages—or at least viewing—by more than one or two visitors at a time. (*Courtesy Sandra Gering Gallery*)

cation—like whispering in your ear. It is language moving away from information and back to immediate experience. The reader of the text can now become the interactive maker of a text. The Internet is not like a book, its role is more to provide ephemeral, transitional communication.

On-line access to information places libraries in a position to be catalysts for change by affecting the way ideas are disseminated and how culture is made. The world's greatest libraries, such as the Bibliothèque de France, the British Library, and the Library of Congress, among others, share a great vision—to scan electronically books, once located in separate libraries, and to transmit them instantly over high-speed networks. Libraries are re-organizing and experiencing structural mutation. Barriers separating libraries by time, distance, and systems from each other are being dissolved. Internet Network terminals now allow access to thousands of libraries. The Library of Congress is there: containing more than twenty million entries; twelve to fifteen million items are now available from the British Library. The Bibliothèque de France will also allow researchers to scan information into their personal data bases. Scanned text on a small Macintosh Powerbook, for example, can be annotated

and indexed and searched in a variety of ways. Some predict that the paper book will be obsolescent by early in the twenty-first century as CD-ROMs, Interactive CDs, on-line periodicals, and computers screens take over.

> The potential loss of the book object, the disappearance of the author and reader as coherent imagined selves constituted through the stabilizing form of the bound book, the disordering of authorial agency in favor of an increasingly active reader (or alternatively, the empowerment of the "on-line" author in control of the uses and distributions of the texts), the displacement of a hermeneutical model of reading by one premised on absorption, the transformation of copyright into contract: all point to the subsuming fear of loss of community . . . Research in all disciplines will be based increasingly on the study of audio-visual documents, which, along with books, constitute objects of knowledge and of memory in their own right.[30]

Countering these fears is the promise of a wider readership, a more global community, where we use ways of communicating knowledge that are not just text-based but connect all the senses via multimedia environments where sound and visuals are summoned up with the text.

International Networks for the Arts

Because artists have a history of working cooperatively to share media arts data bases with information on grants, exhibitions, opportunities of all kinds, access to training, and gallery listings, Internet access has provided a major boon. It has been particularly valuable to those artists in countries such as Canada and Australia where disadvantages of geographical dispersion have been a problem. Often building on existing resources, the Net is now a major site for information exchange. For example, the **ARTSNET** electronic network facilitates teleconferencing amongst artists in Australia to over seventy other countries. Other Australian ventures include **CAAMA** (Central Australian Aboriginal Media Association) and **Murrimage** which utilize satellites that are concerned with cultural exchanges and the sharing and preserving of cultures. **CAAMA** was founded to provide access to media service for aboriginal people in order to record and keep alive aboriginal culture.

The Native American Share Art Project has an on-line gallery from which art work is available as Share-Art. The purpose of this project, which started in 1990, is the promotion and preservation of the culture of Native Americans and the heritage of the American West. Individuals can dial into and browse through the gallery of works. If they wish to download any of those displayed, they are asked to pay for the right. Eighty five percent of the sale goes to the artist.

Many other arts services exist on-line.[31] One of the most useful for American artists is **Arts Wire**—an arts news and information project of the New York Foundation of the Arts which began in 1991. Its goal is to be a resource that

artists and arts organizations can use effectively to communicate and to exchange information. **Arts Wire** hopes to "reflect the country's pluralistic culture by giving a voice to geographically dispersed artists and organizations . . . by providing a common intersection for this flow of information and ideas."[32] It has **Art-21 On-line**—a copyright-free zone where artists publish their writings directly for others to read on-line or to download on their printers. Arts Wire is coordinated from New York, Seattle, and San Francisco. Considered the largest arts network on-line, Arts Wire's importance as a vital information resource and a center for progressive cultural concerns will become even more important.

ECHO, originally developed by feminist Stacey Horn, is an on-line network that is accessible by direct phone line. Bulletin Board Services (BBS) formats allow users to post messages and conduct "on-line discussions within the confines of their servers, not unlike CHAT lines or USENET groups. ECHO has created an art community within itself which is important to a wide group as an exchange of ideas, friendship, and community spirit. The Whitney Museum of American Art in New York has selected it as a site for a discussion forum as well as for its Home Page. One of the oldest visual arts bulletin boards is "The Thing" where subscribers debate cultural theory.

In Great Britain, **ART NET** is a forum for the discussion of art that is concerned with networking, installation projects, and time-based arts. **ARELEC** is a French on-line Minitel videotex service that offers news about art and new technologies. The service is connected to **IDEA**, an electronic newsletter dealing with all aspects of electronic arts and professional mail.

Museums On-line: Will Anyone Come?

With more and more museums digitizing their collections for study purposes and as a catalog reference for the public, some museum professionals are fearful that the public will stop visiting museums in favor of accessing works of art on their home computers. Walter Benjamin observed that mechanical reproduction of a work of art changes a viewer's relationship to it. Most museums have embraced the new technology and younger directors scoff at the fear that virtual visits to their virtual museums on-line will supplant real ones. Director Maurer of the Minneapolis Institute commented: "They said the same thing about live concerts when hi-fi arrived and about sports when television came along. In fact, the opposite happened."[33] Reproductions of works of art tend to build an audience far beyond those lucky enough to own the original. In fact, the museums which embrace the new technologies do so in order to build audience. The Carlos Museum in Seattle, which opened in 1993 is the first to be built with computer wiring and was the first to go on Internet, offering images of some sixty of its works.

Museums and galleries, dealers and auction houses are linking up to the Web because it offers them international coverage. It is possible to see an

image, point and click and wait for it to appear, home-received, on-screen. While it is no replacement for the tactile experience of art objects, it's another way of engaging an audience and attracting more visitors. David Ross, director of the Whitney Museum says he hasn't been so excited about a project's potential since the 1960s. "This is where video art was in 1968. It's not going to change art or replace art. It's simply creating new ways of communicating about art in a new medium."[34]

The Web serves different needs for different participants. It offers commercial opportunities for artists, galleries, and collectors. One of the first pieces of Web Art *The World's Longest Sentence,* by Douglas Davis, was brought by New York collector Eugene Schwartz. The work, designed as a site where Web users are invited to keep adding to the sentence, is described ironically by Schwartz: "It's like buying an infinitely valuable piece of art that's for eternity."[35]

With public access to the Web surpassing the twenty million mark, art institutions see it as a way of expanding cultural consciousness. For the Dia Foundation and the Whitney Museum both on-line from New York, the Net provides a forum for artists to create digital projects especially for the Web and displays them on-line for periods of one to two months at a time. Laurie Anderson's *Green Room* has been displayed on the Whitney's site. At Dia's site, *Fantastic Prayers,* a collaboration by the writer and performer Constance de Jong, artist Tony Oursler, and composer Stephen Vitiello is a performance work adapted for the Web. It is a sophisticated melding of text, sound, and moving images about a fantastical place called *Arcadia.*

Museum and gallery websites allow millions of users to find out more about an institution's collections and public programs. According to Stacey Horn, ECHO is a bulletin-board service she describes as an electronic salon, which fosters on-line forums and discussions. "The potential of the Web is millions. If you have something generally cool, within a matter of days everyone around the world knows about it." Word travels fast in Cyberspace. The Museum has under development a comprehensive offering for users in the future to access selections from its permanent collection, including information not only about the scope of the selections, but also about particular artists and works. Eventually, the public will gain access to its archives as well as being kept up to date on its current offerings, with reviews of the works. Museums can talk to one another and users can talk to museums.

Pioneers of the new technology are finding it easy now to predict that one day images from the great museums will be available digitally on the bookshelf as a CD-ROM[36] or available on-line on the Internet. A viewer can already call up a Rembrandt or examine the pieces of a triptych by Van Eyck close up or call up a retrospective of Cézanne although the originals are literally oceans apart. Because the originals are digitized, the viewer can zoom in to explore the detail. This advance is of major interest to art historians conducting their research internationally. The Internet provides a medium of visual information

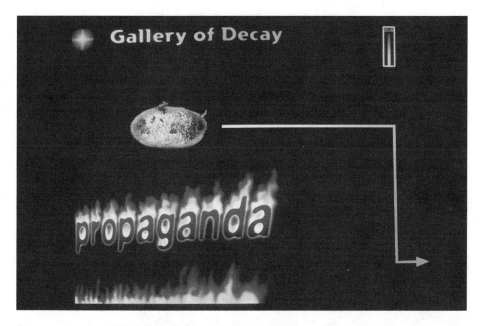

Figure 146. Lane Hall, *Gallery of Decay*, 1996. Website Home page. Interactive Website projects are nonlinear, text-based, image mapped structures which inherently allow the opportunity for setting up links with external sites of common interest. One day, the artist received e-mail from the organizer of the "Potato Famine" site who had discovered the "Blood Potato" project in his *Gallery of Decay* site. He received permission from Hall to link it to his extensive international site created in commemoration of the 150th anniversary of the Potato Famine. (*Courtesy Lane Hall*)

as well as textual research exchange. Browser software makes this possible to access images in full color, with option to download images. This international effort is creating an extraordinary opportunity for art scholarship, for exhibition curating and catalog publication that will rival the impact photography has had on the study of art history. Museums wishing both to inform and interact with the public are already establishing on-line bulletin boards and calendars like the one presently available from the National Museum of American Art. The future effectiveness of museums to broaden and deepen cultural formation and exchange may depend on the WWW.

Interactive Telecommunications Force a Re-Evaluation of What We Have Learned from TV

Some see interactive technological potential, touted as the "extensions of man," as an essential blindness to the infrastructure of technocratic domination and as part of a naive belief in the neutrality of digital control. For critics of technol-

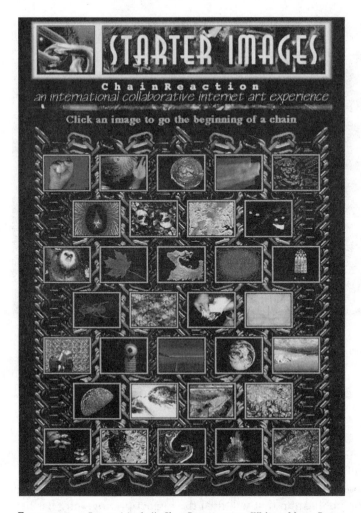

Figure 147. Bonnie Mitchell, *Chain Reaction*, 1995. Website Home Page. *Chain Reaction* is a World-wide collaborative chain art project that continually expands as individuals around the world participate. The project's foundation is based on a complex interface developed for the World Wide Web which includes numerous starter images and interactive methods for inputting information. Participants can download images from the World-Wide Web site, manipulate them, and then upload them back to the home site. The images are then connected back to the Chain via the *Collaboration Engine* and displayed as a link to the image from which it began. Any image can be manipulated by more than one person, thus creating extra links in the chain. As the chain progresses, the images continue to branch off and create a more diverse selection of images to manipulate. (*Courtesy Bonnie Mitchell*)

Figure 148. Muriel Magenta, *The World's Women On-Line!* http://www.asu.edu/wwol, 1995. Frame grab from the interactive animation promotion. This 3-D computer animation forms the backdrop on which the WWOL Internet images of more than 800 images by women artists are screened for public viewing. It was created on the occasion of the United Nations Fourth World Conference on Women in Bejing, China, 1995 as a tribute to the interest by women artists in the future of technological art forms. The work was produced under the co-sponsorship of the Institute for Studies in the Arts and Information Technology of Arizona State University with grants from MCI Telecommunications and the Nathan Cummings Foundation. (*Courtesy Institute for Studies in the Arts, Arizona State University*)

ogy such as Baudrillard, television "is a paradigm of implosive effects . . . it collapses any distinctions between receiver and sender or between the medium and the real . . . who are locked into an 'uninterrupted interface' with the video screen in a universe of fascination."[37] While Baudrillard enunciates the limits of the "society of the spectacle" and writes of the paralysis and unprecedented social contraction of capitalism's ability to expand, Deleuze and Guattari see it as a new phase of reorganization, a globalization of power interests where geographical borders no longer exist.

> Telecommunications is the new arterial network, analogous in part to what railroads were for capitalism in the nineteenth century. And it is in this electronic substitute for geography that corporate and national identities are now carving up. Information, structured by automated data processing becomes a new kind of raw material—one that is not depleted by use. Patterns of accumulation and consumption now shift onto new surfaces.[38]

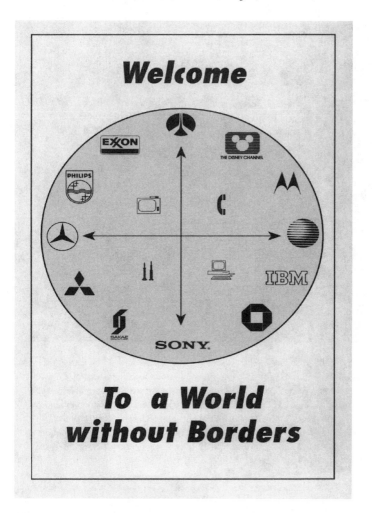

Figure 149. *Welcome to a World Without Borders,* 1994. Illustration from *Electronic Disturbance* by the collective Critical Art Ensemble, and published by Autonomedia. The publication announces itself as "anti-copyright 1994 Autonomedia and Critical Art Ensemble. This book may be freely pirated and quoted. However, please inform the authors and publishers at the address below: Autonomedia, POB 568 Williamsburgh Station, Brooklyn, N.Y. 11211–0568, USA, (718-387-6471)."

Jonathan Crary sees self-delusion in those who embrace communication technologies as positive and liberatory. He argues against the fictions, mystifications and bad faith of those who ignore the violence and immensity of the disequilibrium between the haves and have-nots that exist globally:

The cyberspace mirage of a fiber-optically unified humanity interacting electronically became a charged set of images and terms just as events on the eighties were disclosing an increasingly striated world—a world in which a mosaic of expanding populations and depleted localities has only obsolete or fractured routes, if any at all, into the planetary net of telematics . . .The sleek cyberdream of a collapsed global surface of instantaneity and dematerialization persists only by erasing the waking actuality of a world that is increasingly unliveable for most of its inhabitants.[39]

Andrew Ross and Constance Penley writing in *Technoculture* argue that technological innovation is so much part of the structure of society that it is co-opted into mainstream practice immediately. Carolyn Marvin argues that the history of electronic communication "is less the evolution of technical efficiencies in communication than a series of arenas for negotiating issues crucial to the conduct of social life; among them, who is inside and outside, who may speak, who may not, and who has authority and may be believed. She notes that the introduction of the telephone did more than enable people to communicate over long distances: it threatened existing class relations by extending the boundary of who may speak to whom; it also altered modes of courtship and possibilities of romance."[40]

From the standpoint of culture and creativity, what *content* does the ubiquity of telematics offer? In *The Cult of Information* Theodore Roszak reflects the reservations felt by so many in response to the challenge of new technologies: "Thanks to the high success of Information Theory, we live in a time of blinding speed: *but what people have to say to one another by way of technology shows no comparable development.*"[41]

An upgraded expanded national electronic network with broader bandwidth and greater information compression will soon have the capacity to transmit far greater amounts of material (including TV and film) more rapidly with interactive service allowing the receivers/viewers to make selections. There is an urgent struggle underway to control this more powerful form of communication, which is upgrading the current, relatively low cost access to the Internet. Interactive TV will mean an even greater invasion of boundaries with marketing messages than ever before. It will mean profits from the sale of the household conduit technologies. Primarily, it is understood as an economic highway for extracting fees from transmissions to viewers of shows, games, films, and specialized data such as encyclopedia information, weather, catalogs, and the like.

A recent survey by the *New York Times* (8/20/95) points out that the American public has a starkly negative view of the influence of popular culture. Deeply ambivalent, they blame television more than any other single factor for teen-age sex and violence (over breakdown of family, use of drugs, or lack of parental supervision). A direct link is made by most of those surveyed between pop culture and behavior, and language picked up from TV, movies, and radio.

Questions about Cyberspace: Issues of Concern

Already, the first wave of idealism and the sense of freely sharing information and newly developed software and expertise that has characterized the reactions of the first travelers on the Net is being challenged.[42] For example, Netscape software for the Web, developed and originated by paid student help at the University of Illinois at Urbana Champaign, was offered free to any one who called in requesting it. Use of Netscape software makes "browsing" and moving around in the complexity of the computer WWW surprisingly easy to do. The equivalent of bookmarks can be placed at the sites of greatest interest for later access. The process is a bit like choosing books from a library. However, because the software is such a breakthrough, filling a major communications need, those who wrote it were quickly hired by Silicon Valley firms.

One of the most important combatants in the wars being waged between companies to set the standard that will become the accepted norm for coding information for the Web is Netscape. Netscape has been giving away their Navigator browser software as a way of proving to Web users and providers its superior command structure code and its greater variety of tools for creating attractive Web documents as well as an important speed advantage in opening documents, (crucial to most users using standard slow modems). Because this is a key time when most users are choosing codes to dedicate writing their work to their chosen platforms, Netscape has the advantage of being first to produce the best browser tools with the wide acceptance necessary for winning the market. Commenting on the situation, Terry Mayerson, president of an Internet service company declared: "If we write a 2000 page Web site for Netscape this spring and Microsoft comes out with a superior system in October, we'd have to redo all our work to take advantage of it. Believe me, that's a lot of work."[43] Before adequate "protection for intellectual properties" can be devised, there will be frantic competition and greed-mongering among those jockeying for position in the volatility of the new age. Will the idealism of the pioneers prevail? Artist Emily Hartzell replies: "The idealism is always there, because it's an attitude/approach, it's software independent. Hackers have power."

Will there be cultural dominance and language dominance by those who have greater access to the technology? Will selected access to powerful technologies create an elitism? English, still the lingua franca for banking and science, is the dominant standard mode of telecommunications networking, a situation which is now being challenged by those opposed to its tacit acceptance. However, a universal digital code known as UNICODE allows the computer to represent the letters and characters of virtually all the world's languages with fonts for everything from Chinese ideographs and Russian Cyrillic to Sanskrit characters. As an Internet provider in Korea commented, there is, side-by-side with English language dominance, vast cultural difference. Technology is most often owned and controlled by those in economic power and through govern-

ment regulatory control. Those who receive training in its development and use tend to have been through a process of higher education. Access to equipment is easier for those attached to universities or top research and entertainment establishments. Access to the Internet for artists is still a problem both in the United States and globally, for many who have neither a computer nor a modem.

How can cultural communications be safeguarded? Can a way be found to preserve the public interest in the decision-making process about the sell-off of public property? During this period when the tangled web of competing interests and technological advances are taking place,[44] there is a need to reaffirm the doctrine of public responsibility as a price for private use of the public airwaves and to establish criteria of acceptable performance. Otherwise, powerful monopolies such as telephone or cable carriers will be able to determine what ideas and images are fed into the cultural mainstream.

An artists' collaborative project by Nina Sobell and Emily Hartzell called "Park Bench," still in the developmental stage, opens to a different, more inclusive, view of access to the Internet. Access will be made available to the public through a network of urban kiosks in New York City. The goal of the project is to utilize the most recent communications technology as a means of reinvigorating urban interactions, and it will serve to familiarize the public through awareness of the Internet as a dialogue. Intended sites for the kiosks, complete with their park benches, include a subway station, a church, a university, and a museum, with more planned eventually. The hardware and software will remain at a location for a predetermined amount of time and then moved to another kiosk site, leaving the physical structure of the kiosk in place in the hope that "park bench" interactions, now begun, will continue.

Towards the Evolution of a Global Culture

John Barlow, one of the founders of the Electronic Frontier Foundation (a group formed to protect civil liberties in cyberspace) recently commented:

> Just because I'm observing that a great social transformation is taking place because of technology doesn't mean that I like every single aspect of it. But I do try to adapt to that which I can't change. I do have my own personal sense of whether or not technology is working for me. And that really takes me back to Nietzche's statement about sin. If it feels to me that technology separates me, I try to reject it. If it feels like it has within it the opportunity to bring me closer, on some spiritual level, to the rest of humanity, I accept it.

While a society dominated by computers could on the one hand, bring about a dark age of passive centralization and decay of the human spirit, on the other hand, given the transformative interactive capabilities of the new tech-

nologies, there could arise the evolution of a new kind of cultural response. Artists are vital to the development of this process—probing, exploring, and investigating new directions for the changing technologies to reveal their potential for creating meaningful experiences. As part of the process, new art forms are invented. Artists can be important in heightening awareness of social values. They can challenge the establishment of an all commercial model of the Internet and preserve a certain sense of critical aesthetic use. Because interactive technologies call for the creation of works which require viewers to act as co-creators, audience's choices help to shape and democratize the flow of events, in a work which is incomplete without their participation. Representation is always strongly influenced by contemporary vision and consciousness and by the nature of the tools available to artists.

7

Transaesthetics

Made up of images, urban culture is like a hall of mirrors, its reflections reproduced to infinity. Confronted with their own technical images, the city and the body become ruins. Even technology is attacked by an obsolescence that renders it old instantly. We are faced with a transitory landscape, where new ruins continually pile up on each other. It is amidst these ruins that we look for ourselves.

—*Celeste Olalquiaga*[1]

History as Allegory

In her 1995 video performance work *Stories from the Nerve Bible,*[2] Laurie Anderson asks her audience to confront the future and to determine whether there is hope for human progress or whether we will sink only more deeply into the violence and social upheaval we are experiencing at the end of this millennium. She invoked the allegory of the "angel of history," described by Walter Benjamin in the spring of 1940 as he fled German fascism. Having lost all hope for the future, he could only see loss and devastation ahead, the past and present a heap of lost dreams.

> The angel's eyes are staring, his mouth is open, his wings are spread. His face is turned toward the past. Where we perceive a chain of events, he sees one single catastrophe which keeps piling wreckage upon wreckage and hurls it in front of his feet. The angel would like to stay, awaken the dead, and make whole what has been smashed. But a storm is blowing from Paradise; it has got caught in his wings with such violence that the angel can no longer close them. This storm irresistibly propels him into the future to which his back is turned, while the pile of debris before him grows skyward. This storm is what we call progress.[3]

Simplifying the text, Anderson in the first part of her evening-long performance work which featured projections, moving props, vocals, and texts, intones words based clearly on Benjamin's allegorical statement,:

> *She said: What is history?*
> *And he said: History is an angel*
> *Being blown backwards into the future*
> *He said: History is a pile of debris,*
> *And the angel wants to go back and fix things,*
> *To repair the things that have been broken.*

But there is a storm blowing from paradise
And the storm keeps blowing the angel
Backwards into the future.
And this storm, this storm
Is called
Progress."[4]

Committed to using a variety of technological media tools as a means to amplify powerfully her personal performance with visual elements, Anderson believes that new technological media make possible innovative production for her work, expanding her means of expression. She believes that art has a trans-formative role to play in postmodern culture. However, like Benjamin, she is keenly aware that the benefits derived from the use of technological media have a negative side to them. There is a tension between the extremes of technol-ogy's manifold benefits and its power to unduly control and manipulate public consciousness. Both Benjamin and Anderson understand the paradox technol-ogy represents—that it can be the agency both for terrible spiritual and social loss and for enormous social and cultural gain.

Artists Using Technology Are Caught Between Tensions of Two Different and Divergent World Views

Questions about the use of technology are deeply implicated in questions about the future of art. Contemporary artists attempting to negotiate technologically based media are confronted with two divergent ways of thinking. Many tech-nologists and artists who use technology tend to retain a fundamentally positive belief that they are making progress in understanding and mastering their new tools and in the invention of new cultural forms. Those artists who embrace a technological world-view function from an implicitly Aristotelian point of view. Through tools, they gain the access to new forms of knowledge about the world and powerful contemporary means for representation they did not have before. As we have seen in Chapter 1, confidence in the usefulness of observing the real world through enhanced technological seeing is based on the under-standing that this is the way to new and potent forms of knowledge. This view is energized by a system of values in which knowledge of the observed material world is fundamental to understanding it.

Cultural analysts tend not to share the same world view as scientists and technologists. Each group believes the other wrong. Scientists working in emerg-ing technologies such as virtual reality, artificial intelligence, robotics, simulation, and telecommunications, maintain their faith in progress and see their work as unlocking worlds of knowledge, forging new forms of empowerment and oppor-tunities for human expansion. They believe in their enterprise and are not usually engaged in the self-questioning typical of the humanities and social sciences. On

Figure 150. . Laurie Anderson, *Stories from the Nerve Bible,* 1995. Originating at the Neil Simon Theater in New York. This multimedia work traveled to Chicago, and Boston and overseas. Comprised of a full-scale mix of songs, video, and slide projections, and fast-changing industrial and postindustrial images, *Nerve Bible* explores the future through Anderson's ruminations about life, death, and pleasure through a chain of songs and globe-hopping tales. The *Nerve Bible* is Anderson's metaphor for the body. She refers often to the impermanence of human life. She sees the human eye as "not being much better than a pre-World War II field camera—it doesn't even have a zoom lens." While she acknowledges that technology offers the promise of order and control, "One World, One Operating System," Anderson refers often to the bright antiseptic images drawn from coverage of the war in the Persian Gulf: that of a bombing run that looks like a video game combined with the beautiful light arcs from aerial bombardments. She reminds us that behind those polished media images, people were dying. Multimedia performance work by Laurie Anderson. *(Photo: Courtesy Mark Garvin)*

the other hand, some cultural theorists see technologists as having little autonomy in their research, as having constructed behavior and attitudes and as having little concern about the ultimate ramifications of their technologies.

Artists as makers and theoreticians have spanned both worlds.[5] They see that technology has the power to create significant cultural experiences. At the same time they are critical of the very consciousness-transforming tools they employ to comment on contemporary social implications of its use. Artists who use technology struggle to negotiate the dilemma presented by these conflicting simultaneous directions. The artists who work in these mediums face partic-

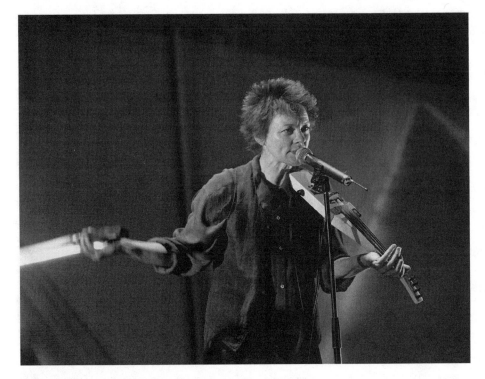

Figure 151. Laurie Anderson performing *Stories from the Nerve Bible*, 1995. Multimedia performance work by Laurie Anderson. *(Photo: Courtesy Mark Garvin)*

ular challenges. For one thing, cultural critics are averse to recognizing their work. They so deeply distrust technology and the losses it will bring in the future that they often do not want to look at an art that uses it as a means of representation. For another, they must contend with scientists whose (sometimes naive) optimism does not allow for any of the skepticism and philosophical complexity so necessary for the creation of contemporary art.

Artists live in a state of tension between these two positions. They must understand the dilemma provoked by change. Still there are barriers to understanding the social and cultural implications of powerful new technologies, unless we are ready to learn the lessons of history that can apply to the crisis of the present.

Living with What We Produce

How can we learn to live with technology? What possibilities does it have? What challenges does it present? These questions are particularly important for artists. In all eras artists have used tools at hand to make their art. It is no differ-

ent with these newer technologies. Because the new tools are ever more complex, no longer innocent but rather implicated with larger issues, their use is associated also with their inherent possibilities for good or evil, as is the use of all technology. These are the issues we must face. We cannot escape them.

In his essay "The Author As Producer," Walter Benjamin sounded a powerful warning note about the risk to artists of all kinds—musicians, actors, writers, filmmakers, dancers, visual artists—of being drawn into use of a powerful technology which in reality possesses them. Because they no longer have control over it, they may lose the power to assert their ideas.

> They defend an apparatus over which they no longer have control which is no longer, as they still believe, a means for the producers but which has become a means to be used against the producers. This theater of complex machineries, gigantic armies of stage extras and extra-refined stage effects has become a means to be used against the producers (artists), not least by the fact that it is attempting to recruit them in the hopeless competitive struggle forced upon it by film and radio.

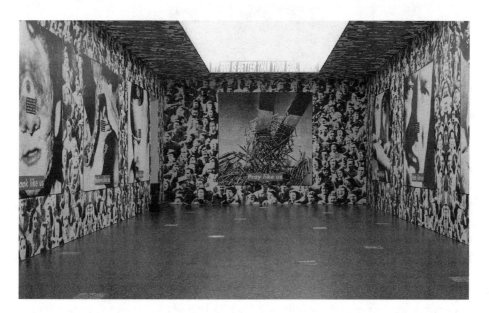

Figure 152. Barbara Kruger, mixed media, *Untitled,* Installation, 1994. Dimensions variable, Photographic silk screen on paper. In this gallery-sized installation, Kruger extends her practice of using graphic black and white found images with red and white text panels. In this one, the texts announce around the top of the constructed room, "My God Is Better Than Your God, Wiser . . ." The large image captions "Hate Like Us," "Pray Like Us," "Fear Like Us," "Believe Like Us," and "Look Like Us" appear on top of their antithetical images. Imbedded in the floor are text plaques which further arrest the viewer's attention. The totality of the installation is a powerful sense-around experience of media, forcing an examination of this powerful and disturbing theme in today's climate of ethnic, racial, and religious wars. (*Courtesy Mary Boone Gallery*)

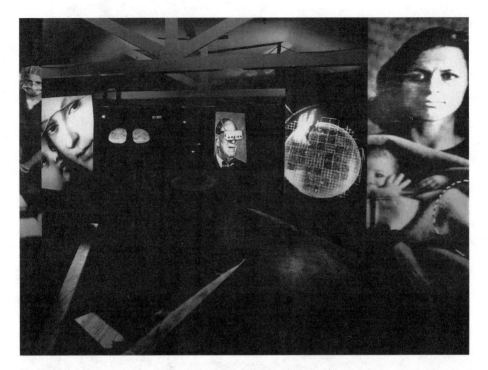

Figure 153. Margot Lovejoy, *Black Box,* 1992. Computerized slide and video projection installation, variable dimensions. A memorialization of the present from the perspective of the future, this mixed-media installation is constructed as a science fiction scenario. The viewer enters a 2025 A.D. environment where pulsing images contrasting realities of the past and present are projected onto large hanging scrims. They are presented as a means for confronting and re-evaluating options regarding the future. Texts flash and swirl about the room. The metaphoric "Black Box" of the title refers to the Flight Voice Recorder mandated by law to be placed on every aircraft. When recovered following a crash, these voice tapes provide the most important evidence in reconstructing the truth about what really happened. *(Courtesy Margot Lovejoy. Photo: T. Charles Erickson)*

His indictment of new technologies' power to subvert or destroy the artist's voice is a major warning. It urges us to remember what has been learned from each art form's simpler original incarnations (such as theater before film). To remember what each *does* (its function) in relation to its audience. Is an artist free to create the work s/he pleases? He is referring here to Brecht's notion of epic theater in which "the functional relationship between stage and audience, text and production, producer and actor" becomes a guiding principle. A contemporary media example of what he meant about using the rough, inherently fundamental form of a medium to retain contact with its source, is Paper Tiger Television. It is a low-cost, low-tech cable TV program (see Chapter 4), transmitted directly on public cable, which comments directly on the fictions of the medium itself while speaking out (with an independent voice) on current affairs with its listeners.

Locating the Future

Can we locate future directions in the arts by looking pragmatically at how technology has affected progress in the past? In an epilogue to a book of essays, *Imagining Tomorrow*, edited by Joseph Corn, the history of past predictions about the future is summarized to provide cautionary insight. Corn names the three fallacies most common in predicting the impact of new technologies: (1) new technologies bring about a total revolution in their field by totally replacing all other existing forms; (2) new technologies will perform only old known tasks and fulfill only known needs; and (3) that new technologies will bring about miraculous utopian, global change.

The first notion conjures up as an immediate analogy the extravagantly foolish promises about nuclear power. New technologies do not replace old ones—we still use fossil fuels and have even harnessed improved natural alternatives like solar and wind power. The same is true in art. Artists will need to continue to paint, draw, and sculpt in order to harness new technologies for image making. Photography, electronic media, and telecommunications technologies extend the potential of art. The new technologies expand the range of possibilities for expressiveness, perception, and communication. In predicting the place of new electronic technologies, it is important to remember that they will not replace older tools in the creation of social meaning, but rather extend and add power to them.

The fallacy that new technological inventions will bring about a complete revolution for the good even though they will create major change in our way of living is tied to a further fallacy—that new inventions will *only* be used to fill obvious needs. The first innovators of the digital computer saw their work applied *only* to the "super-calculator" needs of science and could not imagine or predict the completely universal applications in business, publishing, education, and, of course, art. The computer has, in fact, become a major engine of technological progress in spite of how limited the vision of its impact was at the outset. So far its application in the arts has mostly mimicked prevailing forms and styles of art because new forms take so long to evolve. Use of the computer as a flexible practical tool and medium for art-making began with its use as a replacement for familiar tools. Now that it is becoming deeply integrated into the field, the computer is already taking over tasks performed by older imaging technologies such as photography and graphic arts production. Only now is the computer beginning to be used in ways that hitherto could not be imagined.

A further fallacy combines elements of the first two. We might call this the "technological fix," the utopian idea that new technology has a supernatural ability, a guarantee of omnipotence, a condition of absolute global transformation which might guarantee equality and make all men brothers by conquering distance, abolishing national boundaries. An example of this global view is Marshall McLuhan's global village: "Electric circuitry has overthrown the regime of

'time' and 'space' and pours upon us instantly and continuously the concerns of all other men. It has reconstituted dialogue on a global scale. Its message is *Total Change*, ending psychic, social, economic and political parochialism."[6] World-wide communication would bring about unity and trust between peoples and governments as a way of solving difficult issues between people everywhere. This global view was countered by Lewis Mumford[7] who, throughout all of his writings about the effects of technology, tried to inject a note of balanced realism, criticism, and caution by stating that true change would only come about with significant economic growth, better planning, and social commitment for significant egalitarian measures. Many wild predictions about the advantages of electronic media are represented by this category of the "technological fix," characterized by technoscience talk and "future babble."

The fantasy of a harmonious and affluent future as promised by the new technologies has been mythologized and used as a form of successful ideology in order to obscure real conditions—that actual technological changes have been accompanied by so much privation, conflict, dislocation, and wrenching transformation brought about by the unbridled appetite of global capitalism.

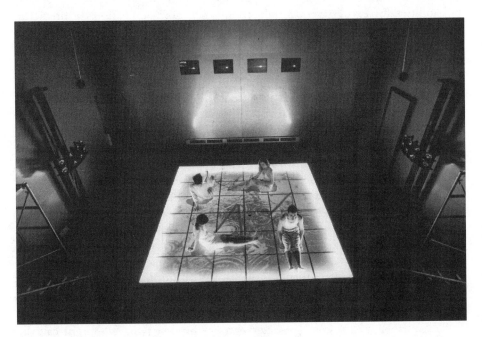

Figure 154. Dumb Type, *Pleasure Life*, 1988. Performance. In existence since 1982, and based in Kyoto, Japan, Dumb Type is a collaborative media group whose members are trained in the visual arts, architecture, music composition, computer programming, and other disciplines. They produce work in nontraditional diverse formats and seek to explore new dimensions of social interaction. The performance area is referred to in the program as "The Colony (an imaginary living space)". As the performance unfolds, it represents various portions of everyday life in "The Colony". It asks the audience questions about technology: "How does one communicate in the systematized life in The Colony? How does one learn the systems of the society? How does one express love? What does pleasure mean?" (*Courtesy Dumb Type*)

The promise of the future as it resonated in popular dreams and expectations amounted to a faith in a better tomorrow through a "technological fix." It was tied to a society based on mass consumption in which a firm faith prevailed that democracy and technology were symbiotic. "As an ideology, a powerful system of rhetoric and belief, technological futurism . . . faith in technology (or more accurately, in the future as promised by technology) became not only a kind of secular religion but also a substitute for politics"[8] (and social justice). This faith continues to influence policy making at all levels even though there is significant change towards widespread awareness that the media is being used to manipulate public consciousness. Prototypical of the dangers Walter Benjamin warns us of in the negative applications of technology are politicians of the extreme right and left who embrace electronic media technologies as an integral strategy in their drive to power. They use Television, the Internet and the Fax machine as powerful tools for conveying their rhetoric."

Representation Changes

New imaging technologies have more and more challenged conventional notions of representation. As we have seen in Chapter 1, representation is a complex system which refers to important aspects of art practice. Representation not only refers to realistic productions of reality, but encompasses all forms of art production, including symbolic manifestations, aspects of an image's likeness, and imitations or copies of work in some material or tangible form including abstract symbols or forms. Most often, representation refers to works of art in which emotion and intellect aim to depict things as they actually appear to the eye. Representation is the making visible of products of the imagination. The artist sees and yet may represent something only related to what one sees. The *means* of representation is the tool or the medium by which something is represented. As we have seen in Chapter 1, there is a tension in the way representation and the *means* of representation intersect.

Representation is part of a larger frame of reference. It changes at different moments of history. When a shift occurs in a cultural paradigm[9] representation changes. All theorization and research is shaped by the guiding assumptions of the new paradigm. Since the Enlightenment the following questions have dominated art discourse: What is the function of art? What is useful and significant to look at? Who has authority? Who should one believe? Who are the most important artists? All of these questions presume the stability of the work of the artist; the position of the observer; the integrity of the subject and of the author. That was all assumed within modernism. All that changed with the shift to postmodernism.

With digital technologies we no longer have a spatial fixed point perspective; with morphing, we no longer have fixed spatial or temporal relationships. Reality can now be paralleled by a completely simulated (virtual) one. Digitization has destroyed the faith in the truthfulness in representation.

Cultural conditions have dramatically changed. Technologically based art does not just change the kind of art that is made and our relationship to it, it changes the nature of human perception. Technological instrumentation makes it possible to see things that could not have been seen before and to see them in a way they could never have been seen before. Just as photography and the cinema opened the world to an expanded consciousness of the close-up, the far distant view, and the psychological, through editing and out-of-context views, so has the use of digital technologies allowed for the complete restructuring of the visual, opening to new territory of completely simulated, or virtual, reality with entirely different space relations. In new forms of technological representation, the technological tool is integral to the form, content, context, and process of the art, not just a way of transmitting it. Much of the new art is interactive, offering participants the opportunity to communicate in a multidirectional way, and facilitating dialogue and collaboration between artists. Interactive digital mediums are international, inviting participation from individuals all over the world. "The world has (now) become too small for an ivory tower mentality."[10]

Images are becoming entirely mediated. Instead of a photograph, an artist may present a disk for either viewing the work on the computer screen or for

Figure 155. Luc Couchesne, *Family Portrait,* 1993. Multiuser interactive video installation. In this work, the artist allows several viewers at once to interrogate each portrait via an interactive program of questions. The viewer poses questions, the portrait subject responds. Each viewer is able to pursue one's own path in finding out about each of the family members represented. (*Courtesy Luc Courchesne*)

printing it out on a high powered laser printer or other device in large or small format. Its appearance will depend on the image resolution provided by information formatted in the disk and by the technical characteristics of the viewing medium. Representation opens to include new aspects now that images can be linked directly to the text and to sound. Digital distortion of image structures allows for the small to appear large, or vice versa; for positive to become negative or be turned inside out; for objects and people to be inserted seamlessly into any image structure on the computer; and for the easy manipulation and alterations of color and tone to create different effects. Totally new kinds of recombinant forms can be constructed to create images of great strength and beauty. Interactive capabilities can create works that require audiences to act as co-creators. Any work is incomplete without the viewer taking action. We are closer to the imaging processes of the imagination linked to dream or logic. With virtual reality, we enter a world of complete simulation moved by a new perspective and new kinds of constructed forms. All of this has led to the destabilization of the image, of the art object, and of the function of art in daily life. It has also led to an overloaded image culture.

In each of the media we have been discussing, there is evidence for a future of unprecedented advance and expansion in the possibilities for representation and convergence of media. Forms of technological representation have potentially, a democratizing influence. Technological tools are capable of making endless copies, transmitting images over long distances, of communicating and exchanging ideas and information far afield. Images can now be reproduced, scanned, digitized, or simulated, reprocessed and manipulated, edited, transmitted internationally via satellite or cable, or printed digitally using electronic printers of all kinds. They can be inserted seamlessly into other images either as still or moving elements to create a true impression of a false reality. They can be instantly copied, reduced, enlarged, changed from positive to negative, or printed in color. Digitized images are set immediately into the electronic page set-up for printing in millions of copies.

Whether or not representation has changed, the culture it is operating in has. Traditional ways of looking at the world have become obsolete. Technology is the new language through which experience is understood.[11] Computer terminals and TV monitors connect us to language and image sources that we require to reach others and see ourselves.

Predictions about the End of Art

As early as 1827, Hegel was predicting the inevitability of art's end. In 1839 when the invention of photography was demonstrated, Delaroche announced the end of painting. Similar predictions arose at the turn of the century, in the 1920s, and in the 1960s. In the 1980s more predictions emerged. Despite these dire predictions, in each of these strikingly new periods the concept of art did

not die. Definitions of art alter with historical and technological change. Art and time are related: art functions as an alternative reality which grows out of the contrasting principles of the dominant world-view by which we live. As we have seen, attitudes towards representation and the art-making that grows out of its assumptions have always been shaped relativistically by powerful social and technological forces, a relationship which is more and more coming into focus through the process of theoretical analysis, revision, and deconstruction.

In his important essay "Revising Modernism, Representing Postmodernism: Critical Discourses of the Visual Arts," critic Michael Newman, discusses the progressive stages.

> It is possible to isolate two tendencies under modernity which could be taken as answers to the question "What is art?" One answers "Art is art": it is the tendency towards autonomy, "art for art's sake." The other answers "art is not-art": the category of art is supposed to "wither away" into social and political practice and/or theory. If we recognize anything as "postmodernist," it is the impossibility of either answer. Art as supposedly autonomous remains dependent upon its Other for its very autonomy, and so is infected by heteronomy. And artists' repeated attempts to defeat art have either been re-incorporated into art, its institutions, and ontology, or else have forgone the radical potential that inheres in art's relative autonomy.[12]

Newman's analysis suggests that the need for art as an autonomous force in society does not fade or change, but rather our perspective changes about its role and its form. The latter are subject to wildly fluctuating external influences in the form of political and social forces which grow inevitably out of changing technological conditions. These transform awareness, provide new tools from which new art forms develop. Each time the conditions of a new paradigm arise, the question "What is art?" surfaces. We are once more at this juncture. Once again we are examining art's different categories of value such as use value, exchange value, commodity value, aesthetic value, exhibition value, as well as its different categories of production, whether by hand or by technological means, and what these entail. And we are examining forms of dissemination and its effects. The question is not whether art is dead but how the need for it has been transformed by technology. In the contemporary world questions need to be about how technology is being used for art, and what new forms are evolving from its use.

Technology Can Be Both Medium and Tool

Each machine places its own imprint on its output. The high-contrast effect of the photocopy is completely different from the dithered look of a projected "virtual" computer image or the dithered effect of a video image with its moving raster lines constantly refreshing and changing with the movement of the

Figure 156. Heinrich Klotz and Monique Mulder, *Catal Huyuk,* 1994. A computer animation of a cult room in Catal Huyuk. Idea and concept: Heinrich Klotz; 3-D. Environment and animation: Monique Mulder; Interactive software, Gideon May; Modeling software: Softimage. Produced at ZKM, Karlsruhe, Germany. Catal Huyuk is a virtual simulation of a city that was built around 8000 B.C. This three-dimensional computer animated reconstruction of Catal Huyuk allows for interactive visiting of its rooms and shrines. It is one of the oldest excavated settlements in the world and is located in Southern Anatolia in Turkey. The community's main deity was female. A labyrinth of interconnected houses provided a comfortable living site for many people with a high standard of civilization. (*Courtesy ZKM, Center for Art and Media*)

image. Most tools such as camcorders and computers can also be thought of as mediums in their own right. When artists use the tool their final production is a complete system, integrating production with statement. A photographer with his camera or a painter with brush or canvas, can say that tool and medium are conjoined. However, some artists, like those in the nineteenth century we have discussed, wish to use technology only as a *tool or as a means* to reproduce work or imagery that has arisen through other means such as still photography, drawing, painting, or sculpture.

All traditional media have been recontextualized as a result of dramatic developments in electronic technology. Can all the media of the past find their place within the same essential individual relationship to image making? Earlier in the century, Man Ray said, "I photograph what I do not wish to paint and I paint what I cannot photograph."[13] Today, many contemporary artists exploit the potential of electronic tools in combination with hand skills and more traditional mediums for what they can offer in terms of scale, effect, style, expressiveness, economy, and all-important communicating effects. Others seek to use

the computer as a medium to create an alternative reality which could be achieved in no other way—such as a projected "virtual reality" production—or to work in new forms such as CD-ROM.

Now that commonly available graphic communication tools such as video camcorders, fax machines, photocopiers, personal computers, and printers have entered into use by a wide public, they are beginning to change the image-cultures in which they exist. Because they are available as imaging devices to a wide population outside of the usual cultural communities, a new populist circulation of images with disregard for "high culture" has arisen through mail and fax-art projects or exhibitions on the Internet, and through new distribution routes. This vernacular phenomenon has been referred to as a form of technological folk art "volks" graphics or "zines" as opposed to more elite forms of representation. As technologies age, become more accessible and more deeply embedded in cultural usage, a different kind of art-making arises. Already, so-called digital "tekkies" or "cyberpunks" acquire outdated equipment that is being junked and continue to challenge its use. Their fresh aesthetic is based on simple graphic applications and a populist imagination. Like the alternative magazine and music culture of the new generation, "zines" are technological productions which often powerfully touch the public nerve.

Reconfiguring the Role of the Artist and of Art Production

In a period in which cultural politics dominates, in which revised assumptions and discourses deconstruct and dismantle the Western tradition, and in which new technologies are having a destabilizing effect, the negotiation of cultural meaning has become even more fraught with difficulty. Questions arise about the role of the artist along with questions about audience and the function of art. Now that creative work can be distributed or transmitted widely, art may come to focus on issues of communication and interactivity. Creative work may proceed entirely outside of museums and galleries, the traditional institutions of art.

Modernism was predicated on the concept of original vision and genius as connected to the conception of a unique self and private identity. As we have seen, this vision of the artist as a creative genius is still deeply ingrained in the Western tradition. The theoretical basis of that kind of individualism is ideological and political.

Artists using contemporary technological means for their art practice can assume many stances in today's climate. On the one hand they can engage in a modernist art practice that assimilates technologically based work within the same conceptual framework as drawing, painting, and sculpture without using it as a means of cultural critique. It then becomes sublimated as a tool for art-making. On the other hand, they can fully engage electronic media in a practice which critically analyzes contemporary media-dominated cultural

conditions using the very tools which power it. Whether they choose technology either as a medium or as a tool for their work, contemporary artists have access to concepts, themes, and methodologies for creating artworks which reflexively examine the process of representation itself. The intentions of some may be to destabilize and expose the narratives of mass media, which cast doubt on normalized perceptions of everyday life. Stephen Wilson comments that because technology is associated with the very cultural concepts being examined through theoretically based analysis:

Figure 157. Mel Chin, *Degrees of Paradise: The State of Heaven*, 1991. Installation consisting of two constructed triangular galleries. This piece directly addresses the global problem of ozone depletion. In the first triangular gallery a hand-knotted rug floats from the ceiling, undergoing a continual state of programmed destruction. This condition is linked to information provided in the adjoining gallery where a triangle of suspended VCR monitors display clouds formulated through a mathematical program which depicts the state of degradation according to global atmospheric dynamics. The extent of ozone damage is periodically composited and scaled to match the original rug as a "pattern of loss." *(Courtesy Mel Chin)*

Figure 158. Mel Chin, *Degrees of Paradise: The State of Heaven*, 1991. Installation. The floating carpet, with all its magic, materialistic, and aesthetic associations will gradually be made to endure the sense of loss and waste which is taking place in the endangered atmosphere. It can provide for us a tangible, material site for realizing the unseen conditions which imperil our earthly habitat. *(Courtesy Mel Chin)*

artists using electronic media for their work can directly and critically tackle the medi-ated sign and codes that shape contemporary life working from within the system. Some artists study the media to such an extent they become capable of knowledgeably imitating, subverting, and redirecting its meaning. Further, it shows the way to a more general critical practice which, surrounding and playing off art, might place in broader circulation an important body of issues and ideas.[14]

This gives to art, a critical responsibility and political potential it is often denied.

Another stance in art practice would be for artists, while remaining aware of the dangers implied by the uses of technology, to enter into the heart of the inventive process itself making themselves available at the core of activity to help elaborate, humanize, and develop the new cultural forms.

All art makes a comment on the ideology of everyday life. It is the nature of art to speak of the moment, in one way or another. Art can be expressive of progress or of alienation: thesis—antithesis. Steven Durland, writing on the future of art, commented: "We can easily get lost in thinking that art is about theories, deconstructing, reifying and the like. Those are the tools for under-standing. Sometimes they are the right tools. The important thing is that artists are trained to look and they're trained to express what they see and under-stand."[15]

Technological tools like video and computer can blur the lines between the production of fine arts works and commercial and design production. Artists must contend with these high/low boundaries if they wish to stay firmly within traditional fine art discourse of cultural institutions. If however, they wish to participate in a mass audience field like film, TV, or CD-ROM, they can seek to develop hybrid aesthetic strategies to suit their intentions of communi-cating within a wider field. It will be difficult to keep their ideas intact as they struggle for access to equipment, funding, and collaborative expertise to create meaningful works with such powerful, demanding media.

Now that the image is digitized, residing primarily within the mainframe of the computer or in cyberspace, art becomes more and more defined in nonvi-sual terms. As we have seen, the work may be composed as an interactive sys-tem designed by the artist to be collaborative with the viewer; it may be pro-grammed with minimal visual resolution for the Internet combined with text-based directories of information; it may be created for viewing via the computer as a CD-ROM, a world of moving image and text designed to be "read" as a composite multimedia experience.

In all of these examples, the ontological status of the image as we have known it, becomes destabilized, a further extension of dematerialization (Chapter 3). It is capable of being constantly invaded and changed by other images. These new conditions, present the opportunity for audience partici-pation and communication. However, they also represent a terrible loss to

artists that will keep them from creating works in the same way that they always have. Benjamin described the arrival of cinematography, as a medium and a tool which shattered existing traditions of representation, the effects of which we are only beginning to understand and fully integrate into the visual arts canon a century later. We are now at a more extreme moment of change in representation.

The Artist's Role

Artist's response to technology ranges from obstinate, aggressive refusal tinged with suspicion, skepticism, and resistance, to outright embrace of "the new" as a positive act of renewal, an engagement with the needs of the present. Those artists who take up the challenge presented by emergent technologies use them because they can interact more intensely and expressively with subject matter of contemporary life *by using the very technologies which power our media-based culture.* Artists using a contemporary technological base gain important insights which clarify the complexity of our era.

Figure 159. Jenny Holzer, *Laments*, 1989. Installation view, Dia Art Foundation. In *Laments*, words pass up and down via vertical columns of Light Emitting Diode (LED) displays as fragmentary first-person confessions of pain, fear, greed, flying by in the dark in glowing reds, greens, and yellows. Occasionally, the spectacle stops, the room goes black and the columns glow in pure color before starting up in motion once again. In an adjoining room, the same texts were etched into stone sarcophagi. (*Courtesy Barbara Gladstone Gallery*)

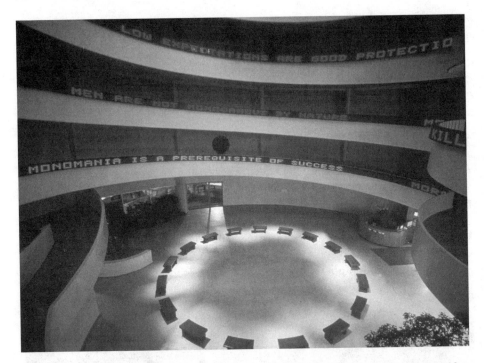

Figure 160. Jenny Holzer, *Survival Series. Benches,* 1990. Installation at the Guggenheim Museum, New York. Etched red granite benches with selected texts on LED signs. The spiral ribbon of LED electronically programmed letters girding the Museum's circular architectural space could be experienced differently depending on the vantage point they were seen from. The work depends on the tension created between the conceptual memorial style of the installation spectacle, and the new more transient informational one. It seemed to be a summing up of a poetic public confession of loss, violation, and entrapment. In this work, Holzer sought to capture the spiritual crisis of the decade. (*Courtesy Barbara Gladstone Gallery. Photo: David Heald, Solomon R. Guggenhem Museum*)

Refusal takes several forms. For some artists, it involves a conservative, obstinate outlook involving loyalty to the traditional practice of art and the patient pleasures of hand gesture and experiment through slow manipulation, using time-honored practices. For others, it is a denial of the present by turning inward to a private metaphorical world apart from time itself. For yet others, it is a political renunciation of technological civilization and technology as the means of human self-destruction promoted by powerful forces interested in perpetuating their own power. Humans are seen by some as a powerless endangered species.

There are real risks in using technology for making art. As we have seen, since the 1970s, there is the danger of dominance by a powerful new technique which can subvert the experimental character of art with its dedication to raising questions and to exploring meaning. Because access to technology is costly and often difficult, artists may have to make important artistic, stylistic, and political concessions in order to obtain funding for their projects through governmental or

corporate institutions. If the project is not a popular one, and does not fit the current funding guidelines, it may never be realized. The technological artwork is sometimes controlled by forces beyond the power of the artist. Through coercion, or co-optation, the artwork might be used as a tool to maintain institutional values rather than as a means of questioning them. If access to technology can be freed from those who use it for power and profit, technology can be used to gain insight, to seek meaning, to open higher levels of communication and perception.

Historically, there have been many ways of representing the artist's role. Among these many, one is as a prophet, pointing to a possible future society; another is as a dissident reflecting the alienation of the marginalized. Yet another is as a public intellectual representing philosophical or conceptualized issues. Many thinkers believe that the artist's role is as a citizen of the future—and that

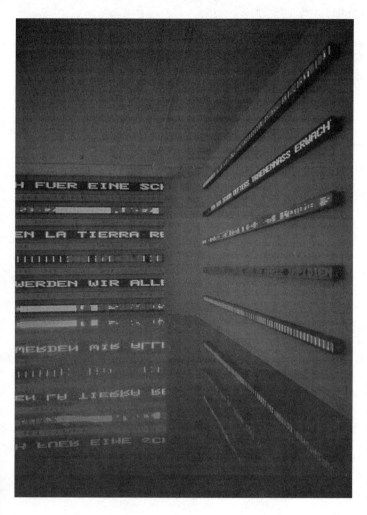

Figure 161. Jenny Holzer, *Installation view U.S. Pavilion 44, Venice Biennale,* 1990. Holzer resists traditional notions of art as a rare and precious object and of art confined within a museum or gallery context. Her technological works present different voices which question power. Holzer's work argues that art is an accessible language, one which can be electronically blended into a public environment for the public at large. An experience which can be as profound as any traditional painting or sculpture. (*Courtesy Barbara Gladstone Gallery*)

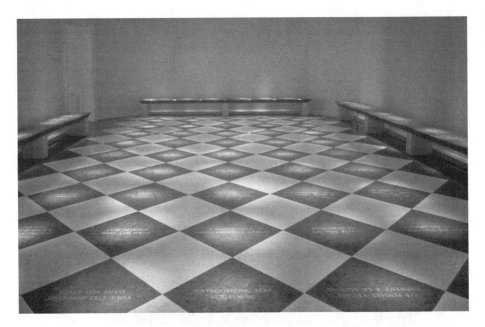

Figure 162. Jenny Holzer, *Installation View U.S. Pavilion 44, Venice Biennale,* 1990. The interior installations consisted of electronic LED signs, stone sarcophagi and tiles, laser projections, and wooden benches. Electronic signboards were placed on columns outside the pavillion and messages designed for TV transmission were prepared. (*Courtesy Barbara Gladstone Gallery*)

artists must be more involved in society and community. They see the artist as a cultural worker, sometimes involved with public art projects, with responsibilities to be involved in its transformation. As such, the artist must be engaged in a continual process of evaluation and assessment of social options, locating and understanding important contemporary issues.

It can be said that historically the self-representations of artists have fallen into the categories that have been available to them. Under the pluralism of postmodernism, can the artist encompass many roles? There is not any clearcut definition of the artist's role.

In one way or another art cannot escape being a commentary on the contemporary moment. The conditions artists face have been brought into focus by, among many others, contemporary writer Celeste Olalquiaga[16] when she discusses postmodern conditions. She notes that the formal mechanisms and functions of modernity remain, although its utopian beliefs have been exhausted, leaving disillusionment in the failure of utopian aspirations. This loss of the dream of progress leaves in its place skepticism, a sense of temporal emptiness with a past whose beliefs have been discredited as stale and insufficient.

The complex image world in which we live requires informed, trained artists who can bring unique perspectives to the task of interpreting and reshap-

ing the world. The contemporary artist must engage in self-scrutiny and self-revision; must have a capacity for empathy and compassion; have an urge to explore the unfamiliar and be comfortable with uncertainty.

Educating Artists for a New Era

Media domination of our culture has created a malaise that is symptomatic of a crisis in fundamental assumptions about society, culture, and the meaning of art itself. In response to this malaise the European Community recently launched an extensive study of the future of European Art Schools. Writing in reaction to the questions being asked, Don Foresta, a professor at the Ecole Supérieure des Arts Décoratifs in Paris proposed that "schools must teach the new technologies, debate their role in society, master their use, and renovate visual languages. They must humanize the new technologies by better adapting them to human creativity fulfilling a role that may never be accepted by the marketplace, but which could have a positive impact on it." Art school should provide an important forum for discussion about technological development and artistic endeavor throughout this century. It is not enough for students to master the operation of the machines, they must understand artistic, scientific, philosophic aspects of twentieth century history.

Foresta also recommended that art schools should be linked to promote "further exchange, interactivity, cross-over, shared resources, and a more organic system with enormous numbers of routes through it providing opportunities beyond the possibilities of a single institution . . . Networking will become the organizational framework for many future tasks and activities and it is important that artists are present in what will become a future institutional form."

Foresta has been instrumental in setting up network programs to explore their potential for the arts. Art en Réseau is an association made up of thirty French art schools. The schools, with the help of the French Cultural Ministry, have acquired a collection of French, German, and American video art which is managed through the telematic Minitel system. Ordering is from the on-line catalogue and other materials such as interviews with the artists and other aspects of their work are included when tapes are sent out. Another network idea is Artistes en Réseau (Artists On-Line) which links schools and independent artists' groups in several countries through computers and ISDN (video) telephone lines. Implicit in this network is the idea of a virtual faculty with student-teacher interaction over long distances.

Exhibitions Surveys as Evidence of New Directions for Art

"Image World" at the Whitney Museum of Art in 1991 was an attempt to encapsulate and give form to the phenomenon of contemporary cultural history.

Figure 163. Whitney Museum of American Art, *Image World: Art and Media Culture*. Installation view from the exhibition (November 8, 1989 to February 18, 1990). Left to right: Mark Tansey "Action Painting 11," 1984; Jeff Koons *Michael Jackson* and *Bubbles*, 1988–1989; Gretchen Bender *TV Text and Image*, 1989; and Robert Longo *Untitled (Men in the Cities)*, 1980.

Created through a collaboration of several curators, the exhibition's focus, as stated in its catalogue, was to provide an overview of the "complex interactions between art and the mass media in postwar America." It was offered as a means for making "a clear case for the increased integration of the visual language systems and technical means with those of art." In interweaving film, video, painting, sculpture, photography, and public art, the curators wished to draw attention to the restructuring of traditional art categories, the dissolution of boundaries between the media and the visual arts, and the changing nature of representation itself. The exhibition's title referred to the overwhelming presence of the myths, mechanisms, and politics of media in everyday consciousness and the negotiation that has taken place between visual artists whose visual sense has been so deeply affected by the storm of images breaking on their shores.

Although other exhibitions in the United States, Europe, and Japan often celebrated the work of artists producing media-based art, "Image World" was one of the first real efforts since the 1968 Museum of Modern Art "The Machine As Seen at the End of the Mechanical Era" (Chapter 3) to explore the circulation of images and influences from popular culture that had taken place. *Hi-Low*, a survey by curators of art at the Museum of Modern Art in 1991, completely omitted references to TV and electronic mass media. "A Forest of Signs:

Art in the Crisis of Representation," 1989, Museum of Modern Art, Los Angeles was serious in intent, but lacked the scope of a survey. Its objectives were to address the central artistic crisis of contemporary times: "The meaning of art in a media and consumer influenced era and the meaning of representation within this art." Its title was meant to suggest that the "forest" of images, signs, and symbols, whose flow surrounds us daily from billboards, television, magazines and films, has come to represent a reality seen through the lens of a consumer society. Images pass through a filtration process leading to the questions:

> What is the meaning of originality and the role of the artist as creator? Does the artist today function simply as a knowing presenter and producer of commodities for a burgeoning art market? And what is the function of art today? . . . [Many of the artists] . . . suggest that all art is yet another set of powerful images and narratives attempting to represent reality. They incorporate slogans, symbols, and stereotypes that pose questions about the social context in which words and images operate and manipulate us. Instead of documenting reality, they fabricate it anew.[17]

The exhibition included, among others, the work of Barbara Kruger, Richard Baim, Laurie Simmonds, Haim Steinbach, Cindy Sherman, Louise Lawler, Ericka Beckman, and Richard Prince.

"Image World" included such well-known media artists as Nam June Paik, Bruce Nauman, Bill Viola, and Gretchen Bender as well as painters Andy

Figure 164. Whitney Museum of American Art, "Image World: Art and Media Culture." Installation view from the exhibition (November 8, 1989 to February 18, 1990). Peter Nagy's *Entertainment Erases History,* 1983.

Warhol, Mark Tansey, Robert Longo, and Jeff Koons. While a much larger space was needed for such an wide-ranging exhibition, only one floor was available. Works were jammed together. With barely enough space, the works suffered, and the exhibition's installation style subverted the desires of the organizers. The show spilled out into the streets with eight huge museum-commissioned billboards installed around the city. Krzysztof Wodiczko designed a projection work for the front of the museum commenting on the cultural power structure. Attacked by most reviewers, the exhibition seemed to go down to some kind of ignominious defeat in the public eye. Instead of constructively critiquing the exhibition, the reviewers treated it as a parody of art.

When the 1993 Whitney Biennial reflected for the first time politically and socially engaged art with a multicultural viewpoint missing from past exhibitions, the same conservative critics attacked again. Not wishing either the boundaries of art or of society to change or migrate, they reacted negatively to the work of ethnically diverse and differently gendered artists. In two articles by the same critic, the *New York Times* called for a return to painting. Although a large segment of the exhibition was video and special video-viewing galleries were designed[18] to highlight this aspect of the exhibition, video was never mentioned by these reviewers.

The mainstream world of art and critical response resists technological art, because it is not tied to developed traditions and because it lacks the aura and commodity status of traditional work so much in demand by the gallery system. Video viewing in general requires a specialized knowledge and familiarity with theory, aesthetics, and history. It requires time for viewing and has a complex layering of images and ideas. (Chapter 4).

Too often, viewing of single-channel video is ghettoized into small hard-to-find back rooms. New projection for video will help to affect much-needed change and commitment to the medium in the museum and gallery context. Not many commercial galleries show video because it has so little "commodity value," though artists' sculptural installations with video continue to be dramatic and theatrical experiences for viewers. In 1994 "Documenta" featured an unusually large number of room-sized video works. These were the most powerful works at this important international exhibition. Those by, among others, Marie Jo Lafontaine, Klaus Von Bruch, Shigeko Kubota, and Ulrike Rosenbach captivated the viewer because of their scale, presence, and relevance.

Video now has a simultaneous festival of its own paralleling the annual New York Film festival. Emerging as an art form with markedly different set of aesthetics from mainstream movies, the video made as a movie represents a more intimate reality. Shot by the artist with equipment that is light and portable, sometimes the Hi-8 camcorder (now as small as a 35 mm still camera) that can poke into places where large format equipment manned by sophisti-

cated film crews cannot, (because every shot has to be carefully planned owing to incredibly high-production costs), video can be more personal and sponta- neous in tone. The video movie is not so much a collective vision as a personal one, because it can remain in the hands of the artist. One of the most spectacu- lar of those videos made for HDTV is Kit Fitzgerald's *Painted Memories, Spider's Garden,* a stunningly visual tone-poem which explores the relations between painting and nature.

The ambitious "Montage '93: International Festival of the Image," was held in Rochester, New York; home of Kodak and Xerox, who supported the summer-long undertaking. Devoted to electronic media art production, it brought together sixteen exhibitions, dance, theater, performance, workshops, lectures, panels, a book fair, a trade show, and a film and video program. Some of the exhibitions were much more successful than others, notably *Iterations* which traveled on to the International Center for Photography in New York and showed a high level of sophistication in its conceptualization and presenta- tion. It encompassed the work of Graham Weinbren, Lyn Hershman, George Legrady, among others. However, the large installations specifically commis- sioned for the exhibition through a competition stole the limelight. For exam- ple, three of these were installed right in the center of town outside of the gallery and museum areas. Mary Lucier's *Oblique House, Valdez* was located in a converted auto showroom; Dawn Dedeaux's powerful *Soul Shadows* took up an entire factory area; and Daniel Reeves' poetic *Eingang/The Way In* based on a poem by Rilke, became much more accessible within a public storefront area. The informality of their settings outside the usual art institutional realm made them more accessible to the townspeople and became an important aspect of the work. A Mail and Fax Art project covered the walls of a nearby public mall.

Festivals highlighting technical work provoke visual and intellectual excitement and exchange, and the importance of the networking between groups that they provide is of incalculable value. In Europe such festivals hap- pen annually such as Ars Electronica Festival in Linz, Austria and ISEA, which meets in different locations each year. In the United States, the huge annual expo Siggraph is well-known and offers courses, panels, and exhibitions, although it tends to be dominated by issues of hardware.

Technologically based work was highlighted at the 1993 Venice Biennale and again at the 1995 Biennale (Jenny Holzer, 1993) when Bill Viola took over the American pavilion with five monumental video installations. At the same Biennale, Gary Hill received the Golden Lion award for his interactive work in which the movement of the audience is linked to changing video images.

In 1995 New York's Museums and galleries were dominated by several important exhibitions which created a major new moment of mainstream accep- tance for video installation. Gallery exhibitions of pioneer video artists, Mary Lucier and Nam June Paik were followed by a major retrospective of Gary Hill's work at the SOHO Guggenheim; and by "Video Spaces: Eight Installations" at

Figure 165. Bill Viola, *Slowly Turning Narrative,* 1992. Computer controlled installation with two video projectors and two sound systems. In this poetic work, images are projected onto a freestanding wall with one side mirrored. The wall rotates on a vertical axis. Two video projectors face the turning screen from each end of a large darkened room. One projects a black and white video close-up of a man's face. He seems distracted and at times, strained. He repeats phrases, chanting them. The second projects a series of color scenes which are full of turbulent light and color—a house on fire, children on a carousel, a carnival. The image angle of each image is narrowed or widened in relation to each projection as the wall rotates. These warped effects from the projector beams spill over onto every surface in the room encompassing and including the viewers who also see themselves reflected in the mirrored wall as it revolves. The work is a meditation on the inclusive nature of the self and of the potentially infinite (therefore unattainable) states of being, all revolving around the workings of the constantly turning mind as it engages in absorbing perpetual change. *(Courtesy Bill Viola Studio, Photo: Gary McKinnis)*

the Museum of Modern Art which featured works by, among others, Tony Oursler, Bill Viola, Gary Hill, Chris Marker, Furuhashi, and Judith Barry. The hybrid form of video installation is different from the single channel video shown at the previously mentioned Video Festival. These exhibitions reflect the fact that the new video works have "staked out territory at the intersection of film, performance, sculpture, and computers. As this striking show demonstrates, some of these artists have begun to produce challenging works that could be created in no other medium."[19]

At the 3rd International Biennale in Nagoya, Japan, ("ARTEC '93"), a huge art and technology exhibition based on the theme of the new relationship

between humans and technology, featured the work of more than fifty artists from around the world. Many interactive works were represented with a majority taking the form of video installations.

Interactive work has been featured in several different exhibitions, among them the 1994 "Interactive Media Festival in Los Angeles," which included the work of twenty-seven artists, among others, Agnes Hegedus, Jean-Louis Boissier, Ken Fiengold, Jeffrey Shaw, Paul Sermon, Ulrike Gabriel, Tamas Walickzy, and Luc Courchesne.

At the ambitious Third Lyon Biennale of Contemporary Art (installation cinema, video, and interactive) held in 1996 at the new Musée d'art Contemporain, seventy four artists were represented, many of them with complex interactive works. At Karlsruhe, Germany, 1995, the "Fourth Biennial of the Multimediale Art Festival" took place at the Museum of Contemporary Art and the Center for Art and Media (ZKM). This exhibition was one of the most ambitious of this genre. Based on the resources of ZKM, many foreign artists were able to create works there which could never have evolved without institutional support which is seemingly more available in Germany than elsewhere. "Photography After Photography," Munich, 1996, an international exhibition dealing with the confrontation of photography and digital media, was also funded by the Siemens Kulfur Program. New Media Museums have recently been established at Karlsruhe, Germany, Linz, Austria, and at the Soho Guggenheim Museum in New York.

1995 performances featured as cutting-edge works at the Brooklyn Academy of Music, included collaborations between visual artists and performers, among them, those by Ilya Kabakov; by Vito Acconci; and by Andrew Ginzell

Figure 166. Agnes Hegedus, *Handsight*, 1992. Detail of interactive environment.

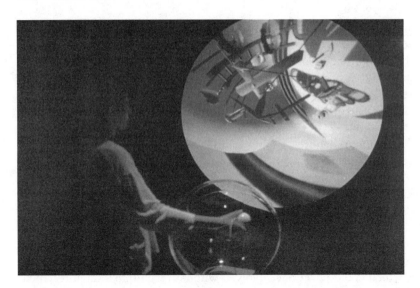

Figure 167. Agnes Hegedus, *Handsight*, 1992. Detail of interactive environment. This installation is built around the metaphor of the eye in several manifestations. The interface itself is designed as an eyeball tracking device which the viewer holds and inserts through an opening in a large transparent bowl, also reminiscent of an eye. When the tracker is held outside the bowl, an image of an eyeball is projected on the circular screen. When the ball is inside it, a computer-generated scene, resembling a glass-bottle bricollaged Calvary scene from nineteenth century Hungarian folk art, is projected onto the circular screen. For Hegedus, the bottle image acts as an ancient reference to a photo-virtual world, one which allows her to engage us in a meditation about two different "virtual" worlds and the different ways we relate to them. The work challenges us to reflect on the historical and ideological nature of our ways of seeing. (*Courtesy Agnes Hebedus*)

and Kristin Jones teamed with Indian choreographer Chandrelekha. The composer Philip Glass has created two operas for BAM based on the films *Orphée* and *La Belle et La Bête* by French director Jean Cocteau. Glass comments:

> In its first one hundred years, the world of film has created a new kind of literature, one that the world of live music, experimental theater, dance and even opera can draw upon; just as in the past historic novels, plays, and poems became the basis of new music/theater works.

Although the primarily visual nature of film is widely acknowledged as a form of representation and has a history of use by visual artists, as we have seen, it has not yet become fully integrated into the visual arts canon. A shift to include it is now occurring because of the prevalence of video, TV, and multimedia technologies and the popular use of the VCR. A generation of artists has evolved which has had access to film history on their own VCRs (as well as

access to historical and contemporary video documentation of dance, music, and theater performances). An illustration of this shift is the separate films made by each of three mainstream visual artists—Robert Longo, David Salle, and Julian Schnabel. They have created full-length narrative feature films which do not challenge traditional conventions of the cinematographic vocabulary of representation while retaining their painterly, intense interest in color, composition, and form, much as artists explored photography in its infancy as a fine-art medium. These painters have taken on filmmaking through the use of narrative film conventions, while independent filmmakers like Peter Greenaway and many single channel videomakers, as we have seen, prefer to try to break with that tradition and straddle the two worlds of representation.

Blade Runner: Politics of Reproduction and Self-Referentiality

Benjamin makes a distinction between the aura of the original based on ritual production and the reproductive copy of the original in which the criterion of authenticity has been lost. He shows us that this loss brings us into the realm of

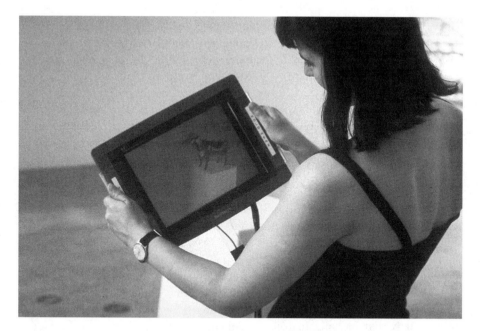

Figure 168. Jeffrey Shaw, *Golden Calf,* views of Interactive installation, 1994. Lifting the hand-held color LCD monitor set from its pedestal, the calf comes into view standing on a pedestal which ressembles the real one actually standing before us. As we move about, holding the display unit with its tracking wires, we are aware that the size of the calf and its pedestal varies as to the distance and the angle of view with which we are holding it. A disturbing and haunting crisis in belief occurs in this process which remains with the viewer long after the LCD monitor is returned to its real pedestal. (*Courtesy Jeffrey Shaw*)

the politics of reproduction. This theme was taken up through the science fiction film *Blade Runner*,[20] a film in which our biological futures are deeply implicated in the new postmodern climate of genetic engineering, simulation, and the hyperreal. It explores the threat posed to society when the body can be reproduced technologically and explores the assumptions underlying this threat, earlier presented in films such as *Metropolis* and *Frankenstein*. What does it mean when the reproduced become a danger to the reproducers? The film connects the fully realized android reproductions with an earlier technology of photography, as proof of their history.

What does it mean that in *Blade Runner* and many other films, photography, another technological imaging device, is used as an inner self-referent? The notion of self-referentiality in art, of one art form paying homage to an older one, is one of the touchstones of postmodern representation. Artists strive to "give the bow," to include within their chosen form of representation, references to the medium they have used in creating the work. Without this reference to the tool, the medium by which it has been produced, the work is felt to lack validity as an artistic statement within its system of representation.

The mise en scène for *Blade Runner*[21] is not the ultra modern, but the postmodern. It gives off the aesthetic of postindustrial decay, exposing the dark side of technology, the process of disintegration. The narrative of the film participates in the logic of imitations, reproductions, simulations, and of the hyperreal. Several "replicants" steal a spaceship, murdering the passengers and illegally land on Earth. Deckard, a hard-boiled antihero, "blade runner," comes back from retirement to track down and destroy the renegade androids. These replicants, as they are called, have been created to serve mankind in dirty, out-of-the-way places and jobs. To keep them from using their superhuman strength and intelligence against their masters, they have been designed with a built-in safety mechanism—they self-destruct four years after their "inception" date. Wishing to survive longer, they seek out their creator, Tyrell who has denied them status as "real" human beings but endows some of them with feelings and even artificial memories. Rachel, the latest model android is so perfect that she doesn't know at first that she is anything less than human. With Rachel, we understand that the distinction between real and artificial, between android and human has become meaningless.

Replicants (androids) are the perfect simulacra of humans technologically replicated to such a degree that they now become dangerous to their human makers. "The unreal is no longer that of dream or fantasy or a beyond or a within, it is that of hallucinatory resemblance to the real itself."[22] Created as slaves, the replicants look like a he or a she. Like all simulacra they undermine the notion of an original by refusing any difference between themselves and their masters. They have neither past nor memory. They are denied a personal identity since they cannot name their identity over time. The viewer is constantly engaged with Deckard in the attempt to discover and separate the artifi-

cial from the real. In this tension, the figure of the mother becomes a breaking point. Rachel goes to Deckard to convince him she is not a replicant. Her argument is a photograph of a mother and daughter. That photograph represents the trace of an origin and thus a personal identity, the proof of having existed and therefore of having the right to exist in 2019. Deckard falls in love with Rachel and she is allowed to live when Deckard is saved by one of the dying replicants. The film thus poses the question: if the replicants are not human, then neither are we; conversely, if we are human, can they be any less?

Technological seeing, whether it is still photography, film, video, or computer assisted video takes on the task of reappropriating the real and creating a record of historical continuity. Deckard's way of interrogating a photographic document is to place it on a video machine for analysis. The photograph is deconstructed visually and restructured to show new patterns of relationships. He is able to shift the direction of the gaze, zooming in and out, selecting and rearranging elements. Here, the still photograph assumes a new meaning, a story, a kind of filmic narrative. In *Blade Runner*, photography is used as a belief mechanism. He pushes a button to collect a blow-up of one of its parts too small to see without technological intervention. It will be used to identify a hunted replicant.

Photographs assert the reality of the referent as having existed in that past moment when the person, the thing, was there in front of the camera. Barthes argues that "by attesting that the object has been real, the photograph surreptitiously induces belief that it is alive." Replicants rely on photography for proof

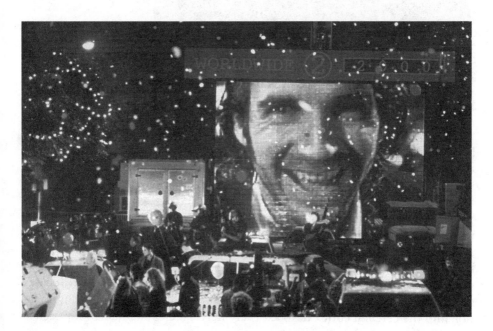

Figure 169. Katherine Bigelow, *Strange Days*, 1995. Publicity Film Still. *(Photo: Marie W. Wallace)*

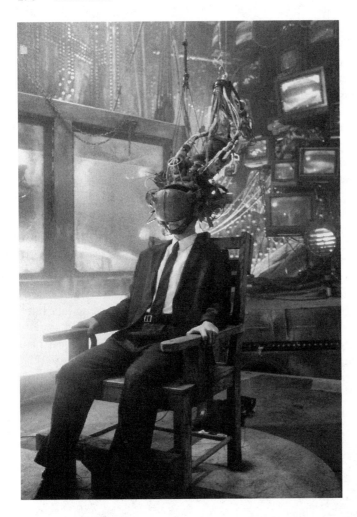

Figure 170. Robert Longo, *Johnny Pneumonic,* 1995. Publicity Film Still.

because of its perverse confusion between the Real and the Live, as it creates the belief and hope of being alive, through history. For them, photography functions as accepted memory. A theoretical link is established between photography, mother, memory, and history.

A, more recent (1995), example of a film which explores technological representation and self-referentiality is the sci-fi film *Strange Days* which invents an Armageddon-like rubble-strewn, crime-ridden landscape of Los Angeles being geared up to celebrate the arrival of the year 2000 when technology has devised bigger and better ways of exploiting the senses. Its crime plot focuses on the use of advanced Virtual Reality clips and headgear, which send information into the cerebral cortex to touch every nerve, recreating human experience

as though the viewer is not only seeing but *experiencing* events with all their senses. Taking advantage of a world obsessed with sex and violence, *Strange Days* relentlessly explores the virtual reality playback machine and the accompanying sale of clips. These tempt customers with offers of illicit sensation, of seeming involvement in virtual sex or violent crime as easy as loading the playback machine. One of the most devastating scenes is one in which diabolical advantage is taken of this new technology and its power to subvert and poison. In this scene, a rapist/murderer forces his terrified victim to see herself, via virtual reality technology, through his eyes. He then tapes the result for later viewing by others. This image, as seen against the powerful figure of the black female heroine and the weak, but transformed hero who chase down the demoniac killer is meant to shock people out of their complacency about a misused technology which has gone "over the edge."

The film's director, Kathryn Bigelow graduated as a conceptual artist from the Whitney Museum Program in the early seventies, before attending film school. She became dissatisfied with the narrowness of the art world audience at the time because too much knowledge of abstract material was needed by the average public to view her work. She challenged herself to try a form of representation that does not require that type of knowledge. In a recent ARTFORUM interview she comments:

> Film was this incredible social tool that required nothing of you besides twenty minutes to two hours of your time. I felt that film was more politically correct, and I challenged myself to make something accessible using film but with a conscience." (Indicating that the film involves a commentary of scopophilia, or addiction to the image, she continued:) "As our environment becomes increasingly mediated, so are all our experiences. . . . The desire to watch, to experience vicariously—there's a tremendous gluttony for images right now, that hunger to experience someone else's life instead of your own is so palpable. It's pure escapism, but it seems fundamental. What else is the appetite for cinema?[23]

Several other 1995 movies such as *Johnny Mnemonic* (based on the novel by William Gibson), *The Net*, and *Virtuosity* exploit irrational technophobic fears, fears that somehow computers will take over our lives, that they will make our brains go haywire. Commenting on the violence of these films and their failure at the box office, film critic Caryn James called these "killer-computer" films. The *New York Times* in an editorial entitled "Hollywood Horrors,"[24] suggests that a public revolt is occurring which may force the filmmaking industry to reassess its focus on film as a cynical vehicle for violence. A public tired of formulaic and derivative filmmaking, produced to bring in top dollar, is letting the industry know, by voting with its feet, that it cannot assume it is easy to manipulate.

Influence of Technology Creates a Wider Public Forum for Art

Availability of mass-media technological tools tend to lead artists to work in expanded creative territory such as video productions, electronic books, outdoor public art projects, and telecommunications projects where their work will be seen by a much wider audience.

The goals of some video artists is to show their work on the public airwaves through local public access cable stations or programs on PBS. Although the numbers of these artists are still extremely small due to problems of funding and access to TV time in comparison to the total field, their influence is important because of new strategies they are developing. Some artists work in the public arena of the streets. Their aspirations have been helped by the Public Art Fund.[25] Creative Time Inc. is another sponsoring organization for public projects. The scope of work being done by both organizations includes artists' outdoor billboards, printed poster displays in subways and buses, and temporary site installations on traffic islands, vacant lots, and department store windows. Getting media attention is one of their strategies—and they make use of media techniques and forms of communication in getting across their messages.

The experimental collaborative impulse of the sixties artists has also now moved from experimental to more direct involvement and heightened public activity. Many groups have evolved. In the eighties, groups such as Colab, the Guerrilla Girls, Political Art Documentation, and Group Material produced projects that required a collective effort in seeking funding and in sharing labor, talent, and equipment. Their goal is to connect art to a wider audience outside the museum and gallery system. For example, in the early 1990s the Baltimore Museum established programs in which an invited artist works for several months within a local community creating a work which is shown in the area, while public programs extending the idea of the work are conducted in the museum.

This is similar to the program of Arts International begun in 1992 where artists committed to community based projects travel to other countries as cultural ambassadors. Returning to home base, they act as facilitators, submerging their own identities in the collaboration with the community group they are working with. The goal of most of these projects is to address cultural and social issues and to attract new diverse audiences from the country visited to the institutions which have supported the grant proposal.

As we have seen, the Internet has become the site for a wide range of work by artists since 1994. Aside from "Home Page" exhibits of their own work, many have designed interactive projects of social concern. An Arts International project about domestic violence, has been uplinked to the World Wide Web. It is an interactive site, complete with resource directories, where viewers can leave their stories, read those of others, and visit visually the monument originally designed as a Museum installation.

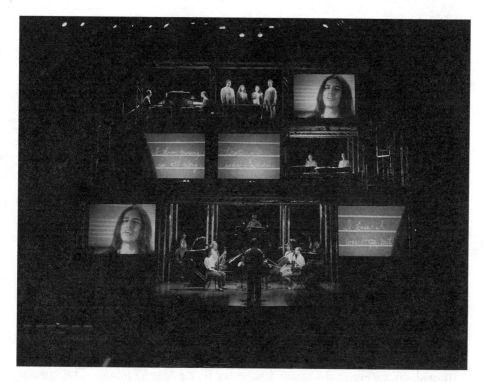

Figure 171. Beryl Korot in collaboration with Steve Reich, *The Cave,* 1994. A documentary music and video theater work. A re-examination of ancient biblical conflicts as seen through the eyes of contemporary Israelis, Palestinians, and Americans who interpret the past in the light of present-day political realities. It harnesses computer technology to synchronize live musicians, digitally sampled speech and Korot's multichannel video. The result is a twenty-first century operatic environment which is part documentary, part music theater, one which overturns operatic tradition. *The Cave* refers to the cave of Machpelah in the West Bank city of Hebron revered, by both Jews and Moslems, as the ancient burial site of biblical patriarchs and matriarchs. *(Courtesy Beryl Korot)*

A Poly-Centered World

Organized to mark the fiftieth anniversary of the United Nations, an exhibition "Dialogues of Peace," featuring the work of sixty contemporary artists from around the world, was installed in the grounds of the UN complex in Geneva in July of 1995. Thousands of ethnically diverse officials and diplomats see the works daily as they pass by. There is no escaping the presence of these works. Some of them are warnings and reminders of world problems such as the huge video wall installation by Nam June Paik on the massacres in Rwanda, and another one designed by Marcel Oldenbach about the world refugee problem. Video artists gained access to UN video archives. Allen Ruppersberg, an American artist, used his research there to create, as a warning to today's diplomats,

As Close As We Have Come, a historical overview about the failure of the League of Nations. Robert Rauschenberg contributed a series of screen prints on different themes which, taken together, cover the range of human experience. Chen Zhen, a Paris-based artist constructed a "Round Table" at which 26 chairs of different size and quality are placed. For diplomats, the work is a pointed reminder that some of the chairs are more equal than others. In choosing the works, curator Adelina von Furstenberg, said she was interested in showing a contrast of cultures. "Through the concept of difference, one reaches the idea of tolerance as a basic human right."[26]

An exhibition of European artists at the National Gallery of Modern Art in New Delhi, India in 1995 organized by Henri-Claude Cousseau raises important questions about the influence of divergent cultures on the West. Of the thirteen artists in the exhibition, ten visited India to create their projects. Critic Gayatri Sinha's description of the exhibition in the *Hindustani Times*[27] notes that the exhibition's title "Thresholds" suggests our place in history between past and present; between tradition and modernity. He notes that, with definitions of art undergoing radical change, conventional aesthetics are being replaced with a pressing anxiety for social and individual identity and a search for expansion through contact with alternative cultures. Another exhibition which raises the importance of international diversity is "Documenta," curated in 1997 by Catherine David. This is a major international art exhibit held every five years in Kassel, Germany. The curator's goal is to broaden the exhibition by making it even more international than it has been and at the same time to re-examine the premises of a global survey. "We're no longer in a postwar North America-Europe dialogue, and we must open up, somehow. What do we mean by international? Without neocolonial attitudes? "Documenta" should be a way of addressing these questions—not necessarily solving them—but at least addressing them . . . It's not a question of quotas or simple political correctness but of methodology, meaning when you present artists from different contexts together you must think about and deal with the meanings of those confrontations. We are now in an increasingly polycentered world."[28] She is interested in the changing dynamic between center and periphery, between north and south the idea that contemporary art is no longer just about Western Europe and New York City. The concept of polycentered, originally suggested by writers such as Baudrillard, and Barthes, seems apt in relation to postmodern webs, nets, and communication modules.

However, when a value structure is overturned or seen differently, there is a feeling of free-fall. Critic/Philosopher Thomas McEvilley writes: "Released gasping from the isolation tank of Euro-Modernism, and the linear Eurocentric view of history, culture may seek a global framework of imperfect meaning constructed by the balanced interplay of sameness and difference."[29] Some, seeking safety, cling to old values and structures while all around them, the entire world

view they have functioned under, is changing. Change occurs through the actions of those who struggle to critique inherited cultural norms and values.

Can the larger context of a global culture enrich us by reducing the gaps between cultures and societies? Writing in a 1989 issue of *Art in America* devoted to global issues, black cultural critic Michelle Wallace wrote:

> I don't think the response of people in the Third World who are confronted by American or European mass culture is to say: "Oh well, what's the use. Let's not make any more music, let's not write any more poetry." I think instead that the impact of mass culture is to generate even greater cultural production. Cultural differences always exist and are important to the perpetuation of mass culture. And I think you'll find that mass culture can stimulate and tolerate much more difference than anyone would ever imagine.

Wallace is right in her feeling that human creativity, identity, and culture is strong and resilient. However, if we are making judgments based on our commercially based culture with its airwaves almost totally controlled by commercial interests, we would miss seeing this point. Taking into account the value and power of systems pre-existing in social and cultural systems before the arrival of a particular technology such as television, the perversity of its affects can be measured by the degree of cultural distortion and dysfunctionality which informs its use. Almost totally controlled by the market economy, there is, at the present, little chance for its reform although its power as a medium could be usurped through public access channels, for positive ends.

Donna Haraway, feminist author of *Simians, Cyborgs, and Women: Re-Inventing Nature*[30] thinks of technological breakdown as an opportunity for the possibility of a positive good. Commenting that disruption of hierarchies and traditional boundaries between things have possible beneficial social uses, she points to the potential to create new social and cultural practices. Haraway sees that subversion and intervention could be effective in creating change. She proposes a hybrid body in the form of a cyborg as a metaphor for the new that could expand boundaries beyond their present margins to include a more diverse discourse. The idea of a recombinant being, conjures up Aristophanes' parable.[31] According to the parable, the original state of the human race was, in earliest times, divided in three: men, women, and a being which was half of each. Each of these types were erect—walking, globular in shape, with rounded back and sides, each having four arms, four legs, two faces, both the same, with double genitalia. With their many arms and legs, these powerful beings, tried to scale the heights and attack the gods. Zeus, in consultation with the other gods, devised a plan to cut them in half to put an end to the disturbance without destroying them. Each now had two arms and legs and separate genitalia but now each had a desperate yearning for its other half which could only be satiated by conjugating one with the other. Thus, both their souls now belonged to something else—a something to which they could only give an inkling of in "cryptic sayings and poetic rid-

dles." Using Aristophanes' parable as an interface for today's relationship between a technological persona and a human being can we imagine yet another formulation? Can we imagine a cybernetically merged body and machine? Biology and technology can instill a system with its own new power, drama, and poetry.

This chapter has meant to reflect the seriousness and complexity of our future practice of the arts. Out of this very concern, out of the knowledge of and resistance to the excesses of technology, we may forge important directions and strategies for the future. The structure of this kind of crisis is very familiar. There is a recurrence of the loss, displacement, and change in consciousness, similar to the effects on society and culture of the machine and of the photographic representation technologies we have been following. The electronic era, because of its greater complexity and its power to disrupt, is causing even more fundamental change and loss than did the machine era. We are again at the end of a century in which technological developments have transformed culture and living standards.

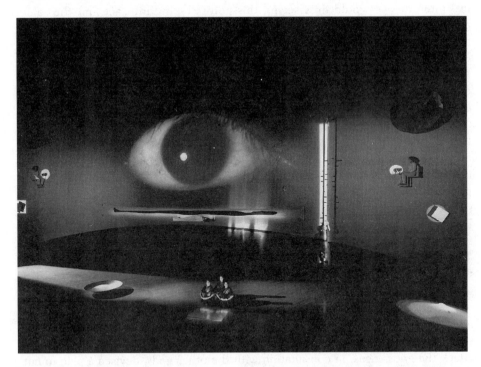

Figure 172. Kristin Jones and Andrew Ginzell with Chandrelekha, *INTERIM: after the end and before the beginning*, 1995. Installation at the Queens Museum with dance performance, sponsored by the Brooklyn Academy of Music Next Wave Festival: Artists in Action. "An exploration of the infinity of time within a single blink of an eye. The forty-minute work involves the expansion of both the concept of movement as well as of isolated expanding elements. The gesture of attempting to contain time is evidence to the sheer impossibility of fathoming it." (*Courtesy Kristin Jones and Andrew Ginzell. Photo: T. Charles Erickson*)

There are many shades of gray between the two poles of a deadeningly repressive system of commercial TV and its opposite, an interactive communications system which could promote open, powerful conditions for humanistic growth. And there are possibilities to use global technologies by artists who have an interest in change even though this would necessitate major changes in the way they think and work in order to communicate with a mass audience. Will the growth of these possibilities allow the emergence of new forms and ideas about art which will have wide significance? If human need and power is predominant and understanding of it is intact, art could continue to flourish in abundance.

The postmodern is both a historical and a cultural category full of paradox, contradiction, and divergent interpretation. But to writers like Lyotard, Fiedler, and Hassan, the "post" signifies not decline or fatigue, but the freedom and self-assertion of those who have awakened from the past. For feminist Vietnamese filmmaker Trinh-Minh-Ha, the postmodern condition implies rather than talking about death: "a new threshold, a suspension of closure and of walking forward into a new space. I prefer to talk about threshold, frontier, limit, exhaustion, and suspension; about void as the very space for an infinite number of possibilities . . . about making possible the undoing, re-doing, and modifying of this very limit."

Notes

Introduction

1. Paul Valery (1871–1945) was regarded as one of the greatest poets of the twentieth century.
2. Walter Benjamin (1896–1940) committed suicide as he was about to be captured by the Nazis at Port Bou in France.
3. Theodor Adorno, Introduction to Benjamin's "Schriften," p. 7. Quoted in Gary Smith, ed., *Benjamin: Philosophy, Aesthetics, History* (Chicago University Press, 1989).
4. Terry Eagleton, *Walter Benjamin*, (London; Verso Books, 1988), p. 179.
5. This discussion of Walter Benjamin's thought owes a debt to John Berger's, *Ways of Seeing* (London: B.B.C. and Penguin Books, 1981).
6. George P. Landow, *Hypertext: The Convergence of Contemporary Critical Theory and Technology* (Baltimore and London: The Johns Hopkins University Press, 1992).

Chapter 1

1. Dick Higgins, questioning changes in art, quoted in Brian McHale, *Constructing Postmodernism"* (London and New York: Routledge, 1992), pp. 32–33.
2. Svetlana Alpers, *The Art of Describing: Dutch Art in the 17th Century*, (Chicago: University of Chicago Press, 1983).
3. For the Greeks, the word *techne,* meant both art and technology. The oldest engineering text, the *Mechanica* was written by the philosopher Aristotle (384–322 B.C.).
4. Deborah Haynes, *The Vocation of the Artist* (Cambridge: Cambridge University Press, 1997).
5. Charles Seymour Jr., "Dark Chamber and Light-Filled Room: Vermeer and the Camera Obscura," *Art Bulletin* 46 (1964): 325.
6. John Berger, *Ways of Seeing* (London: B.B.C. and Penguin Books, 1981).
7. In England, Sir Charles Eastlake, president of the Royal Academy, accepted the presidency of the Photographic Society of Great Britain; and in France, the well-known painter Baron Gros became the first president of the Société Héliographique whose other founding members included Eugene Delacroix and many prominent artists.
8. "A daguerreotype is more than a tracing, it is the mirror of the object, certain details almost always neglected in drawings from nature . . . which characteristically take on a great importance, and thus bring the artist into a full understanding of the construction. There, passages of light and shade show their true qualities, that is to say they appear with the precise degree of solidity or softness—a

very delicate distinction without which there can be no suggestion of relief. However, one should not lose sight of the fact that the daguerreotype should be seen as a translator commissioned to initiate us further into the secrets of nature; because in spite of its astonishing reality in certain aspects, it is still only a reflection of the real, only a copy, in some ways false just because it is so exact." Quoted in Aaron Scharf, *Art and Photography* (New York: Penguin Books, 1986), pp. 119–120.

9. John Berger, Ibid.
10. Walter Benjamin, "The Work of Art in the Age of Mechanical Reproduction," essay in *Illuminations* (New York: Schocken Books, 1978), p. 236.
11. F. Lanier Graham, *Three Centuries of French Art* (Norton Simon Inc., Museum of Art, 1973), p. 41.
12. Sonia Sheridan, *Electra* catalogue, Musée de l'art Moderne de la Ville de Paris, France 1983, p. 396.
13. Ibid.
14. Ibid.
15. Andreas Huyssen, "The Hidden Dialectic: The Avant-Garde—Technology—Mass Culture," essays on *The Myths of Information: Technology and Post-Industrial Culture*," ed. Kathleen Woodward (Madison, WI: Coda Press, Inc., 1980), p. 158.
16. Walter Benjamin, Ibid.
17. Quoted in Van Deren Coke, *The Painter and the Photograph* (Albuquerque: University of New Mexico Press, 1974), p. 299.

Chapter 2

1. Michael Newman, *Postmodernism* ICA Document #4 (1987), p. 33.
2. Later, they began to collage ordinary "found" elements (such as newspaper fragments, postage stamps, nails, string)—as a kind of effluvia of the machine age—both as a reflection of the times and as a challenge to the conventional "preciousness" of standardized art materials used in the production of art projects as commodity items for the art market.
3. Their radicalism included using noise as music, shock and nonsense in theater, and the destruction of all traditional forms and institutions (including museums) in order to create an anarchistic living culture "made in the present for the present" before humans could progress "beyond painting" which was seen as a symbol of the old order and thereby represented a tyranny of "good taste and harmony."
4. Walter Benjamin writes in his essay "The Work of Art in the Age of Mechanical Reproduction:" "'Fiat ars—pereat mundus', says Fascism, and, as Marinetti admits, expects war to supply the artistic gratification of a sense perception that has been changed by technology. This is evidently the consummation of 'l'art pour l'art'. Mankind, which in Homer's time was an object of contemplation for the Olympian gods, now is one for itself. Its self-alienation has reached such a degree that it can experience its own destruction as an aesthetic pleasure of the first order. This is the situation of politics which Fascism is rendering aesthetic."
 Benjamin also wrote in the same essay that photographic reproduction, mixed with sound, saw mass movements, such as demonstrations, more clearly through a camera lens than through the naked eye. In newsreels (as in TV) such mass movements, including war, leads to a form of human behavior which particularly favors mechanical equipment.
5. Rose Lee Goldberg, *Performance Art: From Futurism to the Present* (New York: Harry N. Abrams, 1988), p. 44.

6. He is credited with discovering the photogram in 1922.
7. Calvin Tomkins, *Off the Wall* (New York: Penguin Books, 1983), p. 126.
8. Duchamp designed a book to accompany the work called *The Green Box*. It contained his notes and sketches about the work and was ironically presented in the spirit of an industrial equipment manual.
9. Quoted in *Ideas and Image in Recent Art*, exhibition catalog (Art Institute of Chicago, 1974), p. 10.
10. Quoted in Pontus Hultén, *The Machine*, catalog (New York: Museum of Modern Art, 1968), p. 102.
11. Quoted in ibid., p. 103.
12. Marshall McLuhan, *The Mechanical Bride: Folklore of the Industrial Man* (New York: Vanguard Press, 1951).
13. These were combined with the authoritarian teachings of Josef Albers who transmitted the Bauhaus maxim of design and use, form and function, art and life. (Albers believed in the training of perception and consciousness, a process that also involved learning to understand the true nature of materials and the relationship between them.)
14. These notes are from Martin Duberman's *Black Mountain: An Exploration in Community* (New York: E.P. Dutton, 1972), p. 277.
15. Daniel Wheeler, *Art Since Mid-Century: 1945 to the Present* (Englewood Cliffs, N.J.: Prentice Hall/Vendome Press, 1991), p. 125.
16. Riva Castleman, *Printed Art* catalog (New York: Museum of Modern Art, 1980), p. 11.
17. Daniel Wheeler, Ibid. p. 312.
18. By 1959, the Artists' Technical Research Institute had been founded.

Chapter 3

1. Guy de Bord wrote *The Society of the Spectacle* (published by Buchet-Chastel in 1967). By 1958, 42 million American homes were fed by broadcasts from 52 stations. As a result of the wild barrage of images that flowed through its TV sets from all over the world, the public participated collectively, in the comfort and privacy of their living rooms, in a new cultural condition. Apart from the commercial junk, they saw documentary reportage of the moon landing, Kennedy's assassination, the far-away Vietnam War, Martin Luther King's funeral, and the civil rights marches. These compelling images were mixed in with an odd assortment of cultural manifestations ranging from soap operas, game shows, religious sermons, science programs, cooking lessons, gym classes, and reruns of old movies.
2. Video was welcomed in the art community also as a means of documentation. Those artists doing large-scale Earth Art environmental projects rely heavily on video films and photographs as documentation of their far-away work both for funding purposes and for public awareness of their work. In the spirit of fusing art and life and locating real objects in real space, the earth artists engaged material reality—desert, sky, water, land—and executed their projects in real locales. As a testament, the photographs could never transmit the spirit and the experience of the work's true scale and presence. However, the concept of documentation of a project through the use of all aspects of photography and video became a firmly established practice for all artists, including those in the dance, theater, and performance genres. Funding sources for these costly environmental works also began to dry up during the economic depression of the early 1970s.
3. By 1967, E.A.T. arranged for a juried exhibition "Some More Beginnings" at the Brooklyn Museum in the form of an international competition. Prize-winning

works were to be included in the Museum of Modern Art's "The Machine" exhibition.

4. Calvin Tomkins, *Off the Wall* (New York: Penguin Books, 1985), p. 252.

5. Among the most virulent of the reviews was that of Artforum's Max Kozloff. According to the art historian Jack Burnham, "Multimillion Dollar Art Boondoggle" was "probably the most vicious, inflammatory and irrational attack ever written on the art and technology phenomenon." It posed the museum, Tuchman, and most of the artists connected with Art and Technology as lackeys of killer government, insane for new capitalist conquests in Southeast Asia. Kozloff depicted half of the artists involved as "fledgling technocrats, acting out mad science fiction fantasies." Jack Burnham, "The Panacea that Failed," *The Myths of Information*, ed. Kathleen Woodward (Madison, WI: Coda Press, Inc. 1980), pp. 200–215. Later, bitterly, Burnham commented in the October 1971 Artforum: "Whether out of political conviction or paranoia, elements of the art-world tend to see latent fascist aesthetics in any liaison with giant industries; it is permissible to have your fabrication done by a local sheet-metal shop, but not by Hewlett-Packard."

6. Abigail Solomon-Godeau, "Photography after Art Photography," in *Art after Modernism: Rethinking Representation*, ed. Brian Wallis (New York: The New Museum of Contemporary Art, and Boston: David R. Godine, Publisher, Inc., 1984), p. 80.

7. Peter Frank and Michael McKenzie, *New Used, Improved: Art of the Eighties* (New York: Abbeville Press, 1987), p. 90.

8. Roland Barthes, "The Death of the Author," in *Image-Music-Text*, translated by Stephen Heath, New York: Hilla and Wang, 1977, pps. 146–147. Foucault wrote about representation in the *The Order of Things* and in *What Is the Author*.

9. Michael Brenson, "Is Neo-Expressionism an Idea Whose Time Has Passed?" *New York Times*, Section 2, Sunday Jan. 5, 1986.

10. See Celeste Olalquiaga, *Megalopolis: Contemporary Cultural Sensibilities* (Minneapolis: University of Minnesota Press, 1992).

11. Celeste Olalquiaga, Ibid.

12. Alice Yang, "Cyborg Aesthetics," essay for the exhibition "The Final Frontier," The New Museum of Contemporary Art, New York, May 7 to August 15, 1993.

Chapter 4

1. The Rockefeller Foundation (by 1967); New York State Council for the Arts (1970); and the National Endowment for the Arts (1972). The Canada Council and European government-based arts funding also began supporting video activity. Early grants went to facilities such as the newly founded Electronic Kitchen in New York and the Experimental TV Center in Binghamton, New York (later, Owego), where small format and postproduction equipment were made available to artists together with gallery screening of video.

2. In 1972, the First Annual National Video Festival took place at the Minneapolis College of Art and Design and the Walker Art Center. Later that year, the first Women's Video Festival was mounted at the Kitchen in New York. Video also became part of the annual New York Avant-Garde Festivals. It was widely exhibited in new media centers such as the Visual Studies Workshop in Rochester, New York. In 1970, the magazine *Radical Software*, published by the Raindance video group in New York, began disseminating both technical information and news about individual artists' productions.

3. Film was normally cut and spliced together by hand, using the film frame and sprocket holes as a guide. In video, the electronic signal is transferred to another

tape and reassembled onto another generation of tape through the editing console. Loss of image quality occurs in this transfer.

4. The light 16 mm Bolex camera has been used by "independents" since the 1940s.

5. Phillip Drummond, "Notions of Avant-Garde Cinema," from the catalog *Film as Film, Formal Experiments in Film 1910–1975* (London: Hayward Gallery, Arts Council of Great Britain, June 3–17, 1979), p. 13.

6. The key paradigm development period of modern times (1820–1965) brought together a complex of scientific advance and technological invention that made television possible: electricity, telegraphy, photography, motion pictures, and radio. The discovery of the cathode ray tube (Campbell Swinton and Boris Rosing, 1908), the concept of a scanning system (Paul Nipkow, 1884), and picture-telegraphy transmission (Herbert Ives, 1927) were further discoveries along the way that led in 1928 to the introduction of the first low-definition television system (30 lines). In 1936 the first BBC television broadcast was made from Alexandra Palace, London—and in 1939 from the World's Fair, New York.

 By the 1920s modern urban industrialized conditions and improved transportation systems created new kinds of social organization which led to tendencies towards the self-sufficient family home, sometimes far from the workplace. This "privatization" of the small family home carried "as a consequence, an imperative need for new kinds of contact . . . a new kind of 'communication': news from 'outside', from the otherwise inaccessible sources . . . Men and women stared from its windows, or waited anxiously for messages, to learn about forces 'out there', which would determine the condition of their lives." Raymond Williams, *Television: Technology and Cultural Form* (New York: Schocken Books, 1975), p. 27.

7. The original NTSC recommendation of 525 lines per picture, 30 pictures per second, is still the U.S. standard. After World War II, transmission in France was raised to 819 lines. In the rest of Europe, the standard was set at 625 lines with 25 pictures per second. There is pressure building to change the U.S. standard to allow for higher picture resolution.

8. Gene Youngblood, *Expanded Cinema* (New York: E.P. Dutton, 1970).

9. In the United States, recent surveys show average TV consumption as seven hours per day (almost half our waking hours). An average two to five-year-old watches TV four to four and a half hours per day; an average twelve-year-old, at least six hours.

10. John Hanhardt, "Watching Television," in *Transmission*, ed. Peter D'Agostino (New York: Tanam Press, 1985), p. 59.

11. From Third World countries to highly industrialized ones, the "public resource" of TV is dominated by those countries which can afford to produce programming for hungry global needs. Domination of TV programming by commercial influences reflects erosion of the autonomy of individual nations and communities struggling to voice and project their own social, political, and cultural concerns. Mass TV thus represents a danger, despite its possible transformative benefits in broadening international communication and cultural exchange. "Since the 1950s, the U.S.-made TV programs have saturated the schedules of industrialized and nonindustrialized countries alike. Italian television, for example, is practically an affiliate of the American networks. U.S. commercial television has been a major source of programming for Third World countries as well." Herbert Schiller, "Behind the Media Merger Movement," *The Nation* (June 8, 1985), 697.

12. Walter Benjamin, "The Work of Art in the Age of Mechanical Reproduction," Ibid.

13. Ibid.

14. Edward Slopeck, "Shedding the Carapace," in *The Second Link: Viewpoints on Video in the Eighties*, exhibition catalogue (Banff, Canada: Walter Phillips Gallery, Banff Center, School of Fine Arts, 1983).

15. Willougby Sharp, quoted in Carl Loeffler, "Towards a TV. Art Criticism," *Art Com* #22, 6(2) (1983): 32.

16. Originally published 1967. This translation was published in 1992 by Zone Books, MIT Press.

17. Community Antenna Television (CATV) was developed in the 1940s to provide clear reception to communities where normal broadcast reception was poor due to distance from the main transmitter or to the topography of the terrain. The broadcast signal was received by a high antenna, amplified and retransmitted via coaxial cable to the homes of subscribers.

 It was soon realized, however, that cable, because of its broad bandwidth, offered the possibility of offering many more channels (up to eighty) than the seven or so channels possible with over-the-air VHF broadcasting and the modern cable TV industry was born.

 In 1966, the F.C.C. assumed regulatory powers over cable and in 1972 specified that it allot a certain amount of free access programming to local groups, a decision that the industry has continued to fight through the courts and in Congress. In addition to local access programming, the cable companies make available a variety of programs paid for by a mix of subscriber fees, advertising, pay-per-channel, and pay-per-view. Cable operators base their programming solely on the widest possible appeal to audiences, thereby gaining advertising support. In the U.S., cable serves more than 30 million households, or about 35 percent of the market.

 For homes outside of the high population density urban areas not reached directly by cable, it is possible to receive essentially the same services, (but not local access programming), via a 6 to 10 foot diameter dish aimed at one or other of 24 different satellites. In 1994, a more sophisticated Digital Satellite System (DSS) was introduced in the U.S. It can receive, on an 18 inch dish, 150 or more channels from only one or two satellites, with superior picture reception, almost to laser-disk quality. It offers direct competition to conventional cable services even in urban areas, although siting and orientation requirements may limit its use in the most congested areas. Similar developments are taking place in Europe and Japan.

 The cable-TV industry is now investing heavily in "two-way service" or interactive programming. Seen as the wave of the future, it will permit viewers to order up particular movies, shop by remote control, play computer games, and so on. Cable operators see video-on-demand as a way to finally break into the video-rental and electronic game market, whose annual revenue of $20 billion is roughly equal to the entire cable-TV market. Because of the huge profit potential, telephone companies are now developing advanced technologies to enable them to compete directly with the cable companies in video, interactive, and high-speed data services. This development is now sanctioned in the U.S. following passage of the 1996 federal communications law deregulating the industry.

18. Martha Gever, "Meet the Press: On Paper Tiger Television," in *Transmission* (New York: Tanam Press, 1985), p. 225.

19. Lucinda Furlong, "Tracking Video Art: Image Processing as a Genre," *C.A.A. Art Journal*, 45, no. 3 (Fall, 1985): 235.

20. Such as the Fairlight CVI, the Modified Dubner introduced in 1985, and the Amiga "Toaster." These developments have been superseded by Macromedia and Avid software which are revolutionizing video editing allowing for non-linear methods.

21. A *small* sampling from the early years 1983 to 1990 includes: *Video as Attitude,* Museum of Fine Arts, Santa Fe; *Electronic Vision,* Hudson River Museum, Yonkers; *The Second Link:* Viewpoints on Video in the Eighties, Walter Philipps Gallery, Banff; *Video, a Retrospective,* Parts I and II, Long Beach Museum of Art, California; *The Luminous Image:* Video Installations, Stedelijk Museum, Amsterdam; *Video: A History, Parts I and II,* Museum of Modern Art, New York; *Alternating Currents,* Alternative Museum, New York; *Video Art: Expanded Form* Whitney Museum at Equitable Center, *Bill Viola Installations and Videotapes* Museum of Modern Art New York: and *Documenta Seven (and Eight),* Kassel, Germany.

22. Grace Glueck, "Video Comes into Its Own at the Whitney Biennial," *New York Times,* April 24, 1983.

23. Marita Sturken, quoted in Anna Couey, "Participating in an Electronic Public," *Art Com* #25, 7(1) (1984): 44–45.

24. Jonathan Crary, "Art After Modernism" *Eclipse of the Spectacle,* p. 284, Godine, N.Y. 1984.

25. Developments in two different screen display technologies (plasma-gas and liquid-crystal respectively) are making possible dramatic improvements in monitor screens. The ultra-thin displays can be hung on a wall or placed on a desktop. They will be a major advance over bulky cathode ray tubes (CRTs) currently in use. Screens of up to 60 inches wide by two inches thick can be wall-hung and will provide much sharper and brighter images without the usual flicker caused by the electron gun sweeps of the screen. Flat panel displays dispense with the electron gun used inside the glass vacuum tubes of conventional monitor screens. For example, the most advanced forms of LCDs (the so-called active matrix screens) improve the clarity and precision of the image by giving each tiny picture element (pixel) its own transistor, in spite of the fact that HDTV displays will require upwards of one million pixels, or four times the number in current displays.

26. Charles Hagen, "At the Whitney Biennial," *Artforum* (Summer 1985): 56.

27. Music videos are taking their place along with compact disks (CDs) and audiocassettes in the marketplace. Consumers often tape their own versions directly from TV on their home VCRs. More than 55 percent of American homes now have these. The rate is as high or higher in other parts of the world.

28. Brochure notes, 1990.

29. The three On Line production facilities (two in New York and one in Owego) provide independents with access to ¾- and 1-inch CMX and AVID digital editing equipment, and ADO and Quantel "special effects." Video artists can shoot on inexpensive video 8 mm or ½-inch formats and then postproduce onto the ¾-inch or 1-inch format. *P.M. Magazine* was a popular news and entertainment TV, program directed at the "happy consumer" family.

30. Steve Savage, a video entrepreneur in New York, is selling tapes by artists such as Michael Smith, Keith Sonnier, Dara Birnbaum, Bill Wegman, Joan Jonas, Max Almy, Cecilia Condit, Merce Cunningham, and others. "New Video" and the artists split production costs ($18 per tape) and revenue (tapes sell for $60).

31. Quoted in Robin Reidy, "Video Effects Art/Art Affects Video," *Art Com* #24, 6(4) (1984): 58.

32. Jean-Luc Godard, the experimental French director, uses video extensively to assist in freer visualization of the scenes he composes. By sighting through a video camera he can clearly see and control effects of foreground, background, and reflected lighting, or the effect of camera movement or placement of actors or objects without waiting for film to be developed. This saves time and money and allows a freer rein to the creative impulse.

Chapter 5

1. George Legrady, "Image, Language, and Belief in Synthesis," *CAA Art Journal*, v. 49(3) (1991): 267.
2. Throwing a television image out of sync provides a clear example of imagery as coded electronic information, for the screen's colored images break down to reveal multicolored points of light, much like the Impressionist pointillist paintings. In focus, the screen image seems, because of the phenomena called *persistence of vision* (conventional film images screened at 24 frames per second seem continuous) to be stable and real, although the tiny phosphors of the screen are constantly being rescanned and refreshed many times per second as information about light values and color relationships composed of the basic formulations of red, green, and blue light.
3. George Trow, *Infotainment*, catalog (New York: J. Berg Press, 1985), p. 21.
4. Bill Viola, quoted in Gene Youngblood, "A Medium Matures: Video and the Cinematic Enterprise," *The Second Link: Viewpoints on Video in the Eighties* (Banff, Canada: Walter Phillips Gallery, Banff Center of Fine Arts, 1983), p. 12.
5. Jean Baudrillard *Selected Writings* ed, Mark Poster, (Stanford, Calif.: Stanford University Press, 1988), p. 167.
6. Andrew Menard, "Art and the Logic of Computers," *Journal: Art Criticism* 8(2) 1993; SUNY Stonybrook.
7. Ibid., p. 62.
8. 1985
9. Kate Linker, "A Reflection on Postmodernism," *Artforum* (Sept., 1985): 105.
10. Quoted in Ibid. p. 104.
11. From *S/Z*, Roland Barthes, Paris: Editions du Seuil, 1970. Translated by Richard Miller (New York: Hill and Wang, 1974).
12. I am indebted to Stephen Wilson's important article copyrighted in 1993 and presented in the 1994 *Siggraph* catalog, "The Aesthetics and Practice of Designing Interface Computer Events." Stephen Wilson is Professor of Conceptual Design and Information Art, San Francisco State University. He also adapted his article for a CD-ROM version of the catalog.
13. Cybernetics, a term coined by Norbert Weiner, is defined as "an interdisciplinary science linked with information theory, control systems, automation, artificial intelligence, computer simulated intelligence and information processing."
14. Heuristic: helping to discover or learn, guiding or furthering investigation; designating the educational method in which the student is allowed or encouraged to learn independently.
15. With roots extending as far back as the seventeenth century when mathematicians, philosophers, and scientists such as Pascal and Leibniz began to cope with problems of calculating and storing information, the digital computer or "all purpose machine" began its precipitous ascent to its major place in contemporary life. Charles Babbage's proposal for an analytic engine (1830s), Herman Hollerith's electromechanical counting machine (1890s), Alan Turing's paper "On Computable Numbers" (1936), and John Mauchly and Presper Eckert's first programmable room-sized ENIAC computer (1946), are all milestones in the long developmental search for efficient "intelligent" machines. ENIAC filled an entire room and used 19,000 vacuum tubes any number of which could be expected to burn out in a given hour. It was capable of making about 5000 calculations a second, although it was wired to carry out only one mathematical task at a time. Mathematician John von Neumann suggested a vitally important improvement in the way instructions could be sent into the machine through the use of electronic signals to approximate the data about mathematical sequences. This "soft" form of electronic signal, known as a program, instead of the "hard" form of wiring, came to be known collectively as software.

16. Black-and-white photocopy reproductions of both compositions were shown to a test group of 100 people. The computer-generated rendition was preferred by 59 of those tested.

17. Quoted in Susan West, pp. 36–37, "The New Realism," *Science '84* 5 (1984): 31–39.

18. "Fractal geometry describes the irregularities and infinitely rich detail of natural shapes such as mountains and clouds. No matter how many times it is magnified, each part of a fractal object contains the same degree of the detail as the whole. In science, this new geometry feeds into existing theories about randomness and chaos in nature and has important implications in the overall study of the universe. For computer graphics, fractals represent new possibilities for mathematically mimicking the diffuse irregularity of nature. Using the new geometry, an entire mountain range can be rapidly created from just a few numbers, and it will look more realistic than one made of cones or triangles. Fractals are a category of shapes, both mathematical and natural, that have a fractional dimension. That is, instead of having a dimension of one, two, or three, theirs might be 1.5 or 2.25. A line, for instance, has one dimension, and a plane has two, but a fractal curve in the plane has a dimension between one and two. While dimension usually pertains to direction such as height and width, the fractional part of a fractal's dimension has to do with the way the fractal structure appears under magnification. This is another peculiar characteristic of fractal objects: they contain infinite detail, no matter what scale at which they are viewed. Take, for example, a mountain from half a mile away; a mountain has countless peaks and valleys. From an ant's eye view, a tiny portion of one rocky ledge on that mountain also has countless peaks and valleys" (Susan West, ibid., pp. 32 and 37).

19. Ibid., p. 32.

20. Ibid, pp. 36–37.

21. Quoted in Grace Glueck, "Portrait of the Artist as a Young Computer," *New York Times*, February 20, 1983.

22. From East Village galleries of Manhattan (International with Monument, the New Math Gallery), to Soho (Metro pictures), to 57th Street (Tibor de Nagy Gallery), to New York Museums (the Whitney, International Center for Photography, the Bronx and Brooklyn Museums), recent exhibitions have included work that has begun to bear a mature, integrated stamp. At the Musée d'Art Moderne, Paris, the Electra exhibition in 1982 linked computer work both to kinetic art tradition and to interactive influences. Two Artware exhibitions curated by David Galloway have been exhibited at the Hanover Fair, which brought together European and American artists working in the field. The 1987/88 traveling exhibition, Digital Visions: Computers and Art, curated by Cynthia Goodman, originated at the Everson Museum in Syracuse and traveled to other museums including the IBM Gallery in New York. It was meant as a survey of works by artists over the past twenty-five years who have used the computer either as a direct tool for their work or as an influence. It included work by most of the medium's pioneers, among them Lillian Schwartz, Ken Knowlton, Ed Emshwiller, John Whitney, Charles Csuri, Manfred Mohr, Robert Mallary, and Otto Piene. The show is the largest and most recent of its kind—exhibitions which have served to introduce the computer as a site for art production. By including the work of Andy Warhol, David Hockney, Jennifer Bartlett, Jenny Holzer, Keith Haring, Howard Hodgkin, Les Levine, and Bruce Nauman, proof was established that the computer has entered the studios of mainstream artists.

23. *Siggraph* is the computer graphics special interest group of the Association for Computing Machinery.

24. Images can be imported from other files and moved, cropped, reshaped, reduced and reproduced in different tonal patterns using software designed for text/image

manipulation. Black and white text can be reviewed, with full color images floating behind the masked holes in the white page, to be positioned for closeups or details. A variety of typefaces is available in all sizes, including thick and thin, italic, condensed, uppercase and lowercase. Xerox scientist Robert Gundlach suggests that improved speed and reproduction quality (particularly of laser technologies) is affecting book publishing and seriously challenges the lower-cost conventional offset-litho industry.

25. Quoted in Barbara Bliss Osborne, "Write on the Money," "The Independent," January/February 1994.

26. Nancy Burson works with her scientist collaborators Richard Carling and David Kramlich.

27. Every one of the over 54,000 still-frame pictures on a video disk can be assigned a number. This frame number can be coded along with the picture for the disk player to "read." By punching in selected programmed instruction key numbers, the machine will advance to those frames and hold them on pause for viewing and possibly propose textual multiple-choice questions for further selections. The machine would then reverse or advance to another frame, depending on choices made—and further opportunities for decision making. Images do not lose detail or become grainy because they are computer enhanced. Laser disks are analog, not digital technologies. Thus, laser disk images cannot be manipulated by computer, but they offer higher resolution with more flexible programming than their CD-ROM counterparts. Laser disk technologies have not gained the same commercial distribution as CD-ROM technologies and are used mostly by artists and image professionals. A number of designers build their CD-ROMs using the popular software package called MacroMedia Director. They can have it programmed in C Code, which runs faster.

28. Ibid., Stephen Wilson.

29. Support for the groundwork development of virtual reality technology originally grew out of a complex of military needs (flight simulators, computer animation, robotic image recognition, ray tracing, texture mapping; motion control; robotic image recognition; image recognition), and the video games entertainment industry.

30. I am indebted to Myron Kreuger for this note. Computer-controlled responsive environments date to the 1969 work by Dan Sandin and Myron Kreuger at the University of Wisconsin around the same time as the PULSA group at Yale led by Patrick Clancy created large-scale outdoor environments. Aaron Marcus created an interactive symbolic computer graphic environment in the early 1970s. Through a grant from the NEA, Dan Sandin, Tom Defanti, and Gary Sayers at the University of Illinois invented the data glove. Mike McGreevey was involved in the original development of the head-mounted display used at NASA. Early development involved the work of many artists, especially musicians Jaron Lanier and Tom Zimmerman.

31. Quoted in Myron W. Krueger, "The Artistic Origins of Virtual Reality", *Siggraph Visual Proceedings, 1993*, ACM, New York.

32. Myron W. Krueger, Ibid.

33. Ibid., Barbara Bliss Osborne.

34. Prior to her work at Banff, Tony Dove worked with multiple computer-programmed slide projection and laser disks controlled video projections on 3-D scrims. Her performance/installation works included sound and text.

35. Tony Dove, "Theater Without Actors: Immersion and Response in Installation," *Leonardo*, 27(4) 1994, pp. 281–287.

36. Ibid.

37. Ibid.

Chapter 6

1. See *Harper Magazine* "Forum," "What Are We Doing On-Line," August 1995.
2. Ibid.
3. Internet, the communications "highway," was established with government funds in 1969 primarily to handle defense data. In 1984 the scientific community began data transmission and exchange on it. Now it has become the focus of a major shift in telecommunications and the centerpiece of market economies which are based on information exchange, financial services, software development, and communications markets of all kinds.
4. By dialing an "online" service number, you can be connected to the Net through simple communications software that allows you to pass transparently from computer to computer as you browse, sometimes passing through a more powerful machine (possibly in another country) that enables you to receive a great magnitude of informational possibilities if you know what to ask for or if you know the code. New terminology is arising describing spaces for meeting; for example, a MUD (Multi-User-Dungeon) is accessed through a piece of multiuser software to where many others are "logged on" for a text-based dueling session . . . MOOs (Object-Oriented MUDs) are work group area elaborations both public and private. Experiments with adding sound to text in the MOO space have proven effective in providing an additional lift to communications. Full-screen images will only be possible through the Net once it becomes the broad-band fiber-optic highway now under development by commercial interests. One of the excitements of the Net at the moment is its very freedom, its relative inexpensive functionality, its open-endedness for international e-mail communications and for USENET, a bulletin board that serves millions of users.
5. The neologism "télématique" was coined by Simon Nora and Alain Minc in L'information de la Société (Paris: La Documentation Française), 1978. It is the branch of information technology which deals with the long-distance transmission of computerized information.
6. Quoted in George P. Landow *Hypertext: The Convergence of Contemporary Critical Theory and Technology* (Baltimore and London: 1992) The Johns Hopkins University Press.
7. Quoted in Roy Ascott, "Is There Love in the Telematic Embrace"; H. R. Muturana and F. J. Varela, "The Tree of Knowledge: The Biological Roots of Human Understanding," 1987.
8. Honolulu: Vancouver; San Francisco; Pittsburgh; Toronto; Alma, Quebec; Bristol; Paris; Amsterdam; Vienna; Sydney.
9. Roy Ascott, "Art and Education in the Telematic Culture" *Leonardo*, 1988 Op Cit, p. 10.
10. Ibid., p. 10.
11. Sherrie Rabinowitz in "Defining the Image as Space: A Conversation with Kit Galloway, Sherrie Rabinowitz and Gene Youngblood" *High Performance Magazine*, Issue 37, 1987.
12. Darlene Tong, "New Art Technologies: Tools for a Global Culture" *Art Documentation*, 12 (3): 116, Fall 1993, Bulletin of the Art Libraries Society of North America.
13. More than 60 locations worldwide including Russia, France, Germany, Britain, Canada, Japan, Nicaragua, and South Africa.
14. Nam June Paik, quoted by Laura Foti in Lynette Taylor "We Made Home TV," *Art Com* #23, 6 (3), 1984.
15. In 1986, Paik produced *Bye-Bye Kipling*, jumping live via satellite communications networks in real time from Tokyo and Seoul to New York as a way of challenging Kipling's East and West dictum: "Never the twain shall meet." In 1988, he produced *Wrap Around the World*—an Olympics tribute, broadcast live from three

continents. Paik worries about how people perceive each other in a world that television is constantly reducing to the long-promised (or threatened) "global village."

16. Douglas Davis in 1977 produced the first global satellite performance.

17. Anna Couey "Art Works as Organic Communications Systems," *Leonardo*, 24 (2): 1991, p. 127.

18. *Art Com* is structured in collaboration with Nancy Frank, Anna Couey, Donna Hall, Darlene Tong, Lorna Truck, and the Whole Earth 'Lectronic Link (WELL) as well as Matthew McClure and John Coate.

19. *Art Com* is a monthly periodical within the context of contemporary art and new communications technology with rotating editors. It "is available in ACEN's Newsstand and in alt. artcom, an internationally distributed USENET news group. It is also electronically mailed free of charge upon request to ACEN readers and to readers on other networks. *Art Com* magazine attempts to realize publishing as a creative (art publishing as art work) and communicative medium shaped by the community that reads it." Couey, Ibid., p. 127.

20. New forms of electronic art technologies include such activities as artists' online networks, satellite transmissions, telefacsimile projects, addressable and interactive video and computer works, and most recently, virtual reality. Telecommunications imply electronic transmission of information through computer networks, slow-scan video, telephone, radio, television and satellites.

21. The electronic edition of *Art Com* magazine is available on ACEN (Art Com Electronic Network) "It attempts to realize publishing as a creative (art publishing as art work) and communicative medium shaped by the community that reads it."

22. CU-SEE ME which transmits live digitized video without audio. Developed at Cornell University, live black and white video can be received in a small screen format at 24 frames per second on a regular or Audiovisual MacIntosh and PC with a standard modem and telephone line. To send a video, one only needs a video camera, and a video card capture. The CU SEE-ME software has special significance for the Global School Net Foundation which is designed to integrate Internet tools into the science curriculum. This live six-image window teleconferencing tool simultaneously links students at several schools and allows others at 20 different sites to work on joint projects such as field testing of environmental pollution. Weekly meetings via Internet are scheduled, research results and information are compared while special speakers are sometimes invited to discuss. Although sound is still not available in this program, the fact that students must so far type in their comments, does not diminish the immediacy and excitement of live communication with others. CU-SEE ME software is available for research and educational purposes by e-mail from Cornell University. A video spigot is a video card. Super Mac Digital Video card and Nippon's Telecamera hooked to the computer will get you in business for using the software. The Global School Net Foundation is a twenty-year-old nonprofit organization that has spawned the Global Schoolhouse Project (GSOP) which began in 1992 in schools in Knoxville, TN, Arlington, VA; Oceanville, CA; and London. Many more schools will soon be integrated.

23. From an unpublished text prepared by Lowry Burgess "On Synchronous-Multidraft/Multidrift—Animated-Networked—Gestalts Within the Walls, Avenues, Plazas, Boundaries and Edges of the Net."

24. Quoted in Patricia Thompson "The MBONE's Connected to the Backbone: Video on the Internet" *The Independent*, January–February 1994, pp. 60 and 61.

25. Broadband cable TV lines are capable of transmitting information as much as 1000 times faster than telephone lines do. By connecting the Internet to cable lines, the present telephone bandwidth constraints which prevent transmission of full-motion digitized video and CD-quality sound, over the Internet, can

finally be overcome. Cable modems (broadband) will run at speeds of 10 Mbps (10,000 kbps) and up by contrast with most telephone lines for which the bandwidth roughly corresponds to the 28.8 kbps of the best currently available modems. (This development is already spurring the telephone companies to develop new circuitry and data compression algorithms which promise to provide bandwidths competitive with those offered by cable.) High speed services will start on a regional basis, at first as a series "niche" programs for specialized audiences until broadband is available to a wider audience of potential users. The introduction of cable modems will make possible the convergence of television with computers and the Internet.

26. P. 236 Walter Benjamin "The Work of Art in the Age of Mechanical Reproduction", op. cit, Introduction.

27. P. 243 Roy Ascott, *CAA Journal* 49(3) Fall 1990 Computers and Art, "Issues of Content," guest editor, Terry Gips.

28. The original installation was in conjunction with Chicago's Randolph Street Gallery and the Chicago Cultural Center where it was seen by 80,000 visitors in 1994. It was later exhibited in Leipzig and Bucharest.

29. Howard Bloch, Carla Hesse, Introduction, "Representations" #42 University of California Press, Spring 1993, p. 10.

30. Ibid., p. 10.

31. List on-line Art Nets

32. Quoted in Darlene Tong, "Representations" #42 University of California.

33. Phil Patton, "The Pixels and Perils of Getting Art On-Line" *The New York Times*, 8/7/94.

34. *New York Times*, 4/7/95.

35. Ibid.

36. The National Gallery and the Tate in London; the Louvre and the Beaubourg in Paris; the National Gallery in Washington are representative of the rush to digitize their collections via interactive CD-ROM or laser disks. The latter can hold up to 2000 images but is an analog medium rather than a manipulable digital one and unlike its digital counterpart, cannot be sent down the information highway. Laser disk technology represents higher resolution for images but never became a consumer item. Rather it is used by film buffs and art professionals to view or produce their work.

37. Jonathan Crary, "Eclipse of the Spectacle," *Art After Modernism: Rethinking Representation*," The New Museum, ed., Marcia Tucker, 1984, p. 286.

38. Ibid., p. 286.

39. P. 59, Johnathan Crary, "Critical Reflections", ARTFORUM, February, 1994.

40. Stephen Wilson, "Light and Dark Visions," *Siggraph* catalog 1993.

41. Theodore Roszak, "The Cult of Information" (New York: Pantheon, 1986), p. 16.

42. "Inside Cyberspace," Transmitted 94-10-30 14:23 EST *Time* Magazine On-Line.

43. *New York Times* 3/1/95.

44. Because of the tremendous commercial potential opened up by the integration of telephones, computers and online services, new solutions are in an advanced stage of readiness and will be appearing on the market by 1998. One of these takes advantage of the coaxial cable services, long available in most urban areas to bring multiple TV channels into the home. With the recent deregulation of the cable industry these will bring online services into the home with transmission rates of 10,000 kb/s or more. They will do this using Hybrid Fiber Coax (HFC) technology which is based on ultrahigh capacity optic fiber to the curb, coax cable to the house, and a special cable modem to the computer. Not to be outdone, the telephone companies are now readying their competing technology, ADSL (Asymmetric Digital Subscriber Lines), which will use data compression

and other advanced technologies to provide transmission rates comparable to cable modems but using existing telephone lines, (in which the telephone companies have a huge investment) including the twisted pair copper wire which brings the service from the curb to the home. A disadvantage shared by both cable modem and ADSL is that the high transmission rates will apply to incoming data with upstream rates from the home to the Internet being perhaps 50 times slower. In any event, there is no end in sight for the future expansion of interactive online services which will be available to the artistic community and others.

Chapter 7

1. Celeste Olalquiaga, *Megalopolis: Contemporary Cultural Sensibilities* (Minneapolis: University of Minnesota Press, 1992).
2. Laurie Anderson, *Stories from the Nerve Bible* a multimedia performance work which began at the Neil Simon Theater in New York and traveled to other cities including Boston and Chicago.
3. *Illuminations*, "Theses on the Philosophy of History," completed in the spring of 1940, first published in *Neue Rundschau 61* in 1950, pp. 257–258.
4. Laurie Anderson *Stories from the Nerve Bible Retrospective 1972–1992* (New York: Harper Perennial, 1994), p. 282.
5. "Light and Dark Visions: The Relationship of Cultural Theory to Art That Uses Emerging Technologies," *Siggraph '93* catalog, pp. 175–184 (a document released uncopyrighted on the Internet). Ibid. For this argument I am indebted to Stephen Wilson.
6. Marshall McLuhan and Quentin Fiore, *The Medium Is the Message* (New York; Bantam Books, 1967).
7. Mumford (1895–1990) argued that humanity's only hope lies in a return to human feelings and sensitivities and to moral values. Among his books are "Technics and Civilization" (1934); "The Transformations of Man" (1956); "The Conduct of Life" (1951); "The City in History" (1961).
8. Joseph J. Corn, "Epilogue," in *Imagining Tomorrow: History, Technology and the American Future* (Cambridge, Mass.: The MIT Press, 1986), p. 227.
9. Kuhn
10. Steven Durland "Artist of the Future," *High Performance Magazine*, Winter, 1989.
11. Olalquiaga, Ibid.
12. Michael Newman, "Revising Modernism, Representing Postmodernism: Critical Discourses of the Visual Arts," in *ICA Documents #4, Postmodernism* (London: Institute of Contemporary Arts, 1986), p. 50.
13. Susan Sontag, *On Photography* (New York; Delta Books, 1973), p. 186.
14. Wilson, Ibid.
15. Steven Durland, "Art 21: The Future of Art?" *High Performance Magazine*, Summer, 1994.
16. Olalquiaga, Ibid.
17. From the foreword in the exhibition catalog, by Richard Koshalek, *A Forest of Signs: Art in The Crisis of Representation*, 1989.
18. John Hanhardt curated the video.
19. Charles Hagen, *New York Times*, 7/11/95.
20. *Blade Runner*, 1982, adapted from Philip K. Dick's novel *Do Androids Dream of Electric Sheep* directed by Ridley Scott (Alien), starring Harrison Ford as Deckard.
21. For this discussion, I am indebted to Giuliana Bruno's essay "Ramble City: Postmodernism and Blade Runner," from Annette Kuhn *Alien Zone: Cultural Theory and Contemporary Science Fiction Cinema*, London, Verso, 1990.

22. Bruno, Ibid.
23. "Reality Bytes: Andrew Huktrans Talks with Kathryn Bigelow," *artforum*, XXXIV, No. 3, Nov. 1995, pp. 78–81.
24. *New York Times* 10/20/95.
25. It has been in existence since 1977, when two organizations coalesced: City Walls (which sponsored large outdoor murals by prominent artists) and the Public Arts Council (which coordinated placement of sculpture in city spaces). Artists wishing to participate in the Fund's programs apply by writing a project proposal which is then reviewed by the advisory board. The many artists on this board help to keep the level of the work innovative and of a high quality. However, these "high art" projects are a considerable distance from community-based ones such as those sponsored by City Arts which brings artists in direct contact with community people to help them visualize and announce their goals, generally through mural projects as a method for coalescing community spirit and pride.
26. Alan Riding, "Politics, This Is Art. Art, This Is Politics," *New York Times*, 8/10/95.
27. Gayatri Sinha, "Between Past and Present," *Hindustani Times*, 1/7/95.
28. Michael Kimmelman, "Suddenly I Have Hundreds of Friends," *New York Times* 8/14/94.
29. Thomas McEvilley, *Art and Discontent: Theory at the Millennium*, Documentext, McPherson and Co., Kingston, N.Y., 1991.
30. Donna J. Haraway *Simians, Cyborgs, and Women: Re-Inventing Nature*, (New York: Routledge, 1991).
31. For Aristophanes' complete parable, see *Symposium*, 189b–192e (pp. 542–544), in "The Collected Dialogues of Plato," ed. Edith Hamilton and Huntingdon Cairns, Princeton University Press, 1985 reprint (first edition, 1961).

Bibliography

Books

ALPERS, SVETLANA. *The Art of Describing: Dutch Art in the 17th Century.* Chicago: University of Chicago Press, 1983.

ANDERSON, LAURIE. *Stories from the Nerve Bible Retrospective 1972–92.* New York: Harper Perennial, 1994.

APPOGNANESI, LEIA, and BENNINGTON, GEOFF. *Postmodernism.* London: ICA Documents 5, 1986.

ARAC, JONATHON, ed. *Postmodernism and Politics: Theory and History of Literature. Vol. 28.* Minneapolis: University of Minnesota Press, 1986.

ARMES, ROY. *On Video.* London: Routledge, 1988.

ARNHEIM, RUDOLF, *Toward a Psychology of Art.* Berkeley & Los Angeles: University of California Press, 1966.

———. *Visual Thinking.* Berkeley & Los Angeles: University of California Press, 1969.

ASHTON, DORE, *American Art since 1945.* New York: Oxford University Press: 1982.

———. *The New York School: A Cultural Reckoning.* New York: Penguin Books, 1985.

BARTHES, ROLAND, *Elements of Semiology.* New York: Hill and Wang, 1980.

———. *Mythologies.* New York: Hill & Wang, 1972.

———. *S/Z.* Paris; Editions du Seuil, 1970. Trans. by Richard Miller. New York: Hill and Wang, 1974.

———. *Image-Music-Text.* Trans. by Stephen Heath. New York: Hill and Wang, 1977.

BATTCOCK, GREGORY, *The New Art* (revised). New York: E.P. Dutton, 1973.

———. *New Artists Video.* New York: E.P. Dutton, 1978.

BAUDRILLARD, JEAN, *Selected Writings.* ed. Mark Poster. Stanford, CA: Stanford University Press, 1988.

———. *The Ecstasy of Communication.* New York: Autonomedia, 1988.

———. *In the Shadow of the Silent Majorities: Or the End of the Social, and Other Essays.* New York: Semiotext(e), 1983.

———. *The Transparency of Evil: Essays on Extreme Phenomena.* London: Verso, 1993.

BAZIN, ANDRÉ, *What Is Cinema?* Berkeley & Los Angeles: University of California Press, 1968.

BECKER, CAROL, and WIENS, ANN, eds. *The Artist in Society: Rights, Roles and Responsibilities.* Chicago: New Art Examiner Press, 1994.

BENDER, GRETCHEN, and DRUCKREY, TIMOTHY, eds. *Culture on the Brink: Ideologies of Technology.* Seattle, WA: Bay Press, 1994.

BENEDICT, MICHAEL, ed. *Cyberspace: First Steps.* Cambridge, MA: MIT Press, 1991.

BENJAMIN, WALTER. *Illuminations.* New York: Schocken Books, 1978.

_____. *On Walter Benjamin: Critical Essays and Recollections.* ed. Gary Smith. Cambridge, MA: MIT Press, 1988.

_____. *Reflections: Essays, Aphorisms, Autobiographical Writings.* ed. Peter Demetz. New York: Schocken Books, 1986.

_____. *Understanding Brecht.* New York: Verso, 1988.

BERGER, JOHN, *About Looking.* New York: Pantheon Books, 1980.

_____. *Permanent Red—Essays in Seeing.* London: Writers & Readers Publishing Cooperative, 1979.

_____. *Ways of Seeing.* London: B.B.C. and Penguin Books, 1981.

BERNSTEIN, JEREMY. *The Analytical Engine: Computers—Past, Present and Future.* New York: Random House, 1963.

BISHTON, DEREK, CAMERON, ANDY, and DRUCKREY, TIM, eds. *Ten 8: Digital Dialogues.* Vol. 2, Autumn, 1991. Birmingham: Ten 8 Ltd, 1991.

BURGIN, VICTOR. *The End of Art Theory; Criticism and Postmodernity.* Atlantic Highlands, NJ: Humanities Press International Inc., 1986.

BURNHAM, JACK. *Beyond Modern Sculpture.* London: Brazillier, 1968.

_____. *The Structure of Art.* New York: Brazillier, 1971.

COKE, VAN DEREN. *The Painter and the Photograph.* Albuquerque: University of New Mexico Press, 1974.

CONNOR, STEVEN. *Postmodern Culture: An Introduction to Theories of the Contemporary.* Oxford: Basil Blackwell Ltd, 1989.

CORN, JOSEPH J., ed. *Imagining Tomorrow: History, Technology and the American Future.* Cambridge, MA: The MIT Press, 1986.

CORN, JOSEPH, and HARRIGAN, BRIAN. *Yesterday's Tomorrows.* New York: Summit, 1984.

CRARY, JONATHAN. *Techniques of the Observer: On Vision and Modernity in the Nineteenth Century.* Cambridge, Massachusetts: MIT Press, 1990.

CRIMP, DOUGLAS, *On the Museum's Ruins.* Cambridge, MA: MIT Press, 1993.

CUBITT. *Videography.* Boston: St. Martin's Press, 199.

D'AGOSTINO, PETER. *Transmission: Theory and Practice for a New Television Aesthetics.* New York: Tanam Press, 1985.

DAVIS, DOUGLAS. *Art and the Future.* New York: Prager Publishers, 1974.

_____. *Artculture.* New York: Harper & Row, 1977.

DAVIS, DOUGLAS, and SIMMONS, ALLISON, eds. *The New Television: A Public/Private Art.* Cambridge, MA: MIT Press, 1977.

DE BORD, GUY. *The Society of the Spectacle.* New York: Zone Books, 1994.

DE LAURETIS, TERESA, HAYSSEN, ANDREAS, and WOODWARD, KATHLEEN, eds. *The Technological Imagination.* Madison, WI: Coda Press, 1980.

D'HARNONCOURT, ANNE, and McSHINE, KYNASTON, eds. *Marcel Duchamp.* New York: Museum of Modern Art, 1973.

DUBERMAN, MARTIN. *Black Mountain: An Exploration in Community.* New York: E. P. Dutton, 1972.

DUPUY, JEAN. *Collective Consciousness: Art Performance in the Seventies.* New York: Performing Arts Journal Publications, 1980.

EAGLETON, TERRY. *Walter Benjamin: Or Towards a Revolutionary Criticism.* London: Verso, 1981.

_____. *Ideology: An Introduction.* London: Verso, 1991.

_____. *Literary Theory: An Introduction.* Minneapolis: University of Minnesota Press, 1983.

ELLUL, JACQUES. *The Technological Society.* New York: Alfred Knopf, 1967.

EWEN, STUART, and EWEN, ELIZABETH. *Channels of Desire.* New York: McGraw-Hill, 1982.

FELSHIN, NINA, ed. *But Is It Art? The Spirit of Art as Activism.* Seattle, WA: Bay Press, 1995.

FERGUSON, RUSSELL, OLANDER, WILLIAM, TUCKER, MARCIA, and FISS, KAREN, eds. *Discourses: Conversations in Postmodern Art and Culture.* Cambridge, MA: MIT Press, 1992.

FLORMAN, SAMUEL C. *Blaming Technology: The Irrational Search for Scapegoats.* New York: St Martin's Press, 1981.

FOLEY, JAMES, and VAN DAM, ANDRIES. *Fundamentals of Interactive Computer Graphics.* Reading, MA: Addison-Wesley, 1982.

FORESTA, DON. *Monde Multiples.* Paris: Editions Bas FEMIS, 1991.

FOSTER, HAL, ed. *The Anti-Aesthetic: Essays on Postmodern Culture.* Port Townsend, WA: Bay Press, 1983.

_____. ed. *Dia Art Foundation Discussions in Contemporary Culture #1.* Seattle, WA: Bay Press, 1987.

FOUCAULT, MICHEL, *Order of Things.* New York: Pantheon Books, 1970.

_____. *The Archaeology of Knowledge: And the Discourse on Language.* New York: Pantheon Books, 1972.

FRAMPTON, HOLLIS. *Circles of Confusion.* Rochester, NY: Visual Studies Workshop, 1983.

FRANCKE, H. W. *Computer Graphics/Computer Art.* London: Phaidon, 1971.

FRANK, PETER, and MCKENZIE, MICHAEL. *New, Used and Improved: Art for the 80s.* New York: Abbeville Press, 1987.

FRASCINA, FRANCIS, and HARRISON, CHARLES, eds. *Modern Art and Modernism.* New York: Harper & Row, 1982.

FULLER, BUCKMINSTER. *Operating Manual for Spaceship Earth.* Carbondale: Southern Illinois University Press, 1969.

FULLER, PETER. *Beyond the Crisis in Art.* London: Writers & Readers Publishing Coop, Ltd., 1980.

_____. *Seeing Berger: A Revaluation,* 2nd ed, London: Writers & Readers Publishing Coop, 1981.

GABLIK, SUZI. *The Re-enchantment of Art.* New York: Thames & Hudson, 1991.

_____. *Progress in Art.* New York, Rizzoli, 1980.

GAGGI, SILVIO. *Modern/Postmodern: A Study in Twentieth Century Arts and Ideas.* Philadelphia: University of Pennsylvania Press, 1989.

GENDRON, BERNARD. *Technology and the Human Condition.* New York: St. Martin's Press, 1977.

GERNSHEIM, HELMUT, and GERNSHEIM, ALISON. *The History of Photography.* New York: McGraw-Hill, 1969.

GIEDION, SIEGFRIED. *Mechanization Takes Command.* New York, Oxford University Press, 1948.

GILL, JOHANNA. *Video: State of the Art.* New York: Rockefeller Foundation, 1976.

GILLETTE, FRANK. *Between Paradigms.* New York: Gordon & Breach, 1973.

GOLDBERG, ROSELEE. *Performance Art: From Futurism to the Present.* New York: Harry N. Abrams, 1988.

GOMBRICH, E. H. *The Story of Art.* London: Phaidon Press, 1950.

GOODMAN, CYNTHIA. *Digital Visions: Computers and Art.* New York: Harry N. Abrams, 1987.

GRAHAM, DAN. *Video-Architecture-Television.* New York: Press of N.S. College of Art and Design and New York University Press, 1979.

GRAHAM, F. LANIER. *Three Centuries of French Art.* Norton Simon Inc. Museum of Art, 1973.

GRUNDBERG, ANDY GRAUS, and MCCARTHY, KATHLEEN. *Photography and Art: Interaction since 1946.* New York: Abbeville Press, 1987.

HALL, DOUG, and FIFER, SALLY JO, eds. *Illuminating Video: An Essential Guide to Video Art.* New York: Aperture Foundation Inc., 1990.

HAMILTON, EDITH, and CAIRNS, HUNTINGDON, eds. *The Collected Dialogues of Plato.* Princeton, NJ: Princeton University Press, 1985, (1965).

HARAWAY, DONNA J. *Simians, Cyborgs and Women: The Reinvention of Nature.* New York: Routledge, 1991.

HAUG, W. F. *Critique of Commodity Aesthetics, Appearance, Sexuality and Advertising in Capitalist Society.* Minneapolis: University of Minnesota Press, 1986.

HAWKES, TERENCE. *Structuralism and Semiotics.* Berkeley and Los Angeles: University of California Press, 1977.

HAYNES, DEBORAH. *The Vocation of the Artist.* Cambridge: Cambridge University Press, 1996.

HEIDEGGER, MARTIN. *The Question Concerning Technology and Other Essays.* New York: Harper & Row, 1977.

HERTZ, RICHARD. *Theories of Contemporary Art.* Englewood Cliffs, NJ: Prentice-Hall, 1985.

HERTZ, RICHARD, and KLEIN, NORMAN M., eds. *Twentieth Century Art Theory: Urbanism, Politics and Mass Culture.* Englewood Cliffs, NJ: Prentice Hall, 1990.

IVINS, WILLIAM M. *Prints and Visual Communication.* New York: Da Capo Press, 1969.

JAMESON, FREDERIC. *Postmodernism: The Cultural Logic of Late Capitalism.* Durham, NC: Duke University Press, 1991.

JAMMES, ANDRÉ. *William H. Fox Talbot.* New York: Collier Books, 1973.

KAHN, DOUGLAS. *John Heartfield: Art and Mass Media.* New York: Tanam Press, 1985.

KEINERY, JOHN G. *Man and the Computer.* New York: Scribners, 1972.

KEMP, MARTIN. *The Science of Art: Optical Themes in Western Art from Brunelleschi to Seurat.* New Haven, CT: Yale University Press, 1990.

KEPES, GYORGY. *Language of Vision.* Chicago: Paul Theobald, 1951.

————. *The New Landscape in Art and Science.* Chicago: Paul Theobald, 1956.

KERN, STEPHEN. *The Culture of Time & Space 1880–1918.* Cambridge, MA: Harvard University Press, 1983.

KLINGENDER, FRANCIS D. *Art and the Industrial Revolution.* New York: Augustus M. Kelley, 1968.

KLÜVER, BILLY, MARTIN, JULIE, and ROSE, BARBARA, eds. *Pavilion—Experiments in Art and Technology.* New York: E.P. Dutton & Co., 1972.

KNOWLTON, KEN. *Collaborations with Artists—A Programmer's Reflections.* Amsterdam: North Holland Publishing, 1972.

KOSTELANETZ, RICHARD, ed. *Moholy-Nagy.* New York: Prager Publishers, 1977.

————, ed. *Esthetics Contemporary.* Buffalo, NY: Prometheus Books, 1978.

KRUEGER, MYRON. *Artificial Reality.* Reading, MA: Addison-Wesley, 1983.

KUHN, THOMAS. *The Structure of Scientific Revolutions,* 2nd ed. Chicago: University of Chicago Press, 1970.

LANDOW, GEORGE. *Hypertext: The Convergence of Contemporary Critical Theory and Techonology.* Baltimore, MD: Johns Hopkins Press, 1992.

LANHAM, RICHARD A. *The Electronic Word: Democracy, Technology, and the Arts.* Chicago: University of Chicago Press, 1993.

LAWLER, JAMES R., and MATHEWS, JACKSON, eds. *Paul Valéry—An Anthology.* Princeton, NJ: Princeton University Press, 1977.

LEAVITT, RUTH, ed. *Artist and Computer.* New York: Harmony Books, 1976.

LUCIE-SMITH, EDWARD. *Art in the Seventies.* Ithaca, NY: Cornell University Press, 1983.

LINEHAN, THOMAS E., ed. *Visual Proceedings: The Art and Interdisciplinary Programs of Siggraph '93.* New York: ACM Siggraph, 1993.

LYOTARD, JEAN-FRANÇOIS. *The Postmodern Condition: A Report on Knowledge.* Minneapolis: University of Minnesota Press, 1984.

MACCABE, COLIN. *Godard: Images, Sounds, Politics.* Bloomington: Indiana University Press, 1980.

_____, ed. *High Theory/Low Culture.* New York: St. Martin's Press, 1986.

MCEVILLEY, THOMAS. *Art and Discontent: Theory at the Millennium.* Kingston, NY: McPherson & Co., 1991.

MCHALE, BRIAN. *Constructing Postmodernism.* London and New York: Routledge, 1992.

MCLUHAN, MARSHALL. *Gutenberg Galaxy.* Toronto: University of Toronto Press, 1962.

_____. *The Mechanical Bride: Folklore of the Industrial Man.* Boston: Beacon Press, 1967.

_____. *Understanding Media: The Extensions of Man.* New York: McGraw-Hill, 1964.

MAGNENAT-THALMANN, NADIA, and THALMAN, DANIEL. *Computer Animation—Theory and Practice.* Tokyo, Berlin, Heidelberg, New York: 1985.

MALINA, FRANK J., ed. *Kinetic Art: Theory and Practice.* New York: Dover Publications, 1974.

MOHOLY-NAGY, SIBYL. *Laszlo Moholy-Nagy: Experiment in Totality.* Cambridge, MA: MIT Press, 1969.

MOLES, ABRAHAM. *Art and Technology.* New York: Paragon House Press.

_____. *Information Theory and Esthetic Perception.* Urbana: University of Illinois Press, 1966.

MONACO, JAMES. *How to Read a Film.* New York: Oxford University Press, 1981.

MONK, PHILIP. *Struggles with the Image: Essays in Art Criticism.* Toronto: YYZ Books, 1988.

MOSER, MARY ANNE, and DOUGLAS MACLEOD, eds. *Immersed in Technology: Art and Virtual Environments.* Cambridge, Massachusettes: MIT Press, 1996.

MUELLER, CONRAD G., and RUDOLPH, MAE, eds. *Life. Light and Vision.* New York: Time-Life Books, 1966.

MUMFORD, LEWIS. *Art and Technics.* New York and London: Columbia University Press, 1952, 6th printing 1966.

_____. *The Myth of the Machine.* New York: Harcourt, Brace & World, 1967.

NEGROPONTE, NICHOLAS. *Being Digital.* New York: Vintage Books (Random House), 1996.

The Architecture Machine: Toward a More Human Environment. Cambridge, MA: MIT Press, 1970.

NELSON, THEODORE. *Dream Machines: Computer Lib.* Chicago: Hugo's Book Service, 1974.

NEWMAN, CHARLES. *The Post-Modern Aura.* Evanston, IL: Northwestern University Press, 1985.

OLALQUIAGA, CELESTE. *Megalopolis: Contemporary Cultural Sensibilities.* Minneapolis: University of Minnesota Press, 1992.

PAPIDAKIS, ANDREAS C. ed. *Post-Avant Garde: Painting in the Eighties.* London: Academy Group, 1987.

PAGGIOLI, RENATO. *The Theory of the Avant-Garde.* Cambridge, MA: The Belknap Press of Harvard University Press, 1968.

PAIK, NAM JUNE. *Art and Satellite.* Berlin: Daardgalerie, 1984.

PARENTI, MICHAEL. *Inventing Reality: Politics of the Mass Media.* New York: St. Martin's Press, 1986.

PARKER, WILLIAM E., ed. *Art and Photography—Forerunners and Influences.* Rochester, NY: Peregrine Smith Books with Visual Studies Workshop Press, 1985.

PENLEY, CONSTANCE, and ROSS, ANDREW, eds. *Technoculture.* Minneapolis: University of Minnesota Press, 1991.

PENNY, SIMON, ed. *Critical Issues in Electronic Media.* Albany, New York: SUNY Press, 1995.

PETERSON, DALE. *Genesis II: Creations and Recreation with Computers.* Reston, VA: Reston, 1983.

POPPER, FRANK. *Art, Action, and Participation.* London; New York: Studio Vista and New York University Press, 1975.

_____. *Origins and Development of Kinetic Art.* London: Studio Vista, 1968.

_____. *Art in the Electronic Age.* New York: Abrams, 1993.

POSTMAN, NEIL. *Amusing Ourselves to Death: Public Discourse in the Age of Show Business.* New York: Viking, 1985.

REFKIN SMITH, BRIAN. *Soft Computing: Art and Design.* Wokingham, England: Addison Wesley, 1984.

REICHARDT, JASIA. *The Computer in Art.* London, New York: Studio Vista and Van Nostrand Reinhold, 1971.

_____. *Cybernetics, Art and Ideas.* Greenwich, CT: New York Graphic Society, 1971.

RHEINGOLD, HOWARD. *The Virtual Community: Homesteading on the Electronic Frontier.* Reading, MA: Addison-Wesley, 1993.

RICHARDS, CATHERINE, and TENHAAF, NELL, eds. *Virtual Seminar on the Bioapparatus.* Banff, Alberta: Banff Centre for the Arts, 1991.

RICHTER, HANS. *Dada: Art and Anti-Art.* New York and Toronto: Oxford University Press, 1978.

ROBINSON, RICHARD. *The Video Primer,* 3rd ed. New York: Perigree Books, 1983.

ROCHLITZ, RAINER. *The Disenchantment of Art: The Philosophy of Walter Benjamin.* New York: Guilford Press, 1996.

ROSE, BARBARA. *American Art since 1900: A Critical History.* New York: Praeger, 1967.

ROSENBERG, M.J. *The Cybernetics of Art—Reason and the Rainbow.* New York: Gordon and Breach, 1983.

ROSZAK, THEODORE. *The Cult of Information.* New York: Pantheon, 1986.

RYAN, PAUL. *Cybernetics of the Sacred.* Garden City, NY: Doubleday Anchor, 1974.

SCHARF, AARON. *Art and Photography.* New York: The Penguin Press, 1968.

SCHNEIDER, IRA, and KOROT, BERYL, eds. *Video Art—An Anthology.* New York and London: Harcourt Brace Jovanovich, 1976.

SEKULA, ALLAN. *Photography against the Grain.* Halifax: Press of Nova Scotia College of Art and Design, 1984.

SELZ, PETER. *John Heartfield: Photomontages of the Nazi Period.* 1977.

SHURKIN, JOEL. *Engines of the Mind.* New York: Washington Square Press, 1984.

SIEPMANN, ECKHARD. *Montage: John Heartfield.* West Berlin: Elefanten Press, 1977.

SITNEY, P. ADAMS. *Visionary Film: The American Avant-Garde.* New York: Oxford University Press, 1974.

SMITH, GARY, ed. *Benjamin: Philosophy, Aesthetics, History.* Chicago: Chicago University Press, 1989.

SONTAG, SUSAN. *On Photography.* New York: Delta, 1978.

THACKARA, JOHN. *Design after Modernism.* New York: Thames and Hudson, 1988.

TOFFLER, ALVIN. *Future Shock.* New York: Random House, 1970.

_____. *Previews and Premises.* Boston: South End Press, 1984.

TOMKINS, CALVIN. *Off the Wall.* New York: Penguin Books, 1983.

TOMKINS, CALVIN, and eds. of Time-Life Books, *The World of Marcel Duchamp 1887–1968.* Alexandria, VA: Time-Life Books, 1977.

TOYNBEE, ARNOLD, et al., *On the Future of Art.* New York: Viking, 1970.

TRACHTENBERG, ALAN, ed. *Classic Essays on Photography.* New Haven, CT: Leete's Island Books, 1980.

TUCHMAN, MAURICE. *Art and Technology.* New York: Viking, 1971.

TUCKER, MARCIA, ed. *Art and Representation: Re-Thinking Modernism.* New York: New Museum of Contemporary Art, 1986.

VALÉRY, PAUL, *Aesthetics, the Conquest of Ubiquity.* New York: Pantheon, 1964.

VAN TASSE, DENNIE L., and CYNTHIA L. *The Compleat Computer,* 2nd ed. Chicago; Palo Alto; Toronto: Science Research Assoc. Inc., 1983, 1976.

VARNEDOE, KIRK, and GOPNIK, ADAM. *Modern Art and Popular Culture: Readings in High and Low.* New York: Harry N. Abrams, 1990.

VENTURI, ROBERT, SCOTT-BROWN, DENISE, and IZENOUR, STEVEN, eds. *Learning from Las Vegas: The Forgotten Symbolism of Architectural Form.* Cambridge, MA: MIT Press, 1977.

VICTORUES, PAUL B. *Computer Art and Human Response.* Charlottesville, VA: Lloyd Sumner, 1968.

VIOLA, BILL. *Reasons for Knocking at an Empty House: Writings 1973–1994.* Cambridge: Massachusetts: MIT Press, 1995.

VIRILO, PAUL, and LOTRINGER, SYLVÈRE. *Pure War.* New York: Semiotext(e), 1983.

VITZ, PAUL C., and GLIMCHER, ARNOLD B. *Modern Art and Modern Science The Parallel Analysis of Vision.* New York: Praeger, 1984.

WALLACE, ROBERT, and eds. of Time-Life Books, *The World of Leonardo 1452–1519.* New York: Time-Life Books, 1966.

WALLIS, BRIAN, ed. *Art after Modernism: Re-Thinking Representation.* New York: New Museum, 1984.

WARHOL, ANDY, and HACKETT, PAT. *POPism: The Warhol '60s.* New York: Harper & Row, 1980.

WHEELER, DANIEL. *Art Since Mid-century: 1945 to the Present.* Englewood Cliffs, NJ: Prentice Hall/Vendome Press, 1991.

WILLIAMS, RAYMOND. *The Long Revolution.* London, New York: Chatto & Windus and Columbia University Press, 1961.

————. *Television: Technology and Cultural Form.* New York: Schocken Books, 1975.

WOODWARD, KATHLEEN, ed. *The Myths of Information.* Madison, WI: Coda Press, 1980.

WOOLEY, BENJAMIN. *Virtual Worlds: A Journey in Hype and Hyperreality.* London: Penguin Books, 1993.

YOUNGBLOOD, GENE. *Expanded Cinema.* New York: E.P. Dutton, 1970.

Catalogs

Alternating Currents. New York: Alternative Museum, 1985.

Attitudes/Concepts/Images. Amsterdam: Stedlijk Museum, 1980.

Aurora Borealis. Montreal: Centre International d'Art Contemporain, 1985.

Before Photography. New York: Museum of Modern Art, 1981.

Biennale d'art contemporain de Lyon. Lyon, 1995.

Biennial Exhibition 1985. New York: Whitney Museum of American Art, 1993.

Biennial Exhibition. New York: Whitney Museum of American Art, 1995.

Blam! The Explosion of Pop, Minimalism, and Performance 1958–1964. New York, Whitney Museum of American Art, 1984.

Cadre '84. Computers in Art and Design, Research and Education. San Jose: San Jose State University, 1983.

The Challenge of the Chip. London: Science Museum, 1980.

Comic Iconoclasm. London: I.C.A. (traveling exhibition), 1987–88.

The Committed Print. Text by Deborah Nye. New York: Museum of Modern Art, 1988.

The Computer and Its Influence on Art and Design. Text by Jacqueline R. Lipsky. Nebraska: Sheldon Memorial Art Gallery, University of Nebraska, 1983.

Computer Graphics: Visual Proceedings. New York: ACM Siggraph, 1993.

Cybernetic Serendipity. London: I.C.A., 1968.

Disinformation: The Manufacture of Consent. Text by Noam Chomsky and Geno Rodriguez. New York: Alternative Museum, 1985.

Endgame: Reference and Simulation in Recent Painting and Sculpture. Boston: I.C.A.; MIT Press, 1986.

Energized Artscience. Chicago: The Museum of Science and Industry, 1978.

Film as Film: Formal Experiments in Film 1910–1975. Text by Phillip Drummond. London: Hayward Gallery, 1979.

Frank Gillette Video: Process and Metaprocess. Essay by Frank Gillette. Interview by Willoughby Sharp. Syracuse, New York: Everson Museum of Art, 1973.

German Video and Performance. Text by Wulf Herzogenrath. Toronto: Goethe Institut, 1981.

Gary Hill. Seattle: Henry Art Gallery, University of Washington, 1994.

Image World: Art and Media Culture. New York: Whitney Museum of Art. 1989.

Influencing Machines: The Relationship between Art and Technology. Toronto: Y.Y.Z., 1984.

Information. New York: Museum of Modern Art, 1970.

Iterations: The New Image. Text ed. Timothy Druckrey. New York: International Center of Photography/MIT Press, 1993.

The Kitchen 1974–75. Preface by Robert Sterns. Introduction by Bruce Kurtz. New York: Haleakala, 1975.

Les Immatériaux: Album et Inventaire Epreuves d'Ecritude. Paris: Centre Georges Pompidou, 1985.

Letters to Jill. Pati Hill. New York: Kornblee Gallery, 1979.

Lumières: Perception—Projection. Montreal: Centre International d'Art Contemporain, 1986.

The Luminous Image. Essays by Dorine Mignot, et al. Amsterdam: Stedelijk Museum, 1984.

The Media Arts in Transition. Bill Horrigan, ed. Walker Art Center, NAMAC, Minneapolis College of Art and Design, University Community Video and Film in the Cities, 1983.

Media Post Media. New York: Scott Hanson Gallery, 1988.

MultiMediale 4. Medienkunstfestival des ZKM. Karlsruhe, 1995.

The Museum as Seen at the End of the Mechanical Age. New York: Museum of Modern Art, 1968.

Nam June Paik. Essays by Dieter Renke, Michael Nyman, David Ross, and John Hanhardt. New York: Whitney Museum of American Art, 1982.

National Video Festival. Los Angeles: American Film Institute, 1983.

Nine Evenings: Theatre and Engineering. Text by Billy Klüver. Statements by John Cage, et al. New York: New York Foundation for the Performing Arts, 1966.

On Art and Artists. Chicago: School of the Art Institute of Chicago, 1985.

Photography and Art: Interactions since 1946. New York: Abbeville Press, 1987.

Photography After Photography, Aktionsforum Praterinsel, Munich, 1996.
Printed Art. New York: Museum of Modern Art, 1980 and 1996.

Report on Art and Technology. Text by Maurice Tuchman. Los Angeles: Los Angeles County Museum of Art, 1971.
James Rosenquist. Essay by Judith Goldman. Denver: Denver Art Museum and Viking Penguin, 1985.

The Second Emerging Expression Biennial. New York: Bronx Museum of the Arts, 1987.
The Second Link: Viewpoints on Video in the Eighties. Calgary, Alberta: Banff Center School of Fine Arts, 1983.
Software. Essays by Jack Burham and Theodore Nelson. Introduction by Karl Katz. New York: Jewish Museum, 1970.
Some More Beginnings. New York: E.A.T. in collaboration with the Brooklyn Museum and the Museum of Modern Art, 1968.

Technics and Creativity. New York: Museum of Modern Art, 1971. .
Television's Impact on Contemporary Art. New York: Queens Museum, 1986.
This Is Tomorrow Today: The Independent Group and British Pop Art. New York: P.S. 1, 1987.

United States/Laurie Anderson. New York: Harper & Row, 1984.

Video: A Retrospective 1974–1984. Long Beach, CA: Long Beach Museum of Art, 1984.
Video Spaces: Eight Installations. New York: Museum of Modern Art, 1995.
Vision and Television. Waltham, MA: Rose Art Museum, Brandeis University, 1970.
Bill Viola. Essays by Barbara London, J. Huberman, Donald Kuspit, and Bill Viola. New York: Museum of Modern Art, 1987–88.

Robert Wilson: From a Theater of Images. Cincinnati, OH: Contemporary Arts Center, 1980.

YANG, ALICE. *Cyborg Aesthetics*. Essay for the Exhibition: *The Final Frontier*. New York: New Museum of Contemporary Art, 1993.

Articles

ADAMS, BROOKS. "Zen and the Art of Video." *Art in America*, February, 1984.
ALLOWAY, LAWRENCE. "Talking with William Rubin: The Museum Concept Is Not Infinitely Expandable." *Artforum*, October, 1974.
Art Journal, Fall, 1985. Video Issue.
ArtsCanada, October, 1973. Video Issue.
ASHTON, DORE. "End and Beginning of an Age." *Arts Magazine*, December, 1968.
ATKINS, ROBERT. "The Art World and I Go on Line." *Art in America*, December 1995.
BANGERT, CHARLES, and BANGERT, COLETTE. "Experiences in Making Drawings by Computer and by Hand." *Leonardo 7*, 1974.

BUCHLOCK, BERJAMIN H.D. "Figures of Authority, Ciphers of Regression." *October #16*, Spring, 1981.

BURNHAM, JACK. "Problems in Criticism IX: Art and Technology." *Artforum*, January, 1971.

CORNOCK, STROUD, and EDMONDS, ERNEST. "The Creative Process Where the Artist is Amplified or Superseded by the Computer." *Leonardo 6*, 1973.

COSTELLO, MARJORIO. "The Big Video Picture from Japan: The Future is Projected at Tsukuba Expo '85." *Videography Magazine*, June, 1985.

COUEY, ANNA. "Participating in an Electronic Public: TV Art Effects Culture." *Art Com #25*, 7, 1984.

CRARY, JONATHAN. "Critical Reflections." *ARTFORUM*, February, 1994.

CRIMP, DOUGLAS. "The End of Painting." *October #16*, Spring, 1981.

_____. "Function of the Museum." *Artforum*, September, 1973.

_____. "On the Museum's Ruins." *October #13*, Summer, 1980.

_____. "The Photographic Activity of Postmodernism." *October #15*, Winter, 1980.

DANTO, ARTHUR C. "Art Goes Video." *The Nation*, September 11, 1995.

DAVIS, DOUGLAS. "Art and Technology: The New Combine." *Art in America*, January/February, 1968.

_____. "Video Obscura." *Artforum*, April, 1972.

_____. "The Work of Art in the Age of Digital Reproduction." *Leonardo*, Vol. 28, No. 5, 1995.

DENISON, D.C. "Video Art's Guru." *New York Times*, April 28, 1982.

DIECKMAN, KATHERINE. "Electra Myths: Video, Modernism, Postmodernism." *Art Journal*, Fall, 1985.

DIETRICH, FRANK. "Visual Intelligence: The First Decade of Computer Art (1965–1975)." *Computer Graphics and Applications*, IEEE Computer Society Journal, July, 1985.

E.A.T. *News* 1, nos. 1 and 2, 1967. "New York: Experiments in Art and Technology, Inc."

FINK, DANIEL A. "Vermeer's Use of the Camera Obscura." *Art Bulletin #3*, 1971.

FRIED, MICHAEL. "Art and Objecthood." *Artforum*, Summer, 1967.

FURLONG, LUCINDA. "Artists and Technologists: The Computer as An Imaging Tool." *Siggraph*, 1983 catalog.

_____. "An Interview with Gary Hill." *Afterimage*, March, 1983.

_____. "Notes Toward a History of Image-Processed Video." *Afterimage*, Summer, 1983.

GLUECK, GRACE. "Portrait of the Artist as a Young Computer." *New York Times*, February 20, 1983.

_____. "Video Comes into Its Own at the Whitney Biennial." *New York Times*, April 24, 1983.

_____. "Video Work on Different Wavelengths." *New York Times*, February 26, 1984.

GRAHAM, DAN. "Theatre, Cinema, Power." *Parachute Magazine #31*, June, July, August, 1983.

GRUNDBERG, ANDY. "Beyond Still Imagery." *New York Times*, April 7, 1985.

_____. "Exploiting the Glut of Existing Imagery." *New York Times*, January 31, 1982.

_____. "Images in the Computer Age." *New York Times*, April 14, 1985.

HENDERSON, LINDA DALYRYMPLE. "A New Facet of Cubism: 'The Fourth Dimension' and 'Non-Euclidean Geometry' Reinterpreted." *Art Quarterly*, Winter, 1971.

Heresies 16, 1983. "Film/Video."

HESS, THOMAS B. "Gerbil Ex Machina." *Art News*, December, 1970.

HUYSSEN, ANDREAS. "Mapping the Postmodern (Modernity and Postmodernity)." *New German Critique*, Fall, 1984.

KAPROW, ALLAN. "The Education of the Un-Artist, Parts I and II and III." *Art in America*, February, 1971; May, 1972; and January/February, 1974.
KIRKPATRICK, DIANE. "Between Mind and Machine." *Afterimage*, February, 1978.
KOZLOFF, MAX. "Men and Machines." *Artforum*, February, 1969.
KUSPIT, DONALD. "Dan Graham: Prometheus Mediabound." *Artforum*, May, 1985.

LIPPARD, LUCY and CHANDLER, JOHN. "The Dematerialization of Art." *Arts International* #12, 1968.
LOEFFLER, CARL E. "Television Art and the Video Conference." *Art Com* #23, 6, 1984.

MALLARY, ROBERT. "Computer Sculpture: Six Levels of Cybernetics." *Artforum*, May, 1969.
MAYOR, A. HYATT. "The Photographic Eye." *Bulletin of the Metropolitan Museum of Art*, July, 1946.

New York Times. April 25, 1982. "Video Art's Guru."
NOLL, MICHAEL. "The Digital Computer as a Creative Medium." *IEEE Spectrum*, October, 1967.

OWENS, CRAIG. "Phantasmagoria of the Media." *Art in America*, May, 1982.
_____. "Representation, Appropriation and Power." *Art in America*, May, 1982.

PUNT, MICHAEL. "CD-R OM: Radical Nostalgia?" *Leonardo*. Vol. 28, No. 5, 1995.

REIDY, ROBIN. "Video Effects Art/Art Effects Video." *Art Com* #24, 6, 1984.
RICE, SHELLEY. "The Luminous Image: Video Installations at the Stedlijk Museum." *Afterimage*, December, 1984.
RICHMOND, SHELDON. "The Interaction of Art and Science." *Leonardo* 17, 1984.
RITCHIN, FRED. "Photography's New Bag of Tricks." *New York Times*, November 4, 1984.
ROOT-BERNSTEIN, ROBERT SCOTT. "On Paradigms and Revolutions in Science and Art: The Challenge of Interpretation." *Art Journal, College Art Association of America*, Summer, 1984.

SCHILLER, HERBERT I. "Behind the Media Merger Movement." *The Nation*, June 8, 1985.
SEYMOUR, CHARLES, JR. "Dark Chamber and Light-Filled Room: Vermeer and the Camera Obscura." *Art Bulletin* #46, September, 1964.
SHERIDAN, SONIA. "Generative Systems." *Afterimage*, April, 1972.
_____. "Generative Systems—Six Years Later." *Afterimage*, March, 1975.
STRAUSS, DAVID LEVI. "When Is a Copy an Original?" *Afterimage*, May/June, 1976.
STURKEN, MARITA. "Feminist Video: Reiterating the Difference." *Afterimage*, April, 1985.
_____. "Out of Sync." (Review-Article). *Afterimage*, November, 1983.
_____. "TV As a Creative Medium: Howard Wise and Video Art." *Afterimage*, May, 1984.
_____. "The Whitney Museum and the Shaping of Video Art: An Interview with John Hanhardt." *Afterimage*, May, 1983.

TURNER, FREDERICK. "Escape from Modernism: Technology and the Future of the Imagination." *Harper's Magazine*, November, 1984.

VASULKA, WOODY and NYGREN, SCOTT. "Didactic Video: Organizational Models of the Electronic Image." *Afterimage*, October, 1975.

WEST, SUSAN. "The New Realism." *Science '84*, July/August, 1984.
WOHLFARTH, IRVING. "Walter Benjamin's Image of Interpretation." *New German Critique*, Spring, 1979.

INDEX